PRAISE FOR

Oscar Micheaux: The Great and Only

"It's rare that any life can make such a fascinating story, and Patrick McGilligan's *Oscar Micheaux* packs as much narrative thrust and foolhardy behavior as a biographer (or even novelist) could hope for."
—*Time Out* (New York)

"[An] exceptional new biography. . . . [McGilligan] leaves no source untapped in his comprehensive account." —*BookPage*

"Amazing. . . . Opens a door into a secret past, the world of black Hollywood." —Allen Barra, *American Heritage*

"As Micheaux's films have been unearthed in such far-flung places as Brussels and Tyler, Texas, it is hoped that more may be discovered. For now we have this book, with its compelling perspective on his life and career." —David Ehrenstein, *Los Angeles Times*

"In Patrick McGilligan's riveting biography . . . Micheaux's story is told in voluminous and intricate detail. McGilligan . . . uses public and private records to get into the mind of the legendary black filmmaker."
—Eugene Kane, *Milwaukee Journal Sentinel*

"A culminating work." —Carl Rollyson, *New York Sun*

"Highly recommended." —*Library Journal*

"McGilligan does a fine job of reaffirming Micheaux's significance beyond the appreciation of cineastes." —*Publishers Weekly*

"Micheaux, as this thorough text makes clear, was far ahead of his time."
—*Pittsburgh Post-Gazette*

"A well-researched, passionately felt, and endlessly fascinating look at a singular American life." —*Kirkus Reviews* (starred review)

"McGilligan has made this incredible, half-forgotten life newly available to us all." (London)

"In the skilled hands of Patrick McGilligan, Oscar Micheaux's life story bristles and takes flight."

—Pearl Bowser, coauthor of *Writing Himself into History: Oscar Micheaux, His Silent Films, and His Audiences*

"An enormously moving and compelling account of a quixotic life defined by arduous toil and perpetual optimism." —*DGA Quarterly*

"Patrick McGilligan's absorbing and compulsively readable biography . . . is an impressive feat of period reconstruction that dares to disentangle the myths of this vital and woefully neglected filmmaker. . . . *The Great and Only* is a valuable addition to Micheaux scholarship."

—*Stop Smiling* magazine

William B. Winburn

About the Author

PATRICK MCGILLIGAN's biographies include the Edgar-nominated *Alfred Hitchcock: A Life in Darkness and Light* and the *New York Times* Notable Books *Fritz Lang: The Nature of the Beast* and *George Cukor: A Double Life.* He has also penned biographies of Clint Eastwood, Jack Nicholson, Robert Altman, and James Cagney, along with the oral history *Tender Comrades: A Backstory of the Hollywood Blacklist* (with Paul Buhle). McGilligan lives in Milwaukee, Wisconsin.

OSCAR MICHEAUX
THE GREAT AND ONLY

THE LIFE OF AMERICA'S FIRST BLACK FILMMAKER

PATRICK McGILLIGAN

HARPER PERENNIAL

NEW YORK • LONDON • TORONTO • SYDNEY • NEW DELHI • AUCKLAND

HARPER ● PERENNIAL

A hardcover edition of this book was published in 2007 by HC, an imprint of HarperCollins Publishers.

HarperCollins books may be purchased for educational, business, or sales promotional use. For information please write: Special Markets Department, HarperCollins Publishers, 10 East 53rd Street, New York, NY 10022.

FIRST HARPER PERENNIAL EDITION PUBLISHED 2008.

Designed by Kris Tobiassen

The Library of Congress has catalogued the hardcover edition as follows:

McGilligan, Patrick.
 Oscar Micheaux : the great and only : the life of America's first great black filmmaker / Patrick McGilligan.
 p. cm.
ISBN 0-06-073139-7
 1. Micheaux, Oscar, 1884–1951. 2. Motion picture producers and directors—
United States—Biography. 3. African-American motion picture producers and directors—
Biography. I. Title.

PN1998.3.M494M34 2007
791.43023'3092—dc22
[B] 2007060735

ISBN 978-0-06-073140-3 (pbk.)

08 09 10 11 12 DIX/RRD 10 8 7 6 5 4 3 2 1

TO MARTIN J. KEENAN,

WHO TOLD ME TO GET GOING AND DO IT

CONTENTS

CHAPTER ONE

1884–1900
METROPOLIS,
ILLINOIS

Most people pronounced his last name "Mee-show," though some who knew him insist it was "Mi-shaw."

The correct pronunciation of his name is only the beginning of the ambiguities and mysteries associated with Oscar Micheaux. He had no middle name, or at least no legal document has ever been found that lists one. He started out in life with a different spelling of his surname: Michaux. Perhaps because his family spoke with a soft, Southern twang, his last name has been transcribed in old newspapers and government records in a host of variations: Maschaur, Measchaur, Mishew, Misher, Mischaux, Mischeux, Mischeaux, Mitcheux.

Usually, if nothing else, the reader of a biography can be assured of the name of the central figure, and the facts of his birth and death. Yet the precise place where Micheaux was born remains elusive. Nor does anyone know the exact circumstances of his death. For decades, even his burial site stayed unmarked and unknown.

It is unclear how many times Micheaux was married, or whether he fathered any children; arguable how much of a fortune he amassed, then squandered; uncertain how many times he went bankrupt, or was arrested, though on the record he suffered bankruptcy and found himself in court on several occasions, for different reasons.

Until now, his life story has never been fully told, partly because he lived a furtive existence. Beyond his pioneering work as a maker of all-black films, he was a pioneering author, though it is unclear how many

books he wrote: seven were published, some first-rate works, others pot-boilers. He wrote both memoirs and fiction, and blended the two freely. He embodied many walks of turn-of-the-century African-American life, fulfilling some roles that were archetypal (shoeshine boy and Pullman porter) and others that were special (South Dakotan homesteader). His most exceptional role was as a leading American filmmaker, who wasn't allowed to set foot in Hollywood because of the racism of his times.

When writing the biography of an important film director, one usually has the motion pictures themselves to watch, study, and appraise. In the case of Micheaux, however, even the simplest questions are still debated: how many films he actually wrote, directed, and produced, even whether some rumored titles made it before the cameras at all. Micheaux scholars concur that only about one third of his output survives today; the actual number of Micheaux pictures known to exist—in any condition—is fifteen, out of a possible forty to forty-five.

Because of such uncertainties, the merits of his movies can be argued. But the films that have been found and restored make it increasingly clear that, in the context of American film history, he deserves to be considered in the same breath as the sainted D. W. Griffith. In an era when black people were ignored or belittled by Hollywood, Oscar Micheaux had to work under remarkably restricted and unheralded circumstances to create his own distinctive body of work. In his determination, he cut legal as well as financial corners. But he possessed both storytelling élan and a social conscience, and drew repeatedly on his own life story to articulate universal themes concerning the black experience, working out deeply personal, iconoclastic feelings about America and his people's place within it.

The stories of Micheaux's life were also stories of his race. He pioneered with his heroes and heroines—idealized black doctors, lawyers, and schoolteachers, but also cowboys and detectives—while salting his stories with warts-and-all villains. His films featured sex, violence, frank language, and situations "adult" enough that any studio in Hollywood would have vetoed them; as he struggled to get them distributed across the country, many censors did just that. (Just the fact his stories took place in a black milieu was enough for many Southern sheriffs to seize prints.) His were among the first films in history to attack lynchings, segregated housing, gambling rackets, corrupt preachers, domestic abuse, criminal profiling by police, and all kinds of racial inequities.

Micheaux was an eager courter of fame and attention, and in his time he became as famous—and controversial—as anyone in the field of so-called "race pictures." Yet he was also a master of privacy and secrets. A self-made man who lived the American dream, who boasted a record of undeniable achievement in spite of the obstacles erected against his race, he also led a shadow existence, forced again and again to scrape together the means to continue; and in the end he was brought to ruin, tragedy, and obscurity.

In the twenty years after his death, his remarkable life of aspiration and struggle and conquest was forgotten. His novels and motion pictures were all but lost. In recent years, his reputation has been resurrected by the painstaking research and passionate advocacy of scholars and educators, white and especially black. Some of his films have been found and restored. Though his name is still unknown to most Americans—even to the most zealous motion picture fans—that is bound to change, because as his publicity claimed, Micheaux was truly "The Great and Only."

Indeed, Micheaux was the Jackie Robinson of American film. No, a Muhammad Ali decades before his time, a bragging black man running around with a camera and making audacious, artistic films of his own maverick style, at a time when racial inferiority in the United States was custom and law.

Grover Cleveland had just been sworn in as president of the United States, the year a baby boy in southern Illinois was christened Oscar Michaux. The Emancipation Proclamation was just over twenty years old, and the hopeful, chaotic period of Reconstruction after the Civil War was ending. It took only that long before the equal rights measures of Reconstruction, fiercely opposed by most white Southerners, were subverted, and an economy once dependent on slave labor was reinvented on a foundation of racist social mores known as "Jim Crow."

Emancipation had freed the Confederate slaves in 1863, and by the time of Appomattox, two years later, Southern roads and rivers were clogged with freed and fugitive slave families streaming northward. Slave families fleeing northwestern Kentucky could simply cross the Ohio River into southern Illinois, in order to pursue their dreams of a better life of opportunity and freedom.

The maternal and paternal branches of Oscar Michaux's family came from adjacent counties in northwest Kentucky, so they might have known each other before they crossed over to Massac County in southern Illinois. The southernmost counties of Illinois—those lying between the Wabash and Mississippi rivers and north of the Ohio River—were commonly known as "Little Egypt," a name that alluded to the fertile farmlands provided by the confluence of rivers, and to the biggest town in the area, Cairo. Both sides of the Michaux family took up farming, the occupation they as ex-slaves knew best.

Besides being close to Kentucky, Illinois boasted a liberal state government. Black people could vote in Illinois by 1870, and in 1874, after a long debate, a statute was enacted protecting their right to attend public schools. Illinois was the land of Abraham Lincoln, after all, and home to Chicago, already a magnet for ex-slaves and soon to become "the freest city in the world for the black man," as Micheaux later wrote.

But Chicago was 375 miles north of Metropolis, and southern Illinois, which had been pro-slavery, wasn't as hospitable. Stephen Douglas received 75 percent of the Massac County vote in the 1860 election, 873 votes to Lincoln's paltry 121. The newspapers ran "nigra" jokes on their front pages, and lynchings were part of the near-Southern environment. Massac County had its share of "night rider" episodes ending in "unsolved" murders, and if Micheaux himself never witnessed the mob murder of a black person, knowledge and fear of such incidents were seared into his consciousness. Wrongful arrests of black people would become a common motif in his films, and the graphic lynching scenes in his work provoked discomfort among censors and sometimes his audiences.

But fully one-third of Massac County's population was German American—most of them first-generation immigrants—and they had swung over to Lincoln and the Federal cause during the Civil War. As the ex-slaves went to work and multiplied in numbers, they formed their own close communities, "colored neighborhoods" where few ventured out of bounds, but some thrived. "Aside from a floating element" considered disreputable, as Massac County historian O. J. Page wrote in 1900, the ex-slaves were accepted as "industrious, and law-abiding," while representing "considerable capital."

Many earned modest livings off the land. This part of southern Illinois abounded with small lakes, timbered hills, and rolling earth with tillable soil. Tobacco and cotton were harvested in Massac County, but the

ground was better for corn, wheat, and oats. Fruits and vegetables could be grown in astonishing variety.

Oscar Micheaux's maternal grandparents, the Gough (or "Goff") family from nearby Graves County, Kentucky, were listed in government records as "black." They settled in southern Illinois as early as 1866, one year after the official end of the Civil War. Their only child, Bell Gough, born into slavery in Kentucky in 1856, would grow up and become the mother of Oscar Micheaux, and the first of the women who shaped and guided his life.

Micheaux's father's parents had relocated from Calloway County, Kentucky. Both David and Melvina Michaux show up in record books as "mulatto"—a significant fact considering Micheaux's lifelong preoccupation in his books and films with the problem of "mulattos" passing as white. Their first son, Calvin Swan Michaux, was born in 1847. "Fair of complexion," as Micheaux later wrote, Calvin grew up as a slave in Kentucky, before coming to Massac County while still in his teens, and meeting Bell Gough there.

The surname Michaux, as Micheaux explained in one of his novels, was probably French in derivation and adopted from the family's Kentucky slave-owner. That slave-owner, in fact, had David Michaux's own father "sold off into Texas during the slavery period," according to Micheaux, and the family lost track of him. Micheaux's paternal grandfather David died in Illinois around 1870, long before Oscar was born.

Though Calvin Swan Michaux and his family lived in Illinois for several decades, other Michauxes didn't last long there. They were a restless clan, always hearing the siren song of the frontier. In the 1870s David Michaux's widow took three of her children to Kansas, joining the Exoduster Movement (a phrase inspired by the Book of Exodus), which found thousands of black Americans heading west after the Civil War. This Kansas branch of the family was the first of the homesteading Michauxes, and successful at that: One of Calvin's brothers, Andrew Jackson Michaux, eventually accumulated seven hundred acres in Barton County and became known as "the richest Negro in Kansas and banker to the black community," according to Karen P. Neuforth, who has researched the Micheaux genealogy definitively. Andrew Michaux would become an early investor in Micheaux's motion picture company.

At least one of David and Melvina Michaux's children went farther west. Edward Michaux moved on to California, turning up in voter rolls

in Oakland in 1892 and 1896, before following his muse and embracing
the back-to-Africa movement, moving overseas to the Republic of
Liberia. Edward died in Monrovia in 1910, with his estate turned over to
an editor of the local English-language publication, *The African League*.
So it is quite possible that Uncle Edward was the first Michaux to em-
brace writing as a profession.

Calvin Michaux and Bell Gough were joined in marriage in Metrop-
olis, Illinois, in 1875, but the first extant deed in the name of Calvin
"Mishew," dated 1872, attests that the twenty-eight-year-old former
slave was already a landowner. He paid six hundred dollars that year for
"the South West quarter of the South East quarter of Section Twenty
Eight (28) in Township Fifteen (15) South Range Five (5) East," a parcel
of land about six miles northwest of Metropolis and the Ohio, in a south-
ern corner of Washington Precinct.*

The origin of the phrase "forty acres and a mule" lies in broken prom-
ises of restitution made to slaves during the Civil War and Reconstruc-
tion, but it was a standard equation used for land purchases by ex-slaves;
it can be fairly speculated that both sides of the Michaux family borrowed
start-up sums of money from the Freedmen's Savings and Trust Co. of
Kentucky. Such a loan would have allowed Calvin Michaux to purchase
his first forty acres. And according to surviving records he did own one
mule, sometimes two.

Ten of Michaux's forty acres were "unimproved" woodland; twelve
were planted with wheat, sixteen with corn, three with other "field prod-
ucts." According to the 1880 and 1881 Assessor's Books, the Michauxes
also owned a horse or two, two cows, six hogs, two dogs, one wagon, one
clock ("Value: 1 dollar"), one sewing machine, agricultural tools ap-
praised at twenty dollars, and household furniture; the total value of their
material goods was estimated at $126 to $130. (Even the mules were ap-
parently of modest account: the Assessor's Books list other neighbors
with mules worth as much as $68, whereas the Michauxes' were valued at

* According to the Bureau of Land Management, a township is a major subdivision of land under
the survey system and is approximately six miles square containing more than 20,000 acres. "A
township is identified by its relationship to a base line and a principal meridian," according to the
BLM website. "The Section Number identifies a tract of land, usually one mile square, within
a township. Most townships contain thirty-six sections. Standard sections contain 640 acres. A
section number identifies each section within a township."

only $35.) Their land was taxed at a value of $220. The Michauxes' net worth was approximately $350.

Into this humble life Oscar Micheaux was born on January 2, 1884, the youngest of five in a family that would eventually have eleven children. He had a sister, Ida, older by eight years, and three elder brothers, William (b. 1878), Lawrence (b. 1879), and Finis (b. 1882). The family would ultimately grow to five sons and six daughters, with the last Michaux child, a boy named Swan, born to Calvin and Bell in 1895.

So much about the vanished world of Oscar Micheaux is difficult to conjure up today. But the hallmarks of his character—optimism, resilience, grit, and pride—were bred early and deep in him. His strengths and values came from his parents who believed in hard work, devotion to family, the rights and responsibilities of the law, the teachings of the Bible, and the higher law of God.

His father Calvin, who could neither read nor write, left the child-rearing to his wife, Bell. From dawn to dusk, Michaux's father had his hands full clearing land of tough, deep-rooted trees, stumps, and rocks. Each season brought a new round of planting, gardening, and harvesting; the marketing was year-round, and hunting and fishing kept food on the family table in between. Calvin Michaux was a paragon of hard work and devotion to others; though he "never said much," according to Micheaux, he offered a shining example.

Oscar's mother carried more of the disciplinary duties, but was also more loving and indulgent toward her middle child than his father was. Uneducated herself, Bell Michaux treasured books and education, and instilled in her children an appreciation for high ideals. Among her heroes was Booker T. Washington, who in 1881 had risen from slavery to become the first head of the newly established Tuskegee Institute, a vocational school for African-Americans; the Great Educator became a family role model.

Even in middle age, Oscar "could quote profusely from [Booker T.] Washington," recalled Carlton Moss, who acted in two Micheaux productions in the early 1930s. "One of his favorites," Moss remembered, was a brief recitation on civil rights, its words part Washington and part Micheaux: "It is true, very true indeed, that the Afro-American does not receive all he is entitled to under the Constitution. Volumes could be filled with the many injustices he has to suffer and which are not right before God and man. Yet, when it is considered that other races in other

countries are persecuted even more than the black man in parts of the United States, there should be no reason why the Afro-American should allow obvious prejudice to prevent his taking advantage of opportunities around him."

One Washington maxim Micheaux liked to quote: "It is at the bottom of life we should begin and not at the top. Nor should we permit our grievances to overshadow our opportunities."

Bell Michaux was a deeply religious woman, baptized a Christian and then "united" at age twelve with the African Methodist Episcopal (A.M.E.) Church, an offshoot of Methodism launched by black Americans in 1787. Bell became a "shouting Methodist," in Micheaux's words: When she began to "get happy" at services, her children knew it was time to steal outdoors. Throughout her life she was active in charity and church affairs. Much of the family's social activity, in Illinois and later Kansas, revolved around church events; especially when they lived in the country, the Michauxes hosted Elders and schoolteachers to Sunday supper.

There is some evidence Oscar Micheaux himself was a deeply religious man. Micheaux was persistently autobiographical in his work, and in his second novel, *The Forged Note,* he describes his alter ego Sidney Wyeth as "a hopeless believer." But he seems not to have maintained a commitment to any particular church, and in his books and films he presented a complex, skeptical attitude toward organized religion, and especially toward preachers, with their "assuming and authoritative airs."

This attitude may have had its roots in an incident in Metropolis, when he was a boy of about five. One Sunday after services, a group of Elders wearing Prince Albert coats and clerical vests came in wagons to visit the Michaux farm, accompanied by one of the family's favorite Sunday schoolteachers. The older brothers went hunting for rabbit and quail to supply the special occasion, and when dinner was served the Elders seemed to devour everything in sight. Afraid he was going to be left out of the feast, little Oscar crawled into the lap of his favorite teacher and began gobbling his share. Suddenly, he found himself staring into the "angry eyes" of a tall, stout minister, whose flirtation with the teacher had been interrupted by his actions. The minister upbraided the boy for his bad manners. The boy defended himself, but Bell Michaux uncharacteristically thrashed Oscar, and afterward Oscar's father quarreled with his wife over the incident.

This story may be apocryphal, but Micheaux relates it convincingly in his third autobiographical novel *The Homesteader,* even giving the

teacher and the A.M.E. Elder characters transparent pseudonyms (as he often would in his fiction). In real life, the Elder was Rev. Newton J. McCracken; thirty years later, in a reworking of *The Homesteader* called *The Wind from Nowhere,* Micheaux would suggest that McCracken even had presided over his baptism.

Later, the same Rev. McCracken would reappear, disastrously, in Micheaux's life.

Metropolis, the hub of Massac County, was on the Illinois-Kentucky border, just north of Paducah, Kentucky, across the Ohio River. It was a river town straight out of Mark Twain, dominated by the vast, snaking Ohio, which served Metropolis "as a water supply and as a frequent topic of everyday conversation," according to town historian George W. May. Lumber and flour mills were at the core of local industry, and trade and travel were conducted by horse and wagon (farms were still tractorless, of course), or by steamboat, though the Golden Age of the steamboat was past. Showboats stopped at Metropolis during the summer, bringing plays and recitals. Otherwise the place "lingered in a state of dull lethargy," in Micheaux's words.

Farm life was too busy to be strictly dull. Just as his son would do later in South Dakota, Calvin Michaux bought and sold several tracts of land around Metropolis, sometimes working more than one farm at a time. About four years before Oscar was born, Calvin paid another six hundred dollars to purchase "the undivided one-third of the west-half (½) of the north east quarter (¼) of Section Thirty-Three (33) in Township fifteen (15), South Range 5 (5), east"—a forty-acre plot in Brooklyn Precinct, just over the line from his adjacent Washington Precinct land. The family then took up residence on the Brooklyn farm, closer to Metropolis.

Later, when Oscar was in school, they sold part of the Brooklyn farm and moved into "Township Numbered (16) South of Range Numbered (5) East," another few miles closer to town. The family kept inching nearer to Metropolis, Micheaux later wrote, "not so much to get off the farm or to be near more colored people (as most of the younger Negro farmers did) as to give the children better educational facilities." In fact, the Michauxes lived on the east side of Metropolis, while most of the black population clustered on the west side in an area locally dubbed "Colored Town."

Jim Crow was the way of life in Metropolis, a Southern hamlet in a Northern state. The well-built and -equipped main school was centrally located, but the "colored school" was a substandard facility tucked away in "Colored Town." Though Illinois law guaranteed public education for black people, the issue of whether to mingle the races in the same building or classroom was left to the municipalities, and most Illinois towns and cities maintained separate schools for the races, with separate budgets that guaranteed black people would receive less funds and an inferior education. Southern Illinois was so notorious in its unequal distribution of financial resources that, in 1885, state leaders approved a special bill "designed to protect the liberties of Negroes in the less advanced counties of Southern Illinois."

Micheaux remembered the "colored school" of Metropolis as "an old building made of plain boards standing straight up and down with batten on the cracks," administered by two or three teachers. Students of both sexes and every age were crowded into spartan classrooms. Micheaux and his classmates were part of the phenomenon Booker T. Washington described, in *Up from Slavery,* as "a whole race trying to go to school" after the Great Emancipation—young people sitting alongside illiterate octogenarians, who aspired to read the Bible before they died. As one mark of their ambition, black families in Metropolis had to pay an annual tuition for the privilege of sending their children to the school—a fee identical to that paid by white folks across town with a better school and manifestly greater resources. No refunds were made for sickness or expulsion. Disobedience was met with physical punishment.

But Calvin and Bell Michaux, who put extra food on the table for teachers and preachers, set aside the necessary funds for their childrens' education. Though Metropolis High School graduated its first class in 1877, the first "colored graduating class" didn't make it past the high hurdles until 1896. That year twenty-nine white students graduated from high school, but so did seven who were "colored," including the oldest Michaux child, Ida.

By the time Oscar entered school a few years later, the situation had improved slightly. Although the scope and curricula of the white and "colored" schools was still unequal, the local superintendent of public education boasted of narrowing the gap with good equipment and a supply of "the choicest and most attractive books" for the library. (Metropolis

would maintain separate schools for white and "colored" children into the 1950s.)

Apart from general history, mathematics, and science courses, the "colored school" emphasized reading, writing, and the arts. Students were taught to practice dictation and write form letters and searching essays. They were expected to read certain literary works before promotion. They discussed art, poetry, and music "as agencies of communication between the soul and external things," according to the superintendent's report.

All this was grist for a boy who would grow into an insatiable reader and tireless writer. Yet his later reflections on his education suggest that Micheaux was just as deeply affected by its shortcomings. He described his Metropolis schooling as "inadequate in many respects." In his books he criticized his teachers (who were paid much less than white teachers and were often recent graduates of the "colored school") as "inefficient," and bemoaned the distance between his home and the school on the west side of town.

Though he exalted teachers in his books and films, they often disappointed him in real life. Teaching was his first wife's profession, and that was an ill-fated marriage; when he traveled from city to city to sell his novels, he found that local teachers didn't always rush to purchase copies.

Micheaux insisted he always received "good grades" in his Metropolis school days, but felt unappreciated by those who tutored him. "About the only thing for which I was given credit was in learning readily," Micheaux recollected, "but was continually critiqued for talking too much and being too inquisitive."

By now his father owned some eighty acres and was considered "fairly well-to-do, that is for a colored man," but the Michauxes were merely land-rich and felt constantly beset by upkeep and debt. With springtime came rougher toil and a different set of learning experiences, though Oscar's three older brothers assumed the brunt of the farm chores. Oscar, the fifth-born, was considered the family shirker, always complaining "that it was too cold to work in the winter, and too warm in the summer," as he himself conceded. The Michauxes made ends meet by selling fruit, vegetables, and eggs, and soon—out of "disgust" at his "poor service in the field"—Calvin Michaux reassigned his young teenage son to take the family's goods to the local meat and garden market, a huge open-air building in the center of Metropolis.

At the market, Oscar bloomed. He discovered his métier: a born talker, he was a natural salesman. "I met and became acquainted with people quite readily," Micheaux recalled. He soon developed little tricks, giving "each and every prospective customer" a singular greeting, or suggestion, "which usually brought a smile and a nod of appreciation as well as a purchase." He noticed "how many people enjoy being flattered, and how pleased even the prosperous men's wives would seem if bowed to with a pleasant, 'Good Morning!' "

When one older brother complained that Oscar had it easy at the market, Calvin let the brother try his hand at salesmanship. But the brother found himself tongue-tied with customers; he was no match for Oscar's garrulous personality. One of Oscar's surprising talents was approaching well-dressed white folk, hailing Metropolis's most distinguished citizens by name. (In his very first novel, the autobiographical *The Conquest,* as if to prove his point, he tossed off one example: Mrs. Quante of the Riverside Flouring Mills, wife of the mayor, no less.) The older brother sulkily returned to heavy farm work; Oscar got the regular job as the family pitch man. "I always sold the goods," Micheaux boasted, "and engaged more for the afternoon delivery."

For pocket pennies, the resourceful young man also performed odd jobs wherever he could find them. Micheaux wasn't above taking a home-made box out onto the streets and shining shoes on his knees.

But Metropolis was "gradually losing its usefulness by the invasion of railroads," in Micheaux's words, and as a teenager he could barely tolerate the culture of the backward river town. And he didn't spare the black populace: Probably the most controversial aspect of Micheaux's books and films is his sharp-tongued criticism of his own race, a trait rooted deep in his Metropolis boyhood. He rarely itemized the faults of white people as a group, for Micheaux knew white people primarily as individuals—some as dire enemies, but a few as prosperous, generous friends. "Oscar Micheaux's body of work," as scholar Betti Carol VanEpps-Taylor has written, "shows little curiosity or interest in white society beyond the cordial relationships and a few enduring friendships."

Beginning in Metropolis—and throughout most of his life, with the notable exception of his time in nearly all-white South Dakota—Micheaux strongly criticized the community he knew best, the people he understood as well as he understood himself. He was especially hard on what he saw as the ignoble tendencies of his own race.

In his first novel, *The Conquest,* Micheaux railed against the hypocrisy of churchgoers among the "colored churches" of Metropolis, both the Baptist congregation and the A.M.E. church patronized by his own family. Too many of the men, it seemed to Micheaux, prayed, sang, and shouted on Sundays, while stealing and drinking and fighting during the rest of the week. The colored folk of Metropolis, he complained harshly, "were in the most part wretchedly poor, ignorant, and envious. They were quite set in the ways of their localisms, and it was quite useless to talk to them of anything that would better oneself."

Micheaux learned early to hawk his ideas as well as goods and wares, and even as a teenager he openly vented his views. This habit "didn't have the effect of burdening me with many friends," he conceded in *The Conquest.* "Another thing that added to my unpopularity, perhaps, was my persistent declarations that there was not enough competent colored people to grasp the many opportunities that presented themselves, and that if white people could possess such nice homes, wealth, and luxuries, so in time could the colored people."

To the boys and girls "who led in the whirlpool of the local colored society," Micheaux recalled, he was regarded as being "of the 'too-slow-to-catch-cold' variety." His peers nicknamed him "Oddball," and older people regarded him more suspiciously as "worldly, a free thinker, and a dangerous associate for young Christian folks."

Already Micheaux had set himself apart from the common herd. He was an imaginative talker, an individualist who saw himself as a leader not a follower—a singular, even peculiar, figure among his peers. "At sixteen I was fairly disgusted with it all," he wrote later, "and took no pains to keep my disgust concealed."

It doesn't stigmatize Micheaux to say that he didn't get far in high school. ("I didn't finish school," his alter ego Martin Eden confesses in Micheaux's last film, *The Betrayal.*) The 1899 report on local public schools makes it clear that, after eighth grade, teenage black and white boys alike were siphoned off by work. Certainly, however, Micheaux learned to read and write, and to "learn readily" in many ways.

Realizing that his future would be sorely limited in dull old Metropolis, Micheaux made his first courageous decision: to leave home. Some of his older siblings had come to the same conclusion: His sister Ida, after graduating from high school, took a teaching job in Carbondale, while two of his older brothers had quit before finishing their education to be-

come hotel waiters in a nearby town, "much to the dissatisfaction of my mother, who always declared emphatically that she wanted none of her sons to become lackeys," wrote Micheaux.

In due time, his older brothers Lawrence and Finis would enlist in the Spanish-American War. After decamping to Springfield, their unit was demobilized, though Lawrence elected to join a Chicago troop and was dispatched to Santiago, Cuba. It is unclear how much action Lawrence saw in his short time in the military, only that Oscar's brother died in a San Luis hospital in 1898, one of many victims of a typhoid epidemic.

It was the death of another Michaux, in fact, that helped to liberate the entire family from Massac County. Oscar's father had been struggling with work and debt when, in 1900, he fell heir to part of the estate of his younger brother, William, one of the homesteading Exodusters, who had passed away in Great Bend, Kansas. That triggered the family's move to Kansas.

By this time, Oscar himself was already gone. Metropolis had one train that went to St. Louis and another that led to Paducah, but the river town had been in a state of perpetual suspense hoping for a line upstate. When the Chicago and Eastern Railroad finally reached nearby Joppa in late 1900, Oscar hopped aboard and headed north. Almost seventeen, the future novelist and filmmaker was more than six feet tall, slender, with slightly rounded shoulders. He had a high forehead, a strong chin (like the heroes in his books), and burning brown eyes.

One final ambiguity about Oscar Micheaux: Among the limited primary sources and few surviving eyewitnesses, there is no consensus about the darkness of his skin. The handful of photographs of Micheaux are not much help: He was surely not ebony-complected, yet he was dark enough that he could never have "passed" for white—a quest of so many characters in his books and films.

In a rare mention in *Time* magazine, Micheaux was described as "chocolate-colored." According to people who worked on his last film, in 1947, his skin was more like "coffee with cream." To Agnes Becker, a white homesteader with little experience with black people, who became acquainted with Micheaux in South Dakota, "his tongue was so red, his teeth so white, and his face so black." Perhaps she exaggerated. But even to fellow race-picture pioneer George P. Johnson, a black man who knew him well, Micheaux was "a Negro," and "unmistakably so."

1900–1904 BLACK METROPOLIS

Much of what is known about Micheaux's early life can be gleaned from his autobiographical novels, especially the three that cover his first thirty-five years, time spent largely in Metropolis, Chicago, and South Dakota. His first novel, *The Conquest*, is considered by biographer and historian Betti Carol VanEpps-Taylor as "the most accurate of the autobiographical versions." Scholar J. Ronald Green agreed, saying it was "fundamentally trustworthy as autobiography and history." Again and again, in research for this book, that judgment was upheld: Available documents and accounts corroborate the details and the chronology of Micheaux's early life as recorded in his fiction.

After leaving Metropolis, according to *The Conquest*, Oscar stopped first in a town of about eight thousand people—roughly one tenth of whom were "colored"—where there was said to be work for $1.25 a day at an early car manufacturing plant. The plant employed approximately twelve hundred men, including many black laborers. According to Micheaux, he was hired and assigned to a foundry of roaring furnaces and deafening machines. Though he tried to stretch his designated hours, Micheaux was never quite able to put in a full week of work.

In any event, he didn't enjoy the hot, deafening foundry, and he found the town uninteresting. It didn't help when he developed malaria and missed days on the job, lying in bed. "I came there in June and it was some time in September that I drew my fullest pay envelope which contained sixteen dollars and fifty cents," he later wrote.

In the early fall of that year, Micheaux recalled, "a 'fire-eating' colored evangelist" visited the town, inaugurating a revival at a local church near the foundry. The evangelist's daily preaching and shouting drew so many hundreds that the revival spilled into an open field, with the converts "running about like wild creatures, tearing their hair and uttering prayers and supplications in discordant tones." Oscar himself attended on several occasions, and again was struck by the hypocrisy of some he recognized in the crowd, who outside of church were not known for their virtuous behavior. Feeling the eyes of others upon him, gauging his willingness to surrender to the Lord, Oscar sat stubborn and "quite unemotional" throughout the raucous revival, and was as pleased as the outraged local aldermen when the evangelist left town.

By year's end, Oscar too was ready to move on. From a relative he heard a rumor of employment farther north, "bailing water in a coal mine in a little town inhabited entirely by negroes," according to Micheaux. He joined the overnight shift, a twelve-hour stint for $2.25. "The work was rough and hard and the mine very dark," he recalled. Black smoke hung above the tunnel-like room where he toiled. The damp and headaches forced him to quit after six weeks.

All along Micheaux was thinking of Chicago, where his oldest brother, William, was now working as a train waiter. But first he stopped to visit his sister Ida, who was teaching at a "colored school" in Carbondale. Eight years older, Ida hadn't laid eyes on Oscar for some time. "I had grown into a strong husky youth," Micheaux wrote, "and my sister was surprised to see that I was working and taking care of myself so well."

Impressed by Oscar's prospects, Ida thought her brother might be in the market for a girlfriend. Ida had a candidate in mind, a local girl from nearby Murphysboro, a few years younger than Oscar. The girl's father was a mailman. In Micheaux's novels her surname appears sometimes as Rooks, sometimes as Binga,* but her first name is always the same: Jessie. When Ida described the eligible girl as "the prettiest colored girl in town," however, Oscar balked. Unconventionally handsome himself, he thought people were foolish about feminine beauty. "I was suspicious when it came

* Like many writers and filmmakers, Micheaux liked to play games with names. "Binga" was an in-joke allusion to a prominent black entrepreneur who established the first black-owned bank in Chicago, Jesse C. Binga. Binga probably took early shares in Micheaux's publishing and film company.

to the pretty type of girls," he wrote, "and had observed that the prettiest girl in town was ofttimes petted and spoiled and a mere butterfly."

In spite of his misgivings, Jessie was summoned to meet Micheaux. When she arrived, he recalled, "I found her to be demure and thoughtful, as well as pretty. She was small of stature, had dark eyes and beautiful wavy, black hair, and an olive complexion." The two seemed to click, though Oscar did most of the talking. Jessie shyly averted her eyes and sat with folded hands, answering Oscar's stream of questions in a tiny, quavering voice.

That was in mid-winter, a Sunday morning early in 1902; Oscar left town later in the day. By 9:40 that evening, "the coldest night I had ever experienced," he stepped off the "fast mail" express in the city of his dreams, a place that might as well have been Oz, for all its surreal qualities. Imagine a young country bumpkin of the late nineteenth century, a farm hick acquainted only with backwater towns, passing through a portal into a world of tomorrow. Chicago was "new and strange," Micheaux recalled, and that must have been an understatement.

Trolley lines ran from downtown into the countryside. Horse-drawn vehicles shared the roads with street cars, bicycles, and the occasional chauffeur-driven automobile. The bridges were stone, the sidewalks cement. There was a lake as big as an ocean, vast public parks teeming with activity, an expanse of high-rises (at twenty-one stories, Chicago's Masonic Temple was the world's tallest building), and a public library that flowed around a block. At night the city was afire with lighted windows and corner lamps and electric signs. The streets were loud with music and laughter pouring out of the theaters and saloons. Most astonishing of all were the people thronging the streets—more black people than Micheaux had ever imagined. Although the population of the city was 98 percent white, roughly thirty thousand of Chicago's inhabitants were black.

Ninety percent of Chicago's black citizens lived in the Black Belt, the South Side neighborhood that was Micheaux's ultimate destination, though at that time plenty of white people—up to 40 percent—also dwelled there with little friction. The area ran from Twelfth to Thirty-first streets, bounded by Lake Michigan on the east and Wentworth Avenue on the west. Black physicians, attorneys, and professionals lived in splendid brick homes, while most ordinary folk dwelled in wood houses. The

newcomer wandered the streets for a long time, gawking at the sights before arriving in the residential area where his brother lived.

State Street between Twenty-sixth and Thirty-ninth was fast becoming "the centerpiece of black life in Chicago," as Chicago historian Robin F. Bachin has written. This stretch, soon to be dubbed "the Stroll," was jammed with sports venues, theaters, restaurants, nightclubs, dance halls, and taverns, which catered to a mainly black clientele, though they weren't always owned by black people.

The Stroll was where the black and tans met and congregated, promenading day and night. "Excitement from noon to noon," wrote Langston Hughes in his autobiographical novel *The Big Sea*, describing the thrill of experiencing the Stroll for the first time in 1918. "Midnight was like day."

Oscar's brother lived in a rooming house at 3021 Armour Avenue, two blocks west of the Stroll, not far from the Union Stock Yards. William wasn't home to greet his brother, but his landlady welcomed the young man, who had just turned eighteen, and Oscar eagerly confided in her his dreams of striking it rich in the big city. When William came home and the landlady recounted their conversation, he scolded Oscar, telling him to keep his mouth shut so people wouldn't realize he was so "green." William wrote their parents in Kansas, describing his little brother as "a big, awkward, ignorant kid, unsophisticated in the ways of the world," according to Micheaux. Though Oscar tried to laugh off William's jibes, being painted as a rube in a letter that would be read by his entire family made him feel "heartsick and discouraged," and for the first time in his life he suffered an extended attack of "the blues."

William, who was six years older than Oscar, regarded himself as a man of the world. Oscar, on the other hand, viewed his brother as a poseur who had taken on city airs. William had been gainfully employed as a waiter on a railroad dining car, but "in a fit of independence—which had always been characteristic of him—had quit, and now in midwinter was out of a job." Indeed, William was flat broke, "but with a lot of fine clothes and a diamond or two," Micheaux recalled. "Most folks from the country don't value good clothes and diamonds in the way city folks do," he observed ruefully.

On his first Sunday in Chicago, Oscar thought the two brothers might go to church together. But William got flashily dressed up for the occasion—"wearing his five dollar hat, fifteen dollar made-to-measure

shoes, forty-five dollar coat and vest, eleven dollar trousers, fifty dollar tweed overcoat and his diamonds"—and then headed off without so much as a backward glance at his brother. Oscar trailed behind, sitting alone in an opposite pew and feeling snubbed.

The Armour Avenue landlady, who was embroiled in some kind of romance with William, carried William on his back rent. But Oscar was obliged to pay six dollars a month as his share, so he urgently sought employment at the nearby stockyards ("Mecca for the down-and-out"). The $1.50–a-day work was decent but intermittent, and he drifted elsewhere. "I soon found the mere getting of jobs to be quite easy," Micheaux wrote later in *The Conquest.* "It was getting a desirable one that gave me trouble."

After "trying first one job, then another," Oscar headed for the steel mills of Joliet. A few weeks of heavy toil later—wrecking and carrying around broken iron, and digging in a canal "with a lot of jabbering foreigners," under a foreman who was a "renowned imbecile"—Oscar heard that the nearby coal chutes were paying better, and he quit the steel industry, too.

In charge of the coal chutes was a big black man who hired Oscar to extract coal from a box car, then crack and heave it into a chute; the job paid $1.50 per twenty-five tons. The trouble was, Oscar could only manage sixteen to eighteen tons a day, and his daily earnings peaked at one dollar. When the contractor took him out for a drink, trying to encourage him by telling him he'd be heaving thirty tons in no time, "I cut him off by telling him that I'd resign before I became so proficient."

Resign he did, returning to Chicago to a less sympathetic landlady, and a brother increasingly indifferent to his troubles. Oscar signed with a hiring agency, which promptly did nothing on his behalf, swindling him out of his agency fee of three hard-earned dollars. He tried the newspapers, standing outside when the papers came off the press, grabbing one, scanning the ads, choosing a prospect, then running like crazy to the stipulated address. One way or another, the jobs were always filled before he got there. "The only difference I found between the newspapers and the employment agencies was that I didn't have to pay three dollars for the experience," he wrote.

One day, while talking to "a small, Indian-looking Negro," he heard of an opening for a shoeshine man in a barbershop in the supposed boom town of "Eaton" (probably Wheaton), west of Chicago. Oscar filled his

grip and "beat it," arriving in the town on a cold, bleak day in early May. On the town's main street he found a dingy two-chair barbershop, which had just been taken over by a new proprietor with a German-speaking assistant. "They seemed to need company," Micheaux recalled. He got the position, which paid no wages but all the fees and tips he could wangle from his shoeshine customers—and an upstairs room where he could bed down. "Shining shoes is not usually considered an advanced or technical occupation requiring skill," Micheaux explained later. "However, if properly conducted it can be the making of a good solicitor."

Solicitation was half the challenge: "Eaton" was in rural Illinois, where the rustic class put little stock in the regular polishing of their footwear. Oscar had to hover outside the barbershop, snatching at passersby and launching quickly into his spiel. "If I could argue them into stopping, if only for a moment, I could nearly always succeed in getting them into the chair," Micheaux recalled.

Business was paltry, however, so he found another sideline in which he had some experience: Early in the day he would go out and find spot farm jobs, pitching hay or shocking oats for area farmers, then head to the barbershop to shine shoes by late afternoon. But the local farm youth outworked him—"Whew!"—and as the summer wore on he pined for company. So he began writing letters to Jessie, the pretty, thoughtful girl he had met in Carbondale.

Staying in "Eaton," Oscar accumulated enough savings to open his initial bank account. The sight of his "twenty-dollar certificate of deposit," he later reflected, opened his eyes to new horizons. Soon Oscar was dreaming of saving enough money to invest in land, or a business. It was during his time in "Eaton," Micheaux wrote later, that he laid "the foundation of a future" for himself, with both his first savings and his first stirrings of ambition.

Now he set a fresh goal for himself: to obtain a more decent, better-paying niche as a porter on one of the Pullman Company's "magnificent sleepers"—a job that would offer him "an opportunity to see the country and make money at the same time," in his words. And so Oscar returned to Chicago, temporarily busying himself with lawn-mowing, window-washing, and odd jobs while haunting the different Pullman offices.

"I was finally rewarded by being given a run on a parlor car by a road that reached many summer resorts in southern Wisconsin," Micheaux wrote. He headed out on weekends, returning on Monday mornings, but

he had a hard time making much money on such minor routes—or getting the Pullman bosses, who were besieged by black men seeking porter jobs, to pay any attention to him.

The Pullman Palace Car Company was headquartered in Chicago. Its founder, George Pullman, pioneered the plush sleeper cars with folding upper berths that were used by the higher-paying passengers on trains. Pullman cars were available on Midwestern lines by 1865 (one carried the body of the assassinated President Lincoln from Chicago to Springfield); before long they became common in most overnight routes throughout the United States. Pullman retained ownership of the cars, leasing service to railroad lines, which switched the cars from train to train on long runs so that passengers could stay on their reserved sleepers for the entire trip. The Pullman company swiftly branched into luxury lounge, club, and dining cars.

The first-class services offered on a Pullman car were integral to the glamour and mystique of train travel, and those services were provided by black men with direct or family ties to slavery, a background the company unofficially thought vital to the psychology of the job. Dressed in spotless uniforms of jacket and necktie, the porters were expected to meet a customer's every demand, or indignity, with an obliging smile. Besides stocking linens and amenities and preparing berths and cars for each run, porters brushed clothes, cleaned the cuspidors and lavatories, and shined shoes (by now a Micheaux specialty). They slept in the "smokers," the men's toilets.

Pullman porters were paid $25 to $40 weekly, depending on length of service. But porters were expected to furnish, out of their own earnings, the polish and rags used for shining shoes. They paid for their company-assigned uniforms and regular laundering, as well as any food they bought on the train. These and other requirements, which slashed their salaries in half, forced the porters to survive largely on tips.

In 1894, a bitter, national porter strike marked the first organized uprising against such institutionalized inequities. Only in 1925, after a long struggle, was the Brotherhood of Sleeping Car Porters organized, becoming the first major black trade union. Portering was considered by many "a continuation of the slavery the war [Civil War] supposedly ended," as

Jack Santino observed in *Miles of Smiles, Years of Struggle,* his study of the Pullman porters. At the same time, it was among the best of all possible jobs available to ordinary black men of the time—offering, besides income and tips, exciting travel and a certain cachet.

Visiting the main Pullman office in Chicago twice a week, Oscar grew frustrated by his inability to get past the chief clerk. He already had a wide circle of acquaintances, and one day a friend advised him to leapfrog the clerk and approach the superintendent of hiring directly. So the next day Micheaux waylaid the boss as he arrived, making an appeal to the top man even as the chief clerk stared at him furiously. The superintendent left Oscar outside at the railing, but after a few minutes called him inside and asked for references. Micheaux provided letters from employers and friends, after which the superintendent asked if he could afford the company's uniform. When Oscar said yes, he was directed to the company tailor, and to a man who tutored porters in a Pullman car dubbed "The School."

"The School" sat in a nearby railroad yard for just such tutoring purposes. According to Micheaux, always a ready learner, he absorbed all that was necessary for portering in one day, while other new employees had been in "The School" for five days before they graduated alongside him. All that night, his feverish thoughts about his first assignment, "perhaps to some distant city I had never seen," had him tossing and turning.

When he arrived at porter headquarters the next day, however, Micheaux discovered that the office was crammed with qualified black men waiting for a mere handful of assignments, including old fellows who were "emergies," or emergency substitutes, as well as previously discharged or retired employees, who showed up hoping not enough regulars would materialize. He watched with sinking spirits as the sign-out clerk favored the familiar faces, passing up the "emergies" and most new employees. Finally, the clerk called out Oscar's name, and asked him if he felt confident about serving his first car. When Micheaux declared that he was, the clerk paused suspensefully, then delegated him to the Fort Wayne yards in the West District, to prepare the Atlanta sleeper for its next excursion to Washington, D.C. "Put away the linens," the clerk ordered, "put out combs, brushes, and have the car in order when the train backs down."

Micheaux "fairly flew" to Sixteenth Street, where the yards held "not

less than seven hundred" passenger and Pullman cars, which had to be cleaned and prepared daily for their runs. After searching and searching, the novice porter found the Atlanta. "O wonderful name!" Micheaux later wrote ecstatically. "She was a brand new observation car just out of the shops. I dared not believe my eyes, and felt that there must be some mistake; surely the company didn't expect to send me out with such a fine car on my first trip."

Boarding nervously, Micheaux got busy, making the Atlanta "fairly presentable" in time for the rush of arriving passengers, who called out to have their grips stowed, deflectors arranged for their windows, and other routine requests and special favors. Despite the anxiety and confusion he felt, Oscar performed well, though at Pittsburgh he was "chagrined" to learn that his sleeper was going to be turned around and sent back to Chicago.

According to the Pullman employment card of "Oscar Michaux," this first portering occurred on December 7, 1902. Micheaux had been in Chicago for less than a year; he was a month shy of nineteen years of age.

Having passed his trial by fire, Micheaux was put into the rotation and began to make frequent long trips, gradually visiting all of America's major cities east of the Mississippi. He finally made it to the nation's capital, and discovered that Washington, D.C. had quite a substantial Black Belt, too. As Micheaux later wrote, he "had never seen so many colored people. In fact, the entire population seemed to be Negroes."

Yet Micheaux preferred the rural west, and by February he had wangled a spot on a continuing run that took him through Colorado, Wyoming, and Idaho, to Portland, Oregon. In *The Conquest* he rhapsodized about the time he spent gazing out the windows at the wide-open lands, the train hugging the curves as it climbed high in the Rockies, "their ragged peaks towering above in great sepulchral forms, filling me alternately with a feeling of romance or adventure." It was exhilarating. "I never tired of hearing the t-clack of the trucks," he wrote, "and the general roar of the train as it thundered over streams and crossings throughout the days and nights across the continent to the Pacific coast. The scenery never grew old, as it was quite varied between Chicago and North

Platte. During the summer it is one large garden farm, dotted with numerous cities, thriving hamlets and towns, fine country homes so characteristic of the great middle west, and is always pleasing to the eye."

He was struck by the picturesque American Falls of the Snake River in Idaho, where the federal government had constructed a seventy-mile canal and converted "about a quarter of a million acres of Idaho's volcanic ash soil into productive lands that bloom as the rose." He mused about one day settling near Snake River, "investing in some of its lands and locating, if I should happen to be compelled by stress of circumstances, to change my occupation."

Around February, Micheaux banked his first one hundred dollars earned as a Pullman porter; his financial "modesty and frugality" would become a fixed lifetime habit. He soon realized, however, that he'd never be able to save much money out of his twenty-five-dollar monthly salary—considering that he had to pay for summer and winter uniforms at his own expense (twenty and twenty-two dollars, respectively); train meals (albeit discounted for employees); the regular laundering of his outfit; and rent for intervals spent in Chicago (no longer with his brother).

The tips were good for about another hundred dollars per month, Micheaux calculated, but that still wasn't enough for a man who aspired to leave portering behind one day and do something grand with his life. That was the evil genius of the Pullman system, which kept porters on a taut leash. No wonder cheating and stealing from customers—and management—was so widespread, even, to an extent, "sanctioned by the company," wrote Micheaux.

One lucrative tactic was the practice of "knockdowns," which Micheaux called "a veritable disease among the colored employees." At one point in the long runs, tickets were sold on board; the company revenue was always underreported by the white conductors, and the porters participated in the conspiracy in exchange for their "skim," or "knockdown." "'Good Conductors,'" wrote Micheaux, "a name applied to 'color blind' cons, were worth seventy-five, and with the twenty-five dollars salary from the company, I averaged two hundred dollars a month for eighteen months."

The Portland run was as far as you could get from headquarters, and tailor-made for knockdowns. For a year and a half, Micheaux worked this and other routes, savoring the "great opportunity of observa-

tion" train life afforded. He relished the colorful gamut of people as much as the diversity of places. The passengers often wanted to hear themselves talk, and he listened as they unbosomed themselves. Western sheepherders spoke to him of the tricks of sheepherding, farmers of farming.

As in Metropolis, Micheaux talked easily with affluent white people; equally important, he was also a good, watchful listener. In his novel *The Forged Note*, Micheaux's alter ego, Sidney Wyeth, has a carousing, ragtime-playing friend who complains, "I've never seen you drink anything stronger than beer when you've been with me. You seem to go along with me, to see me and the others act a fool."

Passengers wise and foolish were worth observing; besides advice, travelers gave him valued gifts of whiskey, cast-off clothing, and books. Passengers often left reading matter behind in the sleeping cars, and Micheaux absorbed everything he got his hands on: newspapers, muckraking articles in magazines, government land reports, history books, and novels. He absorbed a wide variety of literature, from Shakespeare's plays to detective stories (he was an unabashed fan of the Nick Carter dime novels) as well as popular Westerns such as Owen Wister's *The Virginian*. He avidly followed the works of the now-forgotten novelist and journalist Maude Radford Warren, who taught literature at the University of Chicago, and who wrote a series of stories extolling the achievements of women pioneers out West.

"What I liked best was some good story with a moral," Micheaux wrote later, and he praised Warren's stories as "very practical and true to life." He enjoyed their travelogue quality, too, even seeking out the real-life settings of her tales. "Another feature of her writings which pleased me," he wrote, "was the fact that many of the characters, unlike the central figures in many stories, who all become fabulously wealthy, were often only fairly successful and gained only a measure of wealth and happiness, that did not reach prohibitive proportions."

As the trips accumulated, so did the money in his bank account. The knockdowns and graft certainly helped. But Micheaux was continually worried about the notorious company practice of employing incognito "spotters," as the company detectives were called, and he had the queasy feeling that he was mired in wrongdoing and doomed to be caught. "While I was considered very fortunate by my fellow employees," Micheaux explained later, "the whole thing filled me with disgust. I suf-

fered from a nervous worry and fear of losing my position all the time, and really felt relieved when the end came and I was free to pursue a more commendable occupation."

The finis was writ between Granger, Washington, and Portland, when Oscar had a run-in with a boozy Irish conductor who was clever at knockdowns but reluctant to yield the porter's fair share. The conductor tried to whittle down Oscar's slice of the extra, and the two had an argument. The debate was settled in Micheaux's favor, but the conductor had been "spotted," and was promptly fired. "They 'got' me on that trip" too, Micheaux wrote.

In the end, Oscar decided that the enormously profitable Pullman business was "greedy and inhuman," oppressing its black porters with "near-slave" wages and conditions. He maintained in *The Conquest* that he had "no apologies or regrets to offer" for his part in the knockdowns and other cheating.

He didn't mention the exact cause of his dismissal, but the company discharge records of "Oscar Michaux" state that he was let go on May 31, 1904, for "Abstracting $5.00 from purse of lady passe."

So that was that. The "stress of circumstances" compelled Oscar to change his profession, or—to use a trick he worked more than once as a filmmaker—to change places.

To the end of his life, Micheaux nurtured a love and nostalgia for Chicago. It was a great and beautiful city, his first home away from Metropolis, which he had abandoned permanently. At the same time, Chicago disappointed, even "disgusted" him in certain ways. The Black Belt had its seamy side, marked by gambling dens, brothels, and a prevalent loafer and criminal presence. Several times in his novels Micheaux complained of the conspicuous "beer cans, drunken men and women" of the Stroll, though Chicago's black underworld also enlivened his films.

While he found cities marvelous, in many ways Micheaux remained a small-town creature, a man of the soil who preferred travel and open land and untamed territory. The Pullman job had hooked him on traveling, and he daydreamed about living out West. Oscar felt "the spirit of Horace Greeley" ringing in his ears. "I come of pioneer stock," he wrote in his

1943 novel, *The Wind from Nowhere.* "It seems to run in our family and blood to make conquest."

He decided he ought to buy land somewhere on the vanishing frontier, but how and where? Micheaux considered the Snake River area in Idaho, but worried that the surroundings might be too arid. He thought hard about Iowa, until one day he spoke with an Iowa farmer in a smoking room during a train trip. The farmer told Micheaux he had paid eighty dollars per acre for his agricultural holdings in that state.

Eighty dollars an acre! "I concluded on one thing," Micheaux explained later, "and that was, if one whose capital was under eight or ten thousand dollars, desired to own a good farm in the great central west he must go where the land was new or raw and undeveloped."

Until he figured things out, he would continue to work hard and save money. Micheaux decamped to St. Louis, Missouri, where he presented a set of non-Pullman references, and underwent the same tutoring, and was promptly hired by the Southwest Division of the very same company that had just fired him, with the Chicago office none the wiser. Rooming on Pine Street in the Ville neighborhood of St. Louis, Oscar went back to work portering for Pullman on short runs to the west and south, while biding his time on his grander ambitions.

The St. Louis job afforded Micheaux his first extended exploration of the South, which had been home to his parents before the Civil War, and he fell in love with the region—its food, climate, terrain, and the gentler aspects of its culture. In many ways he felt himself a displaced Southerner. He abhorred the Jim Crow way of life, which suffocated the humanity out of black and white people alike; all the black passengers on trains crossing into the South had to be gathered up and escorted into segregated cars. But Micheaux realized early on that the North was not the pure haven of freedom that he and many other descendants of slavery had imagined it to be. The stories of his films would often swing between city and country, North and South, reflecting his divided loyalties.

In a sense, the romance of the West was his answer to the divided self. In *The Conquest,* Micheaux wrote of overhearing two waiters at a lunch counter in Council Bluffs, Iowa, talking about the Rosebud reservation in southern South Dakota, which was slated to be opened up by lottery to homesteaders in the fall of 1904. The following day, in Omaha, he encountered two Washington, D.C., surveyors en route to the Rosebud,

who encouraged him to write the Department of Interior for particulars on the land. The pamphlets he received in the mail boasted "deep black loam, with clay subsoil" for the earth, and sufficient average rainfall.

"This suited me better than any of the states or projects I had previously looked into," Micheaux wrote in *The Conquest*. "Besides, I knew more about the mode of farming employed in that section of the country, it being somewhat similar to that in southern Illinois."

Everywhere Micheaux went in the summer of 1904 people were talking about the Rosebud. The newspapers were full of government advertisements for the upcoming lottery. By then Micheaux had saved the remarkable sum of $2,343, a nest egg he thought would be sufficient to purchase a decent homestead. Eager to get in on America's last great frontier, he made the decision to go. "Get there, begin with the beginning, and grow up with the country": that was his credo.

CHAPTER THREE

1904–1906
THE ROSEBUD

North and South Dakota, part of the Louisiana Purchase, were admitted to the union in 1889. Most of South Dakota's white population had streamed to the wild country for the Black Hills gold rush that had erupted less than twenty years earlier, about 1870. Not all the fortune hunters got rich or stayed on, and the ranches and so-called towns of the region—few and far apart, most of them making Metropolis look large and sophisticated—were spread over tens of thousands of square miles of undulating plains, badlands, and rugged mountains. Besides cattlemen, the new state was inhabited mainly by lingering cowboys and a number of Indian tribes, including some not yet vanquished.

The Rosebud Reservation had been part of the Great Sioux Reservation, which was ceded to Red Cloud's warring Oglala tribe in an 1868 treaty that closed the vast expanse between the Missouri River and the Big Horn Mountains to white settlement. The land was held in common by Indian tribes until 1888, when it was divided into six autonomous reservations, one of which, the Rosebud, was designated for Chief Spotted Tail and the Brule Sioux. The Rosebud covered parts of northern Nebraska and a large portion of South Dakota that ranged west of the Missouri River, stretching nearly to the sacred Black Hills. Its name came from the wild yellow and pink flower that carpeted this part of the Great Plains, whose sweet fragrance charged the air in the spring; rosebuds were also used in making a "savory dessert, much prized by the Sioux," as Micheaux biographer and Western historian Betti Carol VanEpps-Taylor has noted.

"The soil of these plains is exceedingly fine," Lewis and Clark wrote

while exploring the territory in 1804, and after the 1868 treaty the U.S. government began pressuring the Sioux to open portions of the Rosebud to farmers, cattle ranchers, and businessmen, selling uninhabited 160–acre allotments as surplus land to raise cash, ostensibly to support Indian land-use projects.

An early attempt to open the Indian lands had been defeated in Congress in 1902, but in April 1904 Congress approved a negotiated agreement with leaders of the Brule Sioux, and on May 13, President Theodore Roosevelt announced that 2,400 allotments would be made available by lottery for homestead settlement in the fall. These land parcels, dug out of an eastern chunk of the Rosebud, would be assimilated by Gregory County, South Dakota. (Gregory was the designated name of the government townsite planned at the western edge of the county.)

Studying the government land surveys, Micheaux concluded that Gregory County might be ideal for farming. "Two hundred miles north, corn will not mature," he wrote. "Two hundred miles south, spring wheat is not grown; two hundred west, the altitude is too high to insure sufficient rainfall to produce a crop; but the reservation lands are in such a position that winter wheat, spring wheat, oats, rye, corn, flax, and barley do well."

One month after Roosevelt's proclamation, according to one South Dakota historian writing fifty years later, the new town of Gregory already boasted "250 buildings and 500 inhabitants that filled an area which had consisted of four surveyors' holes and a stake just the August before." Other tiny towns dotting the county started to mushroom with prospective settlers, capitalists, speculators, and all manner of opportunists and miscreants. Each young town was hoping to become a shipping point for cattle drives and farm products, and the towns competed fiercely over water and railhead advantages, and over which would become the county seat.

The notarized registration was slated to commence at 9 A.M. on Tuesday, July 5, 1904, and to terminate at 6 P.M. on Saturday, July 23. The incorporated towns of Yankton (closest to Iowa), Fairfax (along the Nebraska state line), Bonesteel (west of Fairfax in Gregory County), and Chamber-

lain (in central South Dakota, near the junction of the White and Missouri rivers), would serve as the official registration points.

Early on July 5, Micheaux took a train from Great Bend, Kansas, where he had stopped to visit his family, to South Dakota. The closest stop was the town of Bonesteel, the county terminus of the Chicago & North Western Railroad, but it was notoriously "crowded and lawless" and "overrun with tinhorn gamblers," in Micheaux's words. Instead Micheaux chose Chamberlain, the farthest outpost, but a large town known for its superior hotel accommodations and service from three separate railroads. In Chamberlain, on July 28, a blindfolded child would draw out of a canvas bag the first envelope with a completed government form. The first person selected would have first choice of the available 160-acre sections at four dollars per acre; the second would have second choice; and so on until all the 2,400 allotments were dispersed.

Arriving on the afternoon of the same day, Micheaux was taken aback by the sea of notary tents and booths swarmed by hundreds of people—"all ages and descriptions," he wrote later, "the greater part of them being from Illinois, Iowa, Missouri, Minnesota, North Dakota, Kansas, and Nebraska." He stood in a long line, swore an oath that he was a citizen of the United States and twenty-one years of age (not quite true), and signed his application. By the end of the day, ten thousand applicants had registered in Chamberlain alone. By the end of the week, Micheaux estimated, he was likely facing 75,000 competitors; deflated by the odds, he left Chamberlain and returned to his family in Great Bend.

Later that month, he read in the newspaper that more than 107,000 prospective homesteaders had registered for a mere 2,400 claims in the Rosebud. In due time he received official notification of his number in the mail: 6504. He had no chance. That same day, he lost fifty-five dollars "out of my pocket" and left for St. Louis. There he tried to boost his spirits by roaming the spectacular exhibits and amusements of the Louisiana Purchase Exposition, the World's Fair that was spread over 1,200 acres in downtown St. Louis, feting the one hundredth anniversary of the Louisiana Purchase treaty.

In the weeks that followed, Micheaux had a few work prospects as well as diversions. In September he portered on a limited World's Fair run between St. Louis and New York. There was not much "knocking down," but the salary and tips added up.

Losing the homestead lottery gnawed at him, but Micheaux had not

been idle in Chamberlain. He had gotten wind of the prospect of "relinquishments," homestead claims that had been forfeited, often by death or abandonment. (Just as often, the relinquishments were manipulated by speculators poised to turn a profit on the turnover sale.) Claimholders filing to relinquish their land could sell their allotments to another party, the price varying with the land quality and the eagerness of the seller, or buyer.

By October, Micheaux had banked another $300. He resolved to spend the bulk of his savings on a relinquishment.

Leaving St. Louis on the night of October 4, carrying $2,500 in cash, Micheaux boarded a train for Omaha. There he caught the Chicago & North Western "one train a day" line, this time to Bonesteel. The train was "loaded from end to end" with people talking up relinquishments. "I was the only negro on the train and an object of many inquiries as to where I was going. Some of those whom I told that I was going to buy a relinquishment seemingly regarded it as a joke, judging from the meaning glances cast at those nearest them."

Arriving in the rowdy town of Bonesteel, Micheaux encountered many more such "meaning glances," and worse: his autobiographical fiction suggests that this was the first time the young man encountered blatant race prejudice. The town was awash with "locators," persons who claimed familiarity with the area and drove land-seekers around to look over the best properties. The tour itself was gratis, but if land was purchased the locator was entitled to charge a substantial finder's fee.

Micheaux tried enlisting a locator, but the first one he approached declined to escort him. When he finally found a second one, a buggy-driver at a livery stable, the second man, called Slater, told him that the first locator had already warned him that he'd be a fool "to waste his money hauling a d—nigger around the reservation," because surely Micheaux didn't have enough money to buy a decent relinquishment.

Micheaux flushed angrily. "Show me what I want," he declared, "and I will produce the money." He demanded to be driven to the far west end of Gregory County, where the relinquishments were said to be cheaper, the soil richer. The two men rode in silence for the three miles from Bonesteel to the reservation line, from which the newly opened lands stretched for thirty miles to the west.

This was Micheaux's first tour of the Rosebud, the land he had dreamed of and read about, and in person it seemed to him as beautiful as "the hollow of God's hand." The land cast a spell over him. "To the Northeast the Missouri River wound its way, into which empties the Whetstone Creek, the breaks of which resembled miniature mountains, falling abruptly, then rising to a point where the dark shale sides glistened in the sunlight," he rhapsodized in *The Conquest*. "It was my longest drive in a buggy. We could go for perhaps three or four miles on a table-like plateau, then drop suddenly into small canyon-like ditches and rise abruptly to the other side."

After about fifteen miles, they arrived at the village of Herrick, "a collection of frame shacks with one or two houses, many roughly constructed sod buildings, the long brown grass hanging from between the sod, giving it a frizzled appearance." Here they paused to listen to "a few boosters and mountebanks," who gestured and declaimed with "rustic eloquence" on the virtues of Herrick as the prospective county seat and "the coming metropolis of the west." Herrick was vying to replace the present county seat of Fairfax, about twenty miles east.

Another eight or nine miles to the northwest, they came upon Burke, a similarly unimpressive podunk striving to become the next county seat. Around Burke, Micheaux noticed, the land was sandy and full of pits, "into which the buggy wheels dropped with a grinding sound, and where magnesia rock cropped out of the soil." Too sandy for proper farming, he decided, so the pair drove on. Micheaux was growing apprehensive.

They passed a growing number of spring-fed streams. Then, three miles west of Burke, they ascended a steep hill topped by a grassy plateau. "There lays one of the claims," said the locator, pointing.

"I was struck by the beauty of the scenery," Micheaux wrote later, "and it seemed to charm and bring me out of the spirit of depression the sandy stretch brought upon me. Stretching for miles to the northwest and to the south, the land would rise in a gentle slope to a hogback, and as gently slope away to a draw, which drained to the south. Here the small streams emptied into a larger one, winding along like a snake's track, and thickly wooded with a growth of small hardwood timber.

"It was beautiful. From each side the land rose gently like huge wings, and spread away as far as the eye could reach."

On a small rise, at the highest point of the relinquishment, rested a marker: "SWC, SWQ, Sec. 29-97-72 W. 5th P.M." Slater translated for

Micheaux: "The southwest corner of the southwest quarter of section twenty-nine, township ninety-seven, and range seventy-two, west of the fifth principal meridian."

Nearby to the south could be glimpsed yet another budding town, the hilltop burg of Dallas. To the northwest about four miles was Gregory. All around was beautiful country and blue skies.

They headed back to Bonesteel, where Micheaux dreamed all night of his perfect relinquishment. The original claim had been drawn by a girl who lived across the Missouri, and the next day they set out to visit the girl and her parents. He had expected to pay as much as $1,800 for relinquished land, but now he recognized that he wouldn't have to pay that much for a claim as far west as Gregory. He dickered with the girl and her parents, getting the price slashed to $375. Then he dickered with Slater, the locator, knocking his two hundred dollar fee down to eighty.

Micheaux paid the first installment of $160 on his 160 acres in Chamberlain on October 14, 1904. Then, because it was too late in the season to plant crops or build on the land, he returned to St. Louis.

From St. Louis he wrote to his erstwhile sweetheart Jessie in Murphysboro. Their correspondence had been intermittent of late, and Micheaux couldn't decide how he felt about the younger girl. But she was about to graduate from high school, and in her letters she hailed him as "grand and noble, as well as practical" for having invested in a relinquished homestead. He promised to visit her at Christmas.

After Teddy Roosevelt won the November 1904 presidential election, Micheaux took a Pullman job with a "special party, consisting mostly of New York capitalists and millionaires," traveling from St. Louis down through the Southwest, crossing the Rio Grande at Eagle Pass, Texas, then cutting across central Mexico by way of Torreón, Zacatecas, Aguascalientes, Guadalajara, Puebla, and Tehauntapec. They sailed from Salina Cruz down the west coast to Valparaíso, Chile, heading inland to Santiago, and from there via the Trans-Andean railway to western Argentina.

At Mendoza, they visited an ancient city that had been destroyed and rebuilt fifty years earlier after an earthquake and fire, but fears of the bubonic plague sweeping Brazil sent the party scurrying back to Valparaíso, where they promptly set sail for Salina Cruz. They spent time

originally intended for a tour of Argentina "snoopin' around the land of the Montezumas," which was filled with "gaudy Spanish women and begging peons," in Micheaux's words. Finally, after trekking into the highlands to visit the cathedrals of Cuernavaca, they headed north, passing through Puebla, San Luis Potosí, and Monterrey, en route to Laredo, Texas.

For a man with wanderlust, this was a high point of his life; though he would later boast of international travel in his film publicity, it's unlikely that Micheaux ever again traveled so freely or extensively outside U.S. borders. And there were other benefits to the trip: "I became well enough acquainted with the liberal millionaires and so useful in serving their families," Micheaux wrote later, "that I made $575 on the trip, besides bringing back so many gifts and curiosities of all kinds that I had enough to divide up with a good many of my friends."

Micheaux made friends easily everywhere he went. A big man who loomed over people, he had a salesman's ebullience that won people over. And, one way or another, he was always selling himself. Though he was indeed "well enough acquainted" with a number of prosperous white people, his close friends were members of his own race, and they spanned a spectrum from doctors and lawyers to fellow porters and humble workingmen, not to mention a long list of ne'er-do-wells. He was always coy about lady friends in his fiction, pretending chaste habits. Men "like to be modest," he wrote in one book, "to appear like they have no loves. It creates sympathy." But he pursued women in several cities, and wrote to more than one.

"Love is something I had longed for more than anything else," Micheaux wrote in *The Conquest*, "but my ambition to overcome the vagaries of my race by accomplishing something worthy of note, hadn't given me much time to seek love."

Foremost in his mind, at Christmas 1904, was Jessie, whom he had come to think of as a possible bride. When he returned from South America, he hastened to Carbondale to visit his sister, and then called on Jessie at her home in nearby Murphysboro. He had grown "tall and rugged," he boasted in *The Conquest,* but Jessie was also "much taller." His sister and Jessie's mother excused themselves so the two young people could sit on the settee alone.

Micheaux told Jessie of his "big plans and the air castles I was building on the great plains of the west." Taking her hand, he was just about to

declare his love for Jessie when "I caught myself and dared not go farther with so serious a subject when I recalled the wild, rough, and lonely place out on the plains." First, he vowed silently, he would develop his land into a proper home for a husband and wife.

Micheaux returned to St. Louis and his Pullman job, spending most of the winter on excursions to Florida and Massachusetts. He took repeated runs to Boston, where he explored the Roxbury community and immersed himself in sightseeing. Along with the usual landmarks, he was keen to see Trinity Church, home of the Episcopalian clergyman Phillips Brooks, whose collected sermons he had read. A man who revered education, he also paid what must have been poignant visits to the Polytechnic Institute in Worcester, Smith College in Northampton, Harvard and M.I.T. in Cambridge. He joined other tourists at historical sites in downtown Boston, inspecting the Old North Church, the Paul Revere house, the U.S.S. *Constitution,* Faneuil Hall, "and a thousand other reminders of the early heroism, rugged courage, and farseeing greatness of Boston's early citizens."

Wherever he traveled as a porter, he also kept up with vaudeville and plays and concerts. His appetite for show business had probably begun with the summer riverboat shows that passed through Metropolis when he was growing up. In Chicago his tastes broadened. He had learned to enjoy everything from classical music to spoken recitals to blackface comedy. In writing about the shows he treasured from his travels, he never mentioned that in Boston's "white" theater district, as in the theater districts of all other American cities, he had to endure "nigger heaven" (the widely-used term for the balcony to which black ticket-holders were relegated) and other offensive protocols of segregation—perhaps because the racism was so widely taken for granted.

In Boston, Micheaux was captivated by a performance of Verdi's *Rigoletto,* with the Australian diva Nellie Melba as Gilda and the young Italian tenor Enrico Caruso as the womanizing Count. The Pullman porter's love of music extended to the Irish tenor Chauncy Olcott (composer of "My Wild Irish Rose," among other songs), and he made a point of seeing *Terence,* Olcott's new musical set in Ireland. Micheaux also recalled attending a "gorgeous and bloodcurdling" revival of *Siberia,* a play that incorporated the infamous Kishinev massacre of 1903. (Two hundred people crowded onstage for the climax, depicting the slaughter of Jews on the streets of Kishinev.)

Micheaux would never again have as much idle time on his hands as he did between runs in Boston during that winter of 1905. After the winter he quit Pullman, vowing never again to porter, and paid Jessie one last visit in Murphysboro. But this visit left him dissatisfied, and as he looked ahead to homesteading in South Dakota, he began to feel "a little lonely," he wrote later. "With the grim reality of the situation facing me, I now began to steel my nerves for a lot of new experience which soon came thick and fast."

His savings had crept back up to $3,000 by the time he left St. Louis for Bonesteel around the first of April 1905.

When Slater, his locator, met him in Bonesteel, the town was abuzz with the news that Dallas, the fledgling town perched on a hill near Micheaux's homestead, was being promoted as the next railhead after Bonesteel. Micheaux could have sold his new land immediately for a "neat advance over what I had paid," but he insisted that he had no intention of selling; he was there to farm the land. This didn't please Slater, and automatically set the newcomer apart from many other area homesteaders, who were more interested in speculation than actually tilling the soil.

As the two men rode in Dad Burpee's red stagecoach over the thirty miles to Dallas, Micheaux couldn't help but notice many brand new structures in the rival towns, "strung in a northwesterly direction across the country," in Micheaux's words, like stars forming a constellation. "It was a long ride," he wrote later, "but I was beside myself with enthusiasm."

Arriving in Dallas, "the scene of much activity," Micheaux found that his reputation as the first and only "colored homesteader" had preceded him. "When I stepped from the stage before the post office," he recalled, "the many knowing glances informed me that I was being looked for." Slater introduced him to the Dallas postmaster, then ushered him into the presence of the most important man in town: Ernest A. Jackson, the president of both the bank and the townsite company that was touting Dallas as the best railhead.

Jackson was the second of three sons of Frank D. Jackson, who had served as the Republican governor of Iowa from 1894 to 1896, and who now presided over the Royal Union Insurance Company in Des Moines,

bankrolling the family's real estate and commercial ventures. Jackson's father and his two brothers, Frank and Graydon, were also officers of the Dallas bank; they directed the family's area investments, which included two huge cattle ranches. One, the Mulehead, northeast of Bonesteel, eventually swelled to 169,000 acres.

The Jacksons maintained a cozy relationship with Marvin Hughitt, the hard-driving leader of the Chicago & North Western, who had built his railroad up from a regional carrier into one of the nation's largest. Dubbed "King Marvin," Hughitt had spearheaded the opening of South Dakota to railroads, initially after gold was discovered in the Black Hills. Farsighted in championing train lines to the Missouri River, Hughitt believed that rail routes would pave the way for settlers, whose growing numbers would in turn provide freight for trains, making his investment profitable. The railroad platted the towns, then subcontracted the tracks, the roads, and the buildings.

Besides money and connections, indispensable in all their dealmaking, the Jacksons evinced something else that Micheaux admired: they had swagger. The Jacksons built frontier towns with more ease than other people carved whistles out of wood, manipulating the land sales, anointing townsites, making each new settled place the hub of an area, the county seat, the prime market, the main railhead—before moving on to the next bargain locale.

Meeting Ernest Jackson's gaze, Micheaux shook the muckety-muck's hand. Surprisingly—or not, considering Micheaux's cultivated ability to relate to rich white people—the newly arrived homesteader felt an instant bond with the town's most prominent citizen. "My long experience with all classes of humanity had made me somewhat of a student of human nature," Micheaux wrote later in *The Conquest,* "and I could see at a glance that here was a person of unusual aggressiveness and great capacity for doing things."

That night, over dinner at the hotel he owned, Jackson offered to buy Micheaux's relinquishment and double his investment. "I am not here to sell," Micheaux declared. "I am here to make good, or die trying." They sized each other up, and were mutually impressed. "I admired the fellow," Micheaux decided. Jackson reminded him of "characters in plays that I greatly admired, where great courage, strength of character, and firm decision were displayed." Jackson seemed the embodiment of the ruthless

capitalist dubbed "The Octopus" in *The Lion and the Mouse,* an absorbing stage drama Micheaux had watched in Boston. Jackson also evoked Otis Skinner's swashbuckling scoundrel, Colonel Philippe Bridau, from another play Micheaux recalled seeing, *The Honor of the Family*—a dramatization of Balzac's *La Rabouilleuse.*

The next day, after a good night's sleep, Micheaux ventured out to look over his claim. But for sections burned during a winter prairie fire, the land was as stunningly beautiful as he remembered.

Drawing five hundred dollars from Ernest Jackson's bank on his Chicago account, Micheaux returned to Bonesteel intending to purchase an inexpensive team of horses. There was only one problem: he didn't really know one horse from another. The Michaux family had never had more than a couple of horses in Metropolis. "I looked at so many teams," Micheaux wrote later, "that all of them began to look alike. I am sure I must have looked at five hundred different horses, more in an effort to appear as a conservative buyer than to buy the best team."

Finally he bought "a team of big plugs" from a man whom he later ascertained was a notorious grafter, and who subsequently bragged widely of having effected the sale by gulling a "coon." One of the horses was old and rode awkwardly; the other was a four-year-old gelding with two feet "badly wire cut." Micheaux also bought lumber for a small house and barn, along with an old wagon, "one wheel of which the blacksmith had forgotten to grease." Then he "worked hard all day getting loaded and wearied, sick and discouraged." It wasn't until five o'clock in the afternoon that he was ready to start the thirty-mile drive back to Dallas.

After two miles the big old horse began to hobble, and Micheaux's wagon wheels started to smoke. The sun went down, and a cold east wind came up—the kind of evil, frigid blowing that shot through one's bones and became, in Micheaux's fiction and films, a symbolic obstacle to a decent man's character and ambitions. "The fact that I was a stranger in a strange land, inhabited wholly by people not my own race, did not tend to cheer my gloomy spirits," Micheaux wrote later. Rosebud country "might be all right in July, but never in April."

He turned around and headed back to Bonesteel for the night. The next day he sold the hobbled horse at a considerable loss, then hired a new horse and drove to Dallas, stopping in Herrick briefly to engage a sod mason who was also a carpenter. It took them five days to dig a well

and erect a small frame barn and house. The barn was big enough for three horses, and the sod house was roughly the same size: fourteen by sixteen.

The low, oblong sod house had a hipped roof of two by fours and was covered by plain boards with tar paper; the sod was grass turned downward, laid side by side, its cracks filled with sand. There were two small windows, one door, and the floor was buffalo grass. In one corner stood Micheaux's bed ("large, wide, dirty—'tis true—but a warm bed, nevertheless"), in another a small table. There was a bin for horse's grain, and for cooking and warmth a monkey stove with an oven on the pipe ("a little two-hole burner gasoline").

Micheaux moved in at the end of the first week of April. Already feeling overwhelmed, he wrote another plaintive letter to Jessie.

The horses were always straying, and it took time before Micheaux learned that there was no such thing as a cheap horse worth the savings. He acquired a local reputation as a patsy for horse traders, he recalled. "Whenever anybody with horses to trade came" to Dallas, Micheaux recalled, "they were advised to go over to the sod house north of town and see the colored man. He was fond of trading horses, yes, he fairly doted on it."

He had the same trouble buying mules to help break out his claim. "Back on our farm in southern Illinois," he wrote later, "mules were thought to be capable of doing more work than horses and eat less grain." The team he bought, named Jack and Jenny, were lazy and balkish. He tried whipping them, but that didn't help much. He swapped Jack to a passing trader and acquired a new mule, except this one was not only lazy but fiendish. Micheaux seemed cursed with fiendish mules, once getting spiked in the temple so hard that he was out cold for hours; the incident was almost his "ending," he recalled. So he became known as a patsy for mule traders, too.

Growing up in southern Illinois he had been the family salesman, doing as little plowing as possible. Now he learned the hard way that different kinds of plows were best for different kinds of soil. His was a gummy soil, especially in April after a long winter. Micheaux started out with a standard square-cut, which caused the roots and grasses to clump

on the blade, prompting the plow, pulled by ornery mules, to hop and skip across the ground. Not for some time did he discover that a long, slanting "breaking plow" severed the deep roots more cleanly. That entire first summer, he never went fifty feet without having to stop and recoup.

Anecdotes about Micheaux's troubles with horses, mules, and plows entertained area homesteaders, nearly all of them white. Reviewing Micheaux's fictionalized accounts, one gets the sense that a perpetual cluster of neighbors and passersby stood on the sidelines, observing his struggles with mixed admiration and bemusement.

"You can't find a better metaphor than a Pullman porter pushing a plow," one neighbor, Don Coonen, averred years later. "He must have gone through the agonies of hell."

It rained through most of June, but Micheaux persevered despite the rain and mud, even as the Dallas postmaster pointed him out to bystanders in town: "Just look at that fool nigger a-working in the rain."

Breaking the land was grueling in the sun, and even worse during steady rainfall. Mosquitoes filled the air. The days were always long, the nights longer and "awfully lonesome." Through his small windows Micheaux watched the clouds shifting and reforming in the vast covering sky. He often dropped off to sleep reading by moonlight. A believer in dreams, he hoped his fancies would foretell happiness and prosperity. His films are full of dreams and nightmares, omens and supernatural visitations, and characters whose "second sight" presages coming events.

One pleasure of Micheaux's early fiction is that he also positions himself on the sidelines, using his narrative voice to comment on his own follies and foibles. In *The Conquest,* especially, he exhibits a keen sense of himself as a quasi-comic hero, though always with the heightened consciousness of a black man who knew he stood apart from and was regarded skeptically by the surrounding community of white homesteaders.

Marriages between white men and Indians were not uncommon in Gregory County, and a few Indians had married Buffalo Soldiers. But Micheaux never lost sight of the fact that his skin color made him a genuine rarity, a "novelty" among the predominantly white homesteaders. He met and talked with white families who had children, "in some instances twenty years of age," Micheaux wrote later, "who had never seen a colored man. Sometimes the little tads would run from me, screaming as though they had met a lion, or some other wild beast of the forest." His

neighbors quickly learned the name Oscar, he wrote later, but fumbled over the pronunciation and spelling of his "odd surname." He sometimes got deliveries that were marked, simply, "Colored Man, Dallas."

There was only "one other colored person" residing in Dallas, Micheaux wrote Jessie, "a barber, who was married to a white woman, and I didn't like him." This was the first time in his life Micheaux had lived surrounded by white people, many of them European immigrants— Germans, Swedes, Irish, Czechs, Russians, Danes, and Austrians—still conversing in their mother tongues. "Only about one [homesteader] in every eight or ten was a farmer," Micheaux recalled. "They were of all vocations in life and all nationalities, excepting negroes, and I controlled the colored vote. This was one place where being a colored man was an honorary distinction."

In spite of everything, by September Micheaux had proven his mettle beyond any doubt. His persistence impressed all his neighbors. In the summer of 1905, he later estimated, he pulled a plow fourteen hundred miles to break the bulk of his claim, planting corn, oats, and flax, and fencing off vast sections of his property. He broke over 120 acres, more than most "other real farmers, who had not broken over forty acres, with good horses and their knowledge of breaking prairie."

He had made a home for himself, and triumphed among his peers, showing himself to be not only a hardworking farmer but in many small ways a good neighbor. He was less and less a "novelty" Negro. He had a growing circle of friends among the white settlers. "I began to be regarded in a different light," Micheaux wrote.

CHAPTER FOUR

1906–1908
THE ONE TRUE
WOMAN

Winter came early in South Dakota, and the groundbreaking and plant-
ing halted. With extra time on his hands, Micheaux sought other work.
The long distances between his homestead and others didn't bother him;
when he wasn't riding a horse or buggy, he was a familiar figure striding
across the fields, hiring himself out to neighbors. One of the many tasks
Micheaux performed for the Jackson brothers was freighting coal and
supplies between Bonesteel and Dallas.

When the cold set in and the winds worsened, there was little respite.
Neighbors who visited him recalled Micheaux lying in bed, his little stove
burning fiercely and blankets up around his shoulders, the corner of a
book peeking out.

Micheaux got in the habit, that first year, of heading to Chicago
around Thanksgiving for Christmas and the New Year, staying for as long
as possible. He caught up with friends, celebrated his birthday on the sec-
ond of January, and attended all the shows downtown and in the Black
Belt. He was impressed by the new stock company that had taken over
the Pekin Theater at the corner of Twenty-seventh and State. The Pekin
Players were among the nation's first professional black theater troupes,
mounting original plays as well as Broadway hits and old standards
restaged with all-black casts. Charles Moore and Lawrence Chenault
were two of the regulars in Micheaux films he first applauded on stage at
the Pekin.

That winter of 1905–1906, he also traveled to Murphysboro to visit

Jessie and spent what he called the "happiest week of my life" with her. Then he picked up some extra money portering on runs to the South. Returning to South Dakota as the winter started to ebb, he fell to brooding about Jessie, who was being pressed by a competing Murphysboro suitor, "a three dollar a week menial," in Micheaux's contemptuous words. His rival's growing friendship with Jessie made Micheaux jealous and miserable. He resolved to forget all about Jessie, but suffered attacks of the blues, mingled with daydreams of himself and his ideal wife on the prairie.

Land surveyors and train agents visited Gregory County in the spring of 1906, and rumors flew they were mapping the long-awaited extension of the railroad. The route of the extension would decide future train stops, and that would determine the ultimate fate of the sparring towns, while richly increasing the value of land along the new route. Each of the Gregory County towns had newspapers, bankers, and civic boosters campaigning for itself.

Bonesteel, which had claimed the railhead since 1901, complacently believed that it would be another ten years before the trains passed it by, time it would spend consolidating its status as a prairie capital. If the extension went through Burke and hit Gregory, then it was a cinch to skip Dallas, which fell a little to the south and on irregular high land. By the same token, if the extension chose Dallas, then it was bound to avoid Burke and Gregory.

The Jacksons kept buying up all available land, while talking up the advantages of Dallas. The brothers bought drinks and dinner for their clients and handed out expensive cigars as they consummated their deals. Their opponents in the other towns derided the Jacksons as "windjammers and manipulators of knavish plots," in Micheaux's words. But Oscar himself found the power brokers shrewd and personable. All three brothers were "college-bred boys, with a higher conception of things in general; were modern, free, and up-to-date"; in his view, they far outclassed the local rubes.

Because of his friendship with the Jacksons, and because he had worked as a porter, Micheaux found that other settlers considered him a "railroad expert," and sought out his opinion on the future of the railroad. His relinquishment was halfway between Dallas and Gregory; had

he purchased it because someone had tipped him off about the extension decision? What did he know of the Jacksons' multifarious schemes? Suddenly viewed as an insider, the "only colored homesteader" found himself an increasingly welcome visitor wherever he roamed.

Then, just as the surveyor rumors rose to a fever, Ernest Jackson mysteriously disappeared from the vicinity. Promoters in the other towns seized on the anxiety provoked by his absence to convince the nervous merchants of Dallas to evacuate. A man was hired to bring horses, block and tackle, and massive wagons, and he hauled the main buildings out of Dallas, literally sawing the bigger structures in half to facilitate the operation. Some were taken to Burke, others to Gregory. Soon little was left of Dallas, excepting a two-story bank, a two-story hotel, a saloon, and a few lesser buildings, all owned by the Jacksons.

When Ernest Jackson reappeared, furious at what had transpired in his absence, he confided the details of his mysterious trip to Micheaux. He and other businessmen had gone to see Marvin Hughitt in Chicago, asking for a peek at the blueprints of the Gregory County survey. Hughitt had told them the extension probably wouldn't include Dallas. Knowing this secret, the Jacksons now made a magnanimous show of offering to move their various enterprises into Gregory and consolidate with that town, which would give Gregory a clear edge over Burke, but the Gregory town fathers, "with the flush of victory and the sensation of empire builders," in Micheaux's words, scorned their overtures. The Jacksons, seething, continued to plot.

Micheaux was royally entertained by everything that was going on, making mental if not actual scribbled notes that would prove useful in crafting his first novel, *The Conquest*.

The summer of 1906 was another thoroughly wet one, wonderful for the crops. Micheaux managed to break the rest of the ground he intended to plow, planting wheat along with more corn and flax.

His horse sense was improving: He bought better horses, and added machinery. He spent $3,000 on another relinquishment, north of Gregory and closer to the Missouri River, increasing his holdings to 320 acres. He divided his time between the two Gregory County farms, breaking the ground of the second homestead.

Though he felt bereft of romance, he was also wary of crossing unspo-
ken lines with any of the local ladies—some of them potentially eligible,
many of them friendly with him, but all of them white. Though not
everyone who spoke this way meant to offend him, Micheaux now and
then heard himself referred to by the ugly word "nigger," which was com-
mon parlance among the white settlers.

One neighbor woman to his southeast tried to make him feel at ease,
sometimes inviting Micheaux inside to sit down and eat supper with the
family. "He'd say, 'Nope,' he wouldn't do it," remembered Dick Siler, an-
other neighbor. "'I'll have some dessert,' he'd say. And what he liked for
dessert was homemade bread and milk. He'd have half a loaf of bread and
drink a half gallon of milk, and that'd be his dessert. He'd always have
that, but you had to bring it outdoors, he wouldn't come in the house."

At times Micheaux was a mixer, known for attending the harvest barn
dances hosted by local Bohemian families. He enjoyed the food and
music, but shied away from the white women who tried to pull him into
dancing. (He bared his thoughts on such missed chances via the lead
character in *The Wind from Nowhere*: "He wasn't dancing with any white
girl, for everybody to be looking at them.") He mingled more with the
children, amusing them by singing, according to colloquial accounts, the
schottishe "Any Rags," popularized at the turn of the century by ragtime
artist Arthur Collins. If he danced at all, it was with the children, and
then everyone was delighted—the women envious—because Micheaux
was a free-spirited dancer.

Micheaux tried to picture Jessie living with him on his claim, but
couldn't quite conjure her there; nor could he shake his feelings of jeal-
ousy. He was writing at intervals to another young woman living in Car-
bondale named "Daisy Hinshaw" (at least that is the name he lends her
in *The Conquest*), whom he had known back in Metropolis, where she
used to come to visit her cousins. She was older than Jessie, "not very
good-looking but had spent years in school and in many ways was unlike
the average colored girl," in his words.

He also developed a long-distance relationship with an attractive "St.
Louis octoroon," a trained nurse who wrote him engaging letters. But
three of his best horses died that fall, he was distracted by hard work, and
he let the St. Louis correspondence lapse. When the wet summer turned
into an early, frigid winter, Micheaux almost froze in "my little old
soddy." The temperature could drop to twenty-five below zero, with the

wind screaming and howling. The snow piled into huge sculpted drifts and long ridges that formed "one endless, unbroken sheet of white frost and ice." Inside seemed as cold as outside. "Sod houses are warm as long as the mice, rats, and gophers do not bore them full of holes, but as they had made a good job tunneling mine, I was left to welcome the breezy atmosphere."

He visited Chicago only briefly over Thanksgiving and Christmas, talking up the golden opportunities on the plains. Like his alter egos in his novels and films, however, Micheaux realized that he often grated on "poor listeners," and could "warm up" to a subject "until it evolved into sort of a lecture."

Back in South Dakota, Ernest Jackson vanished again. This time, he returned with the same block-and-tackle man to uproot and haul the Bank of Dallas to a new, unspecified location. No one, not even Micheaux, knew where the bank building was headed, as it ground slowly across the prairie toward Gregory. After a few miles, the bank made a sudden, surprising swerve to the northwest; by sundown it had been deposited on the side of a hill five miles west of Gregory, just short of the Tripp County line.

Jackson then opened the doors of his bank to invite customers in for loans. The few remaining Dallas buildings followed. Jackson named the impromptu settlement "New Dallas." In recent weeks much of the land surrounding the spot had mysteriously traded hands, with ownership passing to the Jacksons. The brothers were back in business, and the fierce competition between Gregory and New Dallas (which soon dropped the "New") resumed.

In the meantime, Gregory had been awarded the railhead. Micheaux moved his post office address to Gregory, while keeping his money safe in Ernest Jackson's Bank of Dallas. It was a pattern he would repeat throughout his life: moving between places, dispersing his savings among banks in different towns and cities, the better to divide risk and elude creditors. Even now, besides South Dakota, Micheaux was maintaining accounts in Illinois, Iowa, Missouri, and Kansas.

Gregory was the bigger, more established town; in frontier terms it was almost a city—"a great place to visit," in Micheaux's words—with

several banks and crowded hotels and teeming saloons, not to mention a slew of gambling dens and brothels. Without going into much detail, Micheaux said that he spent many a long night "answering the call of the wild" in the pleasure joints of Gregory and other nearby towns.

Adding to the excitement, in the summer of 1907, was the belief that four thousand homesteads in Tripp County, immediately to the west, would soon be opened to claims and settlement under another government lottery. Tripp County land would be more expensive land than Gregory County, but still a bargain at six dollars per acre. Congress had passed the necessary legislation in March, and the bill awaited President Theodore Roosevelt's signature. Many of the homesteaders in Gregory County were preparing to sell their land at a profit, and reinvest the proceeds in Tripp.

Another rainy summer passed, the crops bountiful. Strangers and speculators poured into Gregory County. Everyone was certain that the Tripp homesteads would be twice as lucrative, and land prices rocketed. "The atmosphere seemed charged with drunken enthusiasm," Micheaux wrote later. "Everybody had it. There was nothing to fear."

By now, Gregory and Dallas were vying fiercely for the upper hand. Each town boasted that it offered the cheapest water, the finest hotels, free escorted tours of the countryside, and optimal land. ("Whenever anything like a real building goes up in a little town on the prairie, with their collection of shacks," Micheaux observed drily, "it is always called 'the best building' between there and somewhere else.") But Gregory didn't have Ernest Jackson, that "king of reasoning," in Micheaux's words, who welcomed visitors to a "luxuriously furnished" office, its walls "profusely decorated" with portraits of "prominent capitalists and financiers of the middle west, some of whom were financing the schemes of the fine looking young men" smoking the cigars and dispensing the contracts.

Again Jackson confided in Micheaux, telling the black homesteader that Marvin Hughitt had promised him a personal favor. King Marvin had agreed to extend the extension *past* Gregory, for the sake of all those big ranchers who didn't want to drive their herds of cattle through five miles of settled farm country. Usually, as Micheaux understood, it took ten or twenty years for a railroad to extend its railhead. But the first train had come to Gregory on a Sunday in June 1907. And the extension would arrive in the new Dallas by September.

Micheaux savored every morsel of the drama, later writing it all down.

In Micheaux's fourth summer of homesteading, the summer of 1908, the land excitement reached an orgasmic pitch.

Automobiles spread like a rash across Gregory County, bearing speculators driving buyers around the countryside. Ernest Jackson led "booster trade excursions" in his gleaming Packard, "making clever speeches" and inviting prospects back to Dallas for free wining and dining at the hotel and businesses he owned. A man of trains, Micheaux never developed the same ardor for automobiles—when traveling in cars later in life, he preferred to be chauffeured—and now he noted "the exhaust of the engine making a cracking noise" as he stood in his Rosebud fields, watching the boosters roll by. "The motion, added to the speed, seemed to thrill and enthuse the investor, until he bought whether he cared or not," Micheaux observed.

Jackson and other wheeler-dealers often stopped for their clients to meet Micheaux, as his land was considered "the cream of the county as to location, soil, and other advantages," in his words. "I was known as a booster," Micheaux wrote. "Instead of being nervous over meeting me, the dealers would drive into the yards or into the fields, and as I liked to talk, introduce the prospective buyers to me, and we would engage in a long conversation at times."

Having traveled extensively in the central states—indeed through much of America—Micheaux relaxed the nervous newcomers with his droll observations about their home counties. He also held forth about Gregory and Tripp counties, discoursing on the lay of the land and the quality of the soil in areas where homesteads were available. He spoke knowledgeably about farms that seemed "rougher and less desirable," pointing out the fact that water for these plots could be "easily obtained in the draws and hills," though he recognized that the more attractive high lands sold at "higher prices, and much quicker, regardless of the obvious defects."

The Tripp County registration was set for October 7, 1908, and it would run for ten days at registration points including Gregory and Dallas. Swept up in the mania, Micheaux wrote letters to black friends and relatives, urging them to take advantage of the Tripp lottery and hasten to the plains. He later estimated that he sent letters, articles, or pamphlets to

one hundred people, as well as "different newspapers edited by colored people, in the east and other places." When the great day dawned, however, he was disappointed and disgusted to realize that, of the thousands of people converging on Gregory and Dallas, only one new "colored person" had accepted his invitation to come and invest in land there—his own brother from Chicago! William drew a high number and returned to the Black Belt without a homestead.

The crowds on the streets of Gregory and Dallas that day were "more like the crowds on Broadway or State Street on a busy day than Main Street in a burg of the prairie," Micheaux later wrote. Among other come-ons, Gregory had introduced an Information Bureau and ladies' rest rooms. But Dallas, where the Jackson brothers were in charge of the lavish hospitality, offered tents for gambling, and rivers of liquor. The town was crawling with gamblers of every type ("from the 'tin horn' and 'piker' class to the 'fat professionals,'" in Micheaux's words), and pickpockets, con men, and prostitutes were out in force. "The sidewalks were crowded from morn till night," Micheaux wrote. "The registration booths and the saloons never closed, and more automobiles than I had ever seen in a country town up to that time, roared, and with their clattering noise, took the people hurriedly across the reservation to the west."

As the close of registration neared, a prairie fire sprang up. Blown by high winds, it came surging across the plains toward Dallas, threatening not only the wooden businesses and houses, but roughly ten thousand land-seekers and sightseers who had gathered in the town for the nonstop speculating and partying. Unlike Gregory, which had been intentionally built on low ground, where water collected during the rains, the new Dallas—like old Dallas—was on a hill and constantly beset by a lack of water.

Micheaux was out harvesting flax in his fields some miles away when the prairie fire was spotted late that afternoon. The approaching cloud of smoke, "with the little city lying silent before it," reminded him of "a picture of Pompeii before Vesuvius." Dallas rushed out its chemical fire engine and water hose, but the strong wind whisked the chemicals into the air, and the water from the hose flowed weakly for a few minutes before petering out. Ernest Jackson "bravely" led a counterattack with buckets and wet blankets. Micheaux rushed over from his claim to join in the effort. Even the neighboring Gregoryites stopped their merrymaking at the prospect of a conflagration threatening their "hated rival," forming vol-

unteer brigades that loaded water barrels into wagons before racing across the five miles to Dallas.

When the prairie fire reached Dallas, the conflagration destroyed the first magnificent residence it touched, then another and another: "ten houses went up like chaff," Micheaux recalled. Dallas's water brigade was heavily taxed, as the flames spread. Then, all of a sudden—"like a miracle," Micheaux wrote—"the wind quieted down, changed, and in less than twenty minutes was blowing a gale from the east, starting the fire back over the ground over which it had burned. There it sputtered, flickered, and with a few sparks went out."

At that very moment, the first Gregory rescue wagon arrived, drawn by lathered, wild-eyed mules and overloaded with barrels. The Jacksons— "who were said to resemble Mississippi steamboat roustabouts on a hot day"—curtly informed the Gregoryites that Dallas didn't need their damn water.

The fire's miraculous early end transformed a potential death blow for Dallas into a community triumph. Perhaps foolishly, the throngs of speculators were heartened rather than scared off by the town's narrow escape. Micheaux, who had freighted "one of the first loads of lumber" to help build "New Dallas" not long before, mused privately on these dizzying events, that swiftly and sensationally transformed his world. He was living "not in a wilderness—as stated in some of the letters I had received from colored friends in reply to my letter that informed them of the opening—but in the midst of advancement and action."

When the smoke cleared and the lottery was finished, nearly 115,000 people had registered for six thousand homesteads, and Dallas had lured the greatest number of applicants, besting Gregory with 43,000 to 7,000. The Dallas hotels, some charging a dollar a person, had raked in "small fortunes, while the saloons were said to have averaged over one thousand dollars a day," according to Micheaux. "After the opening," he added drily, "land sold like hot hamburger sandwiches had a few weeks before."

Micheaux had learned his lesson with the first lottery he attended, and though he probably registered for a Tripp claim, his expectations weren't high, and he was prepared to bide his time for the relinquishments.

The rain had been incessant throughout the summer of 1908, and

Micheaux had become extremely proficient at cultivating his land, so much so that this man, who at first couldn't tell one horse or plow from another, was now farming with ingenious methods that made him the envy of other homesteaders. At one point Micheaux utilized a team of "eight horses pulling a [grain] binder with a seeder on behind. Harvesting and seeding at the same time was an innovation all his own," recalled neighbor Don Coonen.

Micheaux sold his corn, flax, wheat, and oats for thirty-five hundred dollars that season. After four years of homesteading in South Dakota, he estimated that he owned land and stock "to the value of twenty thousand dollars" and "was only two thousand dollars in debt."

But he had kept "bach"—lived as a bachelor—for too long. His land and life felt empty without a woman there to share it. He wanted a soulmate, and he even had a phrase for the ideal female he visualized, a phrase that recurs in his books and films: the "One True Woman." And in the summer of 1908, when everyone else was being driven into a frenzy by the Tripp County lottery, Micheaux's real crisis was that he had fallen in love with someone: a white woman, the daughter of a neighboring settler.

There is no evidence of this person's identity beyond what we can deduce from Micheaux's novels. But the fact that he wrote passionately about her in three autobiographical novels—*The Conquest, The Homesteader,* and *The Wind from Nowhere*—and later depicted her in several films drawing on his life story, makes nearly every Micheaux scholar who has seriously examined the question believe that this woman existed, and that the two had an anguished, thwarted romance that exerted a lasting effect on Micheaux. Though Micheaux's fictional portraits of this woman varied somewhat in their identifying details, important elements remained the same in each incarnation.

Early in 1908, according to *The Conquest,* a Scottish family consisting of a "a widower, two sons and two daughters," moved from Indiana onto land close to his main Gregory County claim. (In later versions there is only one daughter, though the family is still Scotch and from Indiana.) The friendly neighbors became frequent visitors; Micheaux hired one son to help out with his farming, and occasionally, when Micheaux was at the Scottish family's farm and darkness fell, he would stay overnight in the barn.

The older of the daughters was "a beautiful blonde maiden," about twenty years of age, who was in charge of the household duties.

The young woman hadn't graduated from high school, but she kept a diary, read to her father, and wrote letters for the family. For Micheaux she was a kindred spirit, a reader and a writer, "an unusually intelligent girl," in his words, "anxious to improve her mind." Innocently taking her under wing, the "colored homesteader" passed on newspapers and magazines to his blonde neighbor, along with favorite books from his collection. From time to time, they would sit and discuss what they were reading. The "Scotch girl" also composed verse and wrote songs, and Micheaux helped her out there, too, apparently finding a publishing company that purchased some of her compositions and paid her fifty dollars.

"Before long, however," Micheaux wrote, "and without any intention of being other than kind, I found myself drawn to her in a way that threatened to become serious. While custom frowns on even the discussion of the amalgamation of races, it is only human to be kind, and it was only my intention to encourage the desire to improve, which I could see in her, but I found myself on the verge of falling in love with her. To make matters more awkward, that love was being returned."

According to Micheaux, their situation reached "a stage of embarrassment" one day, when they were reading *Othello* together, Shakespeare's famous play about a Moor whose happy marriage to a white noblewoman is poisoned by jealousy. This anecdote seems almost too good to be true, and perhaps Micheaux was adding literary flair (and a sheen of legitimacy) to the true story. Whatever happened, the event as he told it foreshadows the two greatest, recurring, romantic themes of his work: the "One True Woman," the black soulmate he (and his protagonists) would seek; and the white woman by whom they would be tempted, only to recoil in horror at the dangerous implications of the union.

As Micheaux recalled it, the Scottish blonde was sitting at a table and he was standing over her as they reached the story's climax, in which Othello is driven by the machinations of Iago to murder his beloved Desdemona. "As if by instinct," Micheaux wrote, she looked up, their eyes meeting. "When I came to myself," he said, "I had kissed her twice on the lips she held up."

After that one encounter, however, he felt torn and foolish and endeavored to keep his distance from the blonde neighbor. "During the time I had lived among the white people," Micheaux wrote in *The Conquest,* "I had kept my place as regards custom, and had been treated with

every courtesy and respect; had been referred to in the local newspapers in the most complimentary terms. . . . But when the reality of the situation dawned upon me, I became in a way frightened, for I did not by any means want to fall in love with a white girl. I had always disapproved of intermarriage, considering it as being above all things the very thing that a colored man could not even think of."

Racial intermarriage—what was called "miscegenation"—was not only against accepted custom in most parts of America at the time, in many places it was expressly illegal. Micheaux knew the South Dakota legislature was busy promoting an antimiscegenation statute, forbidding cohabitation or intermarriage between the races and making the crime punishable by a thousand-dollar fine, ten years' imprisonment, or both. That law would eventually pass in South Dakota in 1909, and in *The Conquest* Micheaux wrote of a case he had followed where "the daughter of the only colored farmer" besides himself in all of South Dakota was "prevented from marrying a white man, at the altar," by terms of this law.

Quite apart from custom or law, Micheaux was tormented by his private thoughts on the issue. Hadn't he written to Jessie, saying that he didn't like the town barber, in part because the barber was married to a white woman? He was acutely aware of certain prominent people—famous examples in his mind—who were "of mixed blood, but never admitted it." Among these was a wealthy banker from a northern Nebraska town whom everyone knew was "mixed blood," though he "passed" as white. Spotting this banker's younger brother attending a baseball game in Gregory one day, surrounded by white friends, Micheaux caught his eye. "He looked away quickly, but I shall not soon forget that moment of social recognition," Micheaux wrote.

The banker and his relatives were ashamed of their mixed-race lineage. They had no "race loyalty," in Micheaux's opinion. Indeed, they evinced a "terror of their race; disowning and denying the blood that coursed through their veins; claiming to be of some foreign descent; in fact anything to hide or conceal the mixture of Ethiopian." Micheaux felt he could never curse his own future children to lie and masquerade in such degrading fashion. He turned the problem over and over in his mind, disturbed by it, and disturbed that he couldn't get the subject out of his head.

One day, Micheaux happened to visit his Scottish neighbors and there he came upon the blonde maiden alone. She hadn't expected him, and it was obvious that she had been weeping. "Well, what is a fellow going to

do?" Micheaux wrote later. "What I did was to take her into my arms and in spite of all the custom, loyalty, or dignity of either Ethiopian or the Caucasian race, loved her like a lover."

Afterward, he despised himself for his confusion, his weakness, his vanity, his stupidity. A mixed-race romance was impossible. He could never marry a white woman. It wouldn't be fair to her, or their children.

"I would have given half my life to have had her possess just a least bit of negro blood in her veins," Micheaux wrote in *The Conquest,* "but since she did not and could not help it any more than I could help being a negro, I tried to forget it."

CHAPTER FIVE

1908–1909
A NEW
PERSONA

Out of despondency emerged fresh resolve. When Micheaux decided that he would never marry a white woman, he also decided it was time to buckle down and find a wife "among my own." The week before Christmas, he straightened out his business affairs and left for Chicago.

After spending time with friends and relatives there, he took off for New York, where he sought out the hot clubs and popular shows. He befriended a recent graduate of an agricultural college, one of the sons of Junius Groves, the "Negro Potato King" of Kansas, who at the height of his success owned five hundred acres of potatoes, a business big enough that he had a special Union Pacific track running to his property. Micheaux confided his yearning for a wife, and Groves's son recommended his sister, who lived on the family farm in Kansas. Micheaux started writing to her.

From South Dakota, he had been writing more frequently to Daisy Hinshaw, the twenty-five-year-old daughter of the "most prosperous colored" family in Carbondale, whom Micheaux knew from Metropolis days. While in New York he sent her a telegram, offering to pay Daisy a visit. Daisy wrote back, asking Micheaux to bring her a nice new purse from New York as a token of his affection. "I did not like such boldness," he recalled. "I should have preferred a little more modesty." Grudgingly, Micheaux stopped at a Fifth Avenue shop and spent six dollars on a large seal handbag.

Arriving in Carbondale, he found himself the "Man of the Hour" as word flew around that Daisy Hinshaw had a suitor who had brought her

an expensive gift all the way from New York. The gossips predicted marriage. "The only objector to this plan," wrote Micheaux, "was myself." Spending time alone with Daisy, he found her pleasant enough but dull, and "a little odd in appearance," small, bony, with gray "cattish" eyes.

Half out of boredom, he decided to visit relatives in the mining town where he once had worked, but while he was waiting at the train station he heard the "colored caller" announce a train to Murphysboro. With a pang he remembered Jessie; impulsively, Micheaux boarded the train and showed up at her house. When he rang the doorbell, Jessie herself opened the door. "She had changed quite a bit" since he had last seen her, "and now with long skirts and the eyes looked so tired and dreamlike. She was quite fascinating, this I took in at a glance."

A moment later they were kissing. The next hours were "the most carefree time of my life," he recalled, spent catching up with each other and pouring out their "pent-up feelings." Jessie's father, the mail carrier, had fallen on hard times; he had suffered an injury and lost his job. Jessie too was struggling; she was teaching at a country school but sewing to make ends meet. Micheaux felt badly for Jessie, "so weak and forlorn in her distress."

The midnight train took him back to Carbondale, and the next morning he was brought up short by a pouting Daisy, who suspected Micheaux of lingering in the arms of another woman. Arranging him on a sofa in her house, she made a grand entrance in a black silk dress with her face powdered and her hair done up, announcing that she was ready to make arrangements for moving to South Dakota. "One advantage of a dark skin," Micheaux wrote later, "is that one does not show his inner feeling as noticeably as those of the lighter shade, and I do not know whether Miss Hinshaw noticed the look of embarrassment that overspread my countenance."

Fortunately, they were interrupted by an unexpected visitor, and Micheaux was able to avoid making any false promises to Daisy. The next day he guiltily kissed her good-bye at the train station, knowing he would never see her again. She had grown "sad in appearance," Micheaux wrote, "and looked so lonely I felt sorry for her."

He stopped off in Murphysboro and took Jessie for a long walk. By now it was mid-January, and they talked it over and agreed to get married in October, when Jessie could come to South Dakota and register for a Tripp County relinquishment.

Micheaux returned to South Dakota via St. Louis and Great Bend,

visiting with his family and members of the local ex-slave community in Kansas, many of whom operated thriving farms. While there, he boasted about his engagement. "Shooting jackrabbits by day and boosting Dakota to Jayhawkers half the night," he recalled in *The Conquest,* he wrote to Jessie "sometime during each twenty-four hours, and for a time received a letter as often." He talked up the glories of the Rosebud: Micheaux was eager to expand his holdings with Tripp County relinquishments, but he knew he could file only once under his own name, because of the residency requirements. If he had partners, he could find ways to double his land and loans.

Two of his younger sisters, Olive and Ethel, were both graduating from high school in June, and they told Oscar that they'd be willing to farm relinquished claims in South Dakota, but they didn't have the money to pay the registration and startup costs. Micheaux agreed to mortgage his land and loan them the expenses.

But his hopes that Jessie was the One True Woman were all too swiftly dashed.

Back in South Dakota for the winter, Micheaux continued to write her regularly. He grew "a bit uneasy" when weeks went by without any reply. Then Jessie finally wrote back with devastating news: She had heard through the grapevine that Micheaux was engaged to Daisy Hinshaw of Carbondale, and "as Daisy would be the heir to the money and property of her parents, she felt sure my marriage to Miss Hinshaw would be more agreeable." The grapevine was wrong, but it was too late for him to disabuse Jessie; for on April 1, she explained, she had impulsively married an older man, a cook who was better suited to her humble circumstances.

Micheaux would have been paralyzed with the blues if he hadn't been so preoccupied by spring chores on his two farms. Even so, he felt "jilted" and nursed his hurt for months.

The summer of 1909 was the peak of the land craze. Lot prices soared, as people competed for Tripp County relinquishments. The hotels in Gregory and Dallas filled up with lucky number-holders, novice settlers, and the usual surfeit of speculators and adventure-seekers. The roads were filled with automobiles, and many places now had telephone service.

The harvest looked to be another prosperous one, and Micheaux had become as land-crazy as everybody else. He scouted for possible relin-

quishments far west of Dallas, in western Tripp County. Once again, the county's prospective municipalities were vying for the chance to become the next railhead, the latest prairie boom town. Ernest Jackson drove around in his Packard, offering staggering prices for swaths of unsettled land over twenty miles west of Dallas.

The town of Colome, closer to Dallas and already the bustling county seat of Tripp, tried to ignore Jackson's machinations. The enterprising Jackson called a community meeting in Colome and announced sale prices for lots in a new town he was building farther west, which the first citizens—banking on the Jacksons' sway with the railroad surveyors—were already calling "Winner." As signs of confidence in its future, the town of Colome laid cement sidewalks along its streets and built a modern schoolhouse with a gymnasium. For his part, Jackson then threw a festive auction in Winner, replete with bartenders and gamblers, selling a record $84,000 in lots in two days. When the good citizens of Colome still refused to budge, Jackson bought the town's most important buildings, cut them in half, and used huge power tractors to move them eleven miles west to Winner.

When the time came for Micheaux to choose his Tripp County relinquishments, he oriented himself around the new center of operations for the Jackson brothers, scouting forfeited claims as far as fifteen miles northwest of Winner. He raced around in a borrowed car before pinpointing three properties. The necessary loans would come from the Jacksons' bank in Winner.

As it happened, Micheaux's sister Ethel wasn't due to turn twenty-one—the legal age for filing—by October, when the land opened up. So instead Olive would be joined on the South Dakota homesteading adventure by the family's maternal grandmother, Louisa Gough. Though the former slave was in her mid-seventies, his grandmother "always possessed a roving spirit," in Micheaux's words, and she "wanted to come."

Micheaux mortgaged his 320 acres for $7,600, and paid in the neighborhood of $6,400 for three relinquishments: two for his sister and grandmother, and one for his wife-to-be—the One True Woman, the Mrs. Micheaux he hadn't yet found.

Still, he kept trying. In early September, Micheaux compiled a list of eligible candidates and hurriedly wrote letters to the top three, suggesting

they meet to discuss a proposition he had in mind. One of the women was "a maid on the Twentieth Century Limited, running between New York and Chicago." Another was the daughter of Kansas's Negro Potato King. The third was a schoolteacher in Chicago's Black Belt.

"He was somewhat ashamed of himself when he addressed three letters when perhaps he should have been addressing but one," Micheaux wrote of his alter ego Jean Baptiste in *The Homesteader* (the first sequel to *The Conquest*). "It was not fair to either of the three, he guiltily felt; but business was business with him."

In retrospect—and with cause to regret his actions—Micheaux said that his first choice really should have been the Negro Potato Princess, whom he had never met, but whose letters to him were always so "logical" and "agreeable." But he had waited too long before organizing his trip, and didn't dispatch his urgent missives until just before he left. He tarried at the Omaha train station, waiting for a telegram from the Potato Princess. But none came, so he crossed her off his list and continued on his way to Chicago.

He arrived in late September, hoping to hear from the train maid; instead he received a telegram informing him that his second nominee had suffered a "severe attack of neuralgia" and was under a doctor's care in New York. Thus the list dwindled to one name: Orlean McCracken, a twenty-five-year-old graduate of South Division High School in Chicago and Wilberforce University in Ohio. Micheaux had met Orlean the previous winter in Murphysboro, where she was then teaching school. He had seen her again, on trips to Chicago. He had been writing her intermittently, sending her articles and books; in her responses she had warmed to his tales of homesteading.

Micheaux might have preferred "a farmer's daughter," he reflected later, but "I had lived in the city and thought if I married a city girl I would understand her, anyway. I could not claim to be in love with this girl, nor with anyone else, but had always had a feeling that if a man and woman met and found each other pleasant and entertaining, there was no need of a long courtship."

On the positive side, Orlean was "a kind, simple, and sympathetic person; in fact agreeable in every way." Micheaux had found her pretty (dark-complexioned, "although not black," with "heavy, black and attractive" hair and "coal-black" eyes), and brainy: a college graduate, Orlean was probably "the most intelligent of the three" on his list.

In Chicago, he phoned the McCracken residence. The family lived in a large stone-front house on Vernon Avenue, a fashionable area of the Black Belt referred to as "East of State," where black professionals lived alongside the scattering of white homeowners who hadn't yet abandoned the neighborhood. The black professionals constituted "a sort of local aristocracy," in Micheaux's faintly scornful words, "not distinguished so much by wealth as by the airs and conventionality of its members, who did not go to public dances on State Street and drink 'can' beer." Vernon was "much unlike the south end of Dearborn Street and Armour Avenue where none but colored people live." He made an appointment to see Orlean the next afternoon, which was a Saturday.

It wasn't until Micheaux rang the doorbell and was greeted by Orlean's mother that he recognized Mrs. McCracken and made an unsettling connection: Orlean's father was one of the presiding Elders of the A.M.E. Church who roamed the southern Illinois circuit—in fact, the very same Reverend McCracken who had visited his Metropolis home for Sunday supper and upbraided Oscar when he was a boy, causing a ruckus in his family.

When Micheaux arrived, Orlean's father was at a convention hundreds of miles away. So Micheaux and Orlean went out for dinner and a long walk in Jackson Park, talking easily. She commiserated with him over what had happened in his relationship with Jessie from Murphysboro, a tale she knew through mutual acquaintances as well as their correspondence. The walk climaxed with Micheaux's earnest proposal that Orlean come to South Dakota, file on the relinquishment he'd earmarked for her, and become his bride. Orlean was receptive to the idea, and told Micheaux to come back the next morning and explain things to her mother.

Micheaux did just that, and Mrs. McCracken proved amenable, though she was nervous about making any momentous decision without her husband. Orlean had a younger sister, already married, who hovered about disapprovingly, and impressed Micheaux as jealous and mean-spirited. All three women spoke of Reverend McCracken with awe, as though he were a wise potentate.

They all attended Sunday services and sat through Bible lessons afterward. That evening, Micheaux took Orlean to see a popular revue headed by blackface comic Lew Dockstader and featuring the well-known vaudevillian Neil O'Brien and a rising young entertainer named Al Jolson.

Blackface shows, generally with white men smearing their faces with cork to sing, dance, and tell jokes in "Negro dialect," were a nineteenth-century show business phenomenon; this was one of the last major shows touring nationally. But there were also black masters of minstrelsy like Bert Williams, and the most sophisticated blackface humor cut both ways, satirizing the fatuousness of racial stereotypes and empathizing with the plight of African-Americans. "Simply condemning it all as an entertainment that pandered to White racism does not begin to account for its complexities, its confusion, its neuroses," as John Strausbaugh observes in his thought-provoking *Black Like You: Blackface, Whiteface, Insult & Imagination in American Popular Culture.*

Far from demonstrating backward tastes, Micheaux's presence in the theater suggests his show business sophistication. As Strausbaugh notes, the white, potbellied Dockstader was "one of the premiere monologuists" in minstrelsy. One of the highlights of his act, which he likely performed in Chicago, was a blackface Teddy Roosevelt shtick that mercilessly lampooned Teddy's "tendencies to bloviate," in Strausbaugh's words. Though black audience members were forced to sit in the balcony at the ornate, Louis Sullivan–designed Garrick Theater, Micheaux reveled in the show. "I laughed until my head ached," he recalled.

The couple spent the next day trying to reach Reverend McCracken by telephone, without success. By now, Micheaux was on the verge of panic. It was the last week of September. His sister and grandmother were due to arrive in South Dakota. The stipulated filing date for the relinquishments was October 1. If he wasn't back in South Dakota in time, and if his wife didn't file on the claim he had earmarked, he would lose $1,200 he had paid ahead to the bank.

Finally, a female friend of the McCracken family offered to travel with Orlean to South Dakota as chaperone, if Micheaux would pay her fare, too. Orlean and the chaperone could then return to Chicago, with the marriage ceremony to be put off until the spring, after they had secured Orlean's father's approval.

Micheaux agreed and left immediately for South Dakota, with Orlean and her chaperone trailing a day or two later. Waiting for him back home was a letter from the woman who had once topped his list, the daughter of Potato King Junius Groves, but by then it was too late. He "wistfully" tore up the letter and "flung it to the winds."

The relinquishment system called for claim-seekers to stand in line at

the land office in Gregory. Everyone received a number, and the order of the numbers became the sequence in which people could file their preference of claims, hours or days hence. The line started forming after lunch on the last day of September, and Micheaux got his sister and grandmother in line early, then took Orlean's place in line, so she could have a soft bed in a hotel.

By sunset the line was packed, and the street in front of the land office had become "a surging mass of humanity," in Micheaux's words. Cold set in with the darkness. Hot coffee and sandwiches were hawked. Drunks mingled with the crowd. People linked arms and sang songs, or told campfire stories to keep up their spirits. "I held the place for my fiancée through the night, and although I had become used to all kinds of roughness, sitting up in the street all the long night was far from pleasant," Micheaux recalled.

Squatters arrived in the predawn, and soon places near the door were selling for as high as fifty dollars. By daybreak, roughly 1,700 people stood waiting for the land office to open. "An army of tired, swollen-eyed and dusty creatures they appeared," Micheaux wrote.

His bride-to-be and grandmother received numbers 138 and 139, and were relegated to the second day of filing for a relinquishment, while his sister received number 170 and had to wait a few days longer. Orlean filed on a 160–acre parcel on "the northwest quarter of section 34 in township 100, range 79, 5th Meridian" in Tripp County. Louisa Gough and Olive Micheaux filed on 160–acre parcels near to each other's and Orlean's, in the southwest quarter of Township 101.

After Orlean completed her paperwork, she and her chaperone returned to Chicago, while Micheaux proceeded to his grandmother's and sister's claims. Within a week he had built frame houses on the two properties, and a week later Oscar's grandmother and sister were living on their homesteads. After Orlean joined them, Micheaux later wrote proudly, he could boast of having personally increased South Dakota's sparse colored population by three.

The winter of 1909–1910 was a brutal one. Shortly after the Micheaux women moved in, what the homesteader remembered as "one of the

biggest snowstorms I had ever seen" swept across South Dakota, dumping snow for days. The blizzard was followed by warm weather, then more snowfall and freezing. At times the drifts rose above four feet. Many of the novice homesteaders had moved onto lands twenty and fifty miles from stockpiles of fuel, and they suffered. Thinking ahead, Micheaux had hauled enough coal to last the winter for himself, his grandmother, and sister; and Louisa Gough and Olive Micheaux could always find food in the small town of Witten, not far from their farms.

The crops also suffered. Micheaux's wheat was unthreshed when the early snows came. "The corn in the fields had not been gathered," Micheaux remembered, "nor was it all gathered before the following April."

Letters flew between South Dakota and Chicago. Micheaux and Orlean wrote back and forth, but Reverend McCracken also took up correspondence with his daughter's betrothed. "He did not write a very brilliant letter," Micheaux said, "but was very reasonable, and tried to appear a little serious when he referred to my having his daughter come to South Dakota and file on land. He concluded by saying he thought it a good thing for colored people to go west and take land."

Orlean often wrote sweetly, but at times she pressed Micheaux to make good on the engagement ring he had promised her. He equivocated about the ring. In his letters, he tried to talk her out of the frivolous expense. He knew all about rings and jewelry, and later in his novels complained about how black people were always going into debt for such gewgaws. He was already heavily mortgaged, and snowbound. He would rather put off buying a costly ring.

Not without resentment, Micheaux finally surrendered and bought his fiancée a $40 dollar diamond, "set in a small eighteen karat ring," having it sent to her from a company he identifies in *The Conquest* as Loftis Brothers & Co., which was an actual firm on State Street in Chicago that advertised heavily in the Black Belt ("Diamonds and Watches on Credit"). (By the time of *The Wind from Nowhere*, the ring had grown into "a blue white, sparkling solitaire" worth $250.)

He had hoped to get married by Christmas, but the snow caused delays. Micheaux abandoned his cold "soddy" and moved into a house still standing on the old Dallas townsite. His sister and grandmother came down to take care of his place, so he could leave for Chicago and finalize

wedding plans. "I could scarcely afford it," he explained later, "but it had become a custom for me to spend Christmas in Chicago, and I wanted to know Orlean better and I wanted to meet her father."

The McCrackens weren't expecting him, and when Micheaux phoned from the station and then came by in the early evening, the Elder wasn't yet home from his travels in southern Illinois. When Orlean's father arrived in time for dinner, Micheaux got his first clear look at the man who was only a dim memory from boyhood, but who would loom significantly hereafter in his consciousness, inspiring vivid characters and controversial themes in his novels and films.

The Reverend Newton J. McCracken was in his late fifties, more than six feet tall. He weighed about two hundred pounds, but his small-boned frame gave him a plump appearance. "He was very dark, with a medium forehead and high-ridged nose," Micheaux wrote in *The Conquest,* "making it possible for him to wear nose-glasses, the nose being unlike the flat-nosed negro." The Elder sported a bushy mustache sprinkled with gray, and his shock of white hair, coaxed into a massive pompadour, "contrasted sharply with the dark skin and rounded features," in Micheaux's words.

The Reverend McCracken was prideful of his appearance, Micheaux perceived at once. But the homesteader also detected something else beneath the surface of the Reverend's eyes. His were not the eyes of a "deep thinking man," Micheaux decided. "They reminded me more of the eyes of a pig, full but expressionless."

The family potentate presided at the head of the table in a "ceremonious manner." The Reverend talked freely, but proved a "poor listener." He liked to vent his ideas on religion and politics, especially "the so-called Negro problem," in Micheaux's scornful words. Micheaux had to stifle his sharp disagreement. Micheaux had always been a strong proponent of Booker T. Washington, whose portrait would be seen hanging on walls in his films as often as Abraham Lincoln's. Micheaux endorsed the Great Educator's philosophy of hard work, learning, conciliation with the South, and a gradual uplifting of the race. The Reverend, with his bourgeois airs, scoffed at the Tuskegee founder as a man whose time had passed, too much of an accommodationist in light of the widespread racism, state-sanctioned segregation, and racially motivated mob violence of the era.

Perhaps more than his views, the cleric's manner put Micheaux off.

The Reverend talked as though he himself had money and education, but the homesteader suspected he had little of either. "Although he never cut off my discourse in any way," recalled the equally prideful Micheaux, "he didn't listen as I had been used to having people listen, apparently with encouragement in their eyes, which makes talking a pleasure, so I soon ceased to talk." The family treated the Reverend as though pearls spilled from his mouth, and as Orlean herself stood over the pontificating Elder, stroking his hair, Micheaux realized that she was her father's obedient favorite.

Altogether it was an awkward evening, but not disastrous, and on the Sunday that followed Micheaux accompanied the McCrackens to church services. During the week, he stole Orlean away to see shows downtown. They had their first tiff after watching a production of Alexandre Bisson's melodrama *Madame X*. Micheaux found the story of a weak husband plagued by a flighty, immoral wife "pathetic." Though Madame X redeemed herself in a courtroom climax, Micheaux detested the tearjerking ending, in which she succumbed to her absinthe addiction. Orlean was one of many in the balcony who were sobbing into their handkerchiefs by the end of the show; Oscar was irritated to find even himself choking back tears. He and Orlean argued about the play all the way home.

He was happier with *The Fourth Estate* by Joseph Medill Patterson, a former crusading reporter who was the son of the editor and publisher of the *Chicago Tribune*. This drama about a muckraking publisher in love with the daughter of the target of one of his exposés had "strength of character and a happy finale," in Micheaux's words, "instead of weakness and an unhappy ending." It was the kind of story that would always appeal to Micheaux, whose books and films often featured strong, noble heroes, idealized ingenues, and turnabout happy finales.

He could only afford a week away from his farming responsibilities, and the week was soon up without any resolution as to the when and where of the nuptials. Micheaux wanted Orlean to come back with him to Gregory and be married "quietly." The Reverend kept insisting they be wed properly and festively at home in Chicago.

Talking with his Black Belt friends, Micheaux confessed his prejudices against the Reverend, and he was gratified to learn that many of them, too, considered the Elder an arrogant hypocrite. McCracken was rumored to tyrannize his gentle-hearted wife, and to be a profligate wom-

anizer with one or two illegitimate children in another city. Despite his prominence within the A.M.E. Church, his salary was dependent on tithing; in actuality, Micheaux learned, the family barely scraped by.

All this gnawed at Micheaux as he returned to cold, snowy South Dakota in early 1910.

At least his sister and grandmother were doing well. They returned to their Tripp County farms where the grandmother, considering the fact she was an ex-slave nearing eighty, was well-known among her fellow homesteaders as a "colorful character," according to an account in the *Gregory Times Advocate*. Neighbors brought her dried beans and apples when the snows caught her short, and though Micheaux kept her stocked with coal, "every once in a while," according to the newspaper, Oscar's grandmother could be glimpsed "walking along with a gunny sack and a big stick. She would pick something up and put it in her sack." Neighbors "figured out that she was picking up buffalo chips to burn for fuel."

Olive was also well liked. One neighbor, a Mrs. Bartels, "thought she was a well-informed girl and loved to talk to her," reported the *Gregory Times Advocate*. Like her brother, however, Olive was acutely aware that she and her grandmother were the only "colored homesteaders" for miles around. Olive "would only come and visit when no one else was there. If someone came during her visit, she would immediately get up and leave. Bartels said, 'She seemed to fear that even though I accepted her as a friend, these other people might not.'"

It would be a long, punishing winter. Micheaux poured himself into letters to Orlean, trying to persuade his fiancée to come to Gregory and accept a humble marriage ceremony. He received letters back from her and the Reverend, arguing for a gala wedding with family and friends in Chicago.

Then the homesteader wrote something else: his first bylined article.

The front page of the March 19, 1910, *Chicago Defender* was the showcase for his open letter to black America headlined WHERE THE NEGRO FAILS and datelined Gregory, South Dakota. In this, his first known piece of published writing, Micheaux urged readers of the nation's most widely read black newspaper to do exactly what he had done: follow the advice of Horace Greeley and *Go West!*

"I return from Chicago each trip I make," the citizen of Rosebud wrote, "more discouraged each year with the hopelessness of his foresight (the young Negro). His inability to use common sense in looking into his

future is truly discouraging when you look into the high cost of living. The Negro leads in the consumption of produce and especially meat, and then his fine clothes—he hasn't the least thought of where the wool grew that he wears and describes himself as being 'classy.' He can give you a large theory on how the Negro problem should be solved, but it always ends that (in his mind) there is no opportunity for the Negro."

By Micheaux's reckoning, there were only "eleven Negro farmers" in all of South Dakota. "Isn't it enough to make one feel disgusted," he asked, "to see and read of thousands of poor white people going west every day and in ten or fifteen years' time becoming prosperous and happy, as well as making the greatest and happiest place on earth.

"In writing this I am not overlooking what the Negro is doing in the south, nor the enterprising ones of the north, but the time is at hand— the Negro must become more self-supporting. Farm lands are the bosses of wealth. Land is increasing by strides at the present time. . . .

"I am not trying to offer a solution of the Negro problem, for I don't feel there is any problem further than the future of anything, whether it be a town, state, or race."

For this remarkable article, proclaiming his name and views to black America, he also created a new persona. Up to this time, he had always spelled his last name "Michaux," signing it thus on employment cards and legal documents. Though it was a rite of passage for ex-slave families to alter the surname inherited from their masters, the Michauxes had apparently never bothered to do so—until now. Oscar's change was slight: With the addition of an *e*, he became "Micheaux."

As the snows melted and spring tasks accelerated, Micheaux fretted about the date of his marriage, which was still up in the air. His letters implored Orlean to "condescend" to a wedding in Gregory. If she failed to take up residence in South Dakota by May, she would risk losing her claim. Every time Micheaux went to Chicago the 750-mile trip took one day each way, costing eighty dollars for the train fare. He couldn't afford to keep abandoning the farm; he had corn to gather, oats, wheat, and barley to seed. He tried to explain his precarious finances, "that it was a burden rather than a luxury to be possessed of a lot of raw land, until it could be cultivated and made to yield a profit." The McCrackens, however, seemed to

consider him a rich landowner roosting on miles and miles of fertile acres.

"My letters," Micheaux recalled, "were in vain."

Orlean's replies tapered off. In the third week of April, Micheaux received a letter from Orlean saying that she had decided against marriage and was returning her receipt for the relinquishment to him, "with thanks for my kindness and hopes for future success," in Micheaux's words.

This letter, which he received on a Friday, forced Micheaux into drastic action. "While I did not think she had treated me just right, I would not allow a matter of a trip to Chicago to stand in the way of our marriage," he wrote later. "I had the idea her father was indirectly responsible."

He rode into Gregory on Saturday night, and on Sunday morning boarded a train. From Omaha he sent Orlean a telegram. In Chicago he found his sweetheart at home with the other McCrackens, minus the Elder, who was once again away in southern Illinois. Orlean sulked upon Micheaux's arrival, but soon was nestling in his arms. The younger sister openly inveighed against the marriage and homesteading. The mother was more easily won over, but the family decided they must send a special delivery letter to the Reverend.

In a day the special delivery reply came back, saying that Micheaux had to convince the Reverend, in person, that he was marrying his daughter for love, not merely for the sake of a homestead claim.

The sister, previously Micheaux's enemy, now started giving Oscar advice. Flatter the Elder, she urged the homesteader. "The more I thought of his greatness," Micheaux later wrote, "the more amused I became. I might have settled the matter easily if I had no objection to flattering him."

The next morning the Reverend McCracken arrived home and greeted Micheaux in the parlor, "surveying me as I entered, just as a king might have done a disobedient subject." The family gathered around to hear the father speak, but Micheaux interrupted with a pronouncement of his own: It was true that he hadn't professed his love for Orlean when he first came to woo her, he admitted, but he had grown fond of the schoolteacher, and now they were looking forward with optimism and affection to a future together.

When Orlean spoke up to concur, the Reverend seemed satisfied.

With his imperious air he gave them his permission to proceed to the courthouse and obtain a marriage license—something the two had actually done the previous day. And so, "rather sheepishly," they "stammered out something" and went downtown and "bought a pair of shoes instead."

The great occasion was set for the next afternoon. The Elder tried hard to secure an A.M.E. bishop to preside over the ceremony, but one of the local bishops was sick and the other was out of town, so they had to accept the services of a lesser light. "Some twenty or more" friends and relatives assembled in the McCracken home to witness the exchange of vows, with Orlean wearing her sister's wedding dress and veil. ("The dress was becoming and I thought her very beautiful," Micheaux wrote after.) As for the groom, he borrowed a "Prince Albert coat and trousers to match" from Orlean's sister's husband, his new brother-in-law, which were "too small and tight, making me uncomfortable."

Everyone kissed their congratulations; wine was poured for toasts; ice cream and cake were served. Someone played the piano for a little dancing. Then a tremendous wind came up, a storm broke, and the guests rushed to leave, buffeted by wind and drenched by the downpour. In retrospect, Micheaux said, he should have recognized the wind and storm as auguries.

In *The Conquest,* Micheaux suggests that the newlyweds spent their wedding night at the home of a family friend. In real life, the marriage of the well-known Elder's daughter to that emergent public personality, Oscar Micheaux, was announced in the *Chicago Defender.* "They left the same night," the newspaper reported, "on the Golden Gate Limited for their home" in South Dakota.

CHAPTER SIX

1909–1912
HAMMER BLOWS

The *Defender* wasn't the only newspaper that reported on Micheaux's nuptials. Another paper, this one with a predominantly white readership, congratulated the couple and wished them "a happy journey over life's seas." The *Gregory Times Advocate*, the homesteader's local paper, never—in this or any prior mention of Micheaux—characterized him by race or skin color. "About sixty of my white neighbors gave us a charivari, and my wife was much pleased to know there was no color prejudice among them," Micheaux wrote in *The Conquest*.

The newlyweds temporarily moved into the rented house in old Dallas. Micheaux was relieved that hired hands had taken good care of his Gregory County lands while he was gone, and early in May he and his wife went up to Orlean's claim near Witten in Tripp County, to raise a sod house. At the same time Micheaux pitched in on his grandmother's and sister Olive's homesteads (his sister briefly returned home to Kansas to attend another sister's high school graduation). Micheaux shuttled back and forth between his farms in the two counties; rather than construct all new buildings on Orlean's relinquishment, he decided to move some outbuildings from his original homestead near Gregory to the Tripp County claims, about forty miles overland.

Her new husband's busy schedule left Orlean alone for long spells, and Micheaux's grandmother and sister Olive befriended the new spouse. Though she wasn't much of a cook, Micheaux recalled, Orlean was a good housekeeper and a singer with a pretty voice whose songs cheered up her husband.

In June, the couple returned to Gregory County. The bills were start-

ing to come in from banks, and Micheaux was worried about his cash flow. He could gather his corn and shell and haul it to Winner, a much longer distance than nearby Gregory, but he'd get a higher price at the Tripp County elevators. Once again Orlean was left alone for stretches, and the initial luster of prairie life began to dim.

She received letters from home, reporting familiar names and exciting events in the city, but they only made her pine for Chicago's Black Belt. Her relatives wrote asking for money so that they could buy her items from South Side shops and send them to her out on the prairie. When Orlean asked Micheaux for an allowance to cover the costs, though, Micheaux found himself in a "trying" position, he later recalled. "What I wanted in the circumstances I now faced was to be allowed to mold my wife into a practical woman," but instead, on top of his obligations to the banks, he was being continually dunned by his wife and her family.

The Reverend McCracken wrote Orlean regularly, and she entreated Micheaux to write back to his father-in-law, as a show of respect. In *The Conquest,* Micheaux admits that he probably should have written a few "Dear Father" letters, but he disliked the Elder too much to "play the hypocrite."

Micheaux had his hands full. He was busy supervising five farms in two far-flung counties, coping with the exigencies of farming on the prairie. The first two weeks in June blew hot and dry, and "considerable damage" was done to the expected yield of the farms in Tripp and Gregory counties alike. Rain came toward the end of the month, partially salvaging Micheaux's crops in Gregory County. But by then Orlean was having crying jags, becoming "a veritable clinging vine," according to Micheaux. They had "ugly little quarrels." His portrait in *The Conquest* suggests that their lovemaking lapsed. One quarrel blew up so badly that it terrified them both, and they made amends, vowing to argue no more.

Some time in late June, Orleans blushingly told Micheaux that she was pregnant. Her husband was touched and thrilled, but he persuaded Orlean that it was too soon to inform the Reverend, who had written to announce he was coming to visit at the end of the summer.

Micheaux dreaded the Reverend McCracken's arrival. His difficult circumstances had been aggravated, suddenly, by a legal challenge filed

against Orlean's claim. A banker in a small town in Tripp County, a bitter rival of the Jacksons, had charged that Mrs. Micheaux had never properly established residence on her relinquishment—which was partly true, as the married couple spent most of the summer of 1910 near Gregory.

When the Reverend arrived, he was full of himself as usual. But he also seemed heartened and genuinely enthusiastic about the Rosebud country, and Orlean was so happy to see her father that Micheaux felt momentarily relieved.

Yet neither man could stay away from "the race question," which inevitably led to friction. As Micheaux described it in *The Conquest*, their arguments echoed greater discussions going on within black America over how to overcome widespread racial injustice. At the same time, Micheaux's fictionalized recollections suggest that the homesteader was drawn into heated debate with his father-in-law as much by their mutual arrogance and clash of personalities as by their disagreements over social issues.

The Reverend "had the most ancient and backward ideas concerning race advancement I had ever heard," wrote Micheaux later. "He was filled to overflowing with condemnation of the white race and eulogy of the negro. In his idea the negro had no fault, nor could he do any wrong, or make any mistake. Everything had been against him, and according to the Reverend's idea, was still."

Father- and son-in-law clashed over "mixed schools," that is, over the integration of public education. Here the Elder was a traditionalist, opposed to intermingling the races. "They are like everything else the white people control," the Elder declared. "They are managed in a way to keep the colored people down." Micheaux objected vehemently, and was surprised when Orlean, who had taught in colored schools, weighed in firmly on his side, against her adored father.

Only a small minority of colored people would vote for separate schools if they had the choice, Micheaux argued. "The mixed schools give the colored children a more equal opportunity and all the advantage of efficient management," the homesteader insisted. "Another advantage of mixed schools is, it helps to eliminate so much prejudice."

On issues of race, the two headstrong men were destined never to find common ground. When Micheaux tried to shift the talk to money matters, however, he realized that the Reverend was an impractical man who

understood little about business and finance. Orlean's father was awe-struck by the fact that Micheaux held checking accounts in different cities. When Micheaux mentioned James J. Hill, the famous empire builder of the Great Northern Railway Company—a living legend among railroad men and capitalists—the Reverend looked blank. "My face must have expressed my disgust at his ignorance," wrote Micheaux later, "and he a public man for thirty years."

Then, setting his chin, Micheaux brought up his idol Booker T. Washington, and "his life and his work in the uplift of the Negro." He anticipated the Reverend's negative reaction, and he wasn't disappointed. "He was bitterly opposed to the Educator," wrote Micheaux. The argument grew so fierce that Orlean's father finally "lost all composure." But the Elder "found himself up against a brick wall" in Micheaux, while "attempting to belittle Mr. Washington's work."

For Micheaux, that was the clincher: He diagnosed his father-in-law as a superstitious, unintelligent fraud. Born a slave, the Elder had never been to school; he didn't even possess a theological degree, Micheaux concluded. He certainly didn't read very much, and what he did read was restricted to "colored newspapers" that by and large reinforced his own narrow views. The Reverend McCracken "was a member in good standing of the reactionary faction of the negro race, the larger part of which are African M.E. ministers," Micheaux decided.

Later, he rued some of their arguments. "I might have been more patient with the Reverend," the homesteader told himself afterward, "if he had not been so full of pretense."

For the moment, Micheaux bit his tongue and resolved to stay off of controversial subjects. The Reverend, too, seemed content to switch to small talk. And then Micheaux was surprised to find himself immensely entertained by the Reverend's stories about the great preachers and bishops he had known on the circuit, and his funny, colorful, often salacious gossip about the private lives of women in his various congregations.

Before the Reverend left, they all got into a spring wagon to make the long trek to Orlean's claim. Micheaux used the trip to move another building between the counties. Orlean's father tried to be helpful and positive, but his conversations with Orlean, sympathizing about the

hardships of homesteading, while telling fond stories about folks back in Chicago, only fed her homesickness.

Micheaux was glad to see the Reverend go, just as the contest was being heard against Orlean's claim. The Micheauxes were represented by a local attorney, who felt the law and the evidence were on their side. A ruling wasn't expected for several weeks.

With Orlean's pregnancy growing, they settled in for the coming winter. "The crop was fair," Micheaux wrote, "but prices were low on oats and corn, and my crops consisted mostly of those cereals." Almost everything he earned went into loan payments, interest, taxes, and expenses. Micheaux told his wife that money was too tight to support a trip to Chicago that Christmas, but in truth he wasn't eager to spend time with his father-in-law, who still didn't know that Orlean was pregnant. The Reverend sent a series of letters insisting that they visit, asking what kind of holiday supper they preferred, what Orlean would like for Christmas gifts, and so on. When Micheaux wrote back saying that he couldn't afford to abandon his land, the Reverend offered to pay their train fare. When Micheaux wrote to say he couldn't possibly accept such charity, the Reverend arranged for them to borrow the money from a cousin who worked in one of the Gregory saloons. The episode mortified Micheaux. Orlean, for her part, was torn: She preferred to travel to Chicago, but she also wanted to please her husband.

"The poor girl, with a child on the way, was as helpless as a baby," Micheaux wrote.

They moved many of their belongings onto the Tripp County relinquishment, though they continued to live in old Dallas. As Christmas neared, Micheaux's sister took Orlean home with her for a visit to her Tripp County land, and that is when a letter from the Reverend arrived for Orlean at the Gregory post office. When Micheaux opened the letter, he found a money order and instructions for Orlean to hasten to Chicago, with her husband to follow if he was willing. Micheaux became "the maddest man" in Gregory, returning the money order with "a curt little note." When Orlean returned to the Gregory County farm, she confessed that she'd asked her father for the train fare. They tried to talk the problem through. Micheaux reminded Orlean that a trip to Chicago would reveal her pregnancy, which they had agreed to keep secret from her father and family. Orlean reluctantly agreed to stay in South Dakota until the baby was born.

Reconciled after their talk, the couple celebrated Christmas with a chicken dinner. The baby was due in March, and Micheaux's grandmother came to stay with them for the worst of the winter. By the end of February, Orlean was growing "exceedingly fretful," according to Micheaux, and insisted she ought to give birth to her first child on her own homestead. As soon as weather permitted, Micheaux bundled his wife and grandmother up in a spring wagon and sent them ahead to Tripp County, following with "a load of furniture," making the journey, he wrote, "in a day and a half." With close neighbors pitching in to help the two women out, Micheaux went back for the livestock and a coal shed he planned to buy at a lumberyard in Burke.

The round trip between Tripp County and Burke, more than one hundred miles in total, would take Micheaux a few days at least, especially considering the extra burden of the coal shed, which he was going to have sawed in half and loaded onto two wagons. He would write about this crucial trip first in *The Conquest* and then again in that book's sequel, *The Homesteader*, redressing telling omissions in the earlier version. In *The Homesteader*, Micheaux confessed that he stopped in Gregory to attend a Lyceum concert, its performers "consisting of Negroes," in his words, including a certain lady entertainer he had known back in Chicago. After the concert, he tarried in town and "renewed" his acquaintance with the lady.

In Gregory he also met up with his sister Olive, who was returning from a sojourn to Kansas, and saw her off to Tripp County, where Micheaux expected her to join his grandmother in assisting Orlean.

He continued east to Burke to collect the coal shed. In *The Conquest*, after arriving on Saturday he goes right to work buying the coal shed. In *The Homesteader*—in a dubious coincidence—"the same concerters" he had partied with in Gregory were billed for an evening performance in Burke. Once again Micheaux tarried, lingering through the weekend.

On Monday morning, Micheaux purchased the shed, hiring men to help him rig it for the transfer to Tripp County. Another windstorm came up, mocking and impeding his life's goals, as the wind always seems to do in his fiction. That day he made it only as far as Colome. On his way out of town the next morning, his front axle broke; the tongue of one wagon followed soon after. Repairs had to be made. By the time he pulled into Winner, "tired and weary," it was nightfall.

He was only fifteen miles or so from Orlean's homestead, the next day,

when he was met by a neighbor. Orlean had abruptly gone into labor in his absence. Friends had been trying to reach him by phone at all the towns along the way. Though a local doctor and Micheaux's relatives had attended at the birth, the baby was born breech and died. The news "struck me like a hammer," Micheaux wrote.

The neighbor hastened to assure him Orlean's condition was stable. "When I got to the claim I was weak in every way," Micheaux recalled in *The Conquest.* "My wife seemed none the worse, but my emotions were intense when I saw the little dead boy. Poor little fellow! As he lay stiff and cold I could see the image of myself in his features."

They buried the infant, Micheaux said, "on the west side of the draw."

No historian or researcher has ever located a birth certificate for the Micheauxes' baby, much less a grave. But few scholars doubt there was a pregnancy and a stillborn child.

On Orlean's behalf, Micheaux sent a telegram to the Elder: "Baby born dead. Am well."

The Reverend McCracken left at once to see his daughter, sending a telegram once he was en route by train with Orlean's younger sister. When he arrived, Micheaux thought, the Elder looked like a man who finally had the upper hand. Micheaux peered into his eyes and saw something he hadn't perceived before: "Evil." He saw "Satan" in his father-in-law's face, he said. Yet the Reverend took a solicitous tack; it was the younger sister who upbraided Micheaux: "You and your Booker T. Washington ideas!"

The doctor told Micheaux his wife was out of danger, but she needed peace and quiet to recover her strength. With Orlean's sister and father hovering nearby, the homesteader felt useless around the house. He was also preoccupied with seeding the largest acreage he had ever sowed. He had contracted for a steam rig to break two hundred acres at three dollars per acre on the three Tripp County homesteads, and he had to haul that and other machinery from Colome, which had the nearest railroad extension. (He was intending to break one hundred Tripp County acres on his own, with horses.) He had to make a second trip from Colome to the Tripp County farms, hauling eight thousand pounds of coal in two wagons for the steam rig and other uses.

While Micheaux was hauling the coal, a balky mule caused the two wagons to lurch and topple down a sharp embankment. Micheaux jumped out just as the second wagon, which he was driving, tipped over, but he caught his foot in the brake rope, and the coal and wagon crashed over him. Luckily he was uninjured, but it took a day and a half to clear the wreckage.

Micheaux sent a message ahead to Orlean that he was delayed, trusting that she was safe in the care of her father and sister. Then, just as he was eating his supper in Colome, he learned that three colored people had arrived in town and one of them was a sick woman. "I could hardly believe what I heard," he wrote in *The Conquest*. "My appetite vanished." The temperature had been dropping all day, and snow was coming down as Micheaux raced to the hotel and confronted his wife, who was wheezing and trembling. Orlean was weak and conflicted, and she resented her husband's bullying manner when he demanded to know what she was doing in Colome. But she knew he cared about her, and their baby's death was not his fault, not really.

Any real conversation between the married couple was subverted by the Reverend, who only uttered "kind words" to Micheaux, but insisted on taking Orlean back to Chicago to recuperate in the bosom of her family. A quarrel flared between the men, but the Reverend was adamant; Orlean was passed back and forth like a pawn. The homesteader finally gave in, offering to write the Elder a check for the travel expenses. The Reverend declined. Orlean told her husband confidentially that she'd already drawn fifty dollars from his bank account, at her father's behest.

When Micheaux put the McCrackens on the train to Chicago, his bank account was overdrawn; on top of his loans and mortgage payments, he owed money to doctors, hired hands, and suppliers.

Forlornly, he wrote to his wife. Two weeks went by without any reply.

At last, desperate to speak with his wife, Micheaux took the train to Chicago at the end of April. He learned from friends that Orlean was sequestered at her Vernon Avenue home, where she was being treated by a white doctor. The local scuttlebutt held that the Reverend had rescued his daughter from a harsh life in South Dakota, where the conditions—and mistreatment by her husband—had taxed her health.

The Reverend was once again away from Chicago on church business when Micheaux arrived at the McCracken family residence. Orlean's younger sister refused to admit her brother-in-law, saying that Orlean was too ill to see him. The sister's henpecked husband sympathetically walked Oscar over to a hotel on the Stroll, and Micheaux ended up drowning his misery in "a few Scotch highballs and cocktails."

The next day was Sunday. Micheaux phoned the McCracken house, but again and again his attempts to reach his wife were blocked by Orlean's hate-filled sister. The henpecked brother-in-law conspired to let the homesteader sneak in briefly on Tuesday while Orlean's sister was gone. He was having a tentative conversation with the listless, bedridden Orlean, when the sister returned and started screaming at him, driving him outside.

Anxious to obtain his own diagnosis of his wife's condition, Micheaux came back the next day with a Negro physician, Ulysses Grant Dailey, whom Micheaux had roomed with during Dailey's time as a medical student at Northwestern. U. G. Dailey would later become a preeminent figure, rising from a position as anatomy instructor at Northwestern to become chairman of the surgery department at Provident Hospital in Chicago, with an international reputation as an expert in his field.

Regardless of Dr. Dailey's impeccable credentials, Orlean's sister slammed the door in their faces. When the two men rushed to a nearby phone booth to call the house, the sister answered the phone. "How dare you bring a nigger doctor to our house?" she shouted. "Why, Papa has never had a Negro doctor in this house!"

Micheaux offers slightly differing renditions of this incident in *The Conquest* and *The Homesteader,* but the basic story is confirmed, remarkably, by contemporaneous accounts in the Chicago black press. Word had spread in the Black Belt that the famous homesteader, Oscar Micheaux, was in Chicago, trying to see his estranged wife, the daughter of the well-known Elder McCracken. A front-page headline in the April 29, 1911, *Chicago Defender* told the story:

MR. OSCAR MICHEAUX IN CITY;
Seemed to Be in Family Mix-Up,
Yet Would Not Speak; Seen
With Dr. Daily at Father-in-
Law's Door, But Neither He

Nor the Doctor Were Admitted;
Dr. Bryant (White) is Their Family Physician, Is
Thought is the Cause of the Lockout.

The *Chicago Defender* reporter was actually an eyewitness to this sorry episode in Micheaux's life. As Micheaux and Dailey first approached the McCracken home "in hot haste," the reporter spotted them, and lurked "a block behind" to see what would ensue. As he watched, the two men stood outside the house, "waiting for the door to be opened" for "about half an hour," before gloomily retreating down the steps.

The reporter buttonholed Micheaux, who "admitted his wife returned with her father, but he says she came to spend the summer, for she was quite sick." Asked why he and Dr. Dailey hadn't been allowed in to see Orlean, Micheaux said he thought perhaps his wife had gone downtown. The reporter was unconvinced. "We do know that Mr. Micheaux has only seen his wife once during his week's stay in the city," he wrote.

As the reporter stood by waiting, Micheaux ducked into a telephone booth. "He did not seem to stay on the line; he got his party and they rang off," he wrote. Then the *Chicago Defender* correspondent trailed Micheaux to the train station. The man who had been barred from glimpsing his own wife left on the 5:20 train that "same afternoon," the *Defender* account noted, "and when our reporter tried to get in to see him he locked himself in his drawing room and would not see anyone."

"He is the only colored farmer in his [Rosebud] country," the article concluded with an imaginative flourish, "worth $150,000, all told."

Micheaux slumped in his train seat, not only distraught but publicly humiliated.

Returning to South Dakota, he poured out his feelings in letters to Orlean, according to *The Conquest*, and at first his wife wrote pleasant ones in return. Then her letters turned abusive, accusatory. Finally they stopped altogether. After that, everything he learned about her came in letters from mutual friends and McCracken relatives who were sympathetic to his cause.

Micheaux resolved to go back to Chicago to try again, but first he would have to survive the summer of 1911. Since Micheaux became a

homesteader six years earlier, southern South Dakota had enjoyed only rain-filled summers and luxurious harvests. Thanks to the ample rainfall, Micheaux later wrote, he had raised "fair to good crops every year." The area hadn't endured a severe drought since 1894. Yet old-timers and Indians knew that the weather came in erratic cycles, and a couple of veteran farmers descended from Russian Mennonites, neighbors of his sister Olive, warned Micheaux that a terrible drought was brewing.

Early in May, one rainy day brought an inch of moisture. Micheaux had just completed sowing 250 acres of flax on his wife's claim, and everything looked "beautiful and green." But that was the last soaker in all of May. The soil soon became too dry for Micheaux to go on breaking ground. Though clouds threatened and an occasional gust of wind whipped up his hopes, the rain stayed away for weeks. The budding plants took on a "peculiar appearance," in his words.

In mid-June, Micheaux took his sister to run an errand in Winner. Everyone was talking about the intense dry heat. He drove on to Gregory, stopping in Dallas to send Orlean a telegram offering to send her money to come to South Dakota. No reply came.

A heavy downpour in Gregory County partially salvaged his original homestead, but right away the dry heat resumed, and this time the sinister weather persisted. The nights were punctuated by thundercracks and lightning streaks, but no cloudbursts, not even drizzle. "During that time I could not find a cool place," recalled Micheaux. "The wind never ceased during the night, but sounded its mournful tune without a pause."

After organizing his crops and hired help, he returned to his Tripp County relinquishments. "No snow had fallen in the mountains during the winter," he wrote, "and all the rivers were as dry as the roads." The air was filled with clouds of dust rising from the ground. The vegetation withered, the small grain rattling like dead leaves. The crops were soon beyond redemption. "The atmosphere became stifling," wrote Micheaux, "the scent of burning plants sickening."

The Fourth of July Micheaux spent in Winner, hearing news of the spreading disaster.

"The railroad men who run from Kansas City to Dodge City reported that the pastures through Kansas were so dry along the route," he later wrote, "that a louse could be seen crawling a half mile away. In parts of Iowa the farmers commenced to put their stock in pens and fed them hay from about the middle of June, there being no feed in the pastures.

Through eastern Nebraska, western Iowa, and southern Minnesota, the grasshoppers began to appear by the millions, and proceeded to head the small grain. To save it, the farmers cut and fed it to stock, in pens."

Later that month his flax crop wilted. Then the land was assaulted by millions of army worms. Micheaux returned to Gregory County to harvest his winter wheat, which had been helped by the June rain, but his acres of flax appeared a "brown, sickly-looking mess." He had borrowed his limit, and when he brought his weak harvest of wheat to market, it fell pitifully short of his expenses.

Before the drought, land near Gregory had sold for as high as a hundred dollars an acre, and lots a few miles away routinely sold for fifty to eighty. Now the merchants were pressured by the wholesale houses, the speculators by loan companies, and everyone felt the tightening squeeze of the banks. "No one wanted to buy," wrote Micheaux. "Everyone wanted to sell."

The adversity was worse in Tripp County, which had opened "when prosperity was at its zenith," in Micheaux's words, its streets filled with "money-mad" people buying and spending without caution. Now, homesteaders old and new deserted in droves. Landholders simply up and abandoned their claims, heading back east in a steady stream of horses, wagons, and rickety hacks, their spirits vanquished. One day, as Micheaux headed north across the White River to visit neighbors, he counted forty-seven houses along his route; all but one was abandoned.

A born pragmatist, Micheaux was also an incurable optimist, not a quitter. He rejoiced when a torrential rain fell late in the summer, filling the creeks and draws, though it was too late to make a difference. And in the fall he channeled his mingled hope and bitterness into a front-page article for the *Chicago Defender,* touting new Rosebud lands opening up in Tripp County. The article was headlined:

COLORED AMERICANS TOO SLOW,
To Take Advantage of Great Land Opportunities
Given Free by the Government—
Jews, Germans, Swedes, Arabs, Southern Whites and Irish
Were All On Hand to Get Land—
Negroes Should Not Wait for Cities to be Built, Then Try
TO GET ALL PORTERS' JOBS;
In Sight—White Race Will Run You Off Your Feet

If You Fail to Get and Own Land—
South Not the Only Place for You—
Wherever Flag Floats is the Place for Race—
Only Seven Took Advantage of Free Land
and All Get 160 Acres—
Great Praise is Given *Chicago Defender.*

This time bylining from Witten, Micheaux again criticized "colored Americans" who "do not take the chance advantage that these openings afford, as do the whites." Once more, he noted the paucity of Negroes on Rosebud homesteads. "There can be but one particular excuse," he wrote, "and that is the personal bravery that more do not take advantage of an opportunity that only comes once."

Micheaux reeled off statistics to prove his points (". . . everyone that came here five to eight years ago owns farms that are worth from five to ten times their valuation in 1904 . . ."), and perhaps to impress readers with his status as a newly appointed "Government Crop Expert for Rosebud County."*

One particular colored American came in for especially barbed criticism. Assessing the disappointing initiative of "our people," Micheaux wrote, "I have always felt that the colored people have been held back largely by some of our social demagogues." For example, Micheaux wrote, there was a certain "presiding elder in the Methodist conference," who once had seemed "very explicit in his determination to register for these lands, and according to his advice he was coming this month to register with a great following. The opening closes today. I took pains to notify this elder through information, so that he must be aware. This was last spring when he was going to do this, but I haven't heard nor seen anything of him and his following. It's not the individual, but it's the cause that follow[s] such pretensions that is detrimental to our young people."

Not long before, Micheaux had bundled up the letters he had received from friends of the McCracken family, expressing support for him— along with adverse information and opinions about the Reverend—and mailed them off to his father-in-law. Now he had taken an even bolder

* It's unclear if Micheaux ever held such a job, which was how he was identified in the article. "Rosebud County" does not exist, and, though it may have been a typo, Micheaux was not adverse to inventing a county, or a title for himself.

step, clearly alluding to the Reverend McCracken as a "social dema-
gogue" in a newspaper read widely by black people not only in Chicago
and Illinois, but throughout the nation.

It was a year of unfortunate coincidences, Micheaux said later. The worst
summer drought in two decades was followed by the harshest winter in
memory, with the heaviest snows, which led to calamitous flooding and
freezing. His capital exhausted, Micheaux languished in Orlean's "lonely
claim-house" during the winter, going over and over in his mind every-
thing calamitous that had happened to him: the courtship, the marriage,
the stillborn baby, his wife's desertion.

Fishing and hunting were his only distractions. "I lived in a sort of
stupor," he later wrote, "and my very existence seemed to be a dreadful
nightmare. I would at times rouse myself, pinch the flesh, and move
about, to see if it was my real self; and would try to shake off the loneli-
ness which completely enveloped me. My head ached and my heart was
wrung with agony."

As the days of anguish passed, Micheaux sought "consolation in
hope" and resolved to make one last stab at a rapprochement with
Orlean, when the winter snows finally melted.

At Easter time, he boarded a train to Chicago and checked into the
Keystone Hotel in the heart of the Black Belt. Reverend McCracken was
in town, so Micheaux was obliged to conspire with family friends to lure
Orlean over to a neighbor's house, where he could talk to her outside the
presence of the potentate. When Orlean arrived at the neighbor's house,
looking more "fleshy" than the last time he saw her, in Micheaux's words,
his wife uttered a gasp of surprise and "sank weakly into a chair."

Micheaux published three accounts of what happened next, each
more sensational than the last. But in the first one, *The Conquest,* he men-
tioned buying tickets to see Robert Mantell in *Richelieu,* a real actor and
stage play performed in Chicago at Easter 1912. That, plus the fact that
the Illinois presidential primary fell on the Tuesday after Easter—and
Micheaux was rooting for Teddy Roosevelt—confirms the time frame.

Though at first she was taken aback at her husband's presence, Orlean
warmed up to Micheaux, and as ever they talked easily. After a while she
wanted to phone her father and tell him that her husband had come from

South Dakota to see her. Micheaux tried in vain to talk her out of it. When he heard his father-in-law's despised voice boom out of the receiver ("Why don't you bring him to the house?"), Micheaux reacted irrationally. Grabbing the phone, he started shouting at Orlean's father, blaming the Reverend McCracken for everything that had happened, accusing him of ruining his life.

In all three versions of this incident, what followed was tangled and chaotic. "What passed after that I do not clearly remember," Micheaux explained in *The Conquest,* "but I have read lots of instances of where people lost their heads, where, if they would have had presence of mind, they might have saved their army, won some great victory or done something else as notorious, but in this I may be classed as one of the unfortunates who simply lost his head."

All he could remember was shouting and shouting into the receiver, as his allies who lived in the house tried to pull him away from the phone, and his wife "in a state of terror" turned on him with a vengeance.

"The words I cannot, to this day, believe, but I had become calm and now pleaded with her, on my knees, and with tears; but her eyes saw me not, and her ears seemed deaf to entreaty. She raved like a crazy woman and declared she hated me."

In *The Homesteader,* the Orlean character kicks and pummels Oscar while he is down on his knees. In *The Wind from Nowhere,* his third and final fictionalized account of the Rosebud years, the climax is melodramatic; they struggle over a gun, and he is accidentally shot.

How many minutes passed is uncertain, but the McCrackens lived very close by and soon enough the Reverend raced in the door. Orlean flew into his arms, sobbing. The Elder turned his eyes on Micheaux— "the eyes of a pig, expressionless"—and swept his daughter outside.

"The next moment the door closed softly behind them. That was the last time I saw my wife."

Micheaux took the train back to South Dakota, feeling empty and dead inside. Indeed, he understood that part of him was dead. Writing of his alter ego Jean Baptiste in *The Homesteader,* Micheaux said, "In the days that followed the real Jean Baptiste died and another came to live in his place."

1912–1914 DARK DAYS

These were "dark days" of solitude, despair, and disgrace, Micheaux wrote later. The drought continued erratically, the hot winds blew incessantly, and millions of grasshoppers coated the prairie. The harvest that year would be dismal. Micheaux had lost the heart for homesteading; he knew that his temporary payments were only staving off foreclosure.

Living morosely on his wife's claim during the dark summer of 1912, Micheaux found his principal solace in books. He prided himself on the breadth of his reading, and worked to keep up with works of literary merit and bestsellers alike. Two recent novels nurtured and inspired him: *Martin Eden* and *The Autobiography of an Ex-Colored Man*.

He identified passionately with the title character of *Martin Eden,* Jack London's semi-autobiographical account, first published in 1909, of a San Francisco seaman who dreams of literary accomplishment. Micheaux saw his own life mirrored in the character's poverty and hardship, his struggle to educate and express himself, his youthful idealism turned sour, his failures with women. Though London's story didn't satisfy Micheaux's usual taste for happy resolution, the homesteader was feeling low, and he couldn't argue with Martin Eden's suicide in the final pages.

Although *The Autobiography of an Ex-Colored Man* is considered a literary landmark today, when it was published in 1912 its author chose to remain anonymous, and at first it was little known outside of African-American circles.* The novel is narrated by the son of a light-skinned

* Upon its republication in 1921, the author of *The Autobiography of an Ex-Colored Man* was revealed to be one of the forefathers of the Harlem Renaissance, the poet, composer, and musician

black woman and a white Southern gentleman. But the father has shirked his illegitimate child's upbringing. Growing up in Connecticut, aloof from other black people, the boy doesn't realize he is "colored" until he encounters prejudice in school. Musically gifted, the narrator heads to college in the South, but before enrolling he is robbed, a traumatic event that spurs him to strike out on his own. He travels to Florida, New York, and (as the paid companion of a wealthy white patron) Europe before returning to New York to write ambitious classical music voicing African-American themes. At one point he witnesses a lynching, but he is so light-skinned himself that he "passes" everywhere as an "invisible Negro." By the end, though he has completely adopted the guise of a successful white man, the "ex-colored man" feels deeply conflicted.

Both *Martin Eden* and *The Autobiography of an Ex-Colored Man* affected Micheaux profoundly. His solitary, memorable adventure on the Rosebud struck him as worthy of a novel like London's; and the tragic "memoir" of "passing"—a subject already of keen interest to him, considering his failed romance with the white Scottish neighbor—had an unassuming, confessional writing style that he might emulate. After he was finished with his copy of *The Autobiography of an Ex-Colored Man*, he sent it to his estranged wife, Orlean, in Chicago or, perhaps, as he suggests in one of his novels—to the blonde Scottish maiden.

Gradually, as he devoured these and other books—not just reading, but "studying every detail of construction, and learning a great deal as to style and effect"—Micheaux got the radical notion that he might write down his own life story in the form of a quasi-autobiographical novel.

"In all his life he had been a thinker, a practical thinker—a prolific thinker," Micheaux wrote of the character Jean Baptiste, who served as his alter ego in his third novel, *The Homesteader*. "Moreover, a great reader into the bargain. So the thought that struck him now, was writing. Perhaps he could write. If so, then what would he write? So in the days that followed, gradually a plot formed in his mind."

James Weldon Johnson, who had written anonymously in 1912 partly as a literary device, and partly because he was then serving as the U.S. consul in Venezuela and Nicaragua. Though the novel was regarded, at the time that Micheaux read it, as veiled autobiography, it turned out to be entirely a fiction of Johnson's concoction.

He bought a cheap, thick legal tablet, a handful of pencils, and sat at a small table on his wife's claim. The skeleton of the plot was obvious: His life struggles. "Of writing he knew little and the art of composition appeared very difficult," according to *The Homesteader*. "But of thought, this he had aplenty. Well, after all, that was the most essential. If one has thoughts to express, it is possible to learn very soon some method of construction."

Inspired by Martin Eden's daily writing regimen in London's story, Micheaux sat down on the first day and wrote ten thousand words.* The second day, he "reversed the tablet and wrote ten thousand more" (or so he claimed in *The Homesteader*). "In the next two days he rewrote the twenty thousand, and on the fifth day he tore it into shreds and threw it to the winds."

Having discovered that he had "no difficulty in saying something," Micheaux found that "the greatest difficulty he encountered was that he thought faster than he could write." He couldn't slow down his thinking, so he'd often break off "right in the middle of a sentence to relate an incident that would occur to him." This was a lifelong tendency in his novels and films, whose main stories were often interrupted with digressions, social observations and data, flashbacks (even flashbacks *within* flashbacks)—tactics that could be lively and effective, but also tedious and confusing.

Throughout the autumn of 1912 Micheaux labored at "his difficult task." He was making steady progress as winter arrived and the vicious winds started to blow. Chicago now seemed a distant dream. By December, the speed demon had nearly completed a first draft of his novel, but it needed editorial polish. When Micheaux showed his two hundred handwritten pages to a friend, the friend waved off the challenge. Instead Micheaux found a lawyer named R.H. Molitor in Winner who was willing "to rearrange his scribbled thoughts," and he struck a bargain with the lawyer for seventy-five dollars' worth of editing. The lawyer and his wife agreed to edit, correct, and improve the writing, while also vetting the book—advising slight name changes to avoid legal repercussions, for example. By his own account, Molitor's work may have gone even further. "I personally wrote the Chapter V," the lawyer later asserted, inscribing

* Actually, that was much more than Martin Eden's output; in the novel London says repeatedly that Eden wrote "three thousand words a day."

his claim on an original edition of *The Conquest,* "which the author accepted and incorporated in this book."

A self-taught novelist who never graduated from high school, Micheaux harbored lifelong insecurities as a writer, and over the years he did hire ghost collaborators. As Micheaux scholar J. Ronald Green has pointed out, however, the chapter of *The Conquest* that Molitor claimed to have "personally" written concerned Micheaux's real-life stint as a Pullman porter; one way or another, even this improved material was *his* story, *his* life. The lawyer/editor's inscription went on to note that ultimately he'd been forced to sue Micheaux for his seventy-five dollars, and that Micheaux "resisted so fiercely—and tried to evade the debt by absconding—A statute in So. Dak. made it possible for me to have him jailed for so doing. Only then did . . . I collect."

It may not have been Micheaux's first brush with lawyers, courts, or jail, and it certainly wasn't his last.

Over the holidays, a woman in a nearby town typed the manuscript out for Micheaux, making additional refinements in the process. Friends and neighbors spread the amazing news: The "colored homesteader" had written a book!

By December 12, 1912, the local *Dallas News* was reporting that Micheaux had submitted his "serial story" to the *Saturday Evening Post,* and that the McClury Publishing Company of Chicago soon would publish it in book form. "Oscar, accept our congratulations," enthused the newspaper. "We know that your story will be interesting and will assist in the efforts we are making to boost the Rosebud and tell the world of her unqualified advantages."

The bulletin about the *Saturday Evening Post* ("the editors of the publication are now reediting the works") was prematurely optimistic or, possibly, Micheaux's first deliberate bit of false publicity. In any case, securing publication for the book wasn't quite so easy.

Micheaux did send the manuscript to a Chicago publisher, and sat back to watch the mail for the thin envelope of acceptance Martin Eden described in London's book, as opposed to a bulky package returning all the pages. The mail brought only bulky rejections. He tried writing a few

short stories, hoping these would help him break into print, but only garnered more rejections.

Soon, however, two disparate acquaintances steered him in another direction.

One was a white doctor, a Chicago South Sider who had been part of the U. G. Dailey circle at Northwestern. The doctor's father, John Hamilcar Hollister—an eminent physician and, in his time, ardent abolitionist—had just self-published his autobiography, Micheaux learned. Another Micheaux contact, Roy M. Harrop—then kicking around Gregory County, later a vice-presidential candidate for the People's Progressive Party in 1924*—said he knew something about self-publication. Harrop pointed Micheaux toward an established printing, lithography, and bookbinding firm in Lincoln, Nebraska, that would manufacture his novel for a price.

Micheaux began an encouraging correspondence with this company, the Woodruff Bank Note Co. on Q Street in Lincoln. With his resources at an all-time low, however, he had to borrow pocket money from a friend to pay his train fare to the Jackson brothers' main bank in Dallas. Ernest was out of town, but his brother, bank vice president Graydon Jackson, was just as sympathetic and agreed to underwrite a trip to Lincoln. With a fifty-dollar loan in hand, Micheaux bought a new suit and two days later presented himself to his prospective publishers. "They were rather surprised when they saw that he was an Ethiopian," he wrote of the occasion in *The Homesteader.*

After some negotiation, the Woodruff Company agreed to print one thousand copies of Micheaux's novel at seventy-five cents per copy, one third of the amount to be paid upfront, before the manuscript went to press.

"The book is entitled 'The Conquest' and is a novel story of the development of the Rosebud Country," Micheaux grandly announced in his March 20, 1913, letter from Lincoln to the *Gregory Times Advocate.* That same week, local newspapers posted an official foreclosure notice on Micheaux's original homestead near Gregory. The amount due on the

* Not to be confused with Wisconsin Senator Robert La Follette's Progressive Party. Harrop tried to enlist Henry Ford as his party's presidential candidate in 1924, but Ford demurred and Robert R. Pointer was the presidential aspirant of the People's Progressive Party. Later, Harrop withdrew and endorsed La Follette.

mortgage was $1,888.27. Except for the site farmed by his sister Olive, whose husband helped save it from creditors, all of Micheaux's land would eventually be foreclosed.

After concluding his arrangements with the printing firm, Micheaux returned to South Dakota. To bankroll his initial press run, he went to work collecting advance sales for his as-yet-unpublished novel—a strategy he would return to some years later for his underfinanced motion picture projects.

In the first week of April 1913, he was in Gregory, handing out dummy copies of Chapter One and taking advance orders from friends and neighbors for $1.50 per book (accruing seventy-five cents profit on each copy sold). The local paper reported that Micheaux was "meeting with great success," and the editors (who of course knew him personally) said they could "heartily recommend it as an interesting story if the first chapter is any criteria." Micheaux collected 142 orders in Gregory and Dallas on his first day of pitching the book; in Winner he tallied 153. Within two weeks, Micheaux could boast fifteen hundred orders, enough to start the printing with two runs.

A month later he was back in Gregory flourishing "a few advance copies" of *The Conquest,* which he had subtitled "The Story of a Negro Pioneer." The novel was 311 pages, bound in cloth, with sixteen full-page illustrations by "Negro artist" William McKnight Farrow, a well-known Chicagoan who taught at the Art Institute. Though Micheaux dedicated the book to Booker T. Washington, he took no credit himself; following the example of *The Autobiography of an Ex-Colored Man,* the cover said only that the novel was written "by a Negro Pioneer."

"The book has had a wonderful [advance] sale," enthused the *Gregory Times Advocate,* "and is pronounced by those who have read it as being an excellent story."

Later, Micheaux would explain that he left his name off *The Conquest* because "identifying himself as the author of a book he was trying to sell would diminish its value." After all, his name meant little outside of Chicago and Rosebud country, and he was hoping to sell the book throughout black and (he hoped) white America. Omitting his name also evoked the mystique of *The Autobiography of an Ex-Colored Man,* though most of

the book's initial sales went to friends and neighbors in South Dakota, where Micheaux's authorship was taken for granted and widely confirmed in the local press.

"My folks knew him and liked him," recalled Merrit Hull, the son of a homesteader, in a letter to a Western journal fifty years later. "My mother read the book out loud. My parents commented on it at times as they read it."

And there was much to comment upon. *The Conquest* was filled with local references, which Rosebud residents savored. Even today, contemporary historians consider it one of the best eyewitness accounts of the early twentieth century land boom in South Dakota, with its feuds among Gregory County and Tripp County towns over train routes, county governance, and other commercial bragging rights. Micheaux took pains to ensure the authenticity of his story, sketching in local celebrities, from notorious outlaws to town drunks. Names were usually disguised, but sometimes barely.

Frank, Ernest, and Graydon Jackson, the brothers whose bank helped underwrite the book's publication, are "the Nicholsons" in *The Conquest*. The Jacksons undoubtedly bought a stack of copies for themselves, for the swaggering brothers were treated at length—colorfully, warmly, even heroically.

Yet there was also a gripping personal drama in the midst of the Rosebud history. Micheaux's account of his originally fumbling experience as a homesteader was honest and vivid. The white South Dakota readers of the first printings of *The Conquest* were undoubtedly taken aback by the candid ruminations of "the only colored homesteader" among them: his account of his abortive love affair with a white farmer's daughter, his search for a One True Woman, and his marriage to an ideal lady of his own race, whose father turns out to be a monster. They might have been surprised to find themselves not only immersed in his story, but moved, especially by its heartbreaking ending, when the man they all knew, their friend and neighbor "Oscar Devereaux," is utterly rejected by "Orlean McCraline."

The book's final, painful line: "That was the last time I saw my wife."

As *The Conquest* made clear, Micheaux was still separated from Orlean, still distraught over their rift and unsure whether the relationship might

ever be repaired. Later he would describe being impressed by a sermon he heard during a Catholic service in Gregory, in which the pastor denounced the iniquities of divorce. Micheaux, too, considered himself an "enemy of divorce."

Early in 1913, the challenge against his wife's land resurfaced. Though the case initially had been settled in her favor, it was referred to an appeals board in Washington, D.C. Then, as the summer began, Micheaux received startling news from the lawyer who represented him in the D.C. hearing: The Tripp County banker contesting Orlean's claim had undertaken a secret trip to Chicago, offering to purchase the farm from the Reverend McCracken. Micheaux had spent "$2,500 for the land and $500 attorney's fees for winning it" in the courts, in his words, yet now Micheaux found out his wife's father had sold it to the rival banker for a mere $300.

The banker got the idea, Micheaux's lawyer explained, from reading *The Conquest*!

This was the final crushing blow to Micheaux's marriage. He was forced by the sale of Orlean's land to vacate the Tripp County claim he himself had selected and farmed and done so much to build into a home. Infuriated, he publicly vowed legal action against his father-in-law, announcing a $10,000 lawsuit for "alienating of his wife's affections" in the July 31, 1913, edition of the *Gregory Times Advocate*. Interestingly, as Betti Carol VanEpps-Taylor points out in her biography of Micheaux, "it is the only local article uncovered to date that identifies him as a Negro"—as though reading *The Conquest* had decisively underscored this point among the local populace.

"An hour later his grip was packed," Micheaux wrote of himself in *The Homesteader*. "He went that afternoon back to Tripp County. His three hundred acres of wheat had failed, so he was unencumbered. He returned to Winner, and the next morning boarded a train for Chicago."

In Chicago, Micheaux engaged James W. White, "a Negro attorney with offices in the Loop district," who filed a claim against the Elder. There was special satisfaction in having Reverend McCracken served with papers in Micheaux's old hometown of Metropolis, where McCracken happened to be visiting. Micheaux advised the sheriff that Orlean's father could probably be found at the local Odd Fellows Hall, "where Negroes might be easily found," in Micheaux's words.

The *Chicago Defender* gleefully reported the lawsuit as a front-page

story on August 2, 1913. Below the headline (REV. M'CRACKEN SUED FOR $10,000) flowed a stack of bemused subheads, including, "LOCHINVAR OF THE WEST MUST RIDE THE LAW FOR THE WIFE'S AFFECTIONS" and "Rancher Becomes Angry—Writes a Book, Whose Ad Appears on Another Page, Giving Full Particulars of His Love Affairs."

Flabbergasted and humiliated, McCracken promptly hired his own lawyer—a white one. Micheaux became very friendly with James White, and took pleasure in staying with his own attorney in White's house on Vernon Avenue in the Black Belt, just a couple of blocks away from the McCracken residence. Micheaux never said if he glimpsed his wife Orlean again, but he gave the evil eye to the Elder whenever they crossed paths.

"Whose ad appears on another page": Micheaux was determined to reap the rewards of the disaster, placing ads for *The Conquest* (still advertised as "by a Negro pioneer") in the same newspapers carrying news of the lawsuit. His litigation became the first instance of a cunning pattern in his career: whenever possible, Micheaux exploited current events, including his own scandals and misfortunes, as marketing opportunities. Everywhere he went in the Black Belt, the homesteader was hallooed and clapped on the shoulder. He caught up with the latest revues and plays, and was among the packed audiences enjoying a new phenomenon at the Grand and States theaters. Here, in the fall of 1913, were shown some of the earliest all-colored two-reel comedies produced by a "race man," William Foster, a member of the old Pekin Theatre group.

For the first time, black audiences had the opportunity to watch motion pictures that reflected their culture, their lives, their idea of entertainment. When these earliest "race pictures" were shown, according to the *Chicago Defender*, it was like a revolution breaking out: "Patrons jumped up and shouted, some laughed so loud that ushers had to silence them."

Micheaux didn't extract quite as much fun from his lawsuit. The case was heard and settled in mid-September, and the final disposition is unclear from the surviving records. But McCracken wasn't worth $10,000, as Micheaux well knew, and a scribbled note on one document in the case file indicates that the suit was settled for $300, the amount of money McCracken had received for the deed to Orlean's land.

To Micheaux, the suit had been a matter of honor, not money. "I do not care for the financial loss I have sustained," he told the *Defender*.

Ever the memoirist, he later incorporated the litigation into *The Homesteader*—his rewrite of *The Conquest*—even identifying by name the actual banker in Tripp County, Eugene Crook, who had precipitated his betrayal. He also wrote in *The Homesteader* that the Chicago A.M.E. bishops were so upset by the negative publicity and gossip concerning the Reverend McCracken's shabby treatment of Micheaux, that the Elder's manifest ambitions for rising in the church hierarchy were ruined. That was victory enough.

Out of his days of despair, Micheaux had re-created himself, and set about forging a new destiny. As often happened in his career, touching bottom only spurred him to greater effort and higher ambition. Now he felt renewed, reborn as an author, and even as an author, he was a man of action.

Though his land still needed farming, and there were mortgages to be straightened out with the banks, it's unclear whether he ever returned to the Rosebud country for any length of time. After eight years as a homesteader, in mid-1913 Micheaux began a long period of itinerancy. Starting in the Midwest and then widening his travels to the East and South, he shuttled between major towns and cities, selling *The Conquest*.

Outside South Dakota, the challenges multiplied. "He did not find his new field of endeavor so profitable," Micheaux wrote of himself in *The Homesteader*, "when he began to work among strangers." At first Micheaux tried to hand *The Conquest* over to established traveling salesmen, especially ones with experience selling hair goods or complexion creams in Negro neighborhoods. But he was discouraged by the shipping logistics and the high commissions the salesmen demanded. So Micheaux decided to set up his own sales network, hiring agents in different cities, and—though most of the business would be done by mail order, or door-to-door—making arrangements wherever possible for individual shops, bookstores, and libraries to carry his book.

He began by visiting newspaper offices in Des Moines, Sioux City, Omaha, Lincoln, and other cities whose proximity to the Rosebud ensured the editors' curiosity. He coaxed news items and reviews from papers, coming away with a handful of glowing notices. (Sample from the *Des Moines Register and Leader:* "An unpretentious narrative and should prove an inspiration to young men, both white and black.")

Armed with these snippets of acclaim, Micheaux shaped his publicity for more distant places. By August 1913 he was already running advertisements for the third printing of *The Conquest* in many black newspapers besides the *Chicago Defender.* After the McCracken lawsuit was settled, Micheaux struck out for Detroit, Michigan; Dayton, Cleveland, and Cincinnati in Ohio; New York, Baltimore, and Philadelphia on the East Coast; and Memphis, Atlanta, Birmingham, and New Orleans in the Deep South. In his second novel, *The Forged Note: A Romance of the Darker Races,* Micheaux recounts some of this time he spent on the road, roughly from late 1913 into the summer of 1915, hawking copies of *The Conquest* (called "The Tempest" in *The Forged Note*).

"The distribution and sales operation he organized in the course of the trip was important to his later success in marketing his films," according to Micheaux scholar J. Ronald Green, "and the second novel is worth reading for that information alone."

Most of *The Forged Note* took place in the South. The central figure is traveling salesman Sidney Wyeth, a Micheaux alter ego who doesn't admit to having written the book he is selling. Wyeth is altogether a more guarded personality, more of a watcher and listener, than Oscar Devereaux in *The Conquest.* During his sales trips Wyeth comes into contact with all types of humanity—mostly black people, though he has Jim Crow–tainted encounters with the white world that include a trumped-up arrest and appearance in an Atlanta courtroom.

Micheaux's second novel is more episodic and self-consciously literary than his first. Once again, the story is full of his pungent social observations and political opinions. Of course, Booker T. Washington is praised, but Washington died in 1915, and by the time he finished his second book (ironically, considering his arguments with Reverend McCracken), Micheaux had moved on politically to embrace other views. (It could be said that his politics were as catholic as his interests in entertainment.) In *The Forged Note,* in fact, Micheaux would use Wyeth's voice to extol the militant W. E. B. DuBois, who had risen to eclipse Washington as the master "propagandist for his race," in the words of historian David Levering Lewis. At one point in the story Wyeth cites DuBois's *The Souls of Black Folk* as "the only book in sociology that stands out as a mark of Negro literature," and recommends the journal DuBois edited *(The Crisis,* disguised as "The Climax" in Micheaux's novel) as "the only magazine edited by, and in the interest of this race."

Once again, Micheaux may well have enlisted ghost collaborators on *The Forged Note;* the language is a departure from the first book—rife with "forthwiths," "betooks," and "thithers," as well as long stretches of "Negro dialect." Like *The Conquest,* however, *The Forged Note* was also based on the reality of Micheaux's experiences, and its real-life allusions were unmistakable. Examining the section of the novel that takes place in "Attalia"—Micheaux's fictionalized Atlanta—urban historian Dana F. White has documented a correlation "between 'fictional' and 'factual' characters, places and events" that is as "relatively straightforward" as the Metropolis, Rosebud, and Chicago parallels in *The Conquest.* Micheaux plays word games with names and places, but readers familiar with Atlanta can pick out real streets, neighborhoods, and landmark buildings, as well as thinly disguised portraits of well-known newspaper editors, businessmen, preachers, lawyers, and judges of the era.

One way to date Micheaux's actual stay in Atlanta, which covered several weeks if not months, concerns his fascination with a notorious crime that occurred in the city on Saturday, April 26, 1913, which was Confederate Memorial Day. A thirteen-year-old girl named Mary Phagan went to the National Pencil Factory on that day to pick up her wages. Phagan, who had quit school at age ten for her first job at a textile mill, was employed by the factory to operate a machine that inserted rubber into the metal tips of pencils. She never returned home, and at 3:30 A.M. on the following Sunday she was found strangled, and possibly raped, at the rear of the factory basement. At first the main suspect was a black night watchman, but suspicion switched to Leo Frank, the superintendent and part-owner of the factory. Phagan was white, Frank was Jewish, and it soon developed that the main witness against Frank, a man claiming to be his unwilling accomplice, was another black man, James Conley, a factory sweeper.

Jews were an abstraction to Micheaux, a child of southern Illinois who'd spent his early adult years homesteading in South Dakota.* But he'd also spent time in Chicago and roaming the country by train, of course, and during those years he noticed that Jews were often the chief

* There is no mention of Jews in *The Conquest,* but in Micheaux's second version of his life story, *The Homesteader*—written after his stay in Atlanta and *The Forged Note*—the Rosebud homesteader gained a conspicuously Jewish neighbor, Isaac Syfe, whose unsavory portrait contained a whiff of anti-Semitism. Syfe was part of a small group of like-minded friends, including an ex-preacher, engaged in nefarious activities on the prairie.

lenders and landlords and businessmen in America's Black Belts. Among the businesses they owned were major theater chains in black neighborhoods. He could name some Jews who were important benefactors of black communities, people like Julius Rosenwald, a clothier who became president of Sears, Roebuck, and Co. and then devoted himself to funding hundreds of YMCAs and thousands of "colored schools" in the South. In *The Forged Note* Micheaux wrote appreciatively about such "northern philanthropists," that is, north of the Deep South.

Still, to Micheaux it sometimes seemed that the Jews thrived mysteriously. When he thought "deeply into the conditions of his [own] race, who protested loudly that they were being held down," as he wrote later, he "compared them with the Jew—went away back to thousands of years before. Out of the past he could not solve it . . .

"All had begun together. The Jew was hated, but was a merchant enjoying a large portion of the world commerce and success. The Negro was disliked because of his black skin—and sometimes seemingly for daring to be human."

For a man transfixed by such an "intricate, delicate subject" as the relative fates of Negroes and Jews, the drama and subtext of the Leo Frank trial, which opened in July 1913, was mesmerizing, challenging his own prejudices and race loyalty. Indeed, the spectacle of a lowly black man testifying against a powerful Jew in a section of the South suffused with racism and anti-Semitism riveted much of the nation.

The factory sweeper Conley admitted to writing the cryptic, incriminating notes found near the slain thirteen-year-old, but said he did so—and helped dispose of the body—at the behest of Frank, the true killer. At times in his public appearances, Conley appeared quick-witted; other times he adopted the guise of "a mumbling, subliterate Rastus," in the words of Steve Oney in his authoritative book *And the Dead Shall Rise: The Murder of Mary Phagan and the Lynching of Leo Frank.* But the black factory sweeper's testimony was vital to the prosecution, whose evidence against Frank was otherwise circumstantial.

Micheaux later claimed that he sat in the courtroom as an observer during the four-week trial in the summer of 1913. That is plausible, though in one book he also suggests that he spent six months in Atlanta *after* the trial, when the city was still buzzing about it. Regardless, film scholar Matthew Bernstein has concluded that the two movies Micheaux later based on the case—*The Gunsaulus Mystery* in 1921 and *Lem*

Hawkins' Confession (a.k.a. *Murder in Harlem*) in 1935—indicate that he "clearly knew the details of the case and the prosecution's brief against Frank as they were reported in the city papers."

And it wasn't just the main Atlanta newspapers that Micheaux absorbed: More important, Micheaux read the nation's black press. "The consensus of many black newspapers," wrote Bernstein, was "that Conley's claims were true and that Leo Frank was a duplicitous, lecherous murderer. The black press's attitude to the case arose in part from anger over the amount of attention Frank's fate received when so many black lynching victims never even got a trial."

The consensus today is that Frank was "framed" by an overzealous, anti-Semitic prosecution, but even as late as 2003 Oney's heavily researched book backed away from certainty about the genuine perpetrator. Though it depicts Conley as a cunning liar, Oney's book also casts a measure of doubt on Frank's ultimate innocence.

At the time, Frank's guilty verdict spurred two years of protests and editorials, largely from outside the South, with the campaign to free him led by prominent Jewish and liberal organizations. After failed appeals to higher courts, Frank had his death sentence commuted to life imprisonment by the governor of Georgia, on his last day in office. In August 1915, however, a mob stormed the prison where Frank was held, abducting and lynching him. Photographs of his hanged body, surrounded by gawking crowds, were seen around the world. To the spectacle of a Jew convicted by a black man's testimony was now added the rarity of a Southern lynching of a white man.

In *The Forged Note,* Micheaux brought his alter ego Sidney Wyeth into the case by acquainting him with two cosmopolitan "mixed race" strangers passing through Atlanta. Their business in the city is vague. Only after their departure does Wyeth discover that they were operatives working for "The Great Detective" (his appellation for the renowned detective William J. Burns, who was involved in the Leo Frank case). Their job had been to penetrate the Negro areas of town (or "view the case from a 'dark angle,'" in Micheaux's words) on behalf of Frank's defense team.

Micheaux may have taken literary license with the two mixed race detectives. (As time went on, he would show a penchant for black sleuths in his novels and films.) But they gave the author an excuse to brood over the case, which divided Jews and black America. Indeed, historians regard

the Frank case as a watershed in black-Jewish relations: "the first well-focused incident of national interest in which the needs of blacks and Jews seemed to have been in direct conflict," according to historian Eugene Levy. "Apart from the Frank case there seems to have been little hostility towards Jews among black leaders of the early twentieth century."

In *The Forged Note,* Sidney Wyeth clearly sides with the black press. He is inclined to believe that Jim Dawkins, the Conley character, is telling the truth, and that "the Jew" is guilty. Dawkins was one "lucky Negro," according to Wyeth, to have transformed himself from obvious lynch mob target to star witness. But Micheaux's own authorial perspective is more complicated: Elsewhere in the book he scoffs at the paltry evidence in the case, while taking note of the public hysteria. And his novel even savages the rabble-rousing Populist publisher Tom Watson (dubbed "The Big Noise"), a notorious anti-Semite who strenuously inveighed against Frank, stirring up common opinion against the Jewish factory owner.

There is another way to date Micheaux's stay in the South. Much of *The Forged Note* concerned a young olive-complexioned woman named Mildred, "possibly twenty-one or -two" and "exquisitely beautiful," who buys a copy of "The Tempest" in Cincinnati and develops a crush on Wyeth. Mildred harbors a secret that is withheld from the reader. She pursues Wyeth to the South, though their paths crisscross for much of the book without meeting up. Eventually, Wyeth departs for New Orleans, with Mildred trailing him there.

The Louisiana interlude is fascinating. Wyeth stumbles across the site of a onetime slave market, marked with a plaque. This triggers disturbing visions of the past—the first time Micheaux directly confronts the horror and tragedy of slavery in his work. His time in the South had deepened his awareness of history, stirring his anger and pride; his 1913–1915 immersion into the Jim Crow world was crucial to his later, most ambitious films, about the old South and the legacy of slavery.

At the end of the story Sidney Wyeth and Mildred finally come together, proclaim their love for each other, and make plans to move to the Rosebud. And just as Micheaux, in his foreword to *The Forged Note,* in-

sisted that "Slim," "T. Toddy," "Legs," "John Moore," and other rogues in the novel were based on actual people he had met—"and I really knew them"—there must have been a real-life counterpart for Mildred.

One could not mistake the loving dedication on the opening page:

TO ONE WHOSE NAME DOES NOT APPEAR.*

The dedication was dated New Orleans, Louisiana, August 1, 1915.

Micheaux wrote parts of *The Forged Note* on the road, parts in South Dakota, and parts in Sioux City, Iowa, where, by late 1916, he had taken up temporary residence. His second novel was printed by the same firm in Lincoln, Nebraska, but Micheaux had officially incorporated in Iowa, and now the publisher was identified as his own Western Book Supply Company. And this time his own name was emblazoned on the cover.

Sioux City was a city he knew well and had long enjoyed and appreciated. On the Missouri River in western Iowa, Sioux City was a veritable crossroads of America, with train links leading to Great Bend, St. Louis, Chicago, Gregory, South Dakota, and other places where Micheaux routinely sojourned.

The West Seventh Street area, where Micheaux resided, was a thriving neighborhood to which Southern blacks had flocked since the turn of the century, taking jobs in the meat packing industry while living in rooming houses. At the same time Seventh Street was one of the most diverse sections of Sioux City—densely populated, for example, with Jewish merchants and residents. Seventh Street was known locally as the "Jewish Mile."

The 1917 city directory described Micheaux as a "trav. agent," or traveling salesman of his books. He was also listed in the local "Credit Reference and Trust Book," which advised possible investors in his publishing business to apply to the home office for a special confidential report on his dealings. That implies an official skepticism.

But it is his listing in the 1918 city directory that has raised eyebrows

* Micheaux's wording was probably inspired by W. E. B. DuBois's inscription for *The Quest for the Silver Fleece* (1911), which reads, "To One Whose Name May Not Be Written."

among Micheaux scholars. Not the fact that he is identified as an "author," but that he is recorded as living at 412½ W. Sixth Street with a woman called "Sarah." Her name appears in parenthesis after his, indicating that she is his wife.

That same year, on Micheaux's World War I Draft Registration Card, the name "Sarah" pops up again, listed as the Sioux City resident's wife as of September 1, 1918.

Who is this Sarah Micheaux, named in the 1918 Sioux City directory and again on his draft registration form? Was Sarah the real name of the woman known as Mildred in *The Forged Note* (. . . WHOSE NAME DOES NOT APPEAR)?

Legally, Micheaux was still married to Orlean McCracken; as far as is known no divorce petition was ever filed. Could Micheaux have married a second time, regardless? Or could Sarah have been a sort of "sideliner"—the second wife, in a different part of the country, not uncommon among wide-ranging frontiersmen?

Whatever the case, Sarah disappears from all records shortly after Micheaux leaves Sioux City and enters the film business. No scholar has uncovered any further documentation of her existence: no birth, wedding, or death certificate. But it's hard to dispute the evidence that, for a short while at least, there must have been a second Mrs. Micheaux.

Living in Sioux City with his "second wife," Micheaux spent 1916 to 1917 working on his third novel.

Why, at such an early juncture, did he choose to go back to *The Conquest*, tinkering with events and characters he had already portrayed successfully? The answer is simple, and underlies the many other times he would return to the very same story in later books and films: Micheaux couldn't set aside what had happened. The twin heartbreaks of his mixed-race romance and his marriage to the One True Woman who betrayed him, these were ineluctably yoked to his failure at the dream of homesteading. These were the mingled tragedies that defined him as an individual while at the same time—and this was the inherent tension in his life—setting forth what he viewed as object lessons for his race. With *The Homesteader*, Micheaux was taking a "second chance" with his life story in

order to drive home its moral for the race. And, perhaps, to clarify its elusive meaning for himself.

"The episode that had changed his life from ranching to writing was ever in his mind," publicity for *The Homesteader* would explain, "and always so forcibly, until he was never a contented man until he had written it" again.

Again and again.

In this second version of his homesteading story, Micheaux would enlarge upon and deepen the portraits of his weak-willed wife and her maleficent father. The South Dakota history would be pared down, the swashbuckling of the Jackson brothers minimized. At the same time, "the Scotch girl," who played only a minor role in *The Conquest*, would blossom in importance, providing a continuing subplot and over-arching theme.

This was the biggest shift in the retooled version of *The Conquest* that Micheaux busied himself writing in Sioux City from 1916 to 1917. Though the new work would add some details to events already described in the first novel, Micheaux's third book would be less stringently autobiographical, more fictional and melodramatic. The new novel would have mystery, action, a murder, a suicide, a genuine romance, and a happy ending.

Indeed, *The Homesteader* would have all the ingredients of a crowd-pleasing movie.

CHAPTER EIGHT

1914–1918
THE FILM BUG

Black show business was the most delicious layer cake most of white America never tasted.

This fare was served only at private parties: functions that were segregated, cheapened by inequities and conditions, but nonetheless magical events. Some elements, notably jazz and blues, filtered into the mainstream, but there were brilliant black vaudeville artists and inspired dramatic ensembles and world-class recitalists of every specialty who were only permitted to present themselves to black audiences during this era; and if a few white people showed up, they were treated just fine and didn't have to sit in the balcony.

The lowest, most disadvantaged layer of black show business, at this time and forever after, was film. Relative to most forms of entertainment, motion pictures cost far more money to produce. Most "race pictures," as they were called, turned little profit, and never got beyond the struggling-to-breathe stage.

Micheaux was an avid moviegoer who didn't limit himself to race pictures. Because, in his earliest novels, he used the word "show" for both stage performances and motion pictures (as in "moving picture show"), it is difficult to pinpoint when he first became hooked on movies. Probably it was upon his arrival in Chicago in 1902, when he could have watched silent one-reelers in the balconies of the Loop's grand picture palaces or in humbler Black Belt theaters. At least a dozen moving picture theaters were operating in the Black Belt by 1904, their shows interspersed with variety programs and sometimes performances by blues artists.

Micheaux attended moving pictures in South Dakota too, though it

wasn't until *The Wind from Nowhere*—his third novel recounting his homesteading experiences—that he got around to mentioning it. ("I get lonesome out here alone and often stay in town late at night, at a picture show, or hanging around a saloon.") The town of Gregory had an all-purpose theater by 1907, an outdoor movie theater by 1914. One Gregory theater drummed up crowds by hiring a cameraman to photograph local personalities and settings; the "home-movie footage" was projected on screen between the entertainments. Micheaux might have taken note, for his own films incorporated local sites and celebrities, the places and names flaunted in publicity and advertisements.

By 1913–1915, when he was roaming the South, selling books and absorbing material for *The Forged Note*, Micheaux had already begun to "make a study" (one of his favorite expressions) of the modern medium. In fact he had become a knowledgeable student of film, collecting pointers about the style and content and even the economics of picture-making. Commenting in *The Forged Note* on three theaters he frequented in Birmingham, Alabama, for example, he noted that they "were patronized entirely by Negroes," but "operated and owned by white men." This reality of black show business Micheaux recognized long before he joined the field.

The American film industry—that is, the major producers and studios just beginning to cluster and consolidate in Hollywood—was so lily-white, on screen and off, that conditions would have had to be improved one hundredfold before it could even qualify as Jim Crow. All the ownership was white, of course; and the white ownership determined the complexion of the industry, from the predominantly white writers, directors, and producers, right down to the fundamental nature of the stories filmed and the management of theaters.

If black actors appeared at all in big studio productions, it was on Hollywood's narrow terms. There were "colored actors," but they only played "colored parts." Once in a while these character parts were juicy, but most of the time they played to the demeaning stereotypes Donald Bogle listed in the title of his authoritative history of black film, *Toms, Coons, Mulattoes, Mammies, and Bucks*. "We are always caricatured in almost all the photoplays we have even the smallest and most insignificant part in," Micheaux himself wrote. A black actor was "always the 'good old darkey'," he noted, while the truth about black Americans' "present environments and desires" remained effectively "under a cover" to white Hollywood.

Micheaux wrote those words, incredibly, in 1919. They reflected a love/hate relationship with Hollywood that would abide throughout his career. At times he would be so moved by a Hollywood picture that he'd try to re-create its formula with an all-black cast. At other times the studio's prototype appalled him so thoroughly that he'd fashion his own alternative.

Surely Micheaux was appalled by *The Birth of a Nation*, D. W. Griffith's lavish adaptation of Thomas Dixon's novel *The Clansman*, and one of the most famous films of the early silent era. Its story about two Southern families during the Civil War and Reconstruction was suffused with warped history and "blatant racism," as film scholar Anthony Slide notes in *American Racist*, his definitive study of Dixon's life and career. Griffith's self-styled "super-production," which stretched to twelve reels, not only condemned miscegenation (mixed-race romances) and virulently caricatured black people, but also ennobled the Ku Klux Klan and helped revitalize the then-dormant white supremacist organization, known for lynchings and spreading terror.

Though hailed by some white critics, then and now, as a landmark of early narrative cinema, *The Birth of a Nation* sparked a fierce outcry from black America. Griffith's work was "an incentive to great racial hatred," said William Monroe Trotter, the editor of Boston's black newspaper, *The Guardian*, after being arrested in a violent altercation with police in the lobby of a theater trying to show the film. There were similar protests and demonstrations in many other cities. The National Association for the Advancement of Colored People (NAACP) circulated to the press a flyer in which the social crusader Jane Addams condemned the picture as "pernicious." (Many other white liberals condemned the film; Chicago mayor William H. Thompson was one of a number of U.S. mayors who temporarily banned *The Birth of a Nation* from public exhibition.)

Micheaux likely saw Griffith's "super-production" in Sioux City in 1915, though he may have seen it in Gregory, where it was also shown. (He passed through Gregory and Colome in 1915, selling *The Forged Note*.) Micheaux scholar J. Ronald Green notes that *The Birth of a Nation* controversy was covered extensively in the *Chicago Defender* and other publications Micheaux read, and concludes that he was "certainly aware" of the furor and "of the repeated calls in the black press for a champion to counter the slander of Griffith and Hollywood."

Subconsciously, at least, Micheaux was answering that call as he put

the finishing touches on the second version of his homesteading story—the new, improved, and more cinematic *The Homesteader*—in Sioux City in 1916 and 1917.

With his first autobiographical novel, *The Conquest,* Micheaux had established a number of stock characters who nonetheless were based on real-life people. These types of characters would recur in his stories: the virginal good-girl; her nemesis, the evil vamp; the callous, hypocritical villain; the decent, firm-jawed hero. But, returning to the Rosebud for his third novel, Micheaux added a patently fictional element that allowed him to mock Griffith's fears of miscegenation.

This time, the blonde Scottish good-girl (named Agnes here) wouldn't be left behind in the drama, as happened in real life and in *The Conquest.* This time she wouldn't be a white woman, either.

This time her looks were ambiguous. Her once clearly blond hair was now long and braided, with "a chestnut glint." The secret was in her eyes. Agnes's eyes were striking but "baffling," Micheaux wrote. "Sometimes," when her eyes were "observed by others they were called blue," according to *The Homesteader,* "but upon second notice they might be taken for brown. Few really knew their exact color." *

At the end of the story, Agnes would follow Jean Baptiste, Micheaux's alter ego, to Chicago, and there she'd learn the truth about her lineage from a family member in the Black Belt. Though light-skinned, in the new novel the good-girl would discover that she was "of Ethiopian extraction" and had been inadvertently "passing" for white. This revelation would allow for an archetypal window-into-the-soul moment, which would become common in Micheaux books and films, with the hero gazing into the heroine's eyes and finally achieving a breakthrough, perceiving the other's true race and deeper qualities. Then, the rose-colored ending Micheaux preferred: Jean Baptiste could marry Agnes and return to the Rosebud to live happily ever after.

It was a clever gambit: By changing one critical ingredient in his life story, Micheaux had turned it into a positive "passing" parable. Since the mid-nineteenth century—with books like *Clotel; or, The President's Daughter* by William Wells Brown (about Thomas Jefferson's liaison with

* The racial subtext to this motif is that blue or green eye colors are seldom seen in African-Americans unless there is an interracial lineage.

slave mistress Sally Hemings) and *The Garies and their Friends* by Frank
J. Webb (about the perils of mixed marriage for free Northern blacks)—
a body of literature sympathetic to "passing" had grown into a popular
sub-genre of American letters. Many of these were intended as melo-
drama, while others, such as Charles W. Chesnutt's *The House Behind the
Cedars*, were widely regarded as masterpieces. The "passing" literature,
because it spoke to the hidden history of slavery (black women as mis-
tresses, or rape victims) as well as to contemporary racial prejudices (the
social benefits of lighter skin), resonated deeply among black Americans,
especially in Micheaux's era.

By integrating the issue into a dramatized version of his own life story,
Micheaux had alighted on a theme that was at once deeply personal and
broadly social: one he would explore for years to come, and one that was
made to order for commercial exploitation, if *The Homesteader* should
ever become a moving picture show. "The injection of the white girl who
in the end turns out to be colored, was the cleverest thing that could have
been done [in the story]," Micheaux reflected later, "since nothing would
make more people as anxious to see a picture, than a litho reading: SHALL
THE RACES INTERMARRY?"

The years immediately following the publication of *The Homesteader*
would be a time of transition for Micheaux, starting with the unexpected
deaths of two women who had tremendously influenced his life.

The first to succumb was his estranged wife, Orlean McCracken.
Orlean was on her way to a church picnic in Chicago in mid-August
1917 when she was trampled by a runaway horse. "Tormented by a con-
stant attack of flies," the horse had raced around a street corner and
smashed into the woman. Orlean's front-page obituary in the *Chicago
Defender* decried the fact that "the injured woman was carried to the
[whites-only] Rhodes Avenue hospital, where the officials refused to
admit her, although they must have known the dangerous condition of
the patient." Instead, Orlean had to be taken to St. Luke's, where she died
the same day.

She was still legally Mrs. Micheaux at the time of her death. But
Orlean died after Micheaux had finished writing *The Homesteader*, and in

his second version of life on the Rosebud, he was less dewy-eyed about the woman who had spurned him. Her characterization in future retellings would be tinged with neurosis and madness.

The following year, Micheaux's mother passed away. It was the last in a series of tragedies that had shaken the Micheauxes. In May 1915, the family's two-story home in Great Bend was destroyed by a kitchen fire. One week later, the youngest daughter, twenty-two-year-old Veatrice, who had been visiting her sister Ida in Pueblo, Colorado, was gunned down by a jealous suitor as she returned from a downtown picture show in the company of another man.

Bell Gough Micheaux never rebounded from these heartbreaks. A stroke in May 1918 rendered her an invalid; in December, a second stroke killed her. Micheaux's mother was buried in the same gravesite as Veatrice. Micheaux attended the services, and from this point on, resolved to try to spend Christmases with his Kansas family.

With the sales network and contacts Micheaux had already established, *The Homesteader* quickly outsold *The Conquest* and drew enthusiastic reviews in the black press. Chicago's *The Half-Century Magazine* declared, "*The Homesteader* ranks with the best of novels yet written by a Colored author."

It may have been the drumbeat of Micheaux's advertisements ("A novel that can be called truly great . . . a story of love, high resolve, and ultimate achievement"), or possibly the steady flow of mail-order copies, that caught the attention of a black postal clerk in Omaha named George Perry Johnson.

George P. Johnson was the younger brother of Noble Johnson, "one of the most active and highly paid black movie actors" in Hollywood, as Daniel J. Leab notes in *From Sambo to Superspade.* "Light-skinned, of athletic build, and projecting a powerful personality," in Leab's words, Noble played all kinds of roles for Universal, where he was under contract, but he specialized in cowboys and Indians. Billed in black-only theaters as "the race's daredevil star," Noble was as close as Hollywood got to a black luminary; indeed, he considered himself "the only Ethiopian motion picture star in the World."

But Noble felt frustrated in his secondary roles for the major studios,

and he was farsighted in understanding that black audiences and theaters would welcome an alternative to white Hollywood. With a group of investors—including Clarence Brooks, another black actor—he organized the Lincoln Motion Picture Company in 1915 to produce an ambitious slate of race pictures.

The earliest race pictures had been created as early as 1909 in locales like Fort Lee, New Jersey, and Chicago (with William Foster among the pioneers). These were extremely low-budget productions compared to the major white studio offerings, with the all-black cast members often performing on a voluntary basis. The pictures ran the gamut from knockabout comedy to all-black Westerns to newsreels; their bookings were restricted to small regional circuits of black-only theaters.

In spite of these obstacles, race pictures found a hungry audience, and the negative example of *The Birth of a Nation* doubled that appetite. The Lincoln Motion Picture Company evinced serious, national ambitions; its principals were determined to showcase the race in a positive light while advancing worthwhile social ideas. The company's maiden production was *The Realization of a Negro's Ambition* in 1917, a two-reel Horatio Alger–style success story about a Tuskegee Institute graduate (played by Noble Johnson).

After their first production was under their belts, the Johnson brothers went prowling for other interesting story material. Noble was in Hollywood, but his younger brother George, in his early thirties, worked as "the first Negro postal clerk" in Omaha, anchoring the 3:30 P.M. to midnight shift. "As a side issue," in his own words, George also represented Lincoln's booking interests—"showing the Lincoln films in the theaters in Omaha, Kansas City, and others catering to Negro patronage."

It was George who spotted *The Homesteader*. When he first wrote to Micheaux in early May 1918, sending him circulars about the Lincoln Company, it's clear that neither he nor his brother had actually read the book yet. But Johnson realized it was another story in the Horatio Alger vein—this time set in the West, which might be "a perfect setup for my brother, whose entrance into films with the Lubin Co. of Phila. was due to his reputation as a fighter and cow puncher."

Responding on Western Book Supply Co. stationery from Sioux City on May 13, 1918, Micheaux said he couldn't help but notice from the material Johnson had sent that Lincoln's most recent pictures were "limited to 3 reels, whereas I am sure this voluminous work could not be pos-

sibly portrayed short of eight reels, for it is a big plot and long story." * He said he didn't care to have his novel filmed "until it could be properly done so," but was willing to send Johnson a copy of *The Homesteader* gratis, so "you would be in a position to draw a more definite conclusion of the theme." Micheaux added: "You may return the copy, providing you send for it [postpaid], when through."

Micheaux had done his homework, and he was already thinking big. The longest Lincoln production to date had been the three-reel Western *The Law of Nature,* released in 1918. Micheaux, however, envisioned his novel as an eight-reel "super-production," co-opting D. W. Griffith's phrase as well as his ambitions of epic length. After all, plenty of white people had been buying his book; he told George Johnson that he expected a screen adaptation to appeal to whites, too.

His boldness intrigued the Johnson brothers. George forwarded *The Homesteader* to Noble in Hollywood, who sent back word that he was "exceedingly interested" in filming Micheaux's novel. "The incidents seemed most natural to him, having lived them over and over, more or less, during his lifetime," George reported back to Micheaux.

However, the story also had its problematic elements. "The intermarriage situation may prove a stumbling block," Noble had warned, referring to the romantic tension between a seeming "white woman" (Agnes, the Scottish girl) and the Micheaux alter ego (Jean Baptiste). "To treat of the inter-marriage relationship of the Races brings in a very complicated and delicate situation to handle either in journalism, or its presentation upon the screen," the actor advised his brother, and it would be hard to dramatize that idea without arousing "the ire of the Southern white man," which would hamper distribution in black theaters in the South. "It can be done, but requires study, tact, and a close understanding of the situation," and Micheaux would have to be cooperative. If he agreed, then Lincoln might arrange to produce the film, with Noble playing the lead.

Noble urged George to meet with Micheaux, and after a flurry of letters Micheaux agreed to visit Omaha in the third week of May 1918. Though he arrived on a Sunday, and expected to leave by return train that

* According to film historian Scott Eyman, whose book *The Speed of Sound* chronicles the end of the silent era, "A reel of film was 1,000 feet. Running at the silent speed of 16 to 18 frames a second was the norm, around 10–12 minutes per reel." But the norms varied.

same evening, the author struck up a rapport with the ambitious postal clerk and ended up staying for two nights at the two-story Pratt Street house Johnson shared with his wife and infant child.

Noble Johnson's brother was a native Westerner, born and raised in Colorado before attending Hampton Institute in Virginia. Micheaux was an adoptive Westerner, who respected George's experience and education. Two black men about the same age, they both aspired to attain a foothold in the burgeoning field of race pictures. They were kindred spirits, but Johnson was mesmerized by Micheaux, a self-made man who actually had done the things he boasted. Even Micheaux's clothes and bearing—his "good appearance"—scored points with the postal clerk. Micheaux was charming, charismatic, "a convincing talker," recalled Johnson.

Right off, they began to discuss a long-term relationship that would merge Micheaux's publishing operation with the Lincoln Motion Picture Company. Micheaux, feeling his way in their talks, said he had plans for other novels that Lincoln might produce as films. A solidly written novel, he declared, offered the best foundation for a good script. Perhaps Lincoln could retain "exclusive rights" to the film adaptations of his novels, Micheaux proposed, while he kept all the book profits; he expected the success of the pictures to lead to a sharp boost in book sales.

Johnson was wary of getting too deeply involved in publishing, and he talked about how motion pictures differed from books. He and his brother had qualms about *The Homesteader*, he reminded Micheaux. They admired the novel, but felt they would have to make certain changes in the situations and plot.

Micheaux listened intently to the criticisms. "I agree with you," he wrote Johnson subsequently, "that *The Homesteader* would have to be improved in several places in order to make it a successful picture . . . the book offers a great theme, my plan is then to take the theme, work in more dynamic climaxes, more sympathetic and emotional detail, more fighting in parts which deal with conquest, in short, work the whole story over for Picture purposes."

One idea that Micheaux clung to tantalized the Johnson brothers. An eight-reel *The Homesteader* would create an even bigger stir, he predicted, if it were presented as a "road show," accompanied by tasteful "live" attractions. A traveling extravaganza, if well promoted, might also tempt white moviegoers. Micheaux kept talking about how he had sold his

books to so many white farmers and businessmen. Why wouldn't these same people—and others whose curiosity was piqued—want to see the screen rendition of his life story? "Most of your plays were written with Negro audiences in view," Micheaux argued in a letter. "*The Homesteader* was written with the expectation of the greater returns to be derived from whites."

Johnson had helped organize an informal regional circuit of theaters to show the Lincoln product, and he was responsible for promoting his brother's films in most areas of the country east of the Rockies. Though his experience was modest thus far, he was an old hand compared to Micheaux. Johnson could talk like an expert about the production and distribution challenges. He could reel off the cost of film stock, or cite prospective attendance figures in different areas of the country. Micheaux the talker became Micheaux the listener, as Johnson displayed his expertise, though the ex-Pullman porter had visited many of the places Johnson knew only from clippings or correspondence.

As Lincoln's general booking manager, Johnson understood the pitfalls of booking theaters and circulating prints on the race-picture circuit. There were at most three hundred black-audience theaters in 1919, many of the smaller ones nestled in the so-called "chitlin' circuit" of the South. Most were vaudeville theaters that still rotated "live" shows with motion pictures. Only a fraction were actually owned by black people. According to an account in *The Half-Century Magazine* in 1919, even in Chicago's Second Ward, "the heart of the Colored population," with an estimated 75,000 black denizens of the ward, "not a single theater is owned by Colored men."

While some of the all-black vaudeville houses were splendidly ornate, most venues catering to black audiences were second-rate, ranking "at the bottom of the moviegoing scale," according to Douglas Gomery in *Shared Pleasures*, a history of American film exhibition. "Invariably, they occupied the final runs [of Hollywood pictures] in the area, showing films seen months, sometimes years, earlier by white audiences in the same city. Owners of black-only theaters never expected to make much money with these operations and so invested little in their upkeep and equipment."

Larger theaters in major cities paid the highest daily rates for premieres. But the many lesser theaters in underpopulated areas usually split the gross, sixty-forty, with the advantage accruing to Lincoln. Because

they led such a shaky existence, black theaters were always closing, or changing management. Then there was the problem of "prints," or individual copies of the film. Prints were the largest expense of postproduction, their number always kept to a minimum. The prints of any motion picture had to be safely circulated in a timely manner. If prints were delayed in arrival, bookings were ruined.

Johnson had inaugurated a system in which representatives of Lincoln traveled with the prints, helping to ensure their safety and shipment. In order to guarantee on-time, quality service, Johnson had learned to factor in time zones, daylight savings time, the passenger rates on different train routes, possible weather conditions affecting turnout, and costs of damage to, or required changes in, the existing prints. Along with copies of each film, Lincoln supplied posters and advertising matter, which added to the distribution expenses.

Last but hardly least was the matter of censorship. Micheaux knew little about this side of the film business. As a self-published novelist, he had never confronted even a publisher's professional judgment, never mind the biases and whims of a white censor. He couldn't have guessed how much censorship would color his career.

Several states and many individual cities had all-white censorship boards that officially licensed film showings, Johnson warned Micheaux. That added to costs. Fees had to be paid, sometimes palms had to be greased; it was all par for the course if the film was ultimately approved. But race pictures rarely passed without some problems. Everywhere in America, but especially in the Deep South, race pictures were scrutinized for every conceivable violation, any inference that defied the prevailing social order. In some parts of the South, *anything* black people did on screen would be greeted as an affront by the local white authorities. The censors introduced an inevitable red tape to the process, and mandated cuts from nearly every race picture.

It helped, Johnson said, to have friends in the black press. Lincoln had one mole at the *Chicago Defender,* a vaudevillian-turned-journalist named Tony Langston, who was paid for praising Lincoln films in print and facilitating Midwest bookings. He also had a good man, D. Ireland Thomas, who covered theaters in Louisiana and traveled with prints throughout the South; Thomas also wrote for the *Defender* and other black newspapers.

On the subject of the press, Johnson and Micheaux could finish each

other's sentences. Micheaux could boast of having the editor of the *Defender* as a personal friend, while Johnson could mention another ally of Lincoln productions, Robert L. Vann, publisher of the *Pittsburgh Courier*, a black newspaper second only to the *Defender* in national readership, who was also a lawyer who had helped draw up Lincoln's corporate papers.

Both men talked, both listened. Advice and ideas were traded. Over time Micheaux would adopt and refine many of Lincoln's pioneering strategies, and expropriate all these relationships and more, from the fledgling race-picture company.

Finally, after two days of talking things over, Lincoln and Micheaux agreed to "join forces," in George P. Johnson's words, and produce *The Homesteader* "into a Negro film with my brother as the star." They even drew up a joint stock prospectus. And then, at the last minute, Micheaux balked at the partnership.

Everything he had heard fired his imagination. Now, before signing any papers, Micheaux added a couple of conditions. He said he wanted to go to Los Angeles himself to supervise the filming, or "assist in general with the direction of the picture." Perhaps, Micheaux added, he might even *act* in the film, surprisingly naming "the evil N. Justine McCarthy" (the Reverend McCracken character) as the role he might play.

Johnson was taken aback, but he agreed to consider Micheaux's demands. Micheaux left without signing any contract, telling Johnson he would return to Omaha to finalize plans as soon as the postal clerk and his brother had hashed out the details of the new arrangement. Meanwhile, he said, he would embark on the scenario. On June 3, he wrote George to solicit Noble's professional insights: "You might write your brother and enquire whether he would not be so kind as to give me his idea[s] before I go into the details of picturising the story, that is, parts which he feels should be changed and improved upon."

The devil was in the details, however, and Micheaux seemed conflicted about making the Lincoln commitment. His book business was thriving. In his June 3 letter he urged the Johnson brothers to take *The Homesteader* off its timetable until January 1, 1918, giving him time to wrap up publishing affairs, complete the scenario ("to do this, of course,

will require time and very careful study"), and then "offer same to your Company for examination, at which time I feel you can better appreciate how full well I understand" the requisites of motion pictures.

Yet only a few days later, Micheaux wrote again from Sioux City, sounding more firm and committed. He said he might even move to Omaha to facilitate the filmmaking partnership, that he was looking forward to signing a Lincoln-Micheaux contract. "Expect to send my wife to her home on an extended visit" in order to get busy on the script, he informed George Johnson—the first and only time he is known to have mentioned "Sarah Micheaux" in correspondence.

While Micheaux's letters assured Johnson that "the same ideas and plans which were technically agreed to in Omaha are still my ideas for the sale of the book as well as the production of the picture," he kept adding new stipulations. At the end of June he asked for exclusive exhibition rights to the "white territories" of Wisconsin, Minnesota, both Dakotas, Iowa, Nebraska, Colorado, Utah, Idaho, and Wyoming. Again, this wasn't a deal-breaker, as Lincoln normally skirted such "white territories." Still, bit by bit, the student was taking over the curriculum.

Although George Johnson said later he believed the proposed merger fell apart when his actor-brother rejected Micheaux's assistance and supervision of the film—"because Micheaux not only had no [film] experience but also had no Hollywood connections"—other events proved at least equally decisive.

Chief among them was the news, in July, that Noble Johnson had been called on the carpet by Universal, which insisted he cease and desist all appearances in Lincoln productions. This was one way the studios reined in their black contract players, exaggerating the extent to which race pictures competed with their own releases, for Noble was really making the Lincoln films "between times, or rather, on Sundays," in Micheaux's words.

But Hollywood was the actor's bread and butter, so Johnson quit the company he had founded. Clarence Brooks took over the leads of the Lincoln projects that were already in the pipeline, but Brooks was still in the formative stages of his career; he hardly boasted the box-office mystique of Noble Johnson. The prospect of having Noble play Jean Baptiste, the author's shadow self, had been half the appeal of the Lincoln-Micheaux alliance. Micheaux had seen all the Lincoln productions, and he was a fan of Noble's work in his Universal pictures, too. "Saw Johnson

kill a dozen men, make a great fight in the *Bull's Eye,* and in the end 'die' a horrible death himself," Micheaux told George Johnson in one letter.*

By July, it was clear that Noble would not be playing the homesteader. And with this, Micheaux's thinking took a huge leap: He decided to produce the film himself.

Although Noble's brother George was left empty-handed in Omaha, he made a point of staying in contact with Micheaux. The George P. Johnson archives offer a wealth of material about the whole field of race pictures, including correspondence to and from Micheaux. One revelation of these files is that Johnson sometimes resorted to devious means to keep tabs on Micheaux. He always believed that he was the one who put "the film bug" in Micheaux's ear, and that not just *The Homesteader,* but the film company that Micheaux went on to found, was *his* stolen baby.

Micheaux wrote regularly to Johnson and the remaining Lincoln partners, diplomatically keeping them apprised of his plans to film his homesteading novel. At first there remained a faint possibility that Noble might sneak away from Universal between assignments to star in the first Oscar Micheaux production. "Have you had any word from Noble, as to when he will be through the last serial he is helping make?" Micheaux wrote Clarence Brooks. "I should be pleased to hire him, paying him in cash a goodly sum, providing he will be available."

By August, however, that illusion had evaporated. It was disappointing, Micheaux reflected in a letter to the actor's brother, that Noble couldn't make himself available to act "the hero in this production; but it is obvious that the Negro race contains other talent, and it is that I will shortly set out to seek, not only for the one part, but for the entire picture."

Micheaux knew how to make strength out of weakness. He decided he would in general bypass Hollywood players, saving money by casting stage actors, vaudeville performers, singers and musicians—lesser-knowns and unknowns. An inveterate theatergoer, he was familiar with actors in Chicago and New York, by name and reputation. "I feel I can

* *Bull's Eye* was a 1917 Universal serial starring Eddie Polo, with Noble Johnson in a supporting role.

collect more complete talent—in the cast—in the Negro race, than I could in Los Angeles, and it would be too expensive as well as unnecessary to freight them clear across the continent at present R.R. rates. So it seems that the picture will be made in either Chicago or New York."

The new Micheaux Book *and* Film Company was incorporated in Sioux City, mainly for purposes of convenience. "Although Sioux City is mentioned as the office city," Micheaux told Johnson, "that is only because I expect to sell most of the stock to Sioux City people and in that vicinity, and do not feel that they would appreciate the main office being so far from where they live. But as soon as the subscribed stock has been paid up, incorporation completed etc., I expect to establish the main office in the business district of Chicago, get a Dodge Roadster, and make my home" there.

The first step was finding investors for Micheaux's race-picture enterprise. The legal papers authorized twenty to twenty-five thousand dollars in stock, to be divided into shares of one hundred dollars each.

The brochure, penned by Micheaux himself, foresaw booking *The Homesteader* into "the largest theaters in the largest cities under the personal direction of Mr. Micheaux, whose long experience in publicity work and the sale of his books to individuals, bookstores, libraries, etc., has peculiarly fitted him for the work in hand. After this it will be booked consistently in the smaller places, but always under the personal direction of Mr. Micheaux, who knows and understands more fully, the nature and sentiments of more communities than any man we know of . . ."

The brochure continued: "Aside from the general public, who themselves, having never seen a picture in which the Negro race and a Negro hero is so portrayed, and can therefore be expected to appreciate the photoplay as a diversion and a new interest, is the fact that twelve million Negro people will have their first opportunity to see their race in [a] stellar role. Their patronage, which can be expected in immense numbers, will mean in itself alone a fortune . . ."

Micheaux had a ready-made list of possible investors: the buyers of his novels. Yet it was one thing to purchase a book for $1.50, quite another to spend $100 on film shares. He found that, except for writing to trusted relatives and friends—Ernest Jackson probably kicked in for a few shares—he was obliged to revert to the salesmanship techniques he'd

learned as a boy in Metropolis and honed as a self-published author. He visited each prospect in person, hailed them by name, warmed them up with a smile and small talk, then dazzled them with his pitch.

"I have been soliciting subscriptions to the capital stock about nine days," Micheaux informed Clarence Brooks on August 11, "and have to date a trifle over $5,000 subscribed. Am succeeding as well as I had hoped, only I find it takes longer than I had calculated, it being necessary to get the people's attention and argue sometimes for quite a period. At this rate I contemplate that I will have the $10,000 subscribed and collected by September first."

At length he found his backers, some of them black, many white. Hugh E. McGuire, an auctioneer mainly of farm equipment in Holstein, Iowa, was willing to take a flyer on three shares, and later bought three more; his relatives say that McGuire's Irish Catholicism, and the fact that he and his family were Democrats in a German Republican stronghold, made him sensitive to prejudice and sympathetic to Micheaux's goals. "He'd try anything once," recalled his great granddaughter Martha Boyle, an officer of the Iowa auction company that today is still run by members of the McGuire family. Hugh McGuire died "broke," she added.

Thomas W. Stewart bought seven shares; at one point, Micheaux listed him as the company's vice-president. He was a Tuskegee graduate, a veterinary doctor working as a meat inspector in the Swift, Armour, and Cudahy packing houses for the Department of Agriculture and living in South Sioux City. Besides being a black man of Micheaux's generation and a reader of his self-published novels, Stewart "was always confident of 'get rich quick' schemes, which of course never materialized," according to his daughter Martha (Stewart) Hunter.

It was axiomatic in Micheaux's life that whenever he made a decision, and had mustered enough money to act accordingly, he acted with blinding speed. Earlier in the summer, still hedging about a Lincoln-produced version of *The Homesteader,* the novelist had said he would need roughly six months to effect a proper script. By August 11, completely won over, he was telling Brooks that the scenario would take about "two weeks, this I will perhaps write in Chicago while I am at the same time gathering the players for the act."

And he was already pressing ahead of the script and the actors: Micheaux himself was photographing background scenes. It was harvest season in Iowa, and he realized that he could save time and money by

having a camera crew shoot some footage of fields that would stand in for South Dakota. "It is necessary to get these scenes," Micheaux explained to Brooks in his August 11 letter, "since when I am ready to begin active work on the production, harvest will be over with." He intended to film the harvest that very day unless it rained, in which case he would put it off for a few days "since Ringling Bro's will be here tomorrow, and I contemplate attending the same."

Amazing but true: By mid-September 1918, five months after he was first approached by the Johnson brothers, Micheaux had opened film company offices at 538 S. Dearborn Avenue in the Chicago Loop and rented space at the well-known former Selig Polyscope studios, with production scheduled to start after October 1.*

But the scriptwork could barely keep pace, and according to at least one published source, Micheaux asked for help from an elder statesman: William Foster, who sometimes went under the pseudonym "Juli Jones Jr." "A clever hustler" and jack-of-all-trades, as Thomas Cripps described him in *Slow Fade to Black,* Foster worked at various points as a press agent, a sportswriter, and a salesman of sheet music and coffee. But he also was an actor, writer, and director for the Pekin Players, before turning out some of the very first race pictures before World War I, films Micheaux had seen during his stint in Chicago suing his father-in-law. Foster's 1912 production *The Railroad Porter,* "an imitation of Keystone comic chases" in the words of Cripps, was probably "the first black movie."

With (or without) Foster's help, *The Homesteader* script shaped up. "Writing it caused me considerable worry," Micheaux reported to Clarence Brooks on September 13, "but I am mostly through and relieved."

He was still vacillating over whether to direct. He engaged Jerry Mills to play the Reverend McCracken character, but also as a kind of security blanket. Mills was regarded as one of the "Professors" of the old Pekin Players. Beyond playing the title character in *The Railroad Porter,* Mills had been involved in various capacities in Foster's other pioneering race pictures, and had been a prolific writer and director of Black Belt shows.

* Founded by the Chicago-born pioneering motion picture producer and entrepreneur William N. Selig, the Selig Polyscope complex of buildings and acreage, bounded by Irving Park Boulevard, Claremont and Western Avenues, and Byron Street, had been in operation since 1896, though actual production had started to languish in 1917.

Micheaux was wary of handling actors, and press items of the time suggest that he had Mills in mind as the director. Micheaux praised Mills to Clarence Brooks as "well versed in the theatricals, and is highly respected as a dependable associate."

However, by the time October rolled around, it's clear Micheaux had built up a momentum, and a zest for picturemaking, that he never lost. The book and film, after all, were *his* life story. Farsighted in so many ways, Micheaux was ahead of his time in viewing film as a medium to express his personal beliefs and feelings, and by paying others less and taking the reins himself, he saw that he could reap more profits while protecting his ideas. He would be the supreme boss of his films, directing *and* producing them himself. This was undoubtedly the subtext of his uneasiness with the Lincoln partnership. And as with so many decisions made on his first film, this policy of writing, directing, and producing, once established, became the unwavering pattern of his career.

Micheaux's stock offering had proposed a rock-bottom budget of $15,000 for *The Homesteader*, "which includes four sets of films and $1,500 worth of lithograph posters." *The Birth of a Nation* cost an estimated $100,000, *before* prints and advertising, making its budget more than ten times that of *The Homesteader*.

Micheaux was a cunning economizer, however, and one of the places where he usually saved was on actors' fees. "Most any of the 'big' stars would get this much for their acting alone in such a picture," Micheaux's brochure informed possible investors. "Happily, owing to the peculiar nature of this story, an expensive 'big star' is not essential for its success."

The professional actors he hired were often amateurs where motion pictures were concerned. He introduced many black actors to the screen; most of them were grateful, and few were in a position to demand star treatment. Micheaux also used genuine amateurs from time to time: they came even cheaper, and demanded less.

Especially during the silent era, he drew repeatedly from the pathfinders of Chicago's Pekin Stock Company, from the similarly trailblazing Anita Bush Stock Company of New York, and from the Bush troupe's immediate successor, the Lafayette Players, the most heralded of the all-

black repertory companies, which first had started presenting shows at Harlem's Lafayette Theatre in 1916.

All these ensembles, but especially the Lafayette Players, were renowned for the versatility of their talent and the range of their shows. The Lafayette Players performed everything from light opera to the heaviest Eugene O'Neill tragedy. They presented original plays about black life, and frequently mounted Broadway plays or evergreens as interpreted by all-black casts. They prided themselves on being able to deliver any type of entertainment. And as they began to tour widely, introducing legitimate theater to black audiences in provincial parts of the country, the Players became "in a special way educators as well as entertainers," in the words of Sister Francesca Thompson, who has definitively researched the history of the group.*

The Lafayette Players had come to Chicago for the first time in the spring of 1918, and even as Micheaux was finalizing his casting a second company of the celebrated all-black troupe was finishing a lengthy summer run at the Lafayette on the Stroll. They had taxed the theater's capacity with constant overflow crowds, with the audience at some of the acclaimed plays "at least forty per cent Caucasian," according to Tony Langston in his *Chicago Defender* column.

The Lafayette Players were seasoned performers, whom a novice director didn't have to worry about guiding through tricky emotional scenes; such veterans could virtually "direct" themselves. And the black press had already made the Lafayette Players into celebrities, another valuable asset to Micheaux: They were already marquee names.

Casting the principal roles was the final hurdle, and Micheaux seesawed between candidates. What he looked for in a leading lady was another One True Woman, an actress whose beauty was matched by her intelligence. Of course she had to have ability, and she had to appeal to audiences. For his leading man—not just in *The Homesteader,* which was expressly autobiographical, but for most of his films—Micheaux would look for another archetype: a tall, handsome variant of himself.

* Black theater and film scholar Sister Francesca Thompson also bears the distinction of being the daughter of actress Evelyn Preer and actor Edward Thompson, both of whom played leads for the Lafayette Players and in Micheaux films. In articles and books she is one of the best published sources on her mother and father as well as the Players.

To play the Scottish maiden Agnes ("The Tenderest Little Heroine Ever Created," as he would later advertise her), Micheaux settled on Iris Hall, a petite, fair-skinned ingenue who had come to Chicago with the New York road company of the Lafayette Players. She played French maids and other supporting parts. But the young actress was "sweet, tender, vivacious and clever," Micheaux explained to Clarence Brooks, plus she "can pass for white and is just the size." Besides the Lafayette Players, Micheaux told Brooks, Hall "has worked in movies as a maid with [Famous Players–Lasky star] Pauline Frederick—can make up fine."

When Jerry Mills didn't work out as the Reverend, Micheaux replaced him with Vernon S. Duncan, a Kentucky-born, Chicago-based actor who had the required size and power. For the "despicable" sister Ethel, the first of many "bad girl" or "vamp" characters in his films, Micheaux picked a Harlem actress, Inez Smith, "a striking, highly educated girl from New York that appears to me as having been made for the part."

At first he had a different actress in mind for the Orlean McCracken character, but when she failed to jell Micheaux switched to Evelyn Preer, born in Vicksburg, Mississippi, but reared in Chicago. Just twenty-one, Preer was not yet widely known, though she had been performing in local shows since graduating from high school. Micheaux spotted the light-caramel-skinned, straight-haired beauty on a street corner, where she was using her histrionic talents to help her mother, a devoted Pentecostal, preach and raise money for building a church. "Preer, young, vivacious, and extremely attractive, was capable of drawing crowds to hear and watch her as she made a tearful plea, crying 'Sinners, oh sinners, come home!' with her arms outstretched wide in supplication," wrote Sister Francesca Thompson.

Beautiful *and* intelligent: Preer was an inspired choice. Over the coming years she would develop an impressive range, able to play for laughter or tears, in subtle or dynamic register. Also an exquisite singer, Preer would record blues as "Hotsy" Jarvis (her real last name). In the theater she took leads for the Lafayette Players and appeared in hit Broadway shows. She eventually came to be considered the "Colored Queen of Cinema," for her small Hollywood parts and for her recurrence as Micheaux's most frequent, favored, and greatest female star.

Later, in the 1930s, Micheaux would hire white actors for the occasional role in his productions. But for most of his career even the "white" characters were played by light-skinned black actors. That was the case

with *The Homesteader*: local thespian William George played Agnes's white suitor, while the beloved former Pekin Player and current Lafayette Player Charles Moore portrayed Agnes's Scottish father. He was nicknamed "Daddy" for his many white-haired roles, in which he invariably smoked a cigar or pipe.

It wasn't until the eleventh hour that Micheaux settled on the man who would portray Jean Baptiste, the character based on himself. Originally he had been enthusiastic about a Chicagoan named E. Bismarck Slaughter for the role. "He is intelligent, 6 feet, 200 pounds, good face—bright complexion with good hair and my kind of Chin—we will boil him into the part," Micheaux wrote Brooks early in the casting process.

But Micheaux was fussy about who played his alter egos, and Slaughter could not be boiled into the part. So the director gravitated to a newcomer with relatively little professional experience. His films often left the heavy emoting to the actresses and villains, anyway; it was enough for the heroes—such as Charles D. Lucas, who was ninth- or tenth-billed in the Chicago company of the Lafayette Players—to be tall, good-looking, and strong-jawed. Lucas, whom the well-informed George P. Johnson dismissed as a virtual "unknown," was cast as "the colored homesteader."

News of the production didn't travel far. Not yet alert to what Micheaux was doing, or the budding phenomenon of race pictures, the black press overlooked the actual filming of *The Homesteader*.

For the earliest glimpse of Micheaux as a filmmaker, we have an advertisement he placed in the 1923 *Simms' Blue Book and National Negro Business and Professional Directory*. The ad features a photograph of three men posed outside a small cabin, a setting for one of his earliest films. On the right stands an unidentified actor in the costume of a uniform. On the left stands a photographer next to his camera, which rests on a tripod. The cameraman appears to be a white man. (As far as is known, all of Micheaux's principal cameramen were white. White cameramen were likely to have had more experience, and later the all-white unions would preclude hiring black ones. White cameramen also had the requisite relationships with the white-owned photographic laboratories and postproduction facilities.)

At the center of the photo stands Micheaux himself. He is perched on the steps of the cabin, dressed in the standard outfit of an important Hollywood director during that era: white shirt, necktie, hat, and jodhpurs. Gripping a leather megaphone in his left hand, he is reaching out with his right as though to stroke the hood of the camera. He cuts a commanding and enigmatic figure, radiating power but also warmth and ease on the job.

It had been almost twenty years since Oscar Micheaux had left home in Metropolis to seek his fortune. He had worked and worked as a shoeshine boy, farmhand, factory drudge, coal miner, and Pullman porter—the job that had yielded him savings and inspired higher yearnings. Micheaux had risked all to become a homesteader in South Dakota, and in the end he had lost all. His habit of sending letters to newspapers, to share his perspective on race, class, and the world around him, had evolved into writing books of stories drawn from his own life. Wherever he went, he had always talked people's ears off, impressing upon them his ideas, his opinions, and the lessons he felt were implicit in his life. Now, with his evolution from self-published writer to self-produced filmmaker, he had finally found the combination of autobiography, social criticism, fiction, and show business that was his natural calling.

Yet Micheaux was no longer a young man. He turned thirty-five as he finished *The Homesteader.* By comparison John Ford directed his first feature at twenty-two; Alfred Hitchcock was twenty-five. Micheaux would have to make up for lost time.

This much is known: Interior scenes for *The Homesteader* were filmed in a Chicago studio. A few exteriors were filmed near Sioux City. But some outdoor scenes were also photographed in South Dakota, where Micheaux, the white cameraman, and the three leads made a whirlwind journey in an open-top Dodge Roadster. Back on familiar ground, the former homesteader met up with old acquaintances and, against the backdrop of the Rosebud, directed the group of actors he had hired to play the Scottish girl, "Orlean McCarthy," and himself.

The filming, amazingly, was completed by Christmas 1918. Micheaux had written, directed, and produced his first race picture. And he wrapped up postproduction in time for a February 1919 premiere.

CHAPTER NINE

1919–1921
A TONGUE
OF FIRE

The Homesteader was booked to debut at the Eighth (Colored) Regiment Armory at Thirty-fifth and Forest in Chicago. The armory had a seating capacity of eight thousand, and in half-page newspaper advertisements Micheaux promised a film as monumental as the facility: a "Mammoth Photoplay . . . destined to mark a new epoch in the achievements of the Darker Races." Micheaux's name was set in large type, his photograph included along with the principal players.

"Every Race man and woman should cast aside their skepticism regarding the Negro's ability as a motion picture star," said the ads, "and go and see [the film], not only for the absorbing interest obtaining herein, but as an appreciation of those finer arts which no race can ignore and hope to obtain a higher plane of thought and action."

The premiere, held on February 20, 1919, was just the kind of road show-style gala Micheaux had envisioned—and it was packed. An orchestra played music composed especially for the film by Dave Peyton, a jazz bandleader who was also a *Chicago Defender* columnist; the celebrated tenor George R. Garner Jr. sang selections from *Aida*. There was an extra treat: Micheaux had organized a special newsreel documenting the homecoming of the Illinois Black Devils, the all-black infantry unit that had recently returned from action in World War I.

Then the main event: the world premiere of the first full-length, "all-colored" motion picture.

One thing is safe to say: No moviegoer had ever seen anything like

The Homesteader. It was not exactly a Western, not merely a love story, but a fundamentally serious, truthful drama about one black man's troubles, addressing issues that were both singular to Micheaux and general to the race. The audience was electrified.

But they would be the last to see Micheaux's pioneering film for days.

Whether or not the Reverend Newton J. McCracken mingled with the armory crowd, he certainly knew he was the villain of the picture, as he had been the villain of Micheaux's novel. After the premiere, the A.M.E. Elder and two other ministers filed a complaint with the Chicago censorship board, accusing Micheaux of vilifying preachers. The board decided to ban future showings, citing the film's purported "tendency to disturb the public peace."

Yet Micheaux was a veteran of legal skirmishes with his ex-father-in-law, and he had anticipated a brouhaha. Now he went to work orchestrating its resolution. He organized a protest against the board's decision, and used the protest publicity to pressure the censors into soliciting an outside opinion from prominent Chicagoans.

When the group of chosen outsiders convened to reconsider the banning of *The Homesteader,* they happened to include several appointees firmly in Micheaux's corner: *Chicago Defender* publisher Robert S. Abbott and his wife, along with the newspaper's entertainment columnist, Tony Langston; the crusading journalist and civil rights pioneer Ida B. Wells-Barnett; city councilman Oscar DePriest, who would go on to become the first black person elected from a northern state to the U.S. Congress; Colonel John R. Marshall, a leader of the Eighth Regiment in the Spanish-American War; and Bishop Samuel T. Fallows, an Elder of the Reformed Episcopal Church. After watching Micheaux's film, the group voted to override the censorship board.

All of which improved the advertising. "Passed by the Censor Board Despite the Protests of Three Chicago Ministers," subsequent ads boasted, "Who Claimed That It Was Based Upon the Supposed Hypocritical Actions of a Prominent Colored Preacher of This City!" Rubbing salt in the Reverend McCracken's wounds, the ads quoted the liberal Bishop Fallows: "I can see no just cause for the personal objection to this [photo] play. Every race has its hypocrites. Frequently they are found in the churches."

And the censorship fracas would pay other dividends: Micheaux filed away the incident—and later battles with Chicago censorship authori-

ties—for another day, when they would become the basis of another thinly veiled motion picture about the vicissitudes of his life.

A week after the ban was overturned, *The Homesteader* was launched in the new 1,300-seat Vendome Theatre, the most commodious and prestigious of all Black Belt venues. Lines of eager viewers began forming on the morning of opening day; by the time the theater closed for the night, 5,700 people had seen the once-banned film, "at an advance in price of 10 cents over our regular admission," according to owner O. C. Hammond.

The Micheaux film "played five additional days at this theater," according to Hammond, going on to book dates and return engagements at the other four theaters Hammond operated in the Black Belt, "and I am glad to say that not only has our houses been crowded at each and every evening performance, with a rebooking at each house, but the play has so fully pleased everybody that it has been a great pleasure to exhibit the same."

By all accounts, the Chicago audiences, many of whom were likely drawn to the film because of the controversy, were overwhelmed by the quasi-autobiographical race picture. Local critics raved: OSCAR MICHEAUX'S FAMOUS STORY MAKES GREAT PICTURE, read the headline in the *Chicago Defender*. "Every detail of the production has been given the most minute care," enthused the *Defender* reviewer. "Many scenes," said *The Half-Century Magazine*, "rank in power and workmanship with the greatest of white western productions."

In the reviews, the film sounds surpassing. That it was pathbreaking is inarguable. Yet today it is a "lost" work, one that should be ranked, along with, say, Alfred Hitchcock's first film, among the Ten Most Wanted.

It was a triumph on every level: artistic, commercial, and personal. Micheaux had routed the devil McCracken in his own lair and conquered the Black Metropolis.

Making films was only half of Micheaux's genius. The other half was his P. T. Barnum–like salesmanship.

As soon as he decided against the Lincoln partnership, Micheaux had begun urging George P. Johnson to move to Chicago and become the general manager of the Micheaux Book and Film Company, offering the

Omaha postal clerk a munificent salary of fifty dollars per month. Later Johnson would do some work for Micheaux, covering black-only theaters in the Omaha vicinity, but he never could bring himself to break away from the financial security of the post office and go full-time into the race-picture business.

Johnson was envious of Micheaux's success, and he followed his erst-while associate from a distance. Finally, his curiosity led him to sub-terfuge. On fancy stationery he had dummied up for the purpose, Johnson sent Micheaux letters from a nonexistent brokerage house in-quiring about his corporate records, trying to extract information about his investors and perhaps buy out or undermine the ex-homesteader. When Micheaux told Johnson he was looking for reliable employees, Johnson recommended two men, one of whom was a close friend and the other, his brother-in-law Ira McGowan. Micheaux hired both candidates, who then secretly funneled Johnson intelligence about Micheaux's oper-ations, sometimes writing their tattletale letters from their Chicago desks while the boss was out to lunch. In many ways the business of race pic-tures was as cutthroat and insular as Hollywood.

Through such skulduggery, Johnson managed to monitor the film company he had helped to father. Yet Micheaux too continued to bene-fit from the apparently cordial ongoing relationship, extracting informa-tion and advice about national distribution from the more experienced Johnson.

Micheaux hired a small staff, including a secretary and financial man-ager, to anchor his office in the Loop while key salesmen traveled with the prints. But with *The Homesteader* Micheaux also made a policy of going on the road with the premiere print. He liked the opportunity it gave him to mentor sales agents, forge relationships with theater owners and man-agers, and supervise the quality of crucial screenings. (*The Homesteader* contracts tried quixotically to enforce a standard rate of projection, stip-ulating that the film "shall not be projected at a greater rate of speed than 1,000 feet in 15 minutes.") Above all, he preferred to collect the fees in person.

In May, with the print under his arm, Micheaux embarked on a six-week swing through the Midwest and South. *The Homesteader* had its second premiere in Kansas City, Missouri, followed by a tour to Wichita and Topeka, Kansas; Omaha, Nebraska; Florence, Sheffield, Decatur, Mobile, Montgomery, Birmingham, and Bessemer, Alabama; Chat-

tanooga, Memphis, and Nashville, Tennessee; Shreveport, New Orleans, Alexandria, Monroe, and Baton Rouge, Louisiana; Spartanburg and Columbia, South Carolina; and Reidsville, North Carolina.

The showings were for one, two, three nights at most. With its unusual length (when the eight-reeler was projected in some theaters, *The Homesteader* ran for more than two and a half hours), Micheaux's film was shown twice daily in the bigger cities. Tickets for a local premiere might sell for as high as twenty-five or fifty cents, but usually the charge was much less, ten or fifteen cents.* Micheaux's company furnished heralds for mailings to area residents, posters and advertisements for local newspapers, and sometimes a hired car to cruise black neighborhoods trumpeting the film through a loudspeaker.

For this premiere tour, Micheaux preserved the road-show concept at a lower budget. The filmmaker himself took the stage to host some of the major theaters, and singer George Garner Jr., traveled with the print as well, performing operatic passages to add to the evening's entertainment. Where possible, small local orchestras or a piano man played Dave Peyton's music.

Micheaux had another important reason to travel with the premiere print: to cope with local censors. Though he'd won his first battle in Chicago, the war against race-picture censorship had many fronts, and for Micheaux it would be a lifelong struggle.

Hollywood itself was still young, and throughout the 1920s produced a regular stream of so-called "pink slip" productions, films that, though they avoided race, flirted with risqué topics and broached sensitive social issues. When the Production Code was forced on the major studios in 1930, largely because of these "pink slip" pictures, there developed an intricate system of self-censorship. A small army of full-time studio executives and lawyers formed to collate the national and local censorship rules. By the mid-1930s, the morality of American movies was being enforced right at the source in Hollywood, by the studios themselves.

Hollywood would grow rich and fat perfecting its fantasy morality—a world where religion was rarely questioned, or politics seriously dis-

* The one- to three-day bookings and humble ticket prices were geared to the lower economics of poor black communities and helps to explain why, throughout his film career, it was so difficult for Micheaux to turn a profit. In the white, first-run theaters in the downtowns of major U.S. cities at this time, the going rate for tickets to Hollywood pictures was $1 or $1.50. Audiences were paying up to three dollars for best seats to some D. W. Griffith films in New York, in 1919.

cussed; where murder and other mortal sins (including adultery) never went without severe punishment, preferably death; where liquor was rationed; drugs didn't exist; nary a curse was uttered; and separate beds and bulky underwear were the order of the day. And where the few black people were window dressing at best, buffoons at worst.

Micheaux was determined to depict a different world, exploring forward-looking ideas and feelings about black America, at a time when that province was as foreign and remote to Hollywood as the planet Mars. Working, from the outset, as an artist *and* showman, as both a realist and a fabulist, Micheaux told stories that were both truthful and entertaining—but even the lightest of them challenged the complacency of censors.

Starting with *The Homesteader,* Micheaux's films routinely mocked organized religion and hypocritical preachers. His characters were comfortable in gin joints and flophouses. They gambled, drank to excess, and smoked reefer. The women wore sexy underwear or less, sometimes cohabiting with abusive men who had no intention of marrying them. Even his gangster films and nightclub musicals in the 1930s were flecked with the stark realities of black America.

Chicago's censorship board dominated and influenced other towns and cities in the Midwest. New York, Pennsylvania, and Maryland censors guided the East Coast. The taboos were fairly consistent from place to place, but there were local variations, and entire regions, like the Deep South, where an "all-colored" film directed by an unapologetic black man was unwelcome. The possible transgressions were innumerable.

One controversial story point in *The Homesteader* was the scene where "Orlean McCarthy" was advised by her rotten sister to ingest a herb that will cause her pregnancy to abort. Just mentioning abortion was "immoral," ruled the Motion Picture Commission of New York, and censors in other states concurred. *Snip, snip,* and the scene was gone.

Ironically, Micheaux's insistence on exploring the "passing" theme (in his own life story and in so many films) probably caused him more conflicts with censors, over time, than any other subject. Wherever *The Homesteader* went, North or South, censorship officials zeroed in on the fact that the film portrayed a "white" woman who *appeared* to be embroiled in a romance with a black man. Mingling of the races would be taboo in Hollywood filmmaking into the late 1950s. In Micheaux productions, again and again, it was a crucial part of the drama.

Once in a while—as in Chicago—Micheaux would encounter a

token black censor, but most were white, and Micheaux was forced to smile through their objections, misinterpretations, and paternalism, like the Pullman porter he had once been. After screening the film in Kansas, one woman on the Board of Censors handed Micheaux a written synopsis of *The Homesteader* she had prepared, proposing a number of minor cuts, and offering a suggestion: "You cannot imagine what a perfectly lovely and original [new] title I have given it!" she exclaimed. "A Good Old Darkey." She "looked kindly up into my face for approval," Micheaux recalled. The cuts had to be made, but he kept his own title.

The issues could be murky, and some things that alarmed white censors also threw down a gauntlet to Micheaux's natural constituency. Hollywood sometimes allowed the word "nigger" to crop up offensively in its pictures. Micheaux used it *intentionally* in his dialogue, and in intertitles during the silent era. His low-born black characters sometimes spoke in dialect or slang, and the n-word was part of their vernacular; when his white characters used it, the word demonstrated their prejudice. Usually, the word signaled poor education or uncouthness. (Refined, modern characters cautioned against its usage: "Don't say 'niggah,' Mother," the young daughter Julia Theresa Russell chastises her mother in *Body and Soul.* "It's vulgar.")

For Micheaux, the n-word was a realistic part of black life, as both vernacular saying and racist insult. Time after time, however, Micheaux's censors targeted it for elimination. And while many black moviegoers accepted its usage, some scribes on big-city newspapers also took Micheaux to task for popularizing the slur. Micheaux never gave up; he kept sneaking the word back into his films, tinkering with its frequency and context, but always returning to it.

Micheaux fought these censorship battles himself. In a way he relished being the point man with the censors, savoring the controversies and the skirmishes that resulted. He was a guerrilla fighter, wily about skirting rules that constrained Hollywood directors. After all, he was such a smooth talker, and when talking failed, he found other ways to fight for his ideas.

Travel was a tonic for Micheaux. It gave him time to think and write. While touring with *The Homesteader,* he quickly drafted a story he tenta-

tively titled "The Lie," the first of three films he planned for the year ahead.

Writing to George P. Johnson in May 1919, Micheaux said he was also working on a new novel called *The Ghost of Yesterday,* which would be published to coincide with one of the three films he planned to produce and release in 1920. But there would be no fourth Micheaux novel that year, and none for another twenty years. The author had been bitten by "the film bug," and from this point on he would draw on his quasi-autobiographical streak to enliven the screen, not the printed page. With this full-time switch to filmmaking, there was one loss: during his filmmaking years, the public record of Micheaux's thoughts and deeds grows sketchy, the references to his own life story more allegorical.

Even so, he would pile up an impressive stack of "unpublished" stories and novels, which would inspire Micheaux films for years to come.

By the midsummer of 1919, Micheaux had begun adding dates for *The Homesteader* outside the Midwest and South; circulating his films always took longer than anticipated, and was more fraught with peril than the act of creativity. His staff took over the distribution in July, and the showings fanned out. But *The Homesteader* didn't reach the populous black belts of most East Coast cities, even New York, for months.

And as the prints traveled from town to town, the cuts made by local censors were rarely restored. Even Hollywood was conservative about the number of prints that were manufactured: In 1919, an average Hollywood picture might go out in thirty-five to sixty-five prints.* According to his prospectus, Micheaux could only afford *four* copies of *The Homesteader.* The handful of prints he had struck were worn and nicked by the time they arrived in smaller theaters months after their release, with footage missing and the remaining reels showing considerable wear and tear. By March 1920, according to a notation in George P. Johnson's files, the main print of *The Homesteader* was already in "bad shape."

That small number of prints is the simplest explanation for why no one can claim to have seen *The Homesteader* since it was shown to initial audiences over eighty-five years ago. But wherever the first Micheaux picture was exhibited in 1919 and over the next few years, black people flooded the theaters.

* Indeed, the low number of prints is one key reason why the majority of Hollywood's silent films are also "lost."

* * *

Micheaux was back in Chicago when race riots broke out there in late July 1919. The riots were sparked by a Negro boy swimming into a part of a near South Side beach that was used exclusively by whites, not far from where Micheaux sat at his desk in his office in the Loop, working on the script of his second film, "The Lie." The boy accidentally drowned during the disturbance, which mushroomed into fighting and stone-throwing and citywide violence, resulting in the call-up of the state militia, thirty-eight black lives lost, and 537 people injured over three days.*

Throughout America it was a bloody summer of racial tension—dubbed the "Red Summer" by James Weldon Johnson—with incidents flaring into riots and arrests and beatings and lynchings across America.

All this was happening as Micheaux was completing his scenario. He wrote with a vengeance, and "The Lie" evolved into *Within Our Gates,* a brave story, more socially provocative than the confessional *The Homesteader.* In fact, most scholars agree, *Within Our Gates* was Micheaux's most explicit rebuttal to D. W. Griffith and *The Birth of a Nation.* (Even the new title was a reference to the epigraph that introduced Griffith's 1919 film, *A Romance of Happy Valley* : "Harm not the stranger/Within your gates/Lest you yourself be hurt.")

Micheaux set the story partly in Boston, a city he fondly recalled from his portering days. There, an earnest young schoolteacher, Sylvia Landry—"typical of the intelligent Negro of our times," according to the intertitles—anguishes over "the eternal struggle of her race and of how she could uplift it." After Sylvia's engagement to a world traveler is broken up by a jealous cousin, the teacher accepts a job at the Piney Woods School, an academy for poor, rural black Mississippians run by a Booker T. Washington-type role model.**

* Incidentally, the Chicago Commission on Race Relations later determined that discriminatory practices of moviegoing contributed to the anger that fueled the riot. Black people in Chicago were routinely "turned away from big downtown theaters, guided to second rate seats, or forced to move at the request of white patrons," according to Mary Carbine in "The Finest Outside the Loop: Motion Picture Exhibition in Chicago's Black Metropolis, 1905–1928."

** Piney Woods was—is—an actual all-black boarding school in rural Mississippi. Such real-life references were a constant pleasure of Micheaux's films. White Hollywood, by comparison, maintained busy legal departments that attempted to avoid expensive consent agreements and infringement lawsuits by disguising the actual names of people and places.

When Piney Woods finds itself in danger of bankruptcy, Sylvia must return to Boston to raise funds to rescue the school. When the school-teacher is injured in a car accident, the owner of the car turns out to be a wealthy white philanthropist who adopts the cause of saving the school. The subplots include danger from criminals and a flickering love story. Sylvia happens to meet a gentlemanly Boston physician—another one of Micheaux's exemplars of the race—as fashionably dressed as he is "passionately engaged in social questions." (The doctor is introduced reading an issue of *Literary Digest* with Teddy Roosevelt on the cover.) Though the teacher finds herself attracted to the physician, a secret in her past inhibits her from pursuing their romance.

The jealous cousin undergoes a change of heart, recounting the teacher's sympathetic backstory. The film goes back in time, revealing the teacher as an unwanted baby left on a sharecropper's doorstep. "Micheaux is alluding to what was common knowledge," according to film scholar Pearl Bowser. "When a black female was impregnated by the plantation owner or some member of his family she was sent back to the cabin, away from the big house."

When the sharecropper is accused of the slaying of the wealthy white plantation owner, a white mob gathers to lynch him. Most of his family is caught and murdered. The adopted Sylvia manages to elude the mob, but she's cornered by the wild-eyed brother of the landowner, who tries to rape her. During the struggle, however, he discovers a scar on her chest, identifying the fair-skinned Sylvia as his own biological daughter by a previous liaison.* Stricken with shame, the brother takes the girl under his care and pays for her education in Boston.

Return to the present: The doctor recites a history lesson about the heroism of black soldiers in past wars that is both instructive and healing. Sylvia's mother's story is now knowable and part of their growing bond.

Although Micheaux managed to contrive a happy ending for his drama, the story was rooted in the sins of the South, with a climax that

* Actress Evelyn Preer recalled the ending to that near-rape scene (missing from the incomplete print as it exists today) as being "my lover broke down the door and leaped on the villain's back." But nothing in the only extant version of *Within Our Gates* explains whether the white assailant in the scene is the schoolteacher's father by previous rape, or concubinage. "This suggests that these scenes may have offended some censor boards, theater owners, or archivists," wrote Pearl Bowser and Louise Spence in their book *Writing Himself into History: Oscar Micheaux, His Silent Films, and His Audiences.*

rebuked D. W. Griffith's miscegenation hysteria (the mulatto's near-rape of Mae Marsh in *The Birth of a Nation* becomes a white man's near-rape of a black girl, who turns out to be his own daughter) and dealt with the evils of slavery, the failures of Reconstruction, and the nightmare of lynchings.

Unquestionably, with *The Homesteader*, Micheaux had set a high standard for race pictures. Now, as he began filming *Within Our Gates*, his second, eight-reel "super-production," he bristled with confidence. This ambitious production would require all of his formidable energy and both sides of his personality: the sweet, sunny smile that coaxed cooperation, and the burning gaze of anger and rectitude.

His leads came straight from *The Homesteader*. Only Evelyn Preer could play the idealistic Boston schoolteacher, with Charles D. Lucas as the physician who falls in love with her. E. G. Tatum, Flo Clements, Jack Chenault,* S. T. Jacks, Mrs. Evelyn, William Starks, and Grant Gorman were the other principals.

Though Micheaux had volunteered to act in *The Homesteader* for the Lincoln Motion Picture Company, as far as is known today he did not appear in his first production. Whether motivated by whim, vanity, thrift, or a modern impulse for self-comment, however, Micheaux did favor on-camera cameos, and some experts believe he can be glimpsed fleetingly as a gambler in the Boston part of *Within Our Gates*. He may have been making a statement: As scholar Corey K. Creekmur points out, he plays "the only black character in the film to use the word 'nigger' in an intertitle."

Micheaux shot the film in the fall of 1919 in and around Chicago, with interiors photographed at the Capital City Studios complex. The flashback, with its mob scenes, lynchings, and attempted rape, was the crux of the script and also the high point of the filming—a highlight that was also an ordeal for the lead actress. Having undergone physical ordeals himself, Micheaux liked to pass these experiences on to characters in his stories, sometimes to his leading men, more often to his heroines. His leading ladies learned to expect the worst.

* This may be Lawrence Chenault, making his first appearance for Micheaux billed under another name.

Struggling with her attacker (played by Grant Gorman), Preer had to engage in one of the "most realistic fights" ever filmed, she recalled. But the actress, who was making her second appearance for Micheaux, was already a trouper. Preer was "more versatile than any girl I have ever known," in the director's words, and willing to do anything asked of her "cheerfully and without argument." Preer eschewed dummies or stand-ins. "This scene I consider the best I ever played in," the leading lady of *Within Our Gates* boasted in a subsequent interview.

Once again, postproduction was swift, and so was rejection by the Chicago board of censors. The board was determined to keep *Within Our Gates* from the general public, especially because of its flashback sequence, in which a Southern black family is surrounded by white rabble and lynched from trees, while the film's heroine undergoes sexual assault. The story would have been objectionable to the censors at any time, but it was doubly inflammatory coming so soon after the city's race riots.

The censors had a long list of other complaints. Among other things, Micheaux had loaded the film with another self-serving black preacher (Leigh Whipper), who is indulged by white folk as long as he does his job of encouraging his flock to suffer patiently on this earth, in return for their eternal reward in heaven.

Again, Micheaux rallied allies—he had Mayor Thompson on his side as well as South Side aldermen—and pushed *Within Our Gates* past the censors. But it took "two solid months," according to published accounts, and some 1,200 feet of cuts—an entire reel's worth—before the film was allowed to debut in late January. By February, however, the footage had been restored and the picture could be advertised "as originally produced" and "the biggest protest against Race prejudice, lynching, and 'concubinage' that was ever written or filmed," with "more thrills and gripping, holding moments than was ever seen in any individual production."

But the controversy spread beyond Chicago, and resistance to the picture went beyond censorship. *The Homesteader* had been the story of one man's grievances; it could have been subtitled "The Story of a Negro." But *Within Our Gates* was a much broader canvas, promoted as a "preachment" and "A Story of the Negro," that is, of the entire race. Especially after enduring their own real-life "Red Summer," some black theaters were reluctant to show a film that culminated with a black family's lynching. Some refused to book it. Even some moviegoers were repelled.

George Johnson, who handled theaters in and around Omaha, lectured Micheaux about the film. "You did not take enough of the second reel [of *Within Our Gates*] out and regardless of the fact that the acting was better than *The Homesteader,* the public does not like the picture," he wrote Micheaux. "Quite a few walked out."

Not for the last time, in public or in private, was Micheaux obliged to defend his storytelling philosophy. "It is true that our people do not care—nor the other races for that matter, for propaganda as much as they do for all story," Micheaux replied evenly to Johnson. "I discovered that the first night that *Within Our Gates* was shown. Still, I favor a strong story at all times, since I believe that every story should leave an impression."

In many parts of the country, however, the public did not have the opportunity to walk *in,* much less out of, *Within Our Gates.* In Shreveport, Louisiana, for example, police visited the local black-only theater promoting the Micheaux picture, complaining about the flashback and other scenes "demonstrating the treatment during slavery times with which the negroes were treated by their masters, also shows the execution by hanging of about nine negroes for absolutely no cause." The police easily persuaded the white manager to discontinue showings. "A very dangerous picture to show in the South," the police captain reported to his superior. Then word was quietly passed to other Southern locales, where the race picture was barred in advance.

Within Our Gates is the first Micheaux production to survive for current-day viewing, although the existing version is obviously damaged by both censorship gouges and general age and misuse. (Originally an eight-reeler, the film already had slimmed down to six reels by 1921, according to company advertisements.)

From the moment its darkly comic opening title card appears on screen ("At the opening of our drama, we find our characters in the North, where the prejudices and hatreds of the South do not exist—though this does not prevent the occasional lynching of a Negro"), the film is an astutely written, at times beautifully directed, landmark. Even in its truncated form, it holds up as a gripping, affecting work of quality.

Evelyn Preer's sweet performance centers the film. And while it is true that Micheaux's leading ladies were often subjected to harrowing ex-

tremes of nature and violence, in films like *Within Our Gates* the heroines are smart and strong, and they usually pull through, proving their mettle.

Micheaux was a unique storyteller, using film methods that were as idiosyncratic and modern-minded as anything being tried in Hollywood at that time. One of his unusual techniques was repeating scenes from different subjective viewpoints to reveal the crucial missing pieces of a puzzle. Micheaux liked to fool an audience the first time, then reiterate a scene once or twice, from shifting perspectives. During the lengthy flashback of *Within Our Gates,* he achieves this very cleverly, without any of the usual winking, so the audience is thoroughly gulled by the question of who murdered the white landowner. The landowner's slaying is depicted twice: once to gain the audience's trust and muddy the waters, then a second time to bare the surprising truth.

Micheaux was a believer in dreams and premonitions, and his films have a predilection for fantastical auguries. The eeriest example in *Within Our Gates* occurs during the flashback sequence. The audience meets a black man named Efrem (E. G. Tatum)—"a debased servant" of the landowner, in the words of scholar Corey K. Creekmur—whose misinformation feeds the outrage of the lynch mob. Later in the flashback, "surrounded by an angry white mob that grows less and less appreciative of his services and servility," as Creekmur notes, "Efrem's comic 'glory' dissolves into a nightmare image or projection of his own lynched body, his extended tongue a grotesque parody of the laughing face of the comic darky of the minstrel tradition." His thoughts seal his own doom. "Following Efrem's vision, the white mob chases him, clearly to realize his own grisly projection of their racist desires."

Micheaux's films can be vastly entertaining, but from his first picture to his last, he was always a message bearer, and his "preachment" here— promoting hard work and education, condemning servility and criminal behavior and racism—comes through loud and clear. Writing his films the way he wrote his books, he tossed in facts and information to support his ideas, and the intertitles of *Within Our Gates* are peppered with statistics. He never shied away from big issues, shrewdly portraying the land peonage system that replaced slave economics in the South (a system rigged in favor of plantation owners that victimized all poor people, including whites).

While Micheaux's choice of subject matter is generally given high marks by contemporary film critics, his cinematic skills are often faintly

ridiculed. That seems absurd, considering that he plied his craft as a true "independent filmmaker," long before that phrase became popularized. Hollywood contract directors had large staffs that assisted their every move, expert studio departments at their beck and call, and overall production budgets ranging from $350,000 to $600,000 in the 1920s (depending on the stars). Micheaux, in contrast, worked with ragtag crews and shoestring budgets, inventing as he went along. And yet, when his resources and his imagination were in alignment, he was capable of breathtaking cinematic effects, as in his films' frequently stunning climaxes.

Pearl Bowser and Louise Spence, in their invaluable study *Writing Himself into History: Oscar Micheaux, His Silent Films, and His Audiences,* have written conclusively about the lengthy backstory that forms Act Three of *Within Our Gates,* and the linked series of crescendos, building to a climax, in which the Boston schoolteacher's family is hunted and slain, and she herself is nearly raped. The white mob in the film is sprinkled with American tintypes, including "patrons from the local ice cream parlor, a boy on a bicycle with a baseball bat, a man in a butcher's apron, a woman in a gingham dress armed with a rifle," in Bowser and Spence's words. They congregate in an almost "festive, picnic-like atmosphere."

The black family temporarily eludes their white stalkers by hiding in a swamp. But the family is ferreted out, and the mob is transformed into a grotesque blur, with distorted camerawork that wouldn't be out of place in an early German Expressionist film. (Micheaux didn't restrict his moviegoing to Hollywood fare; later, in one of his 1940s novels, he confessed his admiration of the German masterworks that influenced all great filmmakers.)

The violence in *Within Our Gates* is depicted with a luridness and savagery rare in the American cinema. The youngest boy in the family is fired on as he tries to flee. The boy pretends to have been struck down; then, when the mob turns its back, he jumps on a horse, managing to ride to safety. The parents are surrounded by the bloodthirsty mob.

Preer has fled to a cabin, trapped by the vengeful brother of the dead white landowner. As Preer struggles with him, Micheaux returns to her family's lynching in progress, jumping between the two nightmares. "By crosscutting the defilement of the Black woman and the lynching of the Black male for reasons that have nothing to do with crimes against white women, Micheaux demystifies pervasive racist myths," wrote Bowser and Spence. "In this rape, it is the white man who is the sexual violator, not

the Negro; and the 'promiscuous Black female' is not a willing participant but vigorously fights back."

The bravura crosscutting continues, with the lynch mob stoking a wild bonfire in order to burn the bodies of their victims. From beginning to end, the flashback of *Within Our Gates* is meticulously crafted, densely packed with ideas, and furious with emotion. It is one of the most powerful sequences in Micheaux's body of work.

Not for the fainthearted. Still, if *Within Our Gates* disturbed some people, the film also found many appreciative viewers. "The picture is a quivering tongue of fire," a black schoolteacher wrote to the *Chicago Defender*, "the burn of which will be felt in the far distant years . . .

"The spirit of *Within Our Gates* is the spirit of [Frederick] Douglass, Nat Turner, [William Sanders] Scarborough and [W. E. B.] DuBois rolled into one, but telling the story of the wrongs of our people better than Douglass did in his speeches, more dramatically transcendent than DuBois in his *Souls of Black Folk* . . .

"*The Birth of a Nation* was written by oppressors to show that the oppressed were a burden and a drawback to the nation, that they had no real grievance, but on the other hand they were as roving lions, seeking whom they might devour. *Within Our Gates* is written by the oppressed and shows in a mild way the degree and kind of his oppression. That he is an asset to the nation in all phases of national life, aspiration and development. Nothing like it since *Uncle Tom's Cabin*."

One part of Micheaux's dream—making movies that might attract droves of white patrons, just as white readers had been drawn to his novels—already had begun to evaporate, right away with *The Homesteader*.

There is anecdotal evidence that some white people attended race pictures in mixed neighborhoods in big Northern cities, and even in a few theaters in the Deep South. But by and large, as even the earliest advertisements for *The Homesteader* conceded, "Negro productions such as this are restricted, as it were, to Negro theaters." Micheaux couldn't get his film into white theaters, and he couldn't get white people into black theaters.

Another part of the dream also died from the get-go. Micheaux, who had always mused about making big money, and whose screen stories more than once featured parvenu black millionaires, realized very quickly

that race pictures were not going to make him rich. A Hollywood direc-
tor of that era wouldn't have earned less than $750 a week, with some
salaries rising as high as $2,500 weekly. But Micheaux never made that
kind of money in a week—not *any* week. Privately he always referred to
his earnings as "little money," i.e., not Big Money.

Yet he had the optimism of the pioneering homesteader he had once
been: The seeds sown today would reap a bounty in the future, good
weather permitting. As long as there was cash flow, Micheaux wasn't one
to wring his hands. He knew how to stretch a dollar, and knew even bet-
ter how to stretch credit.

Publicly, he always wore the face of the optimist. Thus it was that,
early in 1920, amid mounting debt, he issued a press release for the
Micheaux Book and Film Company declaring the windfall success of *The
Homesteader* and *Within Our Gates*—and profits for investors. A meeting
of officers would convene in Sioux City, according to the release, to map
out a future agenda and offer additional stock shares at $100 each.
Micheaux also announced that he would publish a journal "of finish and
high aspiration" devoted to "race filmdom," called *The Brotherhood*.

Even as the ink was drying on the press release, however, newspapers
were reporting that the Micheaux company was on the verge of receiver-
ship. His budgets, measly in Hollywood terms, were astronomical for
race pictures. ("MOST COSTLY RACIAL FILM EVER MADE," the
advertising blared.) Revenue was slow to trickle in, and hard to separate
from operating expenses. Genuine profits were a figment of Micheaux's
imagination.

George P. Johnson, boasting of inside information from people in
Micheaux's employ, privately told the *Pittsburgh Courier* publisher
Robert L. Vann that the race-picture pioneer "has made nothing for him-
self, but wasted lots of money on production." *The Homesteader* had been
"produced at a loss," Johnson informed Vann, "but not near what his last
film is. *Within Our Gates* is a complete failure financially."

Johnson wrote on the same subject to Micheaux, not without feeling.
"I know and you know that you have paid dearly in cash, hard work, sac-
rifices, worries, to pull thru the two productions you have made," John-
son said. "The result[s], other than accomplishing a certain prestige for
Oscar Micheaux as a writer, playwright and a coming director, have not
been very encouraging, especially from a personal financial standpoint."

The worries and crises seemed constant. Having failed to lure Johnson

away from Omaha, Micheaux now decided that the only person he could trust to run business affairs in Chicago, while he was on the road, was a member of his own family. His youngest brother, Swan E. (for Emerson) Micheaux, was summoned from Great Bend, Kansas. Slender, curly-haired Swan, twenty-five years old (Oscar was thirty-six), went on the letterhead, initially, as "Secy & Treas" of the Micheaux Film Corporation ("Producers & Distributors of High Class Negro Feature Photoplays").

One way for Micheaux to generate more revenue would be to sell his pictures overseas, where the climate for race pictures was said to be more receptive than in some parts of America. So in the winter of 1919–1920 he left for an extended stay in New York, reportedly en route to Europe, according to newspaper items, where he intended to arrange foreign placements. Whether he himself traveled to any foreign countries is unclear (Micheaux was always "on his way to France" in letters to George Johnson, though he never actually seemed to depart). But the race-picture pioneer did disappear from sight in Chicago, for months over that winter.

Not until May, after "extensive traveling," was he spotted back in the city. During his absence Micheaux had written "a series of features," according to published reports, including—a departure from the controversial *Within Our Gates*—several comedies. The sudden flurry of press items said that Micheaux was already at work filming his next scenario, a boxing picture, and that *The Brute* would be ready for release by July.

Micheaux followed sports the way he followed show business, paying special attention to those athletes who might have been champions and record-holders, if professional sports were not as ruthlessly segregated, in that era, as Hollywood. Boxing was one of his passions; indeed, there is a persistent rumor, dating from the Rosebud years, that Micheaux sometimes donned gloves and took on challengers in a makeshift ring erected outside Ernest Jackson's home in Dallas, South Dakota.

Whatever the case, *The Brute* was partly an excuse for Micheaux to stage a lavish match between two luminaries of the sport, both of whom boasted connections to the legendary Jack Johnson. One was Marty Cutler, a solid fighter and sparring partner of Johnson's—though in this film, Cutler would play the white champion, pitted, in the climax, against a

black challenger played by heavyweight idol Sam Langford, Boston's "Tar Baby." Langford, who fought more than six hundred bouts in his twenty-two-year career (though he never won a major title), was Johnson's worst nemesis. Johnson narrowly defeated Langford in a fifteen-round decision in 1906; thereafter, Johnson rebuffed any suggestion of a rematch. Micheaux would gleefully bill Langford as "the man Jack Johnson refused to fight."

Micheaux would put comedy as well as plenty of action in his third film, though the core drama of *The Brute*—"the most interesting part of the tale," according to at least one critic of the time—followed the misfortunes of a naïve young woman who falls under the influence of a brutal underworld kingpin after her fiancé is lost at sea. The kingpin's specialties are abusing women and rigging prizefights.

Once again Evelyn Preer would play the vulnerable ingenue, with Lawrence Chenault as her "lost" fiancé (who is "found" in time to ensure a happy ending). Chenault had been a dramatic singer at the turn of the century before emerging as a crowd favorite with the Pekin Players in Chicago, and later, a heartthrob with the Lafayette Players in New York. Over time he'd become a stalwart for Micheaux—his most versatile lead, equally at ease in comic or serious roles, able to add age, play "white" (because of his relatively light complexion), villains, or, on rare occasions such as this one, the "ideal hero," as his fellow Micheaux player Shingzie Howard put it.

To portray "The Brute," the underworld boss of the story, Micheaux found another actor who would go on to become a regular in his films. Originally from the West Indies, A. B. DeComathiere was a stellar athlete (football and tennis), before he turned to acting and became a formidable character actor for the Lafayette Players and other troupes. The rest of the cast—including E. G. Tatum, Flo Clements, and Mattie Edwards—already amounted to Micheaux's informal stock company.

Undoubtedly, the highlight of the filming was the July 8, 1920, staged showdown between Cutler and Langford at the Royal Gardens on East Thirty-first Street. Micheaux promoted the event with advertisements in the *Chicago Defender,* throwing the fight open to public attendance and incorporating the hundreds who attended as free extras ("See Yourself in the Movies by Being a Spectator at the Ringside During This Mighty Battle").

Once again, the leading lady may have suffered almost as much as the pugilists. "In one scene," Evelyn Preer recalled, DeComathiere "was sup-

posed to hit me in the eye and knock me to the floor, and when I got up the eye was supposed to be black. I wanted this to be so realistic that I begged Mr. Comathiere to hit me.

"In the movies they usually play the violin to make you cry," Preer continued, "but after Mr. Comathiere hit me, I didn't need music, onions, or glycerin to bring tears. They were there whether they were wanted or not, and the eye was black, not just for an hour, not for just a day, but for *several* days."

For another scene—"one of Mr. Comathiere's best," recalled Preer—the strapping actor "chopped the door down with an ax and yanked me out and dragged me around by my hair. Another bright suggestion from me."

Micheaux productions never involved long schedules, but the boxing choreography and crowd scenes of *The Brute* took more time than usual. The filming lasted three weeks.

"I am expecting phenomenal business," Micheaux wrote to George P. Johnson afterward. "Not because I desire to appear boastful or egotistic, but if everybody who has seen it to date['s] opinion is worth anything—as a Negro picture, it is in a class by itself. It has some faults—none of us have as much money to make the best picture we might think up, as fine as it should be in technical detail, tho' this one is so much more elaborate than anything before.

"But the acting is so fine. To the Lafayette Players I owe this," the director added modestly. "They were able to carry out my direction as fine as I know how to give it to them."

For the August 1920 premiere of *The Brute*, the Langford-Cutler climax was reenacted with heavyweight Sam McVey (famous for lasting forty-nine brutal rounds in a 1909 Paris match) standing in for the absent Cutler. A reported ten thousand boxing fans attended the event in East Chicago, and the next day the film opened simultaneously at the Vendome in Chicago and the Vaudette in Detroit. *The Brute* sustained "a record breaking run" at the Vendome and other Chicago theaters, according to the press, and was seen by "thousands of people."

"There is a great prize fight," said the reviewer for the *Chicago Defender,* "and a world of comedy."

Making its way to other towns and cities, *The Brute* continued to "stack them out," in Swan Micheaux's terminology, that is, draw overflow crowds. "We opened in New York City and in Philadelphia, charging

from 30 to 55 cents," Swan claimed. "Our share in both cities [in the first week], was approximately $3,000.00." The company even manufactured extra prints, so a couple could stay in the East, while the rest circulated in the South.

The serious-minded Micheaux had proven he could also be hilarious; the "preachment" factor in *The Brute* was low-key, there was exciting boxing, and there were no lynchings.

The crowds were royally entertained by Micheaux's rousing action film; the critics, however, had reservations. Almost overnight, Micheaux the heralded pioneer became a magnet for criticism from anyone with a notion of the ideal race picture.

Though *The Brute* had been fashioned as an intentional break from more serious films like *Within Our Gates,* Micheaux's boxing spectacle stirred unexpected grumbling from prestigious figures in the black press who argued that every race picture should be decorous and uplifting in its depiction of black life. Echoing Micheaux's feuds with the Reverend McCracken, these generally big-city, middle-class critics cringed at the director's more realistic and unblinking vision of their shared heritage.

The well-known Lester A. Walton, an early associate of the Lafayette Players, praised *The Brute* in the *New York Age* as "a very creditable endeavor in many respects," conceding that the fight scene was "a genuine thriller." ("When Langford floors Cutler with a knockout wallop with his mighty right, my such a noise from the audience!") But Walton went on to rail against a story set in a sordid underworld that echoed "the attitude of the daily press, which magnifies our vices and minimizes our virtues." *

The national columnist Sylvester Russell, whose jottings appeared in several black newspapers, including the *Indianapolis Freeman,* the *Chicago Defender,* and the *Pittsburgh Courier,* also criticized the film's milieu: its many tavern scenes, the loose morals of its female characters, the pervasive cigarette smoking, and too-brutal violence. *The Brute* "was

* Walton, a pioneering critic of race pictures for the *New York Age* and *Amsterdam News,* had been a part-owner and manager of the Lafayette Theater at the time the Lafayette Players were organized, in 1916. Later, he was appointed Minister (Ambassador) to Liberia on behalf of the U.S. government, serving in that capacity from 1935 to 1946, before returning to journalism.

not elevating," lamented Russell, a one-time vaudeville performer and singer turned drama critic. "All of us well-reared people sighed. Some departed." (As one dubious alternative, Russell urged Micheaux to feature more "unadulterated blackface comedians," which, in fact, he later often did.)

To Micheaux, however, publicity was good, and controversy was extra publicity free of charge. In these early years of his career, praise and criticism alike seemed to roll off Micheaux's back. He had an inner compass and fierce creative momentum.

At the same time, Micheaux was shrewd about critics, and if they talked like censors he treated them like censors. He sought out Sylvester Russell, for example, smiled and shook the enemy's hand, and then launched into a heated argument with the columnist. He sought out his critics often this way during the 1920s, and though he didn't always win them over, his sincerity and conviction gave them pause.

From all accounts, *The Brute* survived reviewers' quibbles. It proved among the most remunerative of Micheaux's early pictures, with repeat bookings into the mid-1920s. As the prints circulated, their number and quality dwindled, and today *The Brute* is another "lost" film, lodged along with *The Homesteader* atop the wish list of Micheaux films scholars hope will one day be rediscovered in an attic—however unlikely that may seem.

By the time *The Brute* had its premiere, in the waning summer of 1920, Micheaux had finalized a difficult decision, one that he had been considering for some time and had come to see as necessary and inevitable. During his long sojourn East (supposedly en route to Europe) earlier in the year, the race-picture producer had quietly laid the groundwork for a big change: He would move his home and central office to New York City—to Harlem.

"I like Chicago," Sidney Wyeth, his recurring alter ego, says in one Micheaux novel. "Like it better than I do New York." But in the same breath Wyeth goes on to concede that "New York is a freer city for Negroes to live in now."

The 1919 riots probably crystallized Micheaux's decision. At the turn of the century, when Micheaux first arrived in Chicago, the Black Belt had seemed alluring to slavery's descendants. But when black soldiers re-

turned from World War I, expecting to be rewarded for their sacrifices, they found pervasive unemployment and a deepening gulf between the races. More ex-Southerners arrived all the time, spreading across the South Side, truly blackening the belt. Rents soared and firebombings greeted newcomers to formerly predominantly white neighborhoods.

For Micheaux, there was another constant irritant: Chicago's provincial censorship board. Micheaux anticipated more leeway in New York. Chicago's days as a hub of motion picture-making were over; its once-premium studios now stood empty or in disrepair. There were first-class production facilities and experienced personnel in New York, and in nearby Fort Lee, New Jersey, where Micheaux had toured the studios and felt welcomed.

Harlem was the new mecca, the new capital of Black America. There was a general feeling among black Americans that New York might succeed where Chicago had failed. In his contemporary book *Negro Life in New York's Harlem,* the African-American writer Wallace Thurman compared the two: "As the great south side black belt of Chicago spreads and smells with the same industrial clumsiness and stock yardish vigor of Chicago," Thurman wrote, "so does the black belt of New York teem and rhyme with the cosmopolitan crosscurrents of the world's greatest city." Clumsy, smelly Chicago was the hope of yesteryear. Harlem, the cosmopolitan black belt of New York, augured the freedom of tomorrow, "a dream city pregnant with wide-awake realities," in Thurman's words.

And by the year 1928, Harlem would have a population of two hundred thousand black people, all of them potential paying customers for a dreamer named Oscar Micheaux. He could reincorporate in Delaware, drawing fresh investors from the many other black belts that were strung along the eastern seaboard. He'd have close proximity to Washington, D.C., Baltimore, Philadelphia, and Pittsburgh, which had proven crucial markets for his pictures.

He publicly announced that he was transferring his headquarters to New York. Not that he would ever leave Chicago entirely behind: Apart from its value as a center of distribution to the Midwest—and his close contacts at the *Chicago Defender,* which for years he would continue to use as a launchpad for national publicity—Chicago was the city Micheaux knew best. It would endure as a symbol and setting in his films and books. He'd visit regularly, keep up with acquaintances, and shoot all or parts of many future films in Chicago.

"The better studio possibilities, together with the fact that the screen artists of the race are available in greater numbers in the big city, and disinclined to leave, has prompted the Micheaux Film Corporation to make their future productions in the vicinity of New York," the official press release announced.

Putting his younger brother Swan in charge of his reduced Chicago operations, Micheaux left for New York in September. Along the way he planned to stop off in Cleveland to meet with the well-known author Charles W. Chesnutt, with whom he had corresponded, hoping to acquire the screen rights to some of Chesnutt's stories and novels. While en route Micheaux also intended to finish the script for his fourth film, which he was calling "The Wilderness Trail."

"The Wilderness Trail" would be, in part, a return to "preachment"— tempting more censorship and controversy. Just as Micheaux couldn't stop himself from arguing politics with the Reverend McCracken, he couldn't refrain from writing "strong stories" about home truths. So he would weave another lynch mob into his latest scenario, and would offer bad as well as good role models for the race. But Micheaux was always experimenting, changing the proportions of his ingredients, and as he became a more nuanced and capable filmmaker, he tried different recipes. This time the "preachment" would be heavily leavened with humor and sentiment.

Micheaux's script concerned yet another "colored homesteader" who falls in love with a female settler whom he believes to be white, but who turns out to be a member of his own race. Again and again in his books and films Micheaux relived his rupture with the Scottish blonde maiden on the Rosebud, trying to find, in fiction, an idealized solution to the real-life failure that still haunted him. "He probably regretted that decision all his life," observed Micheaux scholar J. Ronald Green, "and undoubtedly there is an element of obsession in his repeated plots in which the perennial object of his desire is finally obtained because of a dramatic reversal of her race."

This time, however, the Scottish girl was a "beautiful quadroon" named Eve, who is aware of her racial identity. Living in Selma, Alabama at the beginning of Micheaux's story, Eve learns that her grandfather, a

Negro prospector, has died and left her a claim to a homestead in the Northwest. She travels to "Oristown" (a pseudonym for Bonesteel, South Dakota, that Micheaux first used in *The Conquest*) to lay claim to the land.

Arriving in Oristown, Eve attempts to check into a hotel. The clerk is "a Negro but masquerading as white," according to published synopses, who loathes his own race. In his youth the clerk had tried to carry off a romance with a white woman, until one day his mother accidentally interrupted their embrace. His mother's darker skin revealed the clerk's true identity, and the romance was ruined. (In a flashback, he throttles his own mother over the incident.)

Though Eve is light-skinned, her eyes "betray her origins" to the clerk, and he refuses to give her a regular room, instead showing her to a barn. That night, a great storm wells up, and Eve becomes afraid and rushes outside the barn. Tossed about by Micheaux's customary excesses of wind and rain, she stumbles around the wilderness, lost and hungry, until Hugh Van Allen, a black homesteader with a nearby farm, rescues her.

Van Allen is one of Micheaux's paragons. Goodhearted and hardworking, he grows fond of Eve, but their love goes unrequited; they share an interracial tension similar to that which tortured Jean Baptiste and Agnes in *The Homesteader*. And it's just as misleading because Eve's fair skin has convinced Van Allen that Eve is a white woman, yet Eve doesn't realize her neighbor has this mistaken impression.

Van Allen becomes a target of the hotel clerk's enmity. After learning that Van Allen's land contains oil, the clerk conspires with other ne'er-do-wells to scare the colored homesteader off his property. Micheaux ridicules the purity of the Ku Klux Klan with these hatemongers—one a horse-thief "Indian Fakir" wearing a fez, another a former British clergyman turned swindler; two cowboys, one white and the other a half-breed Indian; and their leader, the Negro hotel clerk "masquerading as white." This motley group rides forth at midnight, wearing white robes and carrying torches, calling themselves a brigade of the "Knights of the Black Cross."

Their attempt to lynch the colored homesteader is foiled by Eve and other settlers who ride to Van Allen's rescue. Oil is discovered; Van Allen becomes a millionaire. In time he is visited by Eve, who is collecting for a Committee for the Defense of the Colored Race. Until this moment, Van Allen had "never dared to declare his love" for Eve, "for fear of being

scornfully rejected." Now, he realizes that she is "of his own blood." Now, the couple is free to love and marry.

As it went before the cameras, Micheaux gave his final script a strong title: *The Symbol of the Unconquered.*

To play Eve, the light-skinned heroine, Micheaux returned to Iris Hall, who had played one of the leads in *The Homesteader*. As Hugh Van Allen he cast tall, firm-jawed Walker Thompson. A former vaudeville performer based in Chicago, Thompson had graduated to the Lafayette Players, where he was amusing in comedies and sensational in dramas like *The Divorce Question*, in which he had played a dope fiend.* Lawrence Chenault was back as Jefferson Driscoll, the sinister clerk "passing" for white. Chenault's mother would be Mattie Wilkes, who had toured as a soprano in the United States before joining the Lafayette Players. Leigh Whipper and Louis Dean were the horse thief and swindler.

This was the first film Micheaux produced in the East. He shot the interiors in Fort Lee, where there were fully operational studios that dated back before 1910. One of the first centers of motion picture production, the Fort Lee complex had been abandoned by the major companies when the industry moved to California, but it was still humming with activity. Besides being close to New York City, the Fort Lee terrain boasted a topography that served nearly every cinematic purpose, from seaside cliffs to tall cornfields to stand-in prairies. Indeed, some of the first American Westerns had been filmed in the Fort Lee area.

The "wilderness" of New Jersey was sufficient for Micheaux's purposes in *The Symbol of the Unconquered*, which was filmed at a gallop and wrapped up entirely before Christmas. And then, because Micheaux had yet to forge strong relationships with the New York press and theater-owners, his fourth feature film was sent back to Chicago for its premiere.

And there, as before, it faced its first attempts at suppression.

Once again, Micheaux's central motif was "passing," and the sexual tension that transpires between a man and a woman of seemingly different races torn by their love for each other. Even when both lovers turn out

* Shortly after filming *Symbol of the Unconquered*, Thompson suffered an illness which caused his death in 1922, at age 34.

to be "black," the mainspring behind such stories was offensive to censors—not to mention the powerful subtextual idea, which is present in nearly every Micheaux book and film, that racial categorization was unjust and indeterminate.

The Chicago authorities wouldn't condone any *hint* of racial intermingling. Among the cuts they demanded in Micheaux's film:

"Subtitle Reel II—ending: 'That they had often lynched his kind for a smaller offense . . . talking to a white girl on the street.'"

"Cut all views of colored man holding girl's hand in [love] scenes."

"Reel 4: All scenes of Englishman looking at colored girl 'strongly desirous . . .'"

No director fought censorship as stubbornly as Oscar Micheaux, though he lost as often as he won. The many deletions the censors demanded, and the limited number of prints he authorized of each film, means that "of the Micheaux films that have survived," in the words of scholar Arthur Knight, "it is unclear how near they are to Micheaux's authorial and directorial intentions, how close they are to his original films, or most importantly, how exactly they relate to what any audiences saw and heard." As Micheaux expert Jane Gaines also noted, contemporary reviews of his pictures often described "a film dramatically different from the one that has survived," with different scenes, characters, and so on. In other words, no surviving Micheaux film exists as he originally intended it to be viewed.

The sole remaining print of *The Symbol of the Unconquered* was rescued from the Cinémathèque Royale in Belgium, and it contains French and Flemish intertitles. (Micheaux scholar Charles Musser has translated the intertitles back into English.) Parts of the film are clearly altered from the original. Though clearly fragmentary—the much-censored subplot of an Englishman married to a "colored woman," for instance, is gone—even in its compromised Belgian version, *Unconquered* is a significant work, showcasing a mature panoply of technique: irises, superimpositions, mirrored shots, parallel editing, and subjective point of view.

The attempted lynching sequence was the censors' main target, and it survives merely in shards. Yet even the truncated version evinces a thrilling blend of German Expressionist–influenced lighting and camera-

work, with an editing style that anticipates rapid-fire Soviet montage. Micheaux was seeing all the latest foreign as well as Hollywood films in New York, and he was up-to-date on the most avant-garde techniques. Amid a darkness made eerie by blazing torches and swirling smoke, the faux-Klan "night riders" of *The Symbol of the Unconquered* gallop to their failed mission in a flurry of grotesque close-ups of cutout eyes, set deeply in hoods.

Within Our Gates had been a traumatic slice of too-real history. But in *The Symbol of the Unconquered,* Micheaux saw to it that his "night riders" were satirized and vanquished. The film was marked throughout by sweetness and humor, and even the advertisements promised an uplifting experience for black audiences. ("See the Ku Klux Klan in Action and Their Annihilation!") Critics and audiences preferred this adjusted mix of realism and entertainment: *Pittsburgh Courier* publisher Robert L. Vann was among the many who hailed Micheaux's fourth film as "a stirring tale of love and adventure," with "impressive lessons on the folly of color" throughout the story.

If Oscar Micheaux had stopped there—after *The Homesteader, The Brute, Within Our Gates,* and *The Symbol of the Unconquered*—he would still have earned his place as a stellar figure in American film. In two years he had gone from regional curiosity as a self-published novelist to national standard-bearer in the world of race pictures—writing, directing, and producing four remarkable films against tremendous odds in a brief span of time.

One of his new friends was Nahum David Brascher, editor-in-chief of the Associated Negro Press, whose offices were in the same building as Micheaux's. Brascher invited him to speak to the organization's conference in Chicago in early 1921. "Moving picures have become one of the greatest revitalizing forces in race adjustment," Micheaux told the national gathering of black journalists and editors, many of whom he already knew on a first-name basis, "and we are just beginning."

CHAPTER TEN

1921–1922
HARLEM AND
ROANOKE

The great migration of Southern blacks, along with a steady flow of arrivals from the Caribbean, tripled the number of "colored people" in New York State between 1890 and 1910, and the total accelerated dramatically after World War I. The vast majority came to New York City, whose black inhabitants, by 1920, finally outnumbered those of Washington, D.C., long in first place; Philadelphia was now ranked second, Chicago fourth. Though they found homes in every borough, colored New Yorkers increasingly packed into a section of uptown Manhattan that was previously dominated by white European immigrants, many of Jewish background. This neighborhood was known by the name of the channel connecting the Hudson and East rivers: Harlem.

By 1920, "Eighth Avenue cleanly severed black from white," as David Levering Lewis observed in his social chronicle *When Harlem Was in Vogue*. "From Eighth to the Hudson River few Afro-Americans were to be found. East of Eighth to the Harlem River, from 130th to 145th Street, lay black Harlem." Estimates of the number of black residents ran anywhere from 75,000 to 100,000, and rising. More than a Black Belt, Harlem was a city within a city, "the largest, most exciting urban community in Afro-America," in Lewis's words. Invisibly walled off from the rest of New York by racist barriers, Harlem had a personality and character like no other part of America. It may have had more than its share of misery, but for people of color (as well as for the color-blind), it was the epicenter of the new world.

The Jamaican-born American poet Claude McKay rhapsodized about Harlem in his 1928 novel *Home to Harlem*: "The deep-dyed color, the thickness, the closeness of it." The district's "semi-underworld" was a wonderland of sound and music: "The noises of Harlem. The sugared laughter. The honey-talk on its streets. And all night long, ragtime and 'blues' playing somewhere . . . singing somewhere, dancing somewhere!"

In early 1921, Micheaux leased an apartment on West 135th Street, opened an office in the small Franklin Theatre nearby on Lenox Avenue, and engaged a secretary. Micheaux had befriended Ira McGowan, George P. Johnson's brother-in-law, helping him out with small loans and bringing him along in the business. Now McGowan became his "utility man" in the New York office and paymaster for the eastern states. And Micheaux hired a traveling partner, John Wade, who'd be his Man Friday on the road, booking and collecting.

The Lincoln Theatre, on 135th and Lenox, was the original home of the Anita Bush Players and still a prime showcase for black performers. A few blocks away, on 131st Street and Seventh Avenue, was Harlem's biggest theater, the 2,000–seat Lafayette, host to the Lafayette Players. In late 1921, Connie's Inn, a basement cabaret destined to rival the more upscale Cotton Club, opened up next door to the Lafayette. (In the early 1920s, "colored customers" were still barred from attending the all-black floor shows at Connie's and the other fanciest Harlem nightclubs, which prided themselves on their white high-society clientele.)

Marcus Garvey's Universal Negro Improvement Association was also on 135th Street, and over on 133rd, between Lenox and Seventh, was the famed "Jungle Alley" of popular bars, nightclubs, restaurants, cabarets, and speakeasies.

With its ambitious length, unusual story, artistic reach, and overall accomplishment, *The Homesteader* had inspired other race-picture producers; indeed, it spawned a movement. All over America, new race-picture companies sprang into existence, trying to imitate the film's success, which most assumed was financial as well as artistic. Micheaux's public optimism left the impression that there was easy gold to be mined in race pictures. And the "gold rush" year for race-picture production was 1920, according to film historians Matthew Bernstein and Dana F. White.

In Jacksonville, Florida, a white Southerner, Richard E. Norman, began to specialize in "all-colored" pictures; his Norman Film Manufacturing Concern would grow to dominate the Southeastern market. Norman's wildly popular first film, *The Green-Eyed Monster,* played in theaters for years after its initial release in 1920; then Norman launched a cowboy series starring the "world's colored champion," Bill Pickett. Norman usually photographed and edited his films, but didn't always direct them. In spite of modest budgets, the Norman films were well-made *(The Green-Eyed Monster* climaxed with a spectacular train wreck), though "by no means a comparison to Micheaux pictures in class or acting or direction," in George P. Johnson's words.

A white New Yorker named Robert Levy also swung over to race pictures. A founder of the Lafayette Players, Levy organized Reol Productions in late 1920. Reol went head to head with Micheaux on challenging subjects as well as casting. Lawrence Chenault would star in the highminded *The Burden of Race,* Reol's first film, in 1921. (The work doubled and tripled for former Lafayette Players in these years; the congenial and versatile Chenault, for example, would continue to act in Micheaux's films, while also becoming a regular for Reol and Norman.)

And there were others: The Maurice Film Company in Philadelphia, the Royal Gardens Film Company in Chicago, and fly-by-night companies in many other cities took flight, some barely getting off the ground, plummeting after one or two films. Even the Lincoln Motion Picture Company had a last gasp of vehicles starring Clarence Brooks.

This parade of imitators wasn't lost on Micheaux. It rankled him that some of the Johnny-come-lately producers were white men—including "some Jews," in his words, people like Levy and the owners of the Colored Players Film Corporation of Philadelphia. In 1926, the Colored Players produced a thoughtful drama called *A Prince of His Race;* the film was hailed by some as a masterpiece, but Micheaux sniffed at it. *A Prince of His Race* "appears to draw [audiences] very well, although mighty badly acted and poorly photographed," he wrote to Richard E. Norman.*

Micheaux did enjoy *The Green-Eyed Monster,* though, and saw

* This letter, incidentally, went on to demonstrate Micheaux's technical know-how, deriding the camerawork of *A Prince of His Race* as inferior and attributing the inferiority "to the use of some Cooper-Hewitt banks alternating current[s] which flicker alternately through all the interiors and refuse to permit a fade-out with any degree of smoothness at all."

Norman as a man not unlike himself. Even though he was a white man, Norman wasn't a dilettante mining for gold. He was devoted to race pictures, a man who wrote, photographed, edited, and directed his own films when necessary. And he wasn't Jewish.

The Jewish producers, complained Micheaux, didn't understand the nuances of black life. Worse yet, they booked their films into all the wrong theaters. "We could help them a great deal," Micheaux wrote, "but since they seem to think they know it all, and regard all of us who have endured through the years gone by as dubbs, and know nothing[s], I am letting them find out for themselves the things we have learned from experience."

Jewish or not, most of the new race-picture producers were frankly commercial (so was Richard E. Norman, for that matter). Micheaux's aesthetic motivations, on the other hand, were different: He made films in large part to hold a mirror up to his race, for better and for worse.

Micheaux had to keep up his reputation in that regard, and to that end he was in the midst of negotiations with an elder statesman of race realism, Charles W. Chesnutt. Regarded today as a major figure of early African-American fiction, Chesnutt was an author Micheaux could admire, "a mature gentleman with a keen sense of literary art," in Micheaux's words. When the director first met with Chesnutt in Cleveland in late 1920, it was to discuss Chesnutt's first book, a short story collection called *The Conjure Woman* from 1900. Having read *The Conjure Woman*, Micheaux thought it might make a good film.

In the course of conversation, though, Chesnutt brought up his first and most famous novel, 1901's *The House Behind the Cedars*. After hearing the author rhapsodize about *Cedars*—his most successful book—Micheaux read the novel himself, and soon decided it would make the better film. Not unlike *The Homesteader,* it was a story about the tragic impossibility of interracial romance, a theme that couldn't help but resonate with Micheaux.

Arguably the greatest of all "passing" novels, *The House Behind the Cedars* concerned Rena Walden, a beautiful "bright mulatto" in North Carolina, whose brother has changed his name and moved away from his family in order to "pass" as white among genteel society. Years after becoming prosperous and successful, the brother returns home to invite Rena into his life. She agrees to join him in his new home elsewhere in South Carolina, "passing" herself to take care of his young child. While

there she meets a white aristocrat, who falls in love with her. When events reveal her secret, her life—and the lives of her friends and family—is wrecked.

Chesnutt himself was a light-skinned black man, as much a "bright mulatto" as Rena, so the character was of "mine own people," as he once put it. "Like myself, she was a white person with an attenuated streak of dark blood, from the disadvantages of which she tried in vain to escape, while I never did," the author wrote. Meeting Chesnutt, Micheaux was reminded of the heroes of his own films: though categorized and stigmatized by racism, the author had rejected falseness and pity and lived an honest, honorable life.

Like many of Chesnutt's other works, *The House Behind the Cedars* was set in the fictional town of "Patesville," a substitute for Fayetteville, North Carolina, where he had grown up. Rena's mother in the story is the mistress of a white man, and her character was patterned after Chesnutt's own paternal grandmother, who bore children from a similar interracial liaison. Thus *The House Behind the Cedars* was not only his most widely read book, but "my favorite child," in his words, in some ways a quasi-autobiographical story (another echo of *The Homesteader*). Chesnutt longed to see the story filmed, but filmed properly.

Micheaux was eager to oblige. He wrote to Chesnutt from Harlem, offering five hundred dollars—for him a stratospheric sum—for the screen rights. But he could only promise a mere twenty-five dollars as down payment. The offer was disappointing to Chesnutt, who knew that even five hundred dollars was a pittance compared to what Hollywood could afford to pay for well-known books. (Just a few years later, for example, producer Sam Goldwyn would pay $125,000 for the screen rights to Harold Bell Wright's *The Winning of Barbara Worth*.) Still, Micheaux was persuasive, and Chesnutt was convinced, first in person and then in correspondence.

From the outset of the lively correspondence that ensued between the two men, Micheaux warned Chesnutt that his film version would inevitably tinker with the novel. "Any story that deals with the relation between these two races in the manner as portrayed in this book is, to say the least, a very delicate subject," Micheaux said in a January 18, 1921, letter. All changes would be "necessary changes that I consider practical."

There were obvious as well as subtle differences between literature and film, Micheaux explained, setting Chesnutt up for changes in much the

same way the Johnson brothers had tried warning him just two years earlier. The word "nigger," for example, was conspicuous in Chesnutt's novel. It was also prevalent in Micheaux's pictures, part and parcel of his populist approach. But the word had encountered censorship, and Micheaux had heard the critical caveats. Since "in the last few years, the Negro race has risen almost in a unit against the use of the word nigger, coon, darky, etc.," Micheaux told Chesnutt, the dialogue or intertitles would minimize such language, which otherwise was natural in a story set in post-Civil War North Carolina.

"Understand me, for being a writer myself," he averred, "I find that being compelled to abstain from the use of these words, a very great deal of originality is lost in portraying the lives of the race to which we belong.

"But public sentiment is stronger than even originality, and, regardless of how much I may object to having or using a word which everyone know[s] would likely be used in a conversation or a controversy, the Negroes of this country will not stand for any of these words flashed on the screen. Of course," Micheaux added tactfully, "I am aware that twenty years have elapsed since the writing of this story and no way seek to criticize it."

From his earliest letters, Micheaux demonstrated how his thoughts raced ahead of his actual writing of the script. Micheaux suggested to Chesnutt that he might begin the screen version of *The House Behind the Cedars* with a chapter drawn from the middle of the novel, an extended flashback that reveals Rena's mother as the mistress of a "rich and liberal" white protector, whose paternity accounts for her light-skinned brood. The film ought to open with that backstory, Micheaux said, and then proceed chronologically. "This is a very strong start," Micheaux explained. "Fading out at this point, a title reading 'Ten years later' would bring us to where the story now starts. From there on I find parts that you have described in places only mildly that I would intensify very greatly, while other more carefully drawn out I would in many instances be compelled to omit or change altogether."

Many of Micheaux's suggestions had less to do with what was realistic than with what was financially "practical," he admitted. While Chesnutt's novel had Rena meet her white beau at a gala racetrack occasion, such a scene "would require a great many people dressed in costumes of that period, which would entail an expense so large that the limited amount of

returns which we can look forward to would not justify [the outlay]," he wrote.

Even as it stood, the bulk of Chesnutt's story took place "shortly after the Civil War," Micheaux noted, and the production "will require such minute detailing to avoid the camera catching some modern incident." In general, the filmmaker warned Chesnutt that he would try to avoid elaborate crowd and street setups in bringing his story to the scene.

But in these earliest letters to Chesnutt, Micheaux was also thinking about story elements that had nothing to do with reality or budget. In the 1950s, the French cinephiles of *Cahiers du Cinéma* and *Positif* would break critical ground by anointing a number of American directors who "wrote with the camera," regardless of whether they wrote the actual scripts of their films, hailing these pantheon directors as the "auteurs," or true authors of their bodies of work. In this way, too, Micheaux was a pioneer, an auteur before the term was coined. He always wrote as well as directed his films. He consistently drew on stories from his own life, of course, but he also "personalized" other people's stories with his ideas.

Though he insisted that he loved everything about Chesnutt's story, Micheaux suggested that one of its characters could be enhanced in such a way that would enable Micheaux to turn a relentlessly grim drama, concluding with Rena's death, into a story with a rosier ending. Rena didn't have to die, he proposed; she could revive and marry a man of her own race. Micheaux zeroed in on one of Chesnutt's secondary characters, a hardworking black man named Frank who grows up across the street from Rena and stays her loyal friend through life. In Chesnutt's novel, the goodhearted Frank can only tell Rena that he loves her, on her deathbed. Micheaux wanted to "improve" the humble character, gradually transforming him into someone audiences would accept as Rena's soulmate. "I would make the man Frank more intelligent at least towards the end of the story," Micheaux suggested, "permitting him to study and improve himself, for using the language as he does in the story he would not in any way be obvious as a lover."

Despite the "wonderful version" of a tragic ending Chesnutt had devised for his novel, such an unhappy ending was wrong for a Micheaux film, he said. The race-picture pioneer was always mindful about possible viewers' reactions; it was a cornerstone of his philosophy to be at one with his audience. Explaining how he wished to please the "colored people

whom we must depend upon as a bulwark for our business," Micheaux said he always tried to "visualize just how they would leave the theatre after the close of a performance."

The way to fix the story, Micheaux advised Chesnutt, would be to make Frank "stronger, and while good as he is portrayed, unselfish and devoted, but in the meantime for permit him to have become sufficiently intelligent, such a reasonably courageous fellow, that during Rena's illness she would be able to see and appreciate in him the wonderful man he really was, and to have her heart go out to him in the end, as his reward."

Micheaux said he was "sure" this changed ending would send "our people" streaming "out of the theater with this story lingering in their minds, with a feeling that all good must triumph in the end," which was preferable to the audiences' "gloomy muttering and a possible knocking with their invisible hammers." Besides, wrote Micheaux, it was his experience that an upbeat finale "would result much more profitably from a financial point of view."

Everything Micheaux proposed met with Chesnutt's approval. And even if Micheaux's five hundred dollars didn't excite the author, he realized that it was "better than nothing"—that is, he had no other bids. Yet Chesnutt's publisher, Houghton Mifflin, urged him to ask for one hundred dollars upfront, not the paltry twenty-five.

So Chesnutt wrote to inform Micheaux that he could have *The House Behind the Cedars* if he could afford to pay one hundred dollars as the first of five installment payments. He had been encouraged by his meetings with Micheaux and by his letters, but it was the quality of his films that really won him over. "I have no doubt that you will make it an interesting and credible picture," Chesnutt wrote. "That you can do so I am well aware, from the specimen of your work that I saw in Cleveland several months ago." *

Corresponding with his publisher, Chesnutt showed himself to be the model of an accommodating author. He fully expected Micheaux to "chop" his favorite book up "more or less, and probably change the em-

* Though, in this letter, Chesnutt does not specify which Micheaux picture he saw, it must have been *Within Our Gates* or *The Brute.*

phasis on certain characters," he wrote, but "this is no more than the usual fate of a novel which is filmed," in Chesnutt's words. Besides, he added, "I have seen one of the films produced by this company, and it wasn't at all bad."

A jubilant Micheaux wrote back to say he would strike the first check promptly after the contract was formally worded and mutually signed. In the first flush of their new partnership, he urged Chesnutt to consider writing original screen stories for other Micheaux productions. He said he'd eagerly pay him for "at least four."

"It is not, when writing directly for the screen, necessary to write a long book," Micheaux explained, giving insight into his filmmaking regimen during the silent era, "synopsis being sufficient. I find that mine approximate 8,000 to 15,000 words, a detailed synopsis setting forth a concrete tho't from which I can make an adaptation."

A concise descriptive synopsis with dialogue highlights was preferable to a novel-length manuscript that might "run to conversation," Micheaux warned. "Bear this in mind if you decide to write more stories for us—description and not such much conversation, plenty of action, intensity, and strong counterplot . . .

"Write of the things you have known more intimately. I like stories of the South—strange murder cases, mystery with dynamic climaxes—but avoid race conflict," i.e., conflict between black and white people, "as much as possible, which does not mean that I want stories 'all colored'— I do not. I desire them as the races live in relation to each other in every day life."

Micheaux said he expected to get right to work on *The House Behind the Cedars.* He hoped the script would come easily and the film version of Chesnutt's novel might rush before the cameras by May or June 1921.

But the hundred-dollar pledge to Charles W. Chesnutt was another figment of Micheaux's imagination. He didn't have the money to spare. Stalling Chesnutt, the filmmaker returned to his own voluminous story file, and pulled out a "strange murder story," set in the South, on a theme that would come to preoccupy him as obsessively as the subject of "passing."

The Leo Frank case involved a sensational crime, a Negro versus a Jew

in the courtroom, and a lynching. Micheaux had first delved into the case in his novel *The Forged Note,* making a study of the trial in Atlanta; and he was not the only person, especially in black America, who believed the Negro in the case might have told the truth, and the Jew was the actual killer.

He tended to impugn Frank in his books, embracing the prosecution's inference that Frank was a "sexual pervert" who disliked ordinary love-making and was therefore compelled to rape or sodomize his victim after killing her. But his films about the case were more searching and enlightened: Though the Negro was always innocent in his on-screen versions of the story, the Jew wasn't necessarily guilty either. Instead, Micheaux suggested that a third, unsuspected party might be culpable.

It appears from press accounts that Micheaux began working on a scenario about the Frank case on his first swing through the South in 1919, promoting *The Homesteader.* At that time, the working title was "Circumstantial Evidence." Although the names and places would be changed when Micheaux switched the setting from Atlanta to New York, there was no question as to the antecedents. In early drafts the victim's name was Little Mary, as in Phagan; later, it would be changed to Myrtle Gunsaulus, giving the film its final, unwieldy title, *The Gunsaulus Mystery.* ("I like odd and peculiar names," the Sidney Wyeth character says in the sound remake of *The Gunsaulus Mystery—Lem Hawkins' Confession—*as though alluding to its predecessor.)

Micheaux boldly inserted himself into the story, writing his *Forged Note* alter ego Sidney Wyeth into the script as a West Indian selling his novel door to door, in order to finance his law degree. Wyeth is captivated by a woman who buys his book, but they are separated by a misunderstanding.

Some time later, Wyeth, now a successful attorney, is drawn into a peculiar homicide and forced to investigate the crime himself to dig out the true facts. Wyeth thus becomes the first "race detective" in film; indeed, most of literature lagged behind.* Like many of Micheaux's innovations, this idea sprang from his own experience: Wyeth, the first of many black gumshoes and undercover agents in his films, was a melding of his Wyeth

* In 1921, "race detectives" existed only in short stories and magazine fiction. Scholars generally pinpoint Rudolph Fisher's *The Conjure Man,* published in 1932, as the first black detective novel written by a black American.

persona with the two mixed-race operatives he counted, in *The Forged Note,* as part of Leo Frank's defense team.

Wyeth agrees to defend the chief suspect in the sordid murder of a female factory worker. As in the actual Frank case, the initial suspect is a night watchman, in this instance, the brother of the woman from Wyeth's past. Reunited, Wyeth and the woman team up as sleuths. Their detective work shifts suspicion to a Negro janitor, who, after being arrested, implicates the factory superintendent.

Micheaux shot *The Gunsaulus Mystery* in the New York area in early 1921. E. G. Tatum played the night watchman; Louis DeBulger was Lem Hawkins, the Negro janitor (the James Conley figure); and Evelyn Preer played the sister quietly in love with the author, lawyer, and "race detective" played by Ed "Dick" Abrams, a well-regarded lead for the Lafayette Players. Lawrence Chenault, with his relatively light complexion, played the sleazy white factory boss.

The seven-reel drama was ready for Micheaux's first Harlem premiere at the Lafayette Theatre in April 1921, and by all indications the film was a crowd- and critic-pleaser. The *New York Age* reported that *The Gunsaulus Mystery* "holds the interest of the audience from start to finish . . . [and] is one of the best pictures the Micheaux Film Corporation has produced." Other black newspapers agreed, praising the suspenseful handling of the plot while noting Micheaux had also managed to sneak in uproarious "bits of comedy."

Micheaux heavily promoted the film's parallels to the Frank case. "The evidence shows that Leo Frank committed the crime and got a COLORED MAN to help him dispose of the body," read a 1921 advertisement in the *Chicago Whip*, "And then tried to blame the crime on the COLORED MAN." But the marketing avoided the word "Jew," and the factory boss in the 1921 film (and its remake) bore the WASPish name of "Brisbane."

Scholars have differed over Micheaux's attitude toward Jews. Betti Carol VanEpps-Taylor argued that some of Micheaux's "public remarks and some of the language in his later novels reflect a bitter anti-Semitism that he always denied." Film scholar J. Ronald Green, who has analyzed Micheaux's Jewish fixation, conceded that the race-picture producer was capable of "ethnically prejudicial observations" in his work, but insisted that Micheaux always stopped short of outright anti-Semitism. And believing in the ultimate innocence of the Negro in the Leo Frank case was

entirely consistent with Micheaux's lifelong stance against the racial pro-
filing of black people and other travesties of the legal system. He was
against wrongful accusation, lynchings, or corporal punishment, for Jews
and Negroes alike.

In Atlanta, where feelings about the case were still raw, *The Gunsaulus
Mystery* wouldn't find a booking until 1923. But officials there didn't
need to parse the characters' names or hear the word "Jew" to recognize
the picture's origins in the Frank case.

Characteristically, Micheaux managed to skirt the three-person (all-
white) censorship committee and screen his movie initially at a black the-
ater on Decatur Street in Atlanta. He was busy advertising a second
opening, on West Mitchell, when a police sergeant, acting on "several
complaints," hauled the print before censors. They promptly ascertained
that Micheaux had peppered his roman à clef with "many identical de-
tails" of the Frank case. The Atlanta censors unanimously condemned
The Gunsaulus Mystery, ordering Micheaux's film "shipped out of the
city"—an action so drastic, according to film scholar Matthew Bernstein,
that it rated mention in the local white press.

One can only speculate on the merits of *The Gunsaulus Mystery,* how-
ever, because Micheaux's fifth film is another "lost" work. Charles W.
Chesnutt was one of those who saw it, however; and in a September 1921
letter to Micheaux he didn't mention any anti-Semitism, but celebrated
Micheaux's latest production as another positive augury for his novel.
"I visited the theatre on Central Avenue [in Cleveland], where your
picture *The Gunsaulus Case* [sic] was shown, and enjoyed it very much,"
Chesnutt wrote. "The picture was well made, and gives me reason to
feel confident that *The House Behind the Cedars* will not suffer at your
hands."

The contract for *The House Behind the Cedars* was not yet cemented,
however: Micheaux was so strapped for cash that he still hadn't come up
with the hundred-dollar advance. The race-picture producer approached
the *Chicago Defender,* cooking up a scheme whereby the newspaper
would serialize the novel, along with advertisements selling a new edition
of the book, to be republished by Micheaux's company. The serialization,

in theory, would provide the godsend that would allow Micheaux to pay Chesnutt his five hundred dollars.

Swan Micheaux had written Chesnutt in June 1921, apologizing for the fact that the company's financial morass, which he attributed to a "depression in business throughout the country," had forced them to delay finalization of the contract. However, if Chesnutt was willing to surrender serial rights to the book, the company would raise its original offer to seven hundred dollars, with the first one hundred upon signing, and six additional hundred-dollar installments "each month until the full contract is paid."

"To go farther," Micheaux's younger brother wrote to the author, doing his utmost to gild the lily, "we will arrange to have you at our Studio during the time of production."

Wary of accepting an extra two hundred dollars on promise from a company that hadn't paid him a penny thus far, the author said he would mull the matter over with his publisher. In any event, Chesnutt was planning to visit Chicago in late August. At that time, he said, he could meet with Micheaux and speak with the *Defender* executives himself.

Micheaux was busy during most of the late spring and summer, hopscotching around the Eastern and Atlantic states, and making forays into the South.

He saved money by staying, often, with theater operators or at the local "colored" YMCA, and especially in the segregated South it was sometimes hard to arrange where to eat or sleep. Even the northernmost Southern states held pitfalls for a proud black man. In late May he found himself in Petersburg, Virginia, not far from Richmond, when he was "commanded to doff his headpiece" in the lunchroom of the train station. He stoutly refused. "Whereupon," according to an account in the *Chicago Defender*, "the white attendant loudly told him that that was a rule which applied to 'every niggah.'" The situation might have deteriorated from there, if the attendant wasn't distracted by worse misbehavior from "a member of his own race."

Matters didn't improve the following day, however, when Micheaux tried to order breakfast at a local restaurant attached to a hotel, entering

a dining room occupied by only two white men. The proprietess anxiously beckoned him over and "respectfully entreated him to please be 'seated in the rear' until the 'white folks' finished their meal." Furious, Micheaux departed.

On trips like this one he added bookings, but also he had experiences that reinforced his determination to make movies that preached against Jim Crow and racism and inequality. In Petersburg, Virginia, Micheaux "got all the material for a 'movie' de luxe," reported the *Chicago Defender*, which knew the autobiographical tendencies of the race-picture pioneer.

Petersburg, Virginia, was on the road north to Harrisburg, Pennsylvania, home to a considerable number of black state government employees.

Armed with his extensive knowledge of the country from his train travel—and the government reports he liked to read—Micheaux would swoop down on a sizable black community, where he would be passed from house to house of doctors, lawyers, preachers, teachers, and librarians, meeting as many middle-class black folks as he could and selling them copies of his novels. Wherever he found buyers for his books, he pitched investment in his films, a time-consuming ritual that always improved his finances, and sometimes added to his retinue.

One day he found himself in the living room of the Howard family in Steelton, Pennsylvania, not far from Harrisburg. A man who always yearned for the family he would never have, Micheaux admired nothing more than a close-knit, hardworking black family. When he met a man he liked, he'd want to meet the man's wife, and then invite both to come and work for him. He often cast husbands and wives and even, when the occasion arose, their children in his motion pictures.

Mr. Howard was a high-school principal, his wife a professional elocutionist who taught and gave recitals. One of their daughters was a New York teacher, and their youngest girl had just graduated from high school. During Micheaux's visit, a pair of portraits displayed on the family's baby grand piano caught his eye: one of the young graduate looking intelligent in her cap and gown, another of her looking radiant in an evening gown. "You know, I think I could use her in my movies," Micheaux told her parents.

The director came back later to meet the girl, Elcora "Shingzie"

Howard. Micheaux struck the young woman at once as a sort of genius. He was "garrulous," but the rush of words, like scenes in his novels or films, was "brilliant" with facts, anecdotes, social observation, and self-deprecating humor. Micheaux towered in size, but had a courtly manner and a winning smile. "He would come into a room and just dominate it with his sheer personality," said Howard.

Petite and fair-skinned, Howard spoke French and Spanish and played the piano. Micheaux seemed even more impressed to learn she could type and take shorthand. So instead of asking her if she could act, he invited her to New York to be a secretary in his office. That was how he worked sometimes, taking bright young people under his wing and waiting to see if they fit into his hurly-burly world. He assured the Howards that he would look out for their daughter's welfare; they consented, knowing that Shingzie could live with her sister, the teacher, in the city.

All this time he was trying to shore up his organization. Management was divided between Chicago and Harlem, but Micheaux had established a southern outpost in Roanoke, Virginia, and a western branch in Beaumont, Texas, both places with enterprising black businessmen who ran a few theaters and were eager to book Micheaux's "All-Colored" pictures into their outlets, while helping to peddle them elsewhere.

In early August, Micheaux met again with Charles W. Chesnutt, this time in Chicago. After visiting the *Chicago Defender*, however, the author of *The House Behind the Cedars* decided to withhold serialization from his Micheaux contract, for the newspaper had offered him higher terms directly. Still, Micheaux persuaded Chesnutt to agree to the original five-hundred-dollar contract, as long as the first payment arrived by September 1.

Having foreseen these complications—and still stalling on handing over the first hundred dollars, which he needed for more urgent purposes—Micheaux had already penned another scenario and launched the filming of his sixth production, *Deceit*, shooting initial interiors at the Solax Studio, an all-in-one production plant in Fort Lee.

Deceit was one of the most amazing projects of Micheaux's amazing career. Imagine a Hollywood director, whose films have been targeted by censorship, creating an autobiographical film about that very topic.

Imagine the scenario as a full-throttle assault on the pettiness and sancti-mony of censorship boards. Imagine characters based on actual censors. Such a thing could never have happened in Hollywood, where deference to the moral guardians of the screen was a deeply ingrained part of the studio system.

Deceit was the story of a first-time race-picture producer whose film, titled "The Hypocrite," encounters a stone wall of narrow-minded cen-sors. The race-picture producer's name is Alfred Du Bois; and "The Hyp-ocrite" is—what else?—*The Homesteader*, playfully restaged as the film-within-a-film under attack.

One of the censors Du Bois must cope with is a black preacher, based on an actual member of the Chicago board, Reverend A. J. Bowling, who was appointed especially to oversee films with a "Negro theme." Among the preachers who join in protesting Du Bois's film is Christian P. Bentley, "an arch enemy of his [Du Bois's] youth" (i.e., the Reverend Newton J. McCracken). Like *The Homesteader*, "The Hypocrite" is banned, until Du Bois appeals the ban, wins the right to have the film judged by a new, impartial audience, and the hypocritical censors are de-feated. Everything in the film was drawn from Micheaux's own history of clashes with Chicago censors.

To play Du Bois, his latest alter ego, Micheaux lured Norman John-stone away from his career as an opera singer. Evelyn Preer returned as the producer's secretary, who believes in him with all her heart. And Bentley, the facsimile McCracken, was played by A. B. DeComathiere, who was making a specialty of villains for Micheaux. The remainder of the cast in-cluded Cleo Desmond, a luminary of the original Lafayette Players, and Louis DeBulger from *The Gunsaulus Mystery*. Micheaux looked on any-one in his circle as fair game for small roles: Ira McGowan, who was still managing the New York office, was asked to fill one minor part, while Leonard Galezio, the white cameraman, also acted a role—as one of the white censors.

As was his wont, Micheaux put Preer through another knock-down-drag-out, this time with Cleo Desmond. (The first tussle between women is in Micheaux's third novel, *The Homesteader*, but "catfights" would become a peculiar, recurring highlight of his films, guaranteed to rouse audiences.) In "The Hypocrite"—the film-within-a-film—the evil Des-mond forces her sister Preer to flee the prairie for Chicago; after receiving a letter from her husband begging her to return to their farm, Preer tries

to leave home, but Desmond blocks her path. The script described a struggle, with Preer biting Desmond's hand.

"I believe in being realistic," Preer recalled, "so I really bit her, which made her forget we were only playing, and I'm telling you she became a sash-weight to me, right there. And oh, how we fought. For two days I saw my teeth prints on her fingers."

Micheaux kept the cameras rolling.

Micheaux finished *Deceit* in Chicago in September, but the film wouldn't find its way into theaters for two years—not because it required especially intricate editing, nor even because it attracted the wrath of censors. The truth was simpler: by the time he finished the photography, Micheaux was once again nearly broke.

Working for Micheaux in New York, Shingzie Howard was one of a handful of office staff. She took dictation and wrote letters for the race-picture producer; when events warranted, she even picked up scissors and helped him splice footage together on the various incomplete productions that had been temporarily expelled from editing facilities. "He trained us to do that," Howard recalled. "He was painstaking in showing me how to cut neatly and how to overlap, which was very important to him. I would spend hours [cutting] until my back would hurt."

Micheaux would dash out to give a talk to an organization, selling some books and collecting a wad of money. "He sold *himself*," Howard said. "If the Elks were having an affair, for example, if they were having a convention or something, he'd be introduced on the stage as this prolific writer, or this maker of movies. That's all they'd have to say: 'He makes movies.' Then he would sell his books, have them stacked [and ready]."

Other times he'd be off chasing footage of some unusual sight he thought might be useful in a future film. "He would go some place with a cameraman and take a scene and he'd come back and say, 'Make something out of it!' " she recalled.

One time a wealthy woman came to visit Micheaux, dressed in a beautiful mink coat. He invited her into his inner office, eyeing the mink. The boss's glance flitted to his secretary. He made a quick call, a cameraman materialized, and while the woman waited for him ("the lady never knew it," Howard recalled), Micheaux draped the coat on his secretary

and had her walk through several rooms of the building and then stroll around outside.

"Make something out of it!"

By the time Micheaux was ready to start his next new production, he'd also be ready to make something out of Shingzie Howard.

But Micheaux's dire financial conditions only worsened. Micheaux had to retrench, to make his movies even more cheaply, in order to keep going. So, as he'd done in the past, he changed places—retreating to Roanoke, Virginia, where there was budding black prosperity and a brand-new group of supporters and investors.

Roanoke was a small, provincial Southern city. There were no motion picture studios, per se. But Micheaux could shoot outdoors most of the year, and the vicinity could simulate any type of wilderness. The Allegheny Mountains lay to the west, the Blue Ridge Mountains to the east, toward the Atlantic.

And Roanoke's population was one quarter black. Locally, three men of color were partners in healthy real estate and theater ventures. William B. F. Crowell was district manager of the North Carolina Mutual Insurance Company, which billed itself as "the largest Negro insurance company in the world." C. Tiffany Tolliver, co-owner of the Ideal Cafe, was a young go-getter from a vaudeville family. (Active in the Republican Party, Tolliver even visited the White House in 1923 to confer with President Coolidge's secretary "over the political situation in the State of Virginia as it affects the Negro.") A. F. Brooks was a successful realtor, one of the state's wealthiest black persons. The three co-owned the Hampton Hotel and the nearby Hampton Theatre, which seated eight hundred people. They had plans to build other black theaters in the South and had set up the Congo Film Service to distribute race pictures and help promote Micheaux's films.

By mid-September, Micheaux had established himself in fresh quarters at the Hampton Hotel on First Street, owned by his Roanoke partners. Sitting at his desk, he shuffled the stories in his file like cards in a deck, trying to decide the best future lineup. *The House Behind the Cedars* remained high on his radar, but Micheaux still hadn't mailed the first rights payment to Charles W. Chesnutt. To his younger brother Swan was

delegated the awkward task of explaining the continued postponement: "We have been disappointed in not receiving returns for several shipments in the past month," Swan Micheaux wrote. In late September a certified check finally did arrive in Cleveland, although it appears that this was a replacement check for an earlier one that bounced, and the bank dunned the Micheaux company with surcharges.

The second check, due on October 1, also failed to materialize on deadline. Later that month, Micheaux himself wrote from Roanoke, enclosing the second installment and admitting that he had "laid off six months in order to put our Company into such financial shape as to commence production again in March and continue without a letup, as we have been forced to do in the past, due to insufficient capital to let us get far enough ahead

"While anybody specializing in Negro feature productions will find it slow doing business with their productions restricted to about 300 colored houses in this country," he continued, "we make enough money out of our pictures to get along very well, but it was necessary for us to get $20,000 or $30,000 ahead in order to maintain a safe equilibrium."

Though Micheaux originally had "contemplated filming" *The House Behind the Cedars* "this past fall," the race-picture pioneer wrote to Chesnutt, "we were unable to financially do so, after completing *Deceit*. So will commence and produce it with great care, starting as soon as the trees are fully bloomed in the spring."

During the winter of 1922–1923, Micheaux hoped to sandwich in a couple of commercial pictures before proceeding with the more ambitious, artistic-minded production, *The House Behind the Cedars*.

As it happened, Micheaux had an ulterior motive for writing Chesnutt. In his letter he enclosed a fund-raising notice announcing the issuance of $30,000 worth of "gold notes bearing interest of 8% payable October 1st and April 1st, due October 1st, 1926." The bulk of this fund-raising, he wrote, would underwrite *The House Behind the Cedars*. A separate letter from Swan asked Chesnutt if he would take "one or two of these hundred dollar notes, which are first lien on the assets of the corporation, which pay interest of $4.00 each six months, in part payment for the notes you are now holding?"

Though he was painfully sympathetic to Micheaux's troubles, Chesnutt had "pressing obligations of his own" and preferred his regular hundred-dollar payments to investing in the company's evanescent master

plan. "I will be very glad, at some time when you may wish it, to write a story for a scenario," the author replied graciously.

Again, the filmmaker urged Chesnutt to do just that: write an original script for Micheaux. "As a whole, I prefer stories of the Negro in the south," Micheaux wrote the author, "and while a good intense love story with a happy ending, plenty action, thrills, and suspense is the main thing, a streak of good Negro humor is helpful."

Feeling reinvigorated in Roanoke, Micheaux resurrected the idea of adapting *The Conjure Woman* to the screen, suggesting that Chesnutt himself write the first treatment, starting with the book's opening story, "The Goophered Grapevine," about a white couple who move to North Carolina to escape Great Lakes winters. The couple buy a vineyard, which, they discover, is "goophered," or in the words of Chesnutt's story, "conju'd," "bewitch'."

A believer in dreams and spirits, Micheaux also liked haunted house stories, and this wasn't the last time he'd think to use a spooky setting in one of his films. "Write the case of the man and woman into a good love story," the race-picture producer encouraged Chesnutt. "Let there, if possible, be a haunted house, the haunts being intrigues to be found out near the end, the heroine to have ran off there and in hiding—anything that will thrill or suspend, but have a delightful ending, and give opportunity for a strong male and female lead."

Besides letter- and scriptwriting, Roanoke afforded Micheaux time for fishing and hunting breaks, and for catching up with the latest Holly-wood movies. Demonstrating how closely he followed major-studio trends, Micheaux encouraged Chesnutt to reread *The Conjure Woman* with a mind to choosing "three of the best of these stories therein and make them into a picture along the lines of Marshall Neilan's *Bits of Life*, or Wm. Fox's *While New York Sleeps*"—two recent Hollywood pictures that showcased the same ensemble in thematically linked short stories.

"These stories are pictures [that] mark a new idea, in that they consist of three or four distinct stories in one production. Nazimova is now making such a picture, and after considering it, it has occurred to me that we might be able to do something like this with your book." Among "possible changes" he suggested to link the stories is that "there should be some sort of romance interwoven, which I might be able to do according to my own idea."

More than once during the month of October, Micheaux pleaded

with Chesnutt to accept stock or bonds in lieu of the unpaid hundred-dollar notes the author was still anticipating for *The House Behind the Cedars*. He painted a triumphal vision of his company after fund-raising was complete. "In the next five years," he wrote to the author, he personally would undertake sales missions to South America, Africa, India, and Japan, vowing to "keep going until Micheaux Productions are being shown through the world." Marketing abroad was the only way to "make up the deficit forced on account of the restricted showing in this country."

But the author wanted his money, not stock, and the hundred-dollar installments lapsed. Writing from Danville, Virginia, on November 13, Micheaux apologized for being two months in arrears, and promised to personally mail the next two checks on the first of December and January. He claimed to be "succeeding so well in the disposition of our Gold Notes" that he'd be in Harlem by Thanksgiving to finalize his 1923 schedule.

Yet it was Christmas before Micheaux got to New York, and promissory notes were not cash, so *Deceit* remained frozen in the laboratory, while Chesnutt continued to await his payments.

By late 1922, Micheaux had to institute even more drastic cost-cutting. Good-bye to his longstanding practice of touring road show acts with his films. Posters and advertising were rationed. His house organ devoted to race pictures, *The Brotherhood,* was gone—if it ever existed. Office and traveling staff were reduced. In Chicago, Micheaux closed his Loop offices and moved the company into low-rent premises in the Black Belt.

After the New Year he returned to Roanoke, resolving to produce his next few films entirely in the South, exploiting cheap local talent and favoring stories that were heavy on exteriors and Southern locales.

His next letter to Charles W. Chesnutt was posted from Jacksonville, Florida, where Micheaux was planning to shoot "a couple of tropical productions by April, and I am waiting to hear from my office where we have sent out a large volume of notes, taken in the sale of our bond issue, for discount, before starting, and will send you the amount due on our past due note as soon as I hear from there, which should be very shortly."

Norman Productions, his friendly competitor in race pictures, was based in Jacksonville, and Micheaux had a collegial relationship with the white owner, Richard E. Norman, who had taken over a complete studio, once owned by the Eagle Film Company, in nearby Arlington.

Evelyn Preer, Micheaux's favored leading lady, was by now sought after by other stage and screen directors. She was either engaged elsewhere, or—just as likely—Micheaux couldn't afford her steadily rising salary. Instead, Micheaux would assemble a cast of relative unknowns, at, no doubt, bargain prices.

For the first time, Micheaux's leading lady would be the young high school graduate he'd discovered in Steelton, Pennsylvania: Shingzie Howard. His firm-jawed hero would be William E. Fountaine. Though new to film, Fountaine had a long resumé. A strapping tenor from Cleveland, he had started out with the Tennessee Ten (an act starring Florence Mills, in which Fountaine's rendition of "Swanee River" reliably brought down the house), toured as a soloist with the Smart Set and other road show companies, and recently launched his own vaudeville act, the Four Chocolate Dandies.

One of Micheaux's Roanoke angels, William B. F. Crowell, had the imposing physique and air of gravitas to play the villain. Other amateurs and locals augmented the cast that went before the cameras in mid-January.

Two films were planned back-to-back, using the backdrops of Florida. Both scripts borrowed heavily from *The Homesteader,* though Micheaux found endless nuance and variation in his autobiographical template.

One of the scripts was *The Virgin of Seminole,* with the "Seminole" suggesting an obvious Florida association and the "virgin" kidding the female lead. Still a teenager, Howard was indeed "the virgin," the baby of the troupe, chaste, early to bed, and holding on tightly to her paycheck. (She was getting fifty dollars a week, Howard recalled, "very, very good money in those days.") The first-time actress was so light-hued that when the train they were riding crossed into the South, she was left at peace in the whites-only section of the train while the others were escorted to Jim Crow cars. The other film Micheaux had planned was *The Dungeon,* a quasi-horror story with a topical message involving segregated housing.

But the cast didn't get very far on either project after assembling on location: Some kind of trouble—unexplained in Micheaux's letters—stopped the production before it got under way. Perhaps Howard was

affected; and Micheaux felt especially protective of the novice actress. Whatever occurred, Jacksonville proved inhospitable for an all-black enterprise.

"Owing to the hatred that exists among our people and the white people," Micheaux explained in a letter to Chesnutt, "I was compelled to change my plans with regard to producing the pictures down there—not caring to subject our ladies to possible insult which we are most likely to encounter." They hastily left Florida and retreated to Roanoke in late February, with only a little scenery on film.

The film troupe was warmly greeted in Roanoke. The black citizens threw open their houses, offering room and board to cast and crew, inviting the cameras inside their homes for interiors. "We were received with open arms," recalled Shingzie Howard. "It was fantastic. We were just swept off our feet by the zeal of the people."

Even the white-dominated Association of Commerce gave Micheaux an official welcome, and in time the civic organization would schedule private screenings of the Roanoke films for local white businessmen at the city's white theaters.

Micheaux concentrated first on finishing *The Dungeon.* According to synopses published in the black press, the story—set in the fictional city of "Cartersville"—concerned the engagement of Stephen Cameron (Fountaine), "a fine, manly and courageous youth," to Myrtle Downing (Howard), "a beautiful girl of exceptional character." But their engagement is broken off after the prospective bride has a foreboding, "terrible dream." Inexplicably, Myrtle decides to marry "Gyp" Lassiter (Crowell), a notorious crook and bigamist who carts his multiple wives off to "a strange and lonely house," where they are imprisoned in a deep, dark dungeon.

Off Myrtle goes to the dungeon, unbeknownst to Stephen, who is bound for Alaska, where he strikes a fortune on a claim. Up in Alaska, there are claim-jumpers and a pugilist pal; back in Cartersville, there are social problems of the sort Micheaux had noticed mounting in Chicago. "Redistribution of the congressional district" makes it "possible for a Negro to be elected to Congress," and Gyp Lassiter is the leading candidate.

However, the corrupt Lassiter has "secretly" formed an alliance with established real estate interests to "permit residential segregation, which deal would compel Colored people to move out of the best section of the city." Learning of this travesty, Stephen decides to return to Cartersville and oppose Lassiter in the election. He wins the campaign, takes on the racist realtors, and saves Myrtle from torture in the dungeon.

March and April afforded balmy weather, and Alma Sewell, one of the many local residents who emoted in Micheaux's films, recalled the director busily guiding scenes for *The Dungeon* and the other Roanoke productions "in the streets, yards, and for inside scenes, the parlor of anyone who would consent to it."

All available cash flowed to the filming budget, however, and Charles Chesnutt's hundred-dollar installments failed to materialize. "I am compelled to ask you to give us until about April 15, before making a remittance," Micheaux wrote the author, "as it will take everything we have in the way of cash to complete this production."

Then Micheaux rushed the editing and premiere of *The Dungeon,* in order to extract some instant revenue from the movie. In lieu of the road show acts he could no longer afford, he introduced the practice of parading his stars at key premieres. Shingzie Howard took the stage to introduce herself and the new picture before "capacity audiences" at the New Douglas and Lenox theaters in Harlem, and she traveled with the print to Eastern cities. William B. F. Crowell billed as "The Meanest Man in the World," toured with the picture to Southern theaters.

On-screen and off, virgin actress Howard was a charmer. Her beauty and intelligence overcame any awkwardness, and her touching naïveté on-screen was genuine. The film—a prototypical Micheaux melange of outdoor adventure and indoor evil, with penetrating social preachment—was a winner with audiences, and with some critics. But others found fault with the scenario ("a rambling maze of incidents that have a tendency to confuse the spectator," according to *The Afro-American**), while still others complained about the acting of the amateurs ("*The Dungeon* is very much like *The Brute,* only *The Brute* is the best produc-

* *The Afro-American* was (and is) based in Baltimore and is sometimes referred to as *The Baltimore Afro-American.* But there were Washington, D.C. and other local editions, and the newspaper ranged over the mid-Atlantic in its coverage, circulating widely in many black belts south of Harlem. In its heyday it was as national a black newspaper as the *Chicago Defender* or the *Pittsburgh Courier.*

tion for many reasons, the main reason being that there were better actors in the cast," wrote the *Chicago Defender*).

The Dungeon also prompted an astonishing criticism of Micheaux's work, one that the black press would revisit in reviewing future Micheaux films. To caveats that the race-picture pioneer raised disturbing issues and highlighted unpleasant realities of black life in America, now was added the perverse complaint that he color-coded his cast: that his "colored" heroes and heroines were too fair-skinned, his villains too dark.

D. Ireland Thomas, a *Chicago Defender* columnist and former sales agent for George P. Johnson and the Lincoln Motion Picture Company, was the first to air this gripe. "The advertising matter for this production has nothing to indicate that the feature is Colored, as the characters are very bright; in fact, almost white," Thomas wrote. "The 'All-Star Colored Cast' that is so noticeable with nearly every Race production is omitted on the cards and lithographs. Possibly Mr. Micheaux is relying on his name alone to tell the public that it is a Race production, or maybe he is after booking it in white theaters."

The black press was hardly monolithic, and many columnists boosted race pictures. ("Supporting Micheaux and his wonderful talents would help us help ourselves," is how one scribe put it.) Others went out of their way, it sometimes appeared, to knock them. Race pictures came in for ten times the criticism of Hollywood's demonstrably racist films in certain quarters, it seemed. Some reviewers brought out magnifying glasses and quibbles and axes to grind. Micheaux was the major symbol of an idea his detractors wanted to perfect.

This latest complaint about his work—that his stories were color-coded in favor of light-skinned "good" characters—was one of the most unfair. And it was a criticism peculiarly oblivious to his life's theme. Micheaux was far-sighted, in film after film, with attacks on any skin-tone or racial distinction as any pretext for injustice.

Indeed, Micheaux's films are full of examples of casting *against* color-type. William E. Fountaine, who played the hero in *The Dungeon,* was hardly "almost white." Lawrence Chenault played heroes or villains, black or "white." The dark-skinned Paul Robeson would represent both sides—good and evil—in the same Micheaux film, *Body and Soul.* Scholars today have struggled with this piercing accusation against Micheaux, but have concluded, almost unanimously, that the occasional Micheaux film that seems "color-coded" is hardly evidence of a consistent trait.

One fact worth noting is that Micheaux characteristically relied on leads who were already well-established in black show business—in an era when many producers favored lighter-skinned performers. Producers had an easier time booking "bright mulattos" into mixed-neighborhood theaters in many parts of the country. "If you were [inordinately] black you couldn't get any work," remembered singer and actress Bee Freeman, who graced several Micheaux films in the 1930s. "A man could, if he could sing or dance, but not a woman. She had to be brown or light-skinned. They would take you to the window and look at your hair, and they would have you pull your dress up so they could see the color of your legs."

A few prominent members of the black press had developed an almost love-hate relationship with Micheaux, sometimes rooting for him, sometimes lambasting him. Their attitude couldn't always be separated from their own conflicts of interest. Like other black reporters who wrote about race pictures, for example, D. Ireland Thomas on occasion took money from Micheaux and other race-picture producers, touting their films while helping to book them into theaters, including one that Thomas operated in Charleston, South Carolina.

When Thomas moved to Charleston late in 1922, taking over the Lincoln, the city's only black theater, he became a full-time exhibitor. But he continued writing his column, periodically sniping at Micheaux. And his new brand of criticism may have hurt even more. According to his 1955 obituary, Thomas "personally" edited the "race pictures" he booked into the Lincoln, "to eliminate racially inflammatory material."

In July and August 1922, Micheaux was back in Virginia, shooting the remainder of *The Virgin of the Seminole* in the bosom of Roanoke. The film reunited Shingzie Howard and William E. Fountaine, this time in a Western of sorts, "built around a brave colored man who received $10,000 for aiding and abetting in the capture of a bandit," according to the *Roanoke Times*. "He buys a ranch and settles down to enjoy life."

Micheaux had been able to take more time with the scenario. And the mood of the story was more romantic than *The Dungeon,* the filming almost a lark. A local farm was turned into a cattle ranch, and the parks and streets of the city were momentarily filled with galloping dark-skinned

cowboys. "This production is a splendid one from every point of view," opined the *Chicago Defender* when *The Virgin of Seminole* was released late in 1922. "The story is one of gripping interest and thrilling episodes from beginning to end."

The two Roanoke crowd-pleasers, *The Dungeon* and *The Virgin of Seminole,* gave the Micheaux company a temporary injection of cash. Sadly, both Shingzie Howard-William E. Fountaine vehicles are "lost" today.

The summer of 1922 was hard on the race-picture business. Richard E. Norman, the white producer Micheaux admired, was already thinking, "Negro pictures have lost their novelty." A flu epidemic kept audiences away from theaters for much of the year, and many theaters shuttered. The flu slump hurt Hollywood too, but the drop in income was devastating to race-picture makers, who depended on a smaller number of constantly floundering theaters.

"There are about 354 Negro theatres in the United States (many now closed) scattered over 28 states," Norman estimated in a January 1922 letter. "Eighty five per cent of these theatres (showing race films) have an average seating capacity of but 250."

Between censorship fees and the "graft" customarily handed over to censors and theater-owners, the costs of doing business on the race-picture circuit had risen prohibitively. In Chicago, O. C. Hammond was breaking up his chain, which had been a safe haven for Micheaux pictures. Some of the theaters were sold to independent management, and the biggest and best theater in the city's Black Belt, the elite Vendome, announced a policy of booking only "high-class" Hollywood fare. Hollywood movies with marquee names "pack them in," according to Norman, who was having the same problems in Chicago as Micheaux, "and the reason is that these pictures have ran for months at downtown white theatres and the negros [sic] are crazy to see what the white people are crazy over, and as the pictures have been well advertised before, they do business."

Micheaux told Norman, "Chicago is a dead one [as a market] and we will have to pass it up for the present."

Norman struck out for nearby Gary, Indiana, a predominantly white

city. He tried to fast-talk his way into a mixed theater called the Broadway, which "was not a negro theater and there is no negro theater there [in Gary]," according to Norman, from a letter sent to his brother. The Broadway "had tried a couple of Michaux's [sic] films to attract negros and they did not go over. They cater to less than 3% negros."

Another negative factor was the "opposition and petty jealousy among the Negro theaters," in Norman's words, which further hindered prospects. The all-black theaters competed fiercely for the first bookings of new race pictures, and tended to punish distributors, declining parallel or second runs, if another area theater was favored for a given film's premiere. Norman estimated that such rivalries had the effect of limiting his first-run playing field to 86 of the existing 354 Negro theatres.

The exhibitors made exorbitant demands, but they had the upper hand. Micheaux closed with an exhibitor on *The Dungeon* for two hundred dollars for rights to *all* showings in both Kansas Citys (Missouri and Kansas), Norman wrote disbelievingly to his brother, and then Micheaux agreed to stand "half of censorship" costs besides.

"It is a hard proposition to book these birds here," Norman wrote in September 1922. "I am good and tired of Kansas City. I certainly walked my feet off and spent half my time riding the street cars keeping appointments that the exhibitors did not keep, and then when I got rentals—it was another thing to get the dates so arranged as to play all at one time and it took me a good two days to do that. Business is bad with these fellows and they certainly sing the Blues. I fought from two to four hours on every contract and then had to go back a couple of times and fight all over again. I got the films censored in both Kansas Citys without a cut and it cost $38."

Continuing on to Omaha, Nebraska, Norman bumped into Swan Micheaux, Oscar's younger brother, who was tracing the same route with much the same disheartening results. "He was playing *The Dungeon* on per cent and not doing much," Norman wrote to his own brother, adding, "Omaha is on the bum."

Inevitably, such helter-skelter business arrangements, built on a quicksand of handshake agreements, shoestring finances, and precarious logistics, were constantly going awry. Micheaux's P. T. Barnum-like side was not above big talk and broken promises, but some mishaps were inadvertent, and they affected Micheaux's reputation as well as his resources. The relentless D. Ireland Thomas extended his public criticism

of Micheaux to business matters, suggesting in one *Chicago Defender* column that Swan "not make another bad deal in New Orleans, like he did the last time he was there, with a certain theater." Then, donning his exhibitor's hat, he chastised Micheaux's Roanoke office, which after making extravagant promises to his Charleston theater, "slipped up again. No advertising matter except 2,000 heralds and you want me to pay big rental and play the picture. Wake up and do as you agreed to."

From his perch in Omaha, George P. Johnson tried to rally Micheaux, Richard Norman, and other struggling race-picture producers into forming a national organization to distribute all their films. "One good releasing organization can release all Negro films at greater returns and cheaper cost than any single firm can release his own productions," Johnson argued in a letter. But periodic attempts to organize just such a race-picture alliance were doomed by the fragile economics, the complicated logistics, and the intense rivalries.

One bright spot: Over the summer of 1922 Micheaux was able to make good on his third and fourth rights payments to author Charles W. Chesnutt. The fifth and final hundred dollars was still outstanding. But Chesnutt remained faithful, and by early October 1922, having polished the scenario during his trips to line up showings of *The Dungeon,* Micheaux finally called action on his adaptation of *The House Behind the Cedars.*

From Roanoke, where he would shoot the bulk of the picture, Micheaux wrote to inform the author of details of the final script. The novel's end, with Rena dying a pathetic death, had been changed as Micheaux envisioned. Now "the young white lover reaches the house in time to see her [Rena] coming down the steps of the house behind the cedars on the arm of Frank Fuller, evidently at the end of the wedding," as Chesnutt later summarized it.

More surprising, Micheaux had changed the famous story's Reconstruction-era setting. The realities of the race-picture business persuaded Micheaux to set the story in "the present day, which was not as difficult as it might seem," as Micheaux informed Chesnutt. "The point being that it is an intricate task, not to say a most expensive one, to film periods gone by."

He wouldn't be able to construct vintage interiors in a studio,

Micheaux explained, nor traipse around the South snapping footage of buildings that accorded with the period. "We are not financially able to do that," Micheaux said. Though he had pulled together the funding for this major production—setting aside pivotal interiors, and the expensive storm sequence that climaxed the story, for studio manufacture later in New York—he was still scrimping. "In the meantime, I cannot pay that [final $100] note," he told Chesnutt.

From the very beginning of his correspondence with Chesnutt, Micheaux had talked about advertising his film as "Oscar Micheaux Presents *The House Behind the Cedars,* A Story of the South by Charles W. Chesnutt, featuring Evelyn Preer." At the moment, however, his originally intended leading lady had decided that she favored the stage over film, and Micheaux was unable to offer Preer a competing salary.

So for the part of Rena, the "bright mulatto" who is encouraged by her brother to "pass," Micheaux turned to his protégée, Shingzie Howard, who had blossomed in *The Dungeon* and *The Virgin of Seminole.* This would be Howard's most demanding role yet. The sly, adaptable Lawrence Chenault would play her "passing" brother, while Andrew Bishop was imported from New York to play "white" (as he often did onstage), the Southern aristocrat who doesn't fathom Rena's true race. The suave Bishop, who had developed from an engaging juvenile to a compelling leading man for the Lafayette Players, often boasted of never darkening his skin with makeup. Later in his career, in fact, he would be passed over by Hollywood as "too white" for their trivial Negro parts, a common tragedy among the race-picture actors whom studios decided couldn't "pass for black."

The Roanoke troupe had grown close-knit, almost like a family, and they were full of affection for their father-figure boss, who could be a tough taskmaster. Sometimes Micheaux had a sunny disposition, but he was also capable of tyrannizing them; he inspired his crew but also amused them. He had "great big hands," recalled Howard, always gesturing vividly when giving directions. He would even "show you how to walk, and he was pigeon-toed and couldn't walk himself," the actress recalled. "We'd go into hysterics behind his back." The director made them perform scenes "over and over again" if he wasn't satisfied. "He was patient with us," Howard said, "and we were long-suffering with him."

The film's four-week shooting schedule was slightly longer than usual, but by Thanksgiving, incredibly, Micheaux had finished his third pro-

duction of 1922, all shot largely in Roanoke. Chesnutt wrote letters pleading for his final hundred dollars. Ever optimistic about getting his pictures into white theaters, Micheaux tried to mollify Chesnutt with his vow to get *The House Behind the Cedars* "distributed by one of the large white distributing concerns."

Yet his company was still scrounging. Micheaux had more than one picture hovering in the laboratory, he had stacks of unpaid bills, and he intended to put extra time into the editing of the story he had adopted as his own favorite child. Two years would elapse before *The House Behind the Cedars* was ready for release.

CHAPTER ELEVEN

1923–1924
THE PALE OF
THE LAW

Micheaux was averaging two pictures a year, censors and critics—never mind profits—be damned. Hollywood directors, by comparison, were fast and fortunate if they could make two a year, and they had all the luxuries of time and money that came with studio overheads and guarantees from banks and theaters.

In 1923, another rough year for race pictures, Micheaux would make another two pictures.

Or three. Maybe four.

One of the riddles of his career is the number of projects Micheaux announced to the press, whose titles he emblazoned on his company stationery, whose casts included actors who later remembered participating in the filming—movies that left behind a paper trail suggesting that the finished product was licensed for exhibition by one state or another—even though no clear proof exists that some of the films were ever exhibited, or even completed.

Micheaux may have made as many as four films in Roanoke in 1923. *Billboard* (which intermittently touched on black show business), the *Chicago Defender,* and *New York Age* all reported on the filming of a picture called "Jasper Landry's Will," said to star Shingzie Howard and William E. Fountaine, early in 1923. Yet no researcher has found a single subsequent review or advertisement for the film.

"A Fool's Errand" was another of these shadowy films, this one based on an anonymously published 1879 bestseller. The author, later revealed

as Albion W. Tourgee, a Northerner of French ancestry, had drawn on his experiences in the South after the Civil War for a quasi-autobiographical novel, which wove together tract and melodrama into a story that excoriated racial intolerance in the South and the failure of Reconstruction. Micheaux was said to have begun filming "A Fool's Errand" shortly after completing "Jasper Landry's Will," in Roanoke, Norfolk, and Nassau in the Bahamas.

Or perhaps "A Fool's Errand" was not based on Albion W. Tourgee's novel. Perhaps it was an original by Micheaux, as he hinted later, using the title as the novel his alter ego Sidney Wyeth writes in *Lem Hawkins' Confession*. Scholars love this aspect of Micheaux films: the teasing self-references and autobiographical allusions.

Were "Jasper Landry's Will" and "A Fool's Errand" simply exaggerated public relations? Or were these genuine Micheaux productions, started and then shut down for lack of funds? Were they abandoned for laboratory costs? Seized by creditors? Spliced together with other unfinished films to create patchwork new ones?

The scholars and educators who formed the Oscar Micheaux Society in 1993 have coined a term for these projects: "ghost films," a subcategory of the "lost" films because they led a phantom existence.

There were also bonafide Micheaux films *about* ghosts.

Micheaux was in New York for much of the winter of 1922–1923, trying to straighten out his finances, and he had time to catch up with the hit shows, including the rollicking musical *Shuffle Along (of 1921)*, written by Flournoy Miller and Aubrey Lyles, with lyrics by Noble Sissle and Eubie Blake. Miller and Lyles were among the onstage entertainers, as was Paul Robeson briefly. The multifaceted Miller and Lyles were long-time performers who once wrote plays for the Pekin Stock Company in Chicago; over years of incessant touring, they had perfected a host of blackface routines that sold out theaters. While "their comedy was invariably stereotypical," in the words of black show business historian Bernard L. Peterson Jr., it also commented wickedly on the stereotypes.

Shuffle Along delighted Micheaux so much that he vowed to shoehorn elements of it into his next project: a haunted-house comedy in the tradition of certain Hollywood films that mingled spooky hijinks with

singing-dancing numbers. "The Ghost of Tolston Manor" was announced as the first in "a series" of four planned Micheaux productions, according to company publicity. "On August 1 a big white association will begin the handling of their product," according to *Billboard,* and "the premiere of the 'Ghost' will be in a Broadway theater."

"The Ghost of Tolston Manor" concerned the spirit of a murder victim that was said to inhabit an old haunted house, and a black man who is trapped inside that house by an evil hooded organization, led by a vicious mulatto. The mulatto and his hooded followers convene a wild conclave on the premises, amusing themselves at their terrified prisoner's expense. The mulatto's goal is to instigate a race riot.

By late March, Micheaux was shooting initial sequences for this fascinating-sounding project in places around New York, including establishing footage at a suitably creepy, two-hundred-year-old mansion in Clason's Point. The musical routines were filmed inside the rented space of a Warner Brothers studio in the Bronx. Micheaux veterans Andrew Bishop (prisoner of the haunted house), Shingzie Howard (his sweetheart), and Lawrence Chenault (villainous mulatto) were joined by Miller, Lyles, and the *Shuffle Along* chorus.

After the studio photography in New York, the principals took the train to Roanoke to finish up scenes, and by the first week of May all the footage was on deposit in a laboratory. There it would sit for a few months while Micheaux figured out how to pay for the processing and editing. Never idle, in the meantime he would shoot another entire film, and "The Ghost of Tolston Manor" would gain a new title: *A Son of Satan.*

The haunted-house comedy was intended as a crowd-pleaser. The adaptation of T. S. Stribling's *Birthright* would be more of a test for audiences, and for Micheaux. Like *The House Behind the Cedars, Birthright* was a serious, acclaimed novel that was interpreted by its admirers as a postmortem of slavery and an indictment of Jim Crow. Stribling was a white Southerner, and *Birthright* was the only time Micheaux embraced the work of a white author (and, along with *Cedars,* one of the rare instances of his filming *anyone else's* story). But Stribling's fiction appealed to Micheaux: It took place in a segregated enclave in a sleepy river town that evoked memories of Metropolis, Illinois; and it had an idealistic hero,

the product of miscegenation, who was made-to-order for a Micheaux message.

Micheaux may not have known (or cared) about the color of Stribling's skin. When *Birthright* was originally published in 1922, the author was flooded by letters from readers. People from the North generally praised his book, Stribling said later, while Southerners usually abused it, asking "to my astonishment," in his words, "if I myself were not a Negro." Also from the South came "many letters from colored people themselves," the author said, which "as a rule, were bitter and condemned my novel."

Before *Birthright,* Stribling's byline had appeared mainly in pulp magazines and Sunday school publications. Before writing the novel, his second, Stribling, born and raised in Tennessee, had looked upon black people "precisely as the great majority of Southerners looked upon them, as a slightly subhuman folk," in his words, "not much, perhaps, but just a little 'sub.' " *Birthright* caused him to reexamine his upbringing and recognize the immorality of slavery and the Jim Crow system that was its replacement. He resolved to make *Birthright* the first of a trilogy, exploring "the social injustices suffered by black people in the South," in his words.

It wasn't hard for Stribling to understand why white Southerners didn't like the book. He had depicted the imaginary river town of "Hooker's Bend" as a microcosm in which whites were poisoned by their own mistreatment and degradation of blacks. His story offered many negative examples of white Southern "inhospitality" to "colored people": everything from blanket search-warrants wielded as racial intimidation, to the "Negro-stopping" clauses in real estate contracts that permitted blacks to purchase land but not to build on or inhabit it.

Yet it took him a while to figure out what offended the black readers: not his depiction of Hooker's Bend, but the attached hamlet of "Niggertown," the home of the book's hero, Harvard graduate Peter Siner. Returning home with dreams of founding a colored school, Siner befriends a "bright mulatto" named Cissie—whose ingrained servitude and inability to break away from her misery is heartbreaking. The sharply drawn residents of Stribling's "Niggertown" speak in a crude dialect, riddled with uses of the n-word, and the author's portrait of life in "Niggertown" was uncomfortably close to the bleak reality of the segregated South.

Though *Birthright* merited "great critical acclaim," as Stribling noted, it also drew condemnation from some critics and readers. And "poor ac-

tual sales" smothered any hopes for a trilogy. The poor sales and the difficult subject matter of the novel—of no interest to Hollywood—undoubtedly explain why Micheaux was able to pick up the rights for a song, less than half of what he paid for *The House Behind the Cedars*.

But Micheaux was far-sighted in admiring Stribling. The author would go on to write many other books set in rural Tennessee and Alabama, often touching sensitively and intelligently on race issues. In 1933 he would win the Pulitzer Prize for *The Store*, the second book of a different trilogy about the Old South. What many readers saw as repellent in Stribling's work, Micheaux recognized as true to life. Stribling's "Niggertown" was objectionable to some, but to him it was "a sort of colored *Main Street*," as the *New York Age* wrote of the film eventually. The story's idealistic hero, its lowborn slang, its Jim Crow details—all of these were grist for Micheaux's creative mill.

Even so, Micheaux set about making changes that would relieve the book's despairing tone. Although later reviews of *Birthright* in papers like the *New York Age* suggested that he followed the novel "very closely," the critics were fooled by the intertitles, whose dialogue was culled from the book. In fact, Micheaux added broad comedy to the story wherever possible, and changed the downbeat ending into one more in keeping with his own outlook.

Stribling's ending had Peter Siner convincing Cissie to leave "Niggertown" with him. By that point in the story Peter has failed to build his dream school, and Cissie is pregnant by another man. Both are shamed, defeated.

In Micheaux's version, Cissie wouldn't end up pregnant, and Siner's no-good nemesis, "Tump" Pack, would be dealt with decisively. Peter's dream of building a school would not be lost, merely deferred. The too-noble hero, the too-sweet ingenue, and the sugary finale were a recurrent flaw of Micheaux's films, but these contortions were no less typical of Hollywood productions of the period. And Micheaux's idealism was genuine—even if it was also genuinely at odds with his practicality and realism.

The cast Micheaux collected was cause for celebration.

At the heart of T. S. Stribling's story was Cissie, the cream-colored

beauty (she is "almost a white girl," according to the novel) who is mired in "the uncouthness of Niggertown," even though her instinctual intelligence sometimes trumps Siner's Harvard education. It was a job that called for a consummate actress who could convey levels of depth. Despite her talent and appeal, Shingzie Howard always had been a placeholder for Evelyn Preer. And now, after several years away from Micheaux and his films, Preer was once again available.

There were two important characters vying for Cissie's affections. One was Peter Siner, who aspires to edify his race, but who is cheated by a white racist banker and stuck with a "Negro-stopper" deed that makes him a local laughingstock.

The other was loud, burly Tump Pack, a decorated soldier on his way home from the war when Peter first meets him in a Jim Crow train car crossing the Ohio River. Though accorded a hero's welcome in Hooker's Bend, Tump is a brutal simpleton. Jealous over the friendship growing between Peter and Cissie, Tump attacks Peter, who is so startled that he flattens him with a wild, un-Harvardlike kick to the groin. After being arrested and released, Tump takes to carrying a gun, vowing to shoot Peter on sight.

Casting about for actors to play the rivals, Peter Siner and Tump Pack, Micheaux had a brainstorm. As the loutish Tump, he chose Salem Tutt Whitney; for the well-intentioned Peter, he picked J. Homer Tutt. It was a wonderful joke for knowledgeable audience members: In real life, Whitney and Tutt were brothers. Tutt was the younger, shorter one with a high-pitched squeak; Whitney the giant with a voice that shook the rafters. Veterans of black show business for a quarter century, they were top-drawer singers, songwriters, comedians, actors, playwrights, and producers of their own Smart Set revue (and many Smarter Set updates), touring widely with original musical shows of such high quality that even white newspapers sometimes took notice.

The fourth principal was the reliable Lawrence Chenault, playing the white Captain Renfrew, who is secretly Peter's father. Himself a Harvard man, Renfrew quietly pays Peter's tuition, and when Peter's mother dies abjectly, he brings the young man into his household under the pretext of having him edit his memoirs.

The cast came from New York to Roanoke for the filming, and principal photography began in July 1923. Micheaux had rewritten Strib-

ling's story, opening up the novel to add some action. He gave Stribling's story a new ending that was not only more cinematic—including a long jailbreak sequence in which Cissie escapes after being arrested for larceny, and flees through a swamp with bloodhounds on her trail—but ultimately happier.

The chase sequence included a moment when the ever-plucky Preer had to cross "a swinging bridge made of board," then climb a high hill, stumble and fall, rolling down the hillside. "I still have a scar on my ankle which lingers from the many bruises I got on this long roll," the actress told the *Pittsburgh Courier* in 1927. "I am not complaining, because Mr. Oscar Micheaux, the director, wanted to use a dummy for the scene, but I said, 'No.'" The bloodhounds doing the chasing "were brought direct from the police station," Preer recalled, "but took a liking to me." The only way Micheaux could coax the affectionate dogs into playing their parts was for Preer to hold out chunks of meat, call to the bloodhounds, and then sprint ahead of the animals yelping after her.

The chase sequence also included a vignette in which the fleeing Cissie waded through deep, stagnant water in order to effect her supposed escape. "So I played the dummy again," according to Preer, "and in the water I went, which I didn't expect to be more than waist deep, but which really came up to my neck and nearly drowned me. My back being to the camera, I expressed my feelings freely to Mr. Micheaux as I waded out."

After shooting was over, Micheaux worked for six months on postproduction and a release schedule for the four films he had brewing: *Deceit, A Son of Satan, The House Behind the Cedars,* and *Birthright.*

For once he did convince a "big white association" to help him distribute his pictures. The Pathé Exchange normally handled Mack Sennett comedies, Our Gang two-reelers, and Will Rogers Westerns, and Pathé wouldn't work very hard looking for new venues for race pictures. The bookings themselves were still Micheaux's responsibility. But the exchange operated offices in major cities that could be used as safe shipping points.

Deceit, Micheaux's daring anticensorship picture, was introduced to audiences first, late in 1923. It didn't take long for real-life censors to rec-

ognize it as their worst possible nightmare: a film that ridiculed them and their profession. In the North, Micheaux could usually satisfy officials with cuts, but Southern states tended to delay suspicious films interminably with elaborate protocol. Northern as well as Southern bookings of *Deceit* had to be canceled at the eleventh hour, with the advertising already paid and lines forming.

D. Ireland Thomas reported many such "miss outs" in his column. Accompanied by "businessmen" interested in investing in Micheaux's future productions, Thomas himself showed up at his Charleston, S.C., theater in late November for a screening of *Deceit,* "according to a contract that I hold with Mr. Micheaux." When the race-picture producer arrived, he "informed me that I could not get the feature booked for that date and offered another feature that had already played Charleston. That was all right, so far as I was concerned, as I had expected some disappointment and had prepared for it, but this disappointment has hurt Mr. Micheaux, and I am sorry."

Deceit's release was scattershot, at best. Censorship and "miss outs" like the Charleston debacle made it the least successful, least widely seen of Micheaux's pictures at a time when he desperately needed revenue. But Micheaux had made *Deceit* whimsically; now, having made his feelings for the censors clear, he just as whimsically jettisoned it.

The failure of *Deceit,* however, put more pressure on Micheaux to make his next release a success. Though *Birthright* had been filmed most recently, the editing was completed quickly and smoothly, and Evelyn Preer's name gave the Stribling adaptation obvious marquee potential. Stribling's novel was also well-known (in part, unfortunately, because it had offended some readers). Micheaux scheduled the national premiere for the Temple Theatre on East Fifty-fifth Street in Cleveland.

Micheaux himself did not attend the movie's week-long run there in the first week of January 1924. Instead his brother Swan traveled with the print, sweet-talking future race-picture investors along the way. And among those in attendance was Charles W. Chesnutt, author of *The House Behind the Cedars.*

Swan took the stage on behalf of his absent brother, reading a statement from Micheaux acknowledging expected "criticisms" of the film,

but hoping that audiences might be "willing to look deeper" into the complexities of the story.

"I am told almost daily by super-sensitive members of my race that, in producing Colored motion pictures, I should show nothing bad," Micheaux's statement read, "that I should not picture us speaking in dialect, shooting craps, boot-legging, drinking liquor, fighting, stealing, or going to jail; that I should, in effect, portray only the better side of our lives—and they have promptly gone to sleep on such pictures when offered.

"This story, as told by an old Negro, living in a little town on the banks of the Tennessee river, at a point where the state lines of Georgia, Alabama, and Tennessee intersect, is a true story; and to have attempted transposing it to the screen without having him do any of the things objected to would have destroyed the origin of theme and story.

"I have heard many criticisms of the book; I expect some criticism of the picture. But to those willing to look deeper . . ."

The Cleveland audience certainly did not doze, or sleep. Many applauded the latest Micheaux film. Some flinched from what they watched.

At least one expert on gritty African-American stories was impressed. Micheaux's longstanding debts notwithstanding, Charles W. Chesnutt once again admired the filmmaker's work. Micheaux's stirring adaptation of Stribling's story boded well for Chesnutt's own novel. Indeed, the author was happy to learn from Swan that Micheaux's screen adaptation of his favorite book was nearly ready for release.

Chesnutt followed up with a letter to Micheaux himself, reminding him that he was still owed his final payment. He complimented Micheaux on *Birthright*, saying that "it was very well done, and was certainly extremely realistic. Neither the author nor the picture flattered the negro one particle, and they both showed up the southern white in his least amiable characteristics, which seem always to come to the front in his dealings with the negro."

There was no immediate reply. Micheaux, never inclined to part with one hundred dollars in the best of circumstances, was busy preparing for the January 14 unveiling of *Birthright* at the Lafayette Theatre in Harlem—an occasion threatened at the eleventh hour by New York censors, who were insisting on cuts (including all "sacrilegious" material, offensive language, shooting of craps, and so on) in at least five of the ten reels. The state board, which monitored the largest market for Micheaux's

pictures, handled so many films that some simply got lost in the shuffle. So perhaps Micheaux did make the trims, although censors usually didn't attend premieres. This one went ahead as scheduled.

The East Coast critics agreed almost unanimously with Chesnutt's assessment. The *New York Age* hailed *Birthright* as "the best colored moving picture that has so far been produced." Though the film version "drags at times," the reviewer noted, it was faithful to the book ("All of the ignorant prejudices and many of the crimes of both races in this town is graphically depicted"), and its cast was superb. Evelyn Preer was singled out as "exceptionally good," as was Salem Tutt Whitney as Tump Pack ("the best part ever seen him in"), and J. Homer Tutt as Peter Siner ("succeeds in bringing some life to [his] character," who was less credible in the novel).

For once, Micheaux even got away with the n-word. "Many comments were uttered [by audience members], regarding the film, some of praise, others of condemnation," wrote Walley Peele in the *Philadelphia Tribune*, another black newspaper, "the main exception being taken to several subtitles and the broad use of the word 'nigger.'" But the n-word was pardonable, wrote Peele, considering how Micheaux's film was set in the vague past and in the South. The film was "educational" about the inequities of Jim Crow, "not one made to wound your feeling; but one to help each individual who witnessed it to do their own share in bettering the conditions which go to make such stories possible." Micheaux "has never before in his career achieved so great a success."

"Micheaux has made a really great picture," J. A. Jackson rhapsodized in *Billboard*. "It is a modern *Uncle Tom's Cabin,* and may not be popular in some quarters, a fact that will but confirm its value."

In some quarters Micheaux's film was *exceedingly* unpopular. The farther South *Birthright* traveled—this film about inequality in an antebellum river town—the greater the effort required to sneak it into theaters.

Booking the film in Virginia, which was still at this point a second headquarters for Micheaux, was a case study in his sneaky practices. In February 1924, *Birthright* was shown in theaters in at least three cities in the state—Roanoke, Norfolk, and Lynchburg. But the Virginia censorship board was alerted by complaints from outraged white citizens, and the board promptly sent communiqués to mayors and police chiefs throughout the state, advising officials that *Birthright* reportedly contained "many objectionable features," and that it "is an audacious viola-

tion of the law to display this picture, and theater managers exhibiting it are liable to prosecution."

"Reportedly": For the Virginia censors could not claim to have seen the offensive drama. Micheaux had not submitted *Birthright* for the state board's approval. But bordering states were good about swapping censorship warnings, and Virginia had heard that Maryland had balked at licensing the film because "it touches upon the relations existing between whites and blacks in a manner calculated to cause race friction."

A letter was sent to the Harlem and Roanoke addresses of Micheaux's company, advising the producer of his breach of law, along with a copy of the "circular warning" furnished to all state officials and theaters. Micheaux did not reply.

The board then demanded an explanation from C. Tiffany Tolliver, the Roanoke businessman listed as an officer of the company on its letterhead. Through his attorney, Tolliver committed what was an unpardonable sin to Micheaux: He disowned the picture, denying "any present connection" with *Birthright* or the Micheaux Film Corporation.

As for the theater managers who showed *Birthright*, they insisted that they'd done so because the print they received bore the Virginia state seal—which, after an investigation, the board concluded had probably been "fraudulently detached from one of the other pictures licensed for the Micheaux Film Corporation and attached to the photoplay under investigation."

The censorship chairman contemplated prosecuting Micheaux if he could be located, but in February the state attorney general advised him that it would be enough to ban future Micheaux productions from Virginia theaters until the company offered *Birthright* for censorship, bringing itself "within the pale of the law."

Remarkably, eight months went by before the issue was taken up. In mid-October 1924, at the tail end of a barnstorming tour of theaters in Texas, Louisiana, Florida, Alabama, and Georgia, Micheaux passed through Roanoke. There, from his office, Micheaux wrote to Virginia censorship officials as though he were hearing of the problem for the first time. (His letterhead still listed the soon-to-be-deposed traitor, C. Tiffany Tolliver, as his company's vice president.)

Micheaux's letter was a masterpiece of cunning and dissembling.

"The only reason the entire matter happened," Micheaux said in his October 14, 1924, letter to the chairman of the Virginia censorship

board, "is because until a few months ago this was a one man's Corporation, with everything from writing the story, directing, cutting, financing, booking and distributing the pictures—and collecting, dependent upon me. At one time we had several exchanges; but the most my exchange men did was to fail to do anything but collect all the money I could sell our pictures for, and talk about me because they could not collect—and keep for themselves—more. Result, I have been traveling so fast over all this country trying to get matters in shape, the first being to get rid of a lot of worthless thieving men—and then to try [to] visit all the theatres in person where our pictures play, and book the pictures and satisfy a lot of exhibitors who had a grouch for what some of our agents 'pulled' on them before I got rid of them."

It was purely accidental, Micheaux explained, that *Birthright* had played Virginia theaters without permission that previous winter. He had left a print of the movie in Baltimore, he explained, ordering that it be sent on to Virginia after the Maryland censor's deletions were made. But the Maryland state board surprised Micheaux by confiscating the print until the cuts were reviewed and affirmed, at which point a company representative, W. B. Hunter, went before the Maryland board and "adjusted the matter."

By then it was too late for "engagements booked solid in the few houses we have to play in Virginia," explained Micheaux. Advertisements had been placed and "it was either miss-out and pay a lot of advertising damage, or take [a] chance. We took the chance. We played three or four [Virginia] towns and the print went into North Carolina, from where we intended bringing it to your board; but before we got to it, you heard about it—and you know the rest."

Trying to shame the censors into sympathizing with him, Micheaux reminded the board of the chronic injustices he suffered as an ordinary black man, much less a race-picture producer, traveling in the South. "I intended writing," Micheaux continued in his letter, "telling you the truth as done above and make [an] apology; but I was covering the south, riding in cinder-ridden Jim Crow cars all night, and was just so tired and distracted half the time that I never felt like [it]—or was ever composed to set down and explain the why of.

"I am sorry it happened. It was not intentional. You had been most considerate—even sociable with me, and I shall not soon forget the pleasant hour I spent at the board about a year ago. I remarked at the time that

I had a picture that I wanted you to see and give me a criticism on. *Birthright* was that picture. Even at that time I had to almost fly to Huntington, W. Va., from here, and get the print of *Deceit* in person (a theater had played it but had made no kind of effort whatever to send it to Richmond as requested); and if I had not gone there at [my] expense and in person, I could not have got it to you, and it was due to play in Virginia the next day after you reviewed it.

"So that is the whole story. I have just been forced to do so much and travel so much until for months I could never be really composed. Happily, honest men associated with me have learned enough about it to relieve me of lots of this and we have things more ordered than ever before, and it looks like we will have to take fewer chances any more, all tho' I am still on the run . . .

"Now I hope you can forgive me and not fine me. I am not able to pay any fines. I certainly have enough troubles without being fined; but if you must, make it as light as possible, and as soon as we have a print here on *Birthright* will send it for examination."

Having placated the Virginia board, or so he hoped, Micheaux pressed his luck, asking a favor. "Also try to give us a license to exhibit *A Son of Satan*," the current picture he was trying to peddle to Virginia theaters. "We have only eight houses in all the State of Virginia to get a little money out of and we need it."

His trickster act both succeeded and failed. Though Virginia's chief censor was thoroughly vexed by Micheaux's "somewhat pathetic story" which "fails to excite commendation," he decided that a modest twenty-five-dollar fine would be adequate to teach the man a lesson. (The fine was more "a sort of sop to conscience" than the actual punishment warranted, in the censor's words.)

The fine was bearable, and in the bargain Micheaux had convinced the censors that the race-picture market was too small to bother about. In a memorandum privately circulated among the board, the chairman reassured his fellow censors that Micheaux's race-picture company "at best can hope for but small gleanings from the State of Virginia. Its output goes only to negro theatres, of which there are less than a dozen in the commonwealth, and these houses, owing to their small patronage, can afford to pay only small sums for the pictures they lease."

And he had sneaked *Birthright*, a film that broached provocative racial subject matter, into Virginia theaters, at least a handful of times. How-

ever, according to scholar Charlene Regester, who has written extensively about Micheaux's tangles with censorship, it is far from certain whether *Birthright* was ever resubmitted or rereleased in the state. Despite the critical acclaim and audience popularity it garnered, Micheaux's adaptation of T. S. Stribling's novel saw an initially spotty release. Still—unlike *Deceit*, which vanished entirely—*Birthright* was a winner for Micheaux that would pay him back gradually over the years to come.

A Son of Satan, Micheaux's quasi-comedy about a haunted house taken over by a Ku Klux Klan-type organization, never had a Broadway premiere, as Micheaux once hoped. But it did have a special preview for New York's censorship board in 1924. The New York censors obliged by ordering cuts; and so did censors in Chicago, Kansas, and elsewhere.

As always, Micheaux created different versions of his films for different markets. But in some areas, no manipulation could save such a tale— which featured a hooded group of racists led by a deranged mulatto, his criminality inherited from white forebears; a white orchestra playing black jazz for "intermingling" dancers ("which would prove offensive to Southern ideas," in the disapproving words of the Virginia censorship board); and, above all, a culminating race riot.

A Son of Satan was promptly banned by Micheaux's nemeses at the Virginia board. Regardless, in the first week of November 1924, Micheaux's haunted-house picture circulated in the state—advertised, for example, at the Attucks Theater in Norfolk. The state censors sent a telegram to stop the film, followed by "a detail of policemen" who seized the print and turned away "scores of theatergoers" on the opening night of a three-day engagement. No matter that the *Norfolk Journal and Guide*, a black newspaper, called *A Son of Satan* "as wholesome and entertaining, if not more so, than *The Birth of a Nation* or *The Klansman*, which have shown here [in Norfolk] many times."

Wholesome it probably wasn't, but even D. Ireland Thomas had to agree it was mightily entertaining. Entertaining *and*, once again, courageous. Even intermittent detractors like Thomas had to admire Micheaux's persistent willingness to take on explicit race realities. No other filmmaker even came close.

"Some may not like this production because it shows up some of our

Race in their true colors," Thomas wrote of *A Son of Satan* in his column. "They might also protest against the language used. I would not endorse this particular part of the film myself, but I must admit that it is true to nature, yes, I guess, too true. We've got to hand it to Oscar Micheaux when it comes to giving us the real stuff. This is all the criticism that I could find and I am a hard critic when it comes to Race pictures, and like Sylvester Russell, I do not want to see my Race in saloons or at crap tables. But it is not what we want, that gets the money, it is what the public clamors for . . ."

As usual, it was a struggle to push the picture past censors and find theaters. But where it could be shown, the public did clamor for *A Son of Satan,* one of the most intriguing of Micheaux's "lost" works.

The final polish of *The House Behind the Cedars* seemed to take forever. Micheaux kept postponing its completion, sandwiching other projects in front of the Chesnutt adaptation.

Traveling extensively with the prints of *Deceit, Birthright,* and *A Son of Satan,* dealing with publicity, bookings, and censorship, Micheaux used his spare time to think and write. As he'd done since his very first film, he also found time to shoot second-unit scenery for the scenario-in-progress he was carrying under his arm. During his swing through the South, he photographed the streets and skyline of Atlanta ("Under the Viaduct on Decatur Street," read one very specific subtitle), and while in North Carolina he filmed cotton-pickers in the fields.

His next script was *Body and Soul,* and its star would be Paul Robeson.

Robeson already loomed as a colossus in American culture. He had played left end on the Rutgers football team, been a two-time All-American (1917 and 1918), and graduated Phi Beta Kappa. He went through Columbia Law School with honors before detouring into show business, becoming a formidable actor and eloquent singer. A lead actor in important Eugene O'Neill plays and other shows, he was also widely praised as one of the finest interpreters of Negro spirituals. He was singing on the New York and London stages as early as 1925. And yet somehow Hollywood had no use for Robeson until the early 1930s. It was Oscar Micheaux who propelled him onto the silver screen.

In *Body and Soul,* Micheaux had a script tailored to Robeson's giant

talent, one that called for an exceptional actor to play identical twins with polar opposite natures. One twin is a hardworking conscientious fellow, like the role models in other Micheaux films. But the main focus of the story is his brother, who masquerades as a minister of the gospel while in reality he is evil personified, a scoundrel who lies, steals, seduces, and murders to achieve his rotten ends.

Where *Body and Soul* would give Robeson his first opportunity in film, for Micheaux it marked a different crossroads. In the past five years he had dashed off a series of fresh, searching, always entertaining (if not always financially successful) pictures—a major accomplishment for a man who had entered filmmaking on a whim. He had established himself as a creative powerhouse, repeatedly using his own life story as a jumping-off point to explore broader cultural concerns.

But when he looked to other interesting voices in his culture (as with Charles W. Chesnutt), he sometimes expropriated ideas without care for the legal niceties. And with *Body and Soul,* he would borrow so directly that some scholars, including the respected authority Charles Musser, have called his script "imitative, derivative," almost "plagiarizing." By Musser's reckoning, *Body and Soul* poached freely from three plays by white playwrights—a kind of "makeshift trilogy" of dramas in which Robeson had starred, three plays that Micheaux had seen.

First and foremost, according to Musser, Micheaux's screenplay drew heavily from Nan Bagby Stephens's *Roseanne,* staged earlier in 1924, which featured Robeson as a corrupt preacher driven from his congregation. Micheaux blended ideas from *Roseanne* with aspects of two Eugene O'Neill plays in which Robeson had played leads: *The Emperor Jones,* about a former Pullman porter setting himself up as an emperor on a West Indies island ("a controversial work from the outset," as Musser noted, in part because O'Neill too was prone to sprinkling his dialogue with the n-word); and *All God's Chillun Got Wings,* about the marriage of an ambitious Negro to a white woman, whose latent prejudice undermines his ambition to become a lawyer.

Micheaux's cabbaging of these sources was knowing and intentional, in Musser's view, "simultaneously a profound reworking and a critique of three plays ostensibly about Negro life and the Negro soul."

This alleged "plagiarizing" should not overshadow that other side of Micheaux's borrowing: the "profound reworking" and "critique" that Musser also stressed. Corey K. Creekmur, another Micheaux expert, has

compared the filmmaker's expropriation of others' published or produced works (there would be later examples) to the "sampling" that is an accepted practice in contemporary hip-hop music. "As an African-American, whose predecessors could not own property because they were in fact legally owned property themselves," Creekmur wrote astutely in *Oscar Micheaux & His Circle,* "Micheaux may have felt righteous justification in playing fast and loose with the 'laws' of 'copyright.' "

Paul Robeson had tentatively agreed to appear in the Micheaux project, but his contract demands couldn't be resolved until mid-October. This notation appears in the October 17, 1924, journal of Robeson's wife, Eslanda Goode Robeson: "Concluded arrangements with Oscar Micheaux for Paul's film. Made satisfactory contract for 3% gross income after the first $40,000 the picture brings in. Salary is $100 per week for 3 weeks." *

Early publicity releases floated the possibility of Evelyn Preer as the good-girl helplessly in the clutches of the duplicitous preacher, and that would have been dream-team casting. But Preer slipped away from Micheaux, and the last-minute substitute was one of his amateur unknowns, schoolteacher Julia Theresa Russell. The slender, fetching Russell was "one of the most beautiful colored women in New York," according to the rare Micheaux–related item, trading on Robeson's cachet, that graced the front page of *Variety* on November 26, 1924.

The third lead was the versatile writer and actress Mercedes Gilbert as Russell's devout, churchgoing mother (who cannot believe that her favorite preacher is diabolical). The omnipresent Lawrence Chenault was also in the cast.

Micheaux poured himself into the unusual drama, which was filmed in New York during November 1924. Robeson was caught up in the intensity and excitement. The story was replete with church scenes, and the film's expensive highlight was another one of those vivid storm sequences that had become a Micheaux hallmark.

* The one hundred dollar weekly salary was more than Micheaux normally paid his leads and the gross-income clause was also unusual. But this was canny dealmaking on Micheaux's part, demonstrating Robeson's naïveté. Certainly no Micheaux picture ever had grossed $40,000, and if one ever happened to do so over time, Micheaux would be the only person to know about it.

According to an entry in Mrs. Robeson's journal of November 4, 1924: "Michaux [sic] made storm scene out in Corona [N.Y.] today. What with the wind machine, fire hose, etc., it was the most realistic thing I ever saw."

By Thanksgiving, they were done. Robeson went off to star in a limited Broadway run of *The Emperor Jones*. And Oscar Micheaux turned his attention to the premiere of *The House Behind the Cedars*.

For once, serendipity lent a helping hand.

That fall, an East Coast divorce trial was making sensational headlines around the country. It was an especially "lurid case," in the words of film scholar Charlene Regester, offering "a tantalizing microcosm of interracial relationships."

In late October 1924, Leonard K. Rhinelander, the blue-blood scion of a socially prominent New York family, secretly married Alice Beatrice Jones, the daughter of a New Jersey cabdriver. The marriage wasn't made public for another month, and when it was, the press revealed that the bride's father was a West Indian native. Under pressure from his disapproving parents, Rhinelander left his West Indian bride and sued for annulment, charging his wife with deception for failing to inform him that she possessed "colored blood."

The West Indian wife surprised everyone by fighting back, filing a suit for alimony. The result was a hotly contested trial that dominated the front pages of America's black press for weeks.

Ultimately, Rhinelander broke down in court, confessing that he had spent many hours with his bride's family, and the family never had concealed their racial identity. That was good enough, but adding to the titillation was a set of revelations from his love letters to his wife, confirming that the husband had engaged in "most unnatural relations" with Mrs. Rhinelander, to the extent that he could not possibly have mistaken her complexion.

The crowning moment came when the wife was persuaded to disrobe in court, to prove that "not even the proverbial blind man could mistake the color of her skin," according to one account. The courtroom was cleared of spectators; then, hysterically weeping, and leaning on her

white-haired mother, Mrs. Rhinelander stripped to the waist and pulled her stockings down to her ankles. Judge and jury stared for a full ten minutes.

"Under her garments," one reporter wrote, "she is much darker than her face, which, with the aid of cosmetics, has a sort of Spanish or Mexican shade. She is underneath what the sheiks and flappers call 'high brown.'"

It was in early December that the jury decided in favor of Mrs. Rhinelander, just as Micheaux was getting ready to launch *The House Behind the Cedars*. Firing on all pistons, he began to promote his newest movie—a similarly misbegotten romance, with the Negro woman's subtle skin shade permitting her to deceive (and dismay) a white gentleman suitor—as "An Amazing Parallel to the Famous Rhinelander Case!"

Micheaux dug into his shallow coffers for a road show–style premiere at the Royal Theater in Philadelphia. "At least two hundred specially invited guests of the owners and management" attended, entertained by a baritone soloist and organist. A "brief but educational statement" from Micheaux was read by leading man Andrew Bishop. It was a rather defensive proclamation, but perhaps understandably so, after five years of seeing his consistently controversial films mauled by censors and, on occasion, assailed by critics of his own race. Even so, as America's leading producer of race pictures, Micheaux saw his statement reprinted in black newspapers across the nation, right next to news bulletins about the Rhinelanders.

"I have been informed that my last production *Birthright* has occasioned much adverse criticism," Micheaux stated. "Certain newspaper men have denounced me as a colored Judas, merely because they were either unaware of my aims or were not in sympathy with them. What, then, are my aims to which such critics have taken exception?

"I have always tried to make my photoplays present the truth, to lay before the race a cross section of its own life—to view the colored heart from close range. My results might have been narrow at times, due perhaps to certain limited situations which I endeavor to portray. But in those limited situations truth was the predominant characteristic . . .

"I am too much imbued with the spirit of Booker T. Washington," he continued, "to engraft false virtues upon ourselves, to make ourselves that which we are not. Nothing could be a greater blow to our own progress."

Considering the "burning criticism" his work had attracted more than once, Micheaux said that he was particularly grateful to black-owned theaters such as the Royal for loyally booking his and other race pictures.

"The colored producer has dared to step into a world which has hitherto remained closed to him. His entrance into this unexplored field is for him trebly difficult. He is limited, in his theme, in obtaining casts that present genuine ability, and in his financial resources. He requires encouragement and assistance. He is the newborn babe who must be fondled until he can stand on his own feet. If the race has any pride in presenting its own achievements in this field, it behooves it to interest itself, and morally encourage such efforts.

"I don't wish anyone to construe this as a request to suppress criticism. Honest, intelligent criticism is an aid to the progress of any effort. The producer who has confidence in his ideals solicits constructive criticism, but he also asks fairness, and fairness in criticism demands a familiarity with the aims of the producer, and a knowledge of the circumstances under which his efforts were materialized."

Yet, for once, the "burning criticism" he anticipated did not materialize. The adaptation of Chesnutt's novel, which Micheaux had worked for four years to bring to the screen, pleased critics as much as any film he would ever produce.

The *Philadelphia Tribune* hailed *The House Behind the Cedars* as "a very faithful adaptation of the novel modernized in such a manner as not to destroy the story and at the same time making it a little more appealing. The photography was splendid, and the direction in the picture is proven by the smoothness and [is] well-placed and not exaggerated in any manner. It may be accorded by many critics as being the greatest work of this producer."

"Even exacting picture fans," agreed the *New York Amsterdam News,* "will find in this story something to keep them interested from the start, for the successful 'passing' of a colored person for white holds an irresistible fascination."

Ticket sales exceeded expectations. Indeed, at one point, *The House Behind the Cedars* was playing simultaneously at three of Harlem's largest theaters, racking up "turnaway" business, according to press accounts. Unfortunately, bookings outside New York were fumbled when the Micheaux film was held over in Harlem. The company "regretted the lack of more prints," according to the *Baltimore Afro-American.*

The noted artist and illustrator Elton Fax, who grew up frequenting the segregated theaters of Baltimore, remembered seeing *The House Behind the Cedars* as one of the moviegoing highlights of his youth. "I recall the thrill that I experienced," said Fax, "because for the first time I saw our people on the screen in roles that were other than roles of the buffoon. The fact that the [Micheaux] pictures were rather crudely done didn't matter as much to me as the fact that they were done at all, and that they were done in his particular way."

The censors took their usual nicks, or worse. Virginia condemned its fourth consecutive Micheaux picture ("aside from presenting the grievances of the negro in somewhat infelicitous subtitles," the state board ruled, *The House Behind the Cedars* "touches even more dangerous ground—the intermarriage of the two races"). But Micheaux could shrug off a few Southern theaters, since he couldn't keep up with the demand elsewhere.

Nineteen twenty-four had been another precarious, uneven year for Micheaux, but not a terrible one. *Birthright* had done solid business and was still selling. And *The House Behind the Cedars* was a lifesaver—not just the lifesaver of 1924, but a permanent bulwark against disaster. This picture, "from the immortal novel by Charles W. Chesnutt," was one that Micheaux could count on for repeat bookings, all the way through the rest of the decade.

As for the immortal novelist, Chesnutt wrote privately to his daughter, saying that he thought the film version was "very well done, but it was not my story." Despite repeated appeals though, the author never got his last hundred-dollar payment from Micheaux. This flim-flam eventually soured the author's opinion. Writing in *The Crisis* in 1926, Chesnutt complained that a "propagandist" had "distorted and mangled" his book into a movie in order "to make it appeal to Negro race prejudice."

1925–1927 STRAWS IN THE WIND

Micheaux put on a show in person, too. He'd taken to speaking and dressing theatrically. Up North in the wintertime he'd wear a long Russian coat, and talk about his audience, his films, his "territories," as though he were running an empire. "He'd come on like Czar Nicholas," artist Elton Fax remembered. "The dusky czar of Race filmdom," the *Chicago Defender* dubbed him.

Late in 1924, "looking the picture of health and prosperity," Czar Oscar stopped by the offices of the *Chicago Defender*, trying to get some news out via Tony Langston's column. Though Langston was out of town, Micheaux regaled other reporters with his castles in the air, telling them he was "contemplating a trip to South America" and the West Indies in January. (A month or two later, he'd tell the press in another city that he was en route to Cairo and "several Russian cities" to arrange foreign bookings.) He foresaw a golden future for race pictures. "Our honored visitor was shown every courtesy at the command of the staff," the *Defender* reported.

As with his earlier air castles, there is no evidence that these far-flung excursions ever materialized, though Micheaux did travel now and then to the West Indies (Kingston, Jamaica, was the last stop for showing his pictures). He was a "one-man corporation," after all, and he knew it would be risky to leave the United States for any extended period. In fact, though his brother Swan had been running the Chicago office for several years, Micheaux had begun to suspect him of negligence or worse. And if not family, who could the race-picture pioneer trust?

But the empire was momentarily stable. The company had benefited from the success of *The House Behind the Cedars,* and Micheaux would maintain his blistering pace by producing three new motion pictures in 1925: *The Conjure Woman, The Devil's Disciple,* and *The Spider's Web.*

Curiously, considering his dubious relationship with Charles W. Chesnutt, for his next film Micheaux would return to his first love among Chesnutt's works: the acclaimed short story collection, *The Conjure Woman.*

His correspondence with Chesnutt had lapsed, but just as Micheaux had envisioned four years earlier, the springboard for his scenario would be "The Goophered Grapevine," the first story in Chesnutt's collection. The story, which followed a Northern white couple who have moved to North Carolina and become proprietors of a vineyard that is "goophered" (that is, bewitched), launched a series of tall tales about the history of the property. The teller was an Uncle Remus–type freed slave named Uncle Julius. Recounted in black dialect, these tales of "slabery days" involved "conjure magic," which was practiced by many blacks (and whites) in the South to ward off evil, mediate disputes, even regulate romances. In a sense, this "conjure magic" helped to redress the social imbalances of the time. "Above all," as Chesnutt scholar Richard H. Brodhead has noted, " 'conjure' figures as a recourse, a form of power available to the powerless in morally intolerable situations."

By now, the Roanoke branch of Micheaux's operation was in its death throes. Some of his local investors, such as C. Tiffany Tolliver, were estranged; others had long since had their coffers drained. Tensions over the censorship snafus had poisoned the bliss. How could Micheaux continue to make films in a state that refused to license them for exhibition? *The Conjure Woman,* with its Southern milieu, would be the last Micheaux production shot in the Roanoke vicinity, in the spring of 1925.

Pleased with the experience of *Birthright,* Evelyn Preer pledged to appear in all three of the films on Micheaux's 1925 roster. She and Percy Verwayen, a dynamic stage performer who went on to originate the role of Sportin' Life in the 1927 Broadway run of Dorothy and DuBose Heyward's *Porgy* (the basis of the Gershwins' *Porgy and Bess*), would portray the white couple. Lawrence Chenault was the story-spinning Uncle

Julius, and Micheaux recalled Mattie V. Wilkes, Chenault's mother in *The Symbol of the Unconquered*, to play the "Conjure Woman."

Some Micheaux pictures are more "lost" than others, and despite the evidence of paid advertising and openings, *The Conjure Woman* received "comparatively few" confirmed showings and "a general dearth of publicity" upon its release in 1926, according to *Oscar Micheaux & His Circle*.

There is no evidence that Chesnutt helped to write the scenario, as Micheaux originally had urged the author to do. Nor is there any evidence that Micheaux paid for the screen rights. Since he had fudged that responsibility in the case of *The House Behind the Cedars*, he may well have skirted the law with this second Chesnutt property, too. And it is just possible that Chesnutt or his publishers may have threatened suit to halt the distribution of *The Conjure Woman*.

Micheaux was billing Preer as "The Screen's Most Beautiful Colored Star," but her new husband was a match for the actress in talent and looks. In Nashville, while on the road with the Lafayette Players in 1924, Preer had married one of her onstage leads, Edward Thompson, the son of DeKoven Thompson, a well-regarded classical composer. The black press had given the marriage a lot of attention, and now Micheaux scurried to pair the newlyweds in two productions that would be shot back-to-back in the New York area.

The Devil's Disciple would be Micheaux's first script centered on Harlem life, though its plot hewed closely to the ideas of his previous pictures. At its center was "a beautiful but vain girl who falls in love with a degenerate" tyrant, according to synopses in the black press. "She determines to reform him, but fails miserably, and is in turn dragged down and down." The villain was an ogre of the underworld, a "disciple of Satan himself." Besides Preer and Thompson, the cast included Percy Verwayen and Lawrence Chenault.

The Devil's Disciple was rapidly organized for the summer, and then Preer and Thompson promptly segued into *The Spider's Web,* the first of several Micheaux productions to take on the issue of the "policy" or "numbers" racket, a form of gambling that victimized poor people, especially blacks. The "policy" game offered bets on numbers drawn by

lottery, or appearing in the financial pages, with the winnings rigged by organized crime.

The story of *The Spider's Web* began in the Delta before shifting to Harlem. Preer played a New Yorker who arrives in a small Southern town to visit her aunt (Henrietta Loveless). The aunt warns her about a white planter's son (Marshall Rodgers), who is notorious for seducing "any colored girl that comes to town." A race sleuth (Lorenzo McLane) arrives in the town from Chicago, befriends Preer, and arrests the ne'er-do-well for "practicing peonage," a uniquely Southern, post-slavery practice that forced borrowers to work off their debts.

Preer and her aunt light out for New York, where the aunt, desperate for money to pay for expensive surgery for her crippled daughter, becomes "hooked" on the policy racket. A Cuban "banker" (Edward Thompson) running the game is found mysteriously slain, and the aunt is arrested for theft and murder.

The race detective rushes to the rescue. Preer aids his investigation of the crime, which leads to a woman (Grace Smith) who eventually confesses to killing the "banker" because he was unfaithful to her.

The Conjure Woman, The Devil's Disciple, and now *The Spider's Web.* For Micheaux, 1925 was the year of Preer. All his time—and all his available money—was expended on these three films starring his favorite actress. The inevitable shortfalls meant he had to stagger the editing and release schedules for each film.

The Spider's Web—the only one of the three that he'd remake in the sound era—met with general approval when it was released two years later. "A great picture!" declared the *Baltimore Afro-American*, while the *Chicago Defender* called the anti–policy-racket film "as interesting a story of Negro life as one can wish to see."

The Conjure Woman went before audiences in 1926, but anything else one might say about it is speculative. Hollywood aficionados take for granted the thousands of film stills and lobby cards generated by the studio system, not to mention the fan clubs, magazines, and gossip columnists on the payroll to spark publicity. But in the case of Micheaux films, especially in the silent era, there is little beyond a few tantalizing mentions in the black press to illuminate some of his pictures. In the case of *The Conjure Woman,* not one still photograph has survived, and no researcher has unearthed a single review of the film.

The Devil's Disciple, the most commercial of the three Preer vehicles,

was the first one Micheaux finished and the only one he was able to rush into theaters by late 1925. It was widely seen. The *New York Amsterdam News* found the latest Micheaux production "intensely gripping and dramatic," and the *Pittsburgh Courier* agreed it was "an ecstasy of entertainment." Preer herself considered the first film that she made with her husband to be among her "best work" for Micheaux, according to her daughter, scholar Sister Francesca Thompson.

Not a single print exists of any of the three Evelyn Preer vehicles made in 1925. Indeed, from the entire decade of the 1920s, during which time Micheaux wrote, directed, and produced at least eighteen feature films, only two survive: *The Symbol of the Unconquered*, and *Body and Soul* starring Paul Robeson.

Nearly a year had gone by since Micheaux had finished filming *Body and Soul*, and by late October 1925 he finally completed all the postproduction and booked the premiere for a New York theater. First, however, it had to be screened for the New York State Motion Picture Commission.

When the New York censors reviewed a nine-reel version on November 5, 1925, their jaws dropped at the film's portrait of a minister of the gospel who was also a gambler, extortionist, liar, thief, drunkard, and murderer. *Body and Soul* was "condemned en toto" as "sacrilegious, immoral, and would tend to incite to crime."

In order to get *Body and Soul* into any theater in New York State, Micheaux was obliged to rework the Robeson picture drastically. Writing to the New York board from Roanoke—still, in late 1925, billed on his stationery as the site of the "Studio and General Offices" of the Micheaux Film Corporation—the director improvised a Plan B. In this solution, Robeson's evil twin would be not a real minister, but a phony. Perhaps he had neglected to make this "fully clear," Micheaux ventured to the censors: the "central figure in this story," the charismatic preacher played by Robeson, "is only masquerading as a minister, [and is actually] not an ordained minister," he explained. "I therefore apologize. . . ." Once the director had done a little reediting, it would be obvious: His story was a genuine moral parable.

Micheaux went to work, whittling down the film's most egregious material, and creating a new prologue that would identify the preacher as an

escaped convict with a knack for disguises (a singular fact that's promptly forgotten in the storyline). Micheaux didn't have time to manufacture a new screen card in Roanoke, but he sent the censors a scribbled version, advising them to stop the film after the opening credits and read his explanatory intertitle. The actual intertitle, he advised them, would take the form of a newspaper clipping: "'Black Carl,' noted Negro detective, reports the escape of a prisoner . . ." In Roanoke, Micheaux shot quick footage of this eleventh-hour character, the shadowy "Black Carl" slipping among trees in a forest, presumably in pursuit of the fugitive Robeson.

Despite Micheaux's ingenious whittling, new prologue, and added footage, the New York censors rejected his appeal and affirmed their original ban. Forced into even more exigent measures, Micheaux began making radical cuts, reducing *Body and Soul* from nine reels to five, "changing the theme and transferring the villainy from the minister to another character [a no-good played by Lawrence Chenault]," in Micheaux's words, "and placing the preacher in no position anywhere, or having him do anything, that would be unbecoming the Clergy." Micheaux even concocted an abrupt new ending that posited the entire story as a dream.

That did the trick. The New York censors approved the condensed, sanitized version of *Body and Soul* on November 12, although even then it was on the condition that Micheaux cut back further on the film's drinking and gambling scenes. But it had all been a short con of thimblerig for Micheaux. Regardless of the censors' decrees, he premiered the original version of *Body and Soul* at the New Douglas and Roosevelt theaters in Harlem in mid-November, before taking the Robeson film on the road to Pittsburgh, Philadelphia, Baltimore and Washington, D.C.

Yet as often happened with Micheaux's most provocative films, what bothered the censors also upset some critics and audiences. Preachers in other cities denounced *Body and Soul* for its unflattering portrait of their calling. Once again, Micheaux was castigated for sprinkling his intertitles with the n-word. And on top of that, the film had boozing, gambling, borderline nudity, ugly violence—something to offend everyone. (A letter to the editor published in the *Chicago Defender* summed it up in one word: "filth").

But it was also an undeniably gripping, unusually powerful movie. Micheaux's colorful character types were culled from real life. His frank depiction of religiosity and hypocritical church leaders resonated with

black America. And in most places where *Body and Soul* was shown, the black press showered it with superlatives.

"Beautifully photographed, extraordinarily original," declared the reviewer for the *New York Amsterdam News,* "one of the most tragic yet sympathetic stories ever filmed."

"A magnificent combination of Negro brains and art," proclaimed *The Afro-American* in Baltimore.

"Oh boy!" Maybelle Crew enthused in her show business column in the same newspaper. "If some of the Reverends could see how Micheaux pictures the harm done by that Jack-Leg Preacher, but of course, they wouldn't go near that den of iniquity, a theater." Micheaux's latest picture demonstrated "great emotional appeal," Crew continued, adding, "If in the end it had not proved to be a dream I know the audience couldn't have stood it. In fact, some of them were talking out loud to the picture, tearfully and wrathfully."

An ending that proved "a dream": Some reviews, puzzling over discrepancies in the storyline, suggest that *Body and Soul* lost many censorship battles outside of New York. Censors in Maryland, Chicago, Kansas, Virginia, and other places hacked pieces out of it. Often the censors took possession of a print and kept the "eliminations"; Micheaux was always complaining about lost or destroyed footage after receiving his returned prints.

The George Eastman House in Rochester, New York, has preserved an eight-reel version of the 1925 film, however, even restoring some of the censored material; and contemporary audiences still find it mesmerizing. Today, *Body and Soul* is the Micheaux picture most likely to be revived in festival screenings, and arguably the closest to an intact original among his surviving films. To those audiences and to most Micheaux enthusiasts, *Body and Soul* holds up as "an extraordinary film," in the words of scholar Charles Musser.

Firstly, it's an anthropological treasure, with Micheaux recreating the public and private spaces of a lost world overlooked by Hollywood. It's a grassroots vision of black America, and the 1920s wardrobe alone would make a fascinating museum exhibit; with one entire wing devoted to hats, and a separate room for the ornate church hats alone.

Cinematically, *Body and Soul* confirms Micheaux's technical mastery. The storm sequence, with the Preacher (Robeson) and Isabelle (Julia Theresa Russell) whipped about by violent winds and drenched by cas-

cading rain, is especially thrilling. The daring scene that follows, with the Preacher stealing into a room in which Isabelle, huddled in front of a fire, has been coaxed into removing her wet garments, is achieved with erotic seminudity, slant lighting, and the intercutting of advancing footsteps— a passage worthy of early Hitchcock.

The protracted church sequence in which the evil Preacher interrupts his flamboyant, revivalist sermon ("Dry Bones—in the Valley") with furtive sips of booze, while the congregation listening to him rocks back and forth, shouting out in mounting ecstasy, is at once dramatically riveting and riotously funny.

Robeson delivers a transcendent performance, his full genius on display. "To my mind, at least," Musser has written, Robeson's acting for Micheaux is "far more inventive and impressive than his work in the film version of *The Emperor Jones* [his first Hollywood movie, eight years later]. It may well be his best screen performance."

After finishing his run in *The Emperor Jones* on the London stage, Robeson had gone to France, and that is where he was vacationing when *Body and Soul* was released in the United States. If he ever saw his first film, made under Micheaux's direction, what he himself thought of his motion picture debut—a blip in a long, magnificent career in which screen roles competed with so many other interests—his opinion has not been recorded.

Way back in 1913, Chicago pioneer William Foster had described race pictures as "a feeble infant, scarcely able to nurse its bottle." In 1924 Micheaux would use the same metaphor, calling race pictures a "newborn babe who must be fondled." In a sense race pictures were always— and destined to remain—a weak child.

The novelty of all-colored films had created a boomlet in the early 1920s, but the "gold rush" years were long past. The insuperable problem was the number of theaters controlled by black capital. Even in Harlem white theater owners predominated; and they preferred the slick, glossy Hollywood assembly-line films featuring black menials, over race pictures of inconsistent, flea-budget quality.

Even the best films of Micheaux—a one-man low-cost corporation, a

lone wolf in an otherwise heavily collaborative industry—inevitably lagged behind the technically polished ones being churned out by his peers in white Hollywood.

Even in Harlem (perhaps *especially* in Harlem) there were prominent members of the black press who found race pictures as "passé" as the phrase "all-colored." They never cut Micheaux any slack.

In December 1925, on the heels of *Body and Soul,* one of his greatest pictures, Micheaux again found himself under ferocious attack from a journalist of his own race. Romeo L. Dougherty of the *New York Amsterdam News* devoted an entire column to Micheaux's body of work, comparing his movies unfavorably to Hollywood's, while approvingly quoting the white manager of the Lincoln Theatre, who said he refused to book Micheaux productions "because they are so far beneath what he has to offer from studios fully equipped and with high-paid writers furnishing the scenarios."

There were still a handful of white theater managers in Harlem willing to book Micheaux's pictures, Dougherty continued, but they did so "more from a mistaken idea of a sentiment which they feel they should exhibit in a colored community, than because of the worth of the pictures . . . it is hard to expect colored people to accept these Mischeaux [sic] pictures here in Greater New York and Northern New Jersey, and they don't."

Black theater owners valued Micheaux films more, but there were precious few in New York City, and never more than two in Harlem. The biggest theaters—the Lincoln, the Lafayette, the Odeon on 145th Street, and the thousand-seat Roosevelt on Seventh Avenue near 145th—were operated by two white Jewish businessmen, Leo Brecher and Frank Schiffman. Only the nine-hundred-seat Renaissance, on Seventh and 137th, had been built by colored capital, challenging the Brecher-Schiffman monopoly of major theaters north of 125th. As Micheaux actor Lorenzo Tucker later quipped, one or two black theaters in Harlem didn't amount to "a pimple on a bedbug's hindparts."

Black-owned theaters were scarce all across America, and the tiny number that existed were always changing hands or going "temporarily" out of business. Losing even one major outlet was a blow to Micheaux, and inevitably the replacements were iffy. Longtime gadfly Sylvester Russell, relishing the race-picture producer's misfortunes, noted in his col-

umn that Micheaux, who once boasted his films wouldn't be screened below Forty-seventh Street in Chicago, was "now showing the poor pictures at the smaller houses all over the district."*

Defections from the East and Midwest couldn't be offset by the South. Southern all-black theaters were smaller and spread out. Big cities in the Southwest lagged even farther behind. "In Houston, [Texas]," reported the *Pittsburgh Courier,* "are two theaters run by white people for colored, and one other colored theater. Also are white theaters which permit colored people to enter by the back and side door."

Micheaux's runs in less populous areas were for one or two days, booked on percentages and slashed ticket prices. Especially in the South, summer heat waves chronically affected attendance. Air conditioning was spreading through the industry, but slowly and only among the biggest, best white theaters showing Hollywood pictures.

Body and Soul was undeniably a hit, and it brought another momentary infusion of revenue to Micheaux's company. But that wasn't enough for a man averaging two pictures a year, and once again the race-picture pioneer was forced to retrench for some emergency revamping.

In late December 1925, the news swept through Chicago like a chill wind: Swan Micheaux was shutting down the local office to take charge of the "New Oscar Micheaux Film Exchange" in New York City. "Another straw that shows the blowing of the wind," reported the *Baltimore Afro-American,* "is the removal of the general offices from Roanoke, Va., to New York City" and "a complete reorganization of the sales force."

The Roanoke experiment was over, and Micheaux needed help in Harlem. Ira McGowan, his chief lieutenant, had sued the boss for back wages and won a judgment against Micheaux in court; now McGowan was moving to the West Coast to join a fledgling race-picture company

* Not white or Hollywood enough for some theaters or critics, Micheaux films were "too white" and Hollywoodish for others. There was less consensus among black film reviewers than there was among white critics, who were in a better position to form big-city organizations like the New York Film Critics to at least pretend a united front with their annual "best" awards. Sylvester Russell, who had railed against Micheaux's "objectionable race features" earlier in the decade, now complained, for example, that "all the features of artifice in scenario and scenic calculations to which the white man has resorted, Mr. Micheaux has now acquired."

spearheaded by white director Harry Gant and a group of Lincoln Motion Picture Company alumni. (Lincoln had been swept under by hard times in 1923.) George P. Johnson had also moved to Hollywood, hoping to revive the Lincoln dream with his brother Noble. But the brothers became estranged, and George lost contact with both Noble and Micheaux.

That rift between brothers would have an eerie echo in Micheaux's own life. The race-picture producer had grown to doubt Swan's honesty as well as his ability, and bringing him to New York was one way to keep an eye on him.

In spite of this crisis and flux—or perhaps because of it, such was his resolute nature—Micheaux continued to sketch his air castles. Through a regular stream of news items, and the titles listed on his ever-evolving letterhead, Micheaux left a record of an ambitious future agenda. It was a time of intellectual and creative ferment in black America, and as race leaders debated their common values and goals, Micheaux planned a series of new films that would explore the full spectrum of that debate.

He laid the groundwork for a project called "Marcus Garland" or "Black Magic," a story patterned after the life of Marcus Garvey and intended to star one of the best-known black actors of the age: Clarence Muse, a onetime Lafayette Player now spotted frequently in Hollywood movies. Muse eventually dropped out of "Marcus Garland" in favor of higher-paid Hollywood parts, but no matter: Salem Tutt Whitney was penciled in.[*]

Another project was filming a play by Mary White Ovington, a prominent white activist and author in New York, who had helped found the National Association for the Advancement of Colored People (NAACP).

Micheaux also contemplated adapting the W. E. B. DuBois novel *Dark Princess*, whose story elements aligned with his own ideas. The novel concerned a young Negro medical student who suffers racial discrimination, sails for Europe, and in Berlin falls for a beautiful colored woman who is plotting an uprising of American blacks. Returning to the States, the ex-student becomes a leader of a fanatical organization—organizing a strike of Pullman porters, witnessing a lynching, planning a train wreck of Ku Klux Klan members.

Also on Micheaux's expandable list was a screen adaptation of a Zora

[*] "Marcus Garland" may have started filming and shut down. But the project was resurrected as the 1932 race picture *The Black King*, which was written and directed by Donald Heywood, and starred A. B. DeComathiere as the Marcus Garvey figure.

Neale Hurston short story called "Vanity," and another story called "Deadline at Eleven" written by Louis DeBulger, who had played Lem Hawkins in *The Gunsaulus Mystery*.* He announced these and other titles as he traveled around the country, closing his Southern offices at last and moving all his business to New York. In Harlem his brother would watch over a shrinking staff, and he would watch his brother. More than ever the Micheaux enterprise was a one-man show, with Oscar counting pennies and guarding every transaction.

As far as is known, the beautiful Julia Theresa Russell, the amateur thespian who had the privilege of acting opposite Paul Robeson in *Body and Soul,* never again emoted on the stage or screen. But the New Jersey schoolteacher would assume a much greater significance for Micheaux, for it was she who introduced him to her older sister, Alice.

Also a teacher, Alice B. Russell lived with her family in Montclair, New Jersey, a community northwest of Newark. The Russells had come to New Jersey from the dirt-poor backwater of Maxton in Robeson County, North Carolina, after the head of the household, Robert Burton Russell, died abruptly in Maxton around 1900.

Alice's father could have been the exemplar of a Micheaux film. Russell had owned his own home in Maxton by the late 1800s, and served on the town board at a time when few blacks in the South ascended to government office. Before the turn of the century he edited and published one Robeson County newspaper, the *Maxton Blade,* while owning shares in another, the *Scottish Chief.* Though the *Blade* reported mainly on the black community, it aspired to broader coverage as a means of increasing circulation; Russell attended services every Sunday at a local white Presbyterian church, sitting discreetly in the balcony and taking down every word of the long-winded sermon in shorthand, publishing the transcript in the Tuesday edition.

The circumstances of Russell's sudden death are elusive. But the Russells were devastated by the tragedy, and the settlement of the estate—the house and newspapers were sold off to relieve the family's debt—left

* "Vanity" is a title that no scholar has been able to authenticate as a published Zora Neale Hurston story. Likewise, the Mary White Ovington play, if it actually existed, was unproduced.

them poor. The family headed north to New Jersey, where the Russells turn up in Essex County records first in 1904, living with Mrs. Russell's parents. Eventually the family settled in a large house at 55 Greenwood Avenue in Montclair.

Mrs. Russell was Mary Malloy Russell, part of an old Maxton family. Though uneducated herself, Mrs. Russell raised her five children in the Booker T. Washington tradition; all her sons and daughters graduated from high school and landed decent jobs, adopting their parents' creed of hard work and faith in God. Mrs. Russell supported her family by working, first as a laundress for private households, and later as a public school custodian. She was a self-sacrificing mother.

The middle Russell child of five was Julia Theresa, who was twenty-seven when she appeared in *Body and Soul.* There were two boys: Robert Jr. (b. 1893) and Albert (b. 1898). The youngest Russell was Blanche, born in 1899, shortly before her father passed away. Alice B., whose middle name Burton was in honor of her father (a family name passed on to the eldest), was the oldest of the Russell children, born in June 1889.*

As the oldest child, Alice B. Russell likely stepped in to help her mother after her father's untimely death, filling in with household and maternal duties, nurturing her younger siblings. After graduating from high school in Montclair, she went on to study music in college. Her obituaries, which her younger sister Blanche—her only surviving sibling at the time of her death—helped prepare, state that Alice graduated from Columbia University, but there is no record of her enrollment at Columbia in New York, or any other Columbia, as far as can be determined. Blanche, who was ten years younger than her sister, may have been mistaken about the details. But Alice was well read and, like her father, a good writer. Her erudition and refined diction were obvious markers of education. "Alice was so damn polished that you thought you were talking to a dictionary," recalled Carlton Moss, a family friend from nearby Newark who acted in two Micheaux films in the early 1930s.

Like her sister Julia, Alice earned a living as a teacher, giving private voice and music lessons in the Montclair area. She sang at church occa-

* One mystery, among the many about Alice B. Russell, is the exact year of her birth, which fluctuates in official documents. The 1900 census, which shows her birth as June 30, 1889, is probably the most reliable. A few years were shaved off in the 1910 census. Her 1926 marriage certificate suggests she was born in 1893. Her social security application attests she was born in 1899. Her obituary and death certificate indicate 1892.

sions, and at least one account suggests she gave community recitals. All the Russell girls were "pretty and charming," remembered Hortense Tate, a Montclair activist who knew the family; and Alice was the prettiest, the most charming. Five years younger than Micheaux, Alice turned thirty-seven in 1926. She was tall and light-skinned, womanly rather than girlish, with dignity and manners: an elegant lady with a smile as persistent, as enigmatic, and as endlessly adaptable, as her husband-to-be's.

Montclair had a close-knit black population, and the Russells were prominent in church and civic activities, especially the (colored) YWCA. The family's Greenwood Avenue home was one hub of black Montclair's social—and political—whirl: When Edwin Barclay, the Liberian foreign minister and secretary of state, made an official visit to the United States in 1925, for example, the Russells hosted the local reception for him there.

In his Pullman porter days, Micheaux had been a ladies' man, and he seemed to have a woman at every port of call. Since the death of his first wife, however (and the abandonment, perhaps, of his second), he had kept his distance from women. Truth be told, he hadn't had much free time to pursue romance. And although the "casting couch" was already a notorious practice in show business, Micheaux was that rarity among motion picture producers, known for behaving in fatherly or gentlemanly fashion toward the many actresses he knew. "I liked his approach," recalled the sexy Bee Freeman, who met Micheaux in the early 1930s, when he was casting a new film. "He was very businesslike—didn't make a pass, which was surprising. I didn't know whether to be insulted."

Micheaux was drawn to the Russells, a family of hard workers and achievers like himself. He was drawn especially to Alice, and as he quietly courted the music teacher throughout 1925 and early 1926, their mutual affection grew. Micheaux was welcomed into the Russell household; he became a frequent guest at Sunday supper and was made to feel at home. Indeed, Montclair would become his real second home, more a refuge and sanctuary for him than anywhere else; Mrs. Mary Russell would become a kind of second, surrogate mother.

Their romance reached fruition on Saturday, March 20, 1926, when Oscar Micheaux and Alice B. Russell exchanged vows in the living room of 55 Greenwood Avenue. A Baptist minister presided. Alice's sisters were maids of honor. The marriage of black America's most famous filmmaker was reported in the black press from coast to coast. "It was quite a social event and was attended by hundreds," according to the *Chicago Defender*.

The newlyweds probably indulged in a brief honeymoon, like the just-married couple Carl Mahon and Starr Calloway at the end of Micheaux's 1932 picture, *The Girl from Chicago,* who sail to nearby Bermuda.

Though it became the cornerstone of his books and films, Micheaux's first marriage had proven disastrous. His second union may or may not have been legally formalized. But he couldn't have acted more wisely in choosing the One True Woman who became the third Mrs. Micheaux.

Got to keep going!

That was Micheaux's motto. Anything for the sake of his work, his career, his art. Some scholars emphasize the scoundrel side of his character, but at times he suffered more than anyone he disappointed. After his marriage, months passed before Micheaux was able to muster the funds to produce another film. At one point he was down to five cents in his pocket, recalled actress Shingzie Howard, who was still helping out in the Harlem office.

Micheaux was traveling frequently between Chicago and New York in this period, and at a certain point he found himself on a train to New York without enough money for food. Some children a couple of rows away from him had an apple and an orange, and when the train lurched, a piece of fruit fell to the floor and rolled toward Micheaux. He snapped it up when no one was looking; it would be his only nourishment on the trip. "When he got to New York," recalled Howard, "all he had was a nickel, and he called his wife and she came to the station to get him."

Micheaux was pitching investment in his future to doctors and lawyers, with one hand; with the other he was borrowing pocket money from friends for daily needs. "He'd borrow from anyone he knew," the actress recalled. "He'd borrow from me. He had an awful hard time."

In public Micheaux always seemed a big, cheerful man, made of India rubber. But his good humor was a pose as well as a philosophy, and the strapping physique was deceptive. Because Micheaux never had money to spare, "his eating habits were poor, very poor," Howard said, and that contributed to chronic health conditions—stomach and digestion troubles, terrible hemorrhoids, lingering attacks of the blues.

Micheaux spent most of late 1926 and early 1927 in Chicago, se-

questered at the Alpha Hotel on the South Parkway, where, according to newspaper reports, he was confronted by "pressing business" of an unspecified nature. While there, he put the finishing touches on a fresh script set partly in Chicago's Black Belt.

It's ironic that, at this juncture, Micheaux concocted his archetypal fantasy involving a black millionaire—a man who has dared to venture "far from the haunts of his race," according to publicity synopses, landing in Buenos Aires, where Micheaux himself had visited in his portering days. Land is tamed, fortune acquired. After fifteen years in a foreign land, "his heart anxious and hungry for that most infinite of all things— woman," the newly wealthy black adventurer returns to America to search for his One True Woman. Unfortunately, the woman he finds, a beautiful cabaret dancer, also happens to be the concubine of an underworld beast known as "The Lizard."

Micheaux shot the bulk of this production, which could have been titled "The Homesteader Goes to South America," in and around Chicago early in 1927, staging the musical sequences at the famed Dreamland Gardens on State Street—the dance hall that was home to Louis Armstrong, Ethel Waters, Alberta Hunter, and other stellar performers—and at the Plantation Cafe, where the house band was Dave Peyton's Orchestra.

The new project would star J. Lawrence Criner, a stalwart character man for the Lafayette Players; Criner often played heavies onstage and in race pictures, but Micheaux cast him against type here as Pelham Guitry, the heroic South American fortune-seeker. Grace Smith, who had made her first appearance for Micheaux in *The Spider's Web*, was an all-around entertainer who danced and sang with her own vaudeville act, the Four Buddies; here she'd portray the oppressed cabaret dancer. The villainous Lizard was portrayed by the Venezuela-born Lionel Monagas, who had just scored a career breakthrough as a bellhop falsely accused of raping a white woman in *Appearances*, a meaty drama that was among the first Broadway plays written by a black playwright.*

Cleo Desmond, William Edmondson, S. T. Jacks, and E. G. Tatum had supporting parts in the picture, which also boasted walk-on appear-

* "Because of his fair skin and Venezuelan background," wrote Bernard L. Peterson Jr. in his authoritative *Profiles of African-American Stage Performers and Theater People, 1816–1960,* Monagas "was thought by the White cast to be White himself, since it was the custom at that time for Black roles to be often played by White actors."

ances by *Chicago Defender* publisher Robert S. Abbott and his wife, Micheaux acquaintances since his homesteading days. As Micheaux foresaw, the Abbotts' cameos garnered the film plenty of free publicity in the *Defender.*

Though the main photography was finished by spring, theaters wouldn't get the new Micheaux offering until Thanksgiving 1927. The intervening six months were consumed by a "seven-thousand mile trip by auto through the South," according to the *Defender,* where Micheaux "lined up the bookings of his films for the coming season." Winding up his trip in Chicago, where he showed local theater owners his first new picture since *Body and Soul,* Micheaux paid another ceremonial visit to the *Defender* offices. "The motion picture magnate was somewhat gleeful over the outlook for the coming season with his master photoplays," reported the paper in September 1927.

But the filmmaker's gleeful public façade was as far a cry from his fragile reality as the final title he chose for his latest film: *The Millionaire.* By the end of 1927, Micheaux was practically drowning in debt.

Three unrelated factors had converged to threaten Micheaux's future in film.

The first was the October 10, 1927, premiere of a motion picture Micheaux had nothing to do with. Warner Bros.' *The Jazz Singer,* the first feature-length "talkie," was the opening shot of a show business revolution, as Micheaux would have appreciated instantly. (He knew the lead actor, the blackface performer Al Jolson, from his own theatergoing.) *The Jazz Singer* was a milestone "fraught with tremendous significance," as Robert Sherwood proclaimed in *Life.* "The end of the silent drama is in sight." And with it, no doubt, the end of silent race pictures.

Micheaux, who had to finagle bookings in the best of times, now had to scurry around frantically to get his silent pictures into theaters before they switched over entirely to sound. Silent films were not yet dead in the fall of 1927, but they had received a terminal prognosis with only months to live. Micheaux's old pictures, which he constantly (and profitably) recycled to black theaters, were about to lose all their future value.

The second circumstance also involved Hollywood and black faces. Although Evelyn Preer long had a career independent of Micheaux, in

recent months she had taken steps that would finally put her beyond his reach for good. After finishing *The Spider's Web,* the multitalented actress had been cast by David Belasco in his extravagant production of *Lulu Belle,* a much-ballyhooed play about "colored life" that opened on Broadway early in 1926 and then ran for a year. Preer was acclaimed for her featured role but also for understudying the lead, Lenore Ulric. Following that triumph, Preer joined her husband Edward Thompson (a fellow *Lulu Belle* alumnus) in another smash hit, the musical revue *Rang Tang.*

Preer's first loyalty was to the stage. In early 1928, when she learned that Robert Levy was organizing a company of veteran Lafayette Players to go to Los Angeles, Preer and her husband were among the first to volunteer for the adventure. Others heading west included Cleo Desmond, J. Lawrence Criner, Laura Bowman and her husband Sidney Kirkpatrick. All the "new" West Coast Lafayette Players had appeared in "old" Micheaux films.

The Players took up residence in the new Lincoln Theatre on Central Avenue in Los Angeles in April 1928, opening with a production of *Rain.* Preer starred in the part Jeanne Eagles had immortalized on Broadway. "It was the dawn of a new day for the Negro in Hollywood," Ina Duncan, the famous musical revue dancer, told the black press. The West Coast Lafayette Players became an instant sensation: Charles Chaplin, Gloria Swanson, Harold Lloyd, and other Hollywood worthies were spotted among the capacity crowds who came to cheer the performances and line up backstage afterward to congratulate the troupe. And before long the Players' dressing-rooms were thronged with casting agents from the major Hollywood studios.

Sleepy Hollywood was slowly waking up to black America. When an actor whose name was known to black audiences played even a minuscule role in a major studio production, no matter how caricatured the part— even a maid or shoeshine "boy"—black fans streamed to white theaters in Northern cities, and the sub-run theaters dotting black neighborhoods further augmented the studio's box office. Character parts that didn't rub up against the tender sensibilities of Southern whites were becoming more common, almost fashionable in Hollywood.

Micheaux couldn't compete with the Hollywood offers, which were lavish by his standards and which came in urgent telegrams accompanied by travel vouchers. Ida Anderson, who had performed in *A Son of Satan* for Micheaux, wrote to the white race-picture producer Richard E. Nor-

man in 1923, declining a role in one of his planned productions. Anderson was currently receiving forty dollars per day, "including concessions," from the Lasky and Selznick studios, she told Norman. "If you could get $45 or $50 a day [in race pictures] you were getting big money!" recalled actor Leigh Whipper, who appeared in films directed by Micheaux. "We used to go over to Fort Lee, N.J. and work there for $5 and $10 a day." Lawrence Chenault, who often starred for Micheaux, received $75 to $125 a *week*.

And Hollywood's terms rose steeply with sound. The studios began producing a flurry of "talkies" targeting black audiences, often singing-and-dancing "short subjects" designed to precede the major attraction. The studios sought out "fresh" black faces they could claim as their own discoveries—preferably stage-trained actors, because it was thought that "types" recruited from the street or the lot "cannot remember the lines and are subject to mike-fright," according to one skeptical fan-magazine article on the new "ebony heroes," penned by a self-described white "daughter of Dixie."

The West Coast Lafayette Players were well positioned to satisfy this sudden craving. Yet Hollywood relegated many of even the most schooled black thespians to "Negro dialect" humor, or background singing in nightclub scenes. The Christie Film Company offered Preer and Thompson a thousand dollars a week for a series of shorts based on the Old South stories of Octavus Roy Cohen, a story writer for the *Saturday Evening Post, Collier's,* and other magazines. Lafayette Players like Laura Bowman and Sidney Kirkpatrick also found steady employment in studio music departments, singing in Bebe Daniels and *Amos 'n' Andy* vehicles.

Although Cohen's Negroes were meant to be sympathetic, they were invariably uncouth and prone to dumb comedy. And the skin of the first lady of race cinema had to be "darkened beyond the duskiness of her natural make-up" for the series, according to a 1929 article in *Motion Picture Classic.* ("When she spoke off-stage, her voice was as cultured as Jeanne Eagles's and bore none of the dialect she had affected before the microphone," reported the magazine.) The Christie comedies, according to Preer's daughter, Sister Francesca Thompson, "might be considered throwbacks to the minstrel style or the 'coon shows' of the nineteenth century."

Indeed, Preer "broke her contract" with Christie after only three such pictures, according to Thompson, "refusing to continue to wear blackface makeup, or to speak in the fractured English required." Over time Preer

would play other small parts at nearly every major studio. The lucrative Hollywood moonlighting permitted the actress to continue onstage at the Lincoln Theatre on Central Avenue, performing everything from Shakespeare to Gilbert and Sullivan.

One thing was certain: Evelyn Preer had starred in her last Oscar Micheaux picture. She had been Micheaux's favorite leading lady, his greatest star, his only guaranteed box-office draw. And, as it turned out, she was irreplaceable.

Micheaux's growing conflict with his brother Swan was his third problem, and just as irreparable.

Like his brother, Swan Micheaux had a taste for fame. His earliest press notices, written when he first joined the Chicago office, portrayed Swan not as a junior officer, but as a take-charge business executive who was destined to play a key creative role in the company. Swan supplied a publicity photo of himself to newspapers and posed for advertisements for Carter's Little Liver Pills. He dabbled in real estate. He gave only occasional interviews, but he was as garrulous and glib as his brother, and the press found him quotable. "The [race-picture] game is too fast for slow thinkers," he told one reporter. "There must be quick action regardless of cost, all hours working hours, every day a working day."

When Micheaux brought Swan to New York in 1926, he was hoping to rein in the crooked salesmen and booking foul-ups. It is hard to know how many of these persistent problems could be fairly blamed on Swan, or whether Micheaux was growing paranoid and looking for a scapegoat. But Micheaux thought Swan was incompetent or dishonest or both, whereas Swan thought he was underpaid and deserved greater opportunity.

The tension between the brothers was aggravated after Micheaux's marriage to Alice B. Russell. The new couple took bigger living quarters on Morningside Avenue and Mrs. Micheaux joined the business, now headquartered in the modern Harlem Center building at 135th and Seventh Avenue. Swiftly, she became the conduit of all important financial (and, soon enough, creative) decisions. Furious, Swan stormed out of the office in the winter of 1926–1927, temporarily accepting a post as manager of the New York branch of the Agfa Raw Film Company.

In late 1927 the acrimony between the brothers accelerated and broke out into the public forum. Micheaux had just returned from another extended stay in Chicago, where he had finished editing *The Millionaire* and then quickly shot another film, *Thirty Years Later*. That October, eager to get *The Millionaire* approved by the New York State censors, Micheaux consented to numerous cuts in every reel of the nine-reeler, except for reels 7 and 8—mainly offensive intertitles, or scenes of drinking, gambling, violence, or sexy dancing. In early December, however, inspectors got a tip to visit the Lafayette Theatre in Harlem, where *The Millionaire* was being shown—in a mint print, without any of the censors' deletions.

Curiously, the theater manager, Peter Eckert, worked for Micheaux on the side; his name even appears on the documents submitting *The Millionaire* for censorship review. When the print was seized, Eckert was fined; he responded by suing Micheaux, claiming that he'd been duped into showing an uncensored print.

In a fury, Micheaux fired off a letter to the censors. Insisting that his company had been made "the victim of an organized effort to get possession of and to exploit our films"—not just *The Millionaire*, but "at least one print of all the pictures we make"—Micheaux fingered the man he maintained was the real culprit. "This plot was engineered and has been directed by the former General Manager of the concern, whose name you may observe at the bottom of this page"—Micheaux could not bring himself to identify his own brother, still conspicuous on the letterhead. Swan had been aided by "the trickery of his associates," Eckert and others among them. Having secured "temporary possession" of the original print of *The Millionaire*, they were circulating it to New York theaters without the stipulated cuts, or Micheaux's approval.

At the moment, his younger brother was hiding out somewhere in New York. "Although I have a summons out and papers to haul him into Court," Micheaux added bitterly, "we cannot lay hands on him."

The only legal papers that survive this imbroglio indicate that Micheaux lost the Eckert case, with the court levying damages of $331.66 against him. Eckert then *bought* the print of *The Millionaire* at public auction for two hundred dollars.

If Swan was indeed hiding out in Harlem, he didn't stay concealed for very long. Within three months he had organized his own Dunbar Film Corporation, opening offices on Lenox Avenue not far from those of his more famous brother. Swan "is not connected with his brother Oscar

Micheaux," the press accounts stated plainly, "any more." By the end of April, Swan had actually produced his first race picture, *The Midnight Ace;* its actors—A. B. DeComathiere, William Edmondson, and "discovery" Mable Kelly (Miss Lincoln of the Howard–Lincoln 1927 football rivalry)—were recruited directly from the cast of *Thirty Years Later.*

Besides stealing his brother's actors, Swan successfully rallied Micheaux's remaining staff against him. By then, Micheaux's employees had lost all hope of obtaining the back wages their boss owed them. Peter Eckert was the president of the Dunbar Film Corporation; as the secretary and treasurer Swan secured Bertha Elwald, formerly Micheaux's secretary. And John Wade, Micheaux's onetime Man Friday on the road, was director of the new company's first film.

The coming of sound, the desertion of Evelyn Preer and other Lafayette Players, and the nasty bust-up with his brother—all of this combined to overwhelm Micheaux. No wonder, on February 8, 1928, the race-picture pioneer filed for bankruptcy, a voluntary maneuver intended to protect his meager assets while staving off collapse.

The filing in New York's Seventh District Court demonstrated just how undercapitalized Micheaux's corporation was, after a decade of scrimping and scraping. The bankruptcy papers listed the acknowledged assets of the corporation at $1,400, with liabilities at $7,837. The worst liabilities, according to published records, were "to cover securities to creditors," $2,930; "to unsecured credit given," $1,600; "to wages," $1,125.

The news flashed across the nation in headlines in black newspapers. "Despite the filing of bankruptcy proceedings," reported Baltimore's *Afro-American,* "Mr. Micheaux is busy seeking bookings for films at present, and it is felt by those who are acquainted with the workings of the defunct corporation that the promoter has been able to retain his hold on many of the numerous productions set on celluloid." The newspaper announced that Alice B. Russell had been appointed the new general manager of the corporation, and "now controls many of the reels" of past and forthcoming Micheaux pictures.

The "one-man corporation" was now a thing of the past, along with brotherly love and silent pictures. Now the Micheaux Film Company was a one-man, one-woman corporation, a husband and wife enterprise.

CHAPTER THIRTEEN

1928–1931
A MIRACLE
REBOUND

In 1928, two Micheauxes would vie for theaters, audiences, and the accolades of the press.

Despite his bankruptcy, older brother Oscar managed to finish two pictures in the wake of the break-up with his brother. Both were silent: *Thirty Years Later,* shot in Chicago in late 1927, and *The Broken Violin,* produced early in 1928 amid the court filings. The first was adapted from the stage, while the latter was another Micheaux original.

The source for *Thirty Years Later* was Henry Francis Downing's play *The Racial Tangle,* which had been presented in Chicago in 1920 by a touring company of the Lafayette Players. Micheaux couldn't help but admire the redoubtable life of Downing, a black American whose career included diplomatic service as well as the authorship of poetry, fiction, and plays—much of it preoccupied, like Micheaux's work, with the topic of "passing."

Downing's cousin had served as president of Liberia, and after the Civil War, Downing himself lived in the African republic for several years. After a posting as U. S. consul to St. Paul de Loanda in Portuguese West Africa, Downing had moved to London; he lived there for two decades, married to a prominent white Englishwoman. While in London, Downing also had written, besides his plays and poetry, a novel called *The American Cavalryman,* set in Liberia. In the mid-1920s, Downing moved back to the States, and lived in Harlem, near Micheaux.

Micheaux was friendly with the octogenarian, who remained an out-

spoken advocate of American support for Liberia.* Micheaux had family ties and political sympathies with the African nation, and after he was done with his adaptation of Downing's play he thought he might film the author's Liberian novel.

The "passing" in *Thirty Years Later* was done by a man: a rich white man (William Edmondson) posing as a man of color in order to woo a beautiful "race girl" (Ardelle Dabney), only to discover that he is actually the son of his Negro housekeeper, whom he had previously scorned. Advertising a story as "patterned after Alice Rhinelander's famous case" had worked magic once before, and Micheaux tried it again to boost ticket sales. (Though it was more of a stretch for *Thirty Years Later*, "the Rhinelander case" was practically a byword in the black press, which referenced the 1924 story with each new headline scandal involving mixed-race romance.)

The Broken Violin was more intriguing, a melodrama about a gifted young violinist, the daughter of a washerwoman and an abusive, alcoholic father. For this film Micheaux carried over some of the cast members from *Thirty Years Later*, including Ardelle Dabney, who had been associated with W. E. B. DuBois's Krigwa Little Theatre movement. The other cast members included the brothers Salem Tutt Whitney and J. Homer Tutt, and Alice B. Russell herself, making her first known appearance in one of her husband's films.**

Neither of Micheaux's 1928 pictures circulated widely, and both are "lost" today. At the time, columnist Obie McCollum of the *Afro-American* found *Thirty Years Later* "the best [film] put out by the pioneer" yet, in spite of its catchpenny limitations ("Why does the heroine not 'sport' a few more changes of clothing as almost any New York stenographer in real life would?" McCollum complained).

For every booster like McCollum, though, there was a more dubious critic. And the skeptics had an opportunity to compare the brothers Micheaux in October 1928, when the maiden Dunbar Film Corporation production, *The Midnight Ace*, held its New York premiere. The story as well as the casting bore Oscar's influence, though Swan Micheaux neither wrote nor directed. Some sources indicate the director was indeed John

* Downing died at age 82 in February 1928, shortly before the release of *Thirty Years Later*.
** But records are spotty and it is possible Russell, immediately after her marriage to Micheaux, took roles in *The Millionaire* and *Thirty Years Later*, which preceded *The Broken Violin*.

Wade; others propose A. B. DeComathiere, who also starred as the "Midnight Ace," a clever race detective who solves a series of robberies hatched by a criminal mastermind.

Though *The Midnight Ace* supplied only "fair" entertainment, as one of the Micheaux skeptics, Sylvester Russell, wrote in the *Chicago Defender*, "it is a slight improvement on his brother, Oscar." It's impossible today to second-guess such judgments, since *The Midnight Ace* is another "lost" Micheaux film, albeit one of Swan's. But Swan's publicity was every bit as grandiose as Oscar's. Declaring his new company to be fully capitalized, he announced plans to follow up with an ambitious series of motion pictures at a record pace. "Film Corporation To Make Picture Every Six Weeks!" vowed the publicity.

Brother Oscar, who'd spent much of 1928 in the dumps, followed Swan's notices in the press, seething with anger and resentment. "I came on with Micheaux after Swan had left," remembered actor Lorenzo Tucker, "so I don't really know what went on between them. But there was bad blood, you could tell."

No doubt Micheaux was already planning his characteristic revenge—in the form of a new quasi-autobiographical film.

Tall, handsome Lorenzo Tucker would become Micheaux's newest on-screen surrogate. Born in Philadelphia, educated at Temple, Tucker had danced in Atlantic City and stinted as a straight man in vaudeville before landing parts with a Lafayette Players touring company. Tucker was at the Dunbar Theatre in Philadelphia in the spring of 1927, trying out for the chorus of *Rang Tang*, when Micheaux arrived to see Evelyn Preer.

Tucker, who had never heard of Oscar Micheaux, paid little attention to the big, well-dressed stranger heading toward the back rows where Tucker was seated. "If you passed him [Micheaux] on the street," Tucker recalled, "you'd say, 'Look at that big lug!' He had a very pleasant face and lumbered along because he was a huge man, about 6'3" tall and well over two hundred pounds. He wore a black homburg hat and his overcoat was dragging the ground. Nothing was right. He walked like he had two left feet."

Glancing at Tucker as he passed by, the big pleasant-faced man

slipped into a seat behind the young actor and tapped him on the shoulder, proffering a business card. "I make movies," said Micheaux, baring his winning smile. "If you ever want to act in movies, look me up."

Tucker wasn't particularly interested in movies. Vaudeville and road shows paid better, he reckoned. But he didn't make it into the chorus of *Rang Tang,* and Micheaux already knew that when they bumped into each other on the street in Harlem, weeks later. Micheaux invited Tucker up to his office, offering him a part in his next film, "The Fool's Errand," one of those "ghost films" no one is quite certain ever came to life.

According to early news items, Micheaux had begun filming "*A* Fool's Errand" back in 1923. But the director may have shelved that project: Tucker was certain that "*The* Fool's Errand" was restarted, and perhaps even completed, in late 1927 or early 1928, though he couldn't recall much about the script or circumstances of production. Interviewed for Richard Grupenhoff's biography, *The Black Valentino: The Stage and Screen Career of Lorenzo Tucker,* Tucker remembered that Micheaux "had enough capital to finish shooting the film, but his funds ran out while the film was in the middle of postproduction, and he didn't have enough money to pay the processing lab for its work." Time passed, and the lab took possession of the print. More time passed, and the lab "decided to edit the film, shoot the title cards, and distribute the completed product themselves . . ."

"The Stern Labs called me up," Tucker continued, "and offered to pay me to come down and write the titles, since I knew what the script was about. So I went to Micheaux to get his permission."

Micheaux glared at him. "Hell," the race-picture pioneer said finally, "I don't care what they do with it."

"Then you don't mind me doing the titles?" Tucker said.

"Are they paying you?" asked the ever-practical Micheaux.

"Yes."

"Good," said Micheaux. "Get as much as you can from them."

As far as is known, the lab sent the finished reels to South American theaters.

Be that as it may, Tucker was emceeing a cabaret in Saratoga Springs in the spring of 1928 when a telegram arrived from Micheaux. "The telegram said something like: 'Role for you in film. Start next week. Get your suit out of hock,' " the actor told his biographer. "See, those were the days before we had actors' unions, and we had to provide our own

costumes for many of the roles we were cast in. And often between shows we had to hock our suits to get money to live on until our next show."

This time, Tucker was going to play a race-picture producer named Winston Le Jaune—Micheaux by another name—in the most brazen installment yet in the director's ongoing life-on-film.

The Wages of Sin would open with Le Jaune in mourning at his mother's gravesite in a small prairie town, vowing to take care of his ne'er-do-well younger brother Jefferson Lee. Le Jaune employs J. Lee and brings him to teeming Chicago, where his brother embezzles company funds and squanders money on alcohol, gambling, and loose women. Though forced to fire his brother—and then to work overtime to resuscitate his business—Winston remembers his pledge to his deceased mother and decides to reconcile with his brother. But even after Winston rehires him, J. Lee nurses a grudge, and schemes to betray and destroy Le Jaune.

In the summer of 1928, even as Swan was planning the premiere of *The Midnight Ace,* Micheaux was busy filming this scenario attacking his brother. There was no ambiguity about Micheaux's casting: William A. Clayton Jr., whose glowering face and piercing eyes had typed him as a villain ever since his noteworthy debut in the race picture *A Prince of His Race,* would portray J. Lee, the Swan Micheaux figure. The employee torn between two brothers would be played by Baltimore actress Katherine Noisette, who had captivated Chicago when touring with a Lafayette Players troupe. Also in the cast were Ardelle Dabney and Alice B. Russell.

On the set, Micheaux radiated an intense focus. He "reminded me of a symphony orchestra leader," Tucker recollected. "He could get down behind the camera, or on the side, and it was like the director with his baton. Every moment of the action [he'd follow] with his body; he would wring and twist, and naturally when there was sound he couldn't talk, make [a] sound; he would just be ready to burst. He would just . . . Ooo . . . he'd look at you; if it was anger [he wanted], like my god, [you'd think] I'd better give this guy a [good] job!"

The Wages of Sin was rushed into theaters in February 1929, just in time to take the edge off Swan's plaudits. And Oscar's version of the split with his brother made for a fascinating, passionate film that drew reviews as glowing as any he had earned since *The House Behind the Cedars.* "One of the best to be shown here in a long time," said the *Pittsburgh Courier,* "well worth seeing." "An interesting and dramatic story," echoed the *New*

York Amsterdam News, "one of the finest pieces of work ever produced by the colored motion picture makers."

One can only guess at how truthful *The Wages of Sin* was in its blanket condemnation of Swan. Autobiography, for Micheaux, had become an increasingly crafty, nearly indivisible blend of fact, fiction, and public relations.

Micheaux's brother did not respond in kind. In fact, Swan Micheaux never produced another picture after *The Midnight Ace.* All the publicity for Swan's Dunbar Film Corporation had been so much grandstanding. The "Picture Every Six Weeks" never happened. As Micheaux well knew, producing a race picture was a snap compared to booking one into theaters, circulating several prints around the nation, sidestepping censors and critics, and crossing one's fingers for profits.

"Any time any other company would start up—like the Goldbergs, which was a white company—he would laugh," remembered Tucker. "He'd say, 'Well, they're spending too much money.' He knew to the penny how much to spend on a production, because he knew what he could get back."

The bad blood between brothers was permanent. Micheaux never again mentioned Swan by name. He dedicated later novels to his wife, his mother-in-law, his sisters, practically every family member except Swan, who disappeared as a character in his stories and films. With *The Wages of Sin,* Swan Micheaux was erased from his older brother's life.

In like fashion, Swan erased himself from the race-picture field soon thereafter, returning home to Great Bend, Kansas. His wife left Swan after their daughter came of legal age, and he briefly returned to Harlem in the early 1940s, earning a living as a carpenter and odd jobs man. Some unconfirmed reports suggest that a house fire may have ravaged him financially. He ended up back in Kansas, doing house and lawn work. He drank to excess. Declared mentally incompetent, Micheaux's younger brother was in and out of state institutions before his death in 1975.

Swan Micheaux was a quitter. Not his brother Oscar.

Censors dogged his heels. Films were abandoned in labs and theaters. Checks bounced.

Got to keep going!

In at least one city, Baltimore, Micheaux's check-kiting caught up with him; Micheaux was served with papers, his print of *Thirty Years Later* confiscated by authorities until the penalties were paid.

Despite his constant problems, Micheaux fed sunbeams to the press. When Chappy Gardner of the *Pittsburgh Courier* found him at his favorite Harlem eatery, Tabb's, after the New Year, "the pioneer of Negro films" insisted that "in every city where they are shown crowded houses greet" his films. Micheaux was busy directing his latest project, featuring "the best actors and some of the prettiest and brainiest of our feminine kind," wrote Gardner.

That was *When Men Betray*, made in New York in early 1929, with a cast recycled from *The Wages of Sin:* Lorenzo Tucker, William A. Clayton Jr., Katherine Noisette, Alice B. Russell. Even the story sounded vaguely similar: two Chicago brothers, one a cad, fall in love with the same sweet girl; the young innocent chooses the cad, who deserts her on her wedding night, leaving her desperate and vulnerable to misfortune.

It would be Micheaux's last pure silent film. And what little is known about *When Men Betray* comes, not surprisingly, from the censors. The Pennsylvania State Board complained about Noisette's "nude form from waist up, after she has removed [her] pajama jacket," the unsavory character of a "deacon," and "close-up and near views" of two actresses clawing at each other's faces (the old, crowd-pleasing "catfight"). Micheaux agreed to make changes, but the print was seized and Micheaux fined after *When Men Betray* was discovered in theaters with an inauthentic Pennsylvania seal.

The mask he offered to the public might have been cheer and confidence. But Lorenzo Tucker also noticed how badly Micheaux suffered from the stress and strain. More than once, Tucker watched as the filmmaker stretched out on a couch, right in the middle of photographing a scene, sometimes lying there even while calling the camera takes. Among other ailments, he was beleaguered by chronic stomach pain. While on the set, Micheaux would swallow handfuls of raw starch from an Argo box, "keep tossing it in his mouth as if it were peanuts," Tucker recalled.

"What's wrong with you?" Tucker asked him once.

"Oh, don't bother me," the director replied. "Nervous indigestion. You make me nervous!"

"Everybody made him nervous," Tucker concluded.

His money problems forced Micheaux to make films even faster, in the late 1920s, cutting back on multiple takes and rehearsal time. Tucker recalled pleading with the director for more rehearsal. "You young actors!" Micheaux would shout at him. "I don't know what I'm going to do with you. What's the matter, Tucker, you can talk, can't you? And you can walk, can't you? Well, then, let's shoot the scene!"

No matter how fast he churned out the pictures, there were never enough bookings. And Micheaux no longer had any sales force, only himself. True, his wife was able to help with practically everything else. Alice B. Russell was the perfect complement to Micheaux: A discerning reader, she listened to his stories as they evolved and edited his scripts. Well-organized, already acting as de facto producer of his films, she assisted her husband in every possible way on the set and whispered to the actors after he was done shouting. She was taking more significant acting roles. A natural diplomat, she could represent his films to censors, especially in all-important New York State.

But Micheaux knew best how to sell his pictures, and when he was on the road the finances were in suspense.

By mid-1929, only about 3,500 of the nation's twenty thousand movie theaters were wired for synchronized sound, but those 3,500 were doing about 75 percent of the box office.

Sound was the trend, and all the black theaters were mad to catch up. No race-picture producer had yet made an "all-talking" picture. Micheaux was the leading candidate, but he was daunted by the risk and expense. Quite apart from the costs, which he would have to shoulder alone, he faced all the transitional difficulties that Hollywood took years to solve: coping with an adjusted acting style that relied more heavily on dialogue; retreating indoors to controlled soundstages (Micheaux had always relished exteriors); restraining his camerawork, as his newly paralyzed actors hovered near the dangling overhead microphones.

In the chaotic wake of *The Jazz Singer,* Micheaux lit upon the same temporary solution as his Hollywood counterparts: His next two pictures would be "part-talkies," with a few musical numbers spicing up the mainly silent stories.

Both would star Lorenzo Tucker. Micheaux was determined to build

up Tucker into "The Colored Valentino." The mystique of Hollywood's dark romantic idol, who had died abruptly in 1926, was still strong.

Like other Micheaux regulars, Tucker was expected to make personal appearances at big-city premieres as part of his contract, with Micheaux paying train fare and other expenses. Often Tucker was sent to his own hometown of Philadelphia, where he'd take the stage to address the crowds and sign autographs before showings. Micheaux took a fatherly interest in the younger man, reminding him to visit his mother while he was in town. And if Micheaux was in Philadelphia without Tucker, *he'd* stop by and greet Tucker's mother, telling her, "Don't worry, I'm looking after him. He's doing well."

Audiences were happy to meet Tucker, but it was just as vital for black exhibitors to shake his hand. They might shell out bigger advances if "The Colored Valentino" was going to star in the next Micheaux film.

"In those days, Rudolph Valentino was very, very popular," Tucker recalled in one interview. "They said I looked like him. I did look a little like him, but to me, personally, I didn't think so."

"If you really want to know," the actor mused another time, "I was even lighter than Valentino himself."

The irony was bittersweet: Tucker was "lighter than Valentino," but his light skin prevented him from getting higher-paying jobs in Hollywood pictures. The white studios had what film historian Donald Bogle has called a "blackface fixation." Thus Micheaux's "passing" theme had a professional corollary in the Hollywood system; and other Micheaux actors like ex-Lafayette Players Andrew Bishop and Charles Moore ran into the same dilemma as Tucker. They might have played "white" characters in Micheaux films, but they were considered "too white" for the Hollywood studio producers "searching for dark subjects with bulging eyes and thick lips," according to Chappy Gardner in his *Pittsburgh Courier* column.

"I never got any white press at all," Tucker recalled, "and very few people outside of the black community ever heard of me."

Then, when someone like William Fountaine, who had a medium complexion, lucked into a Hollywood part, his background with Micheaux was trivialized. Though he had been the leading man in Micheaux's *The Dungeon* and *The Virgin of Seminole,* the MGM press release for *Hallelujah!* claimed that Fountaine was "discovered on the street" in New York by King Vidor, who promptly "sent him to have a

screen test." Fountaine would be cast as the shady gambler Hot Shot in Vidor's "all-Negro" feature, a rarity from a major Hollywood studio.

"Lorenzo Tucker's light complexion was perhaps the central anomaly of his life," wrote Richard Grupenhoff in *The Black Valentino: The Stage and Screen Career of Lorenzo Tucker*. "Although he had black blood in him, he was light-skinned, and he could have chosen to pass as white and hide his ancestry. Instead, he remained true to his heritage, a decision that often left him stranded between the two worlds of black and white."

Micheaux never found another leading lady with the histrionic talent and marquee wattage of Evelyn Preer. But under his rough tutelage, the dapper, likable Tucker emerged as his most reliable leading man.

The two "part-talkies" were *Easy Street* (which some scholars believe was a remake of Micheaux's earlier "ghost" film, "Jasper Landry's Will") and *A Daughter of the Congo* (Micheaux's adaptation of Henry Francis Downing's Liberian novel). Their filming was spread out over late 1929 and early 1930.

Easy Street was a Harlem story involving a gang of city slickers who swindle an old man. The oldster was played by Richard B. Harrison, a son of fugitive slaves, born in Ontario, who had toured Canada and the United States as early as the turn of the century, presenting recitals of Shakespeare, literature, and poetry. Once again Micheaux's casting acumen was ahead of the white world, which didn't hear about the sexagenarian actor until February 1930, when the musical Biblical fable *Green Pastures* opened on Broadway. Harrison's bravura performance as De Lawd, which led an all-black cast, convinced many critics he was actor of the year.*

Besides Tucker and Harrison, the cast featured William Clayton Jr. as a sinister criminal and member of the gang—which was headed by Alice

* A unique musical combining comedy, drama, fantasy, folklore, and spiritual reflection, with some ninety-five black performers among the cast and chorus, *Green Pastures* was hailed by critics, including J. Brooks Atkinson of the *New York Times,* who said it was "best described as Uncle Remus's 'Story of the Bible.' " Harrison played De Lawd on Broadway, road, and revival companies for a total of 1,675 performances, before collapsing in his dressing room before the show at the Mansfield Theatre in 1935, dying shortly thereafter.

B. Russell, proof that Mrs. Micheaux's parts were growing and branching out in variety.

If *Easy Street* was a kind of chamber work, *A Daughter of the Congo* was a grandiose project, a loose rendition of Henry Francis Downing's 1917 novel *The American Cavalryman,* which required an exotic "African" setting, a large cast of principals and extras, aerial scenes, and singing and dancing numbers. Katherine Noisette would head the cast as a beautiful mulatto, lost as a baby in Africa. Her father was Charles Moore, who makes a fortune as a New York banker "passing" as white. (When his sister tells the banker that he should be ashamed of his racial deceit, he blithely explains, "There are thousands of Negroes doing the same thing.") Comes word from Liberia that the mulatto child has been identified as a female Tarzan, brought up by natives, now grown into a beautiful jungle woman. On her way to marry a powerful tribal chief (Salem Tutt Whitney), the mulatto and her female companion (Wilhelmina Williams) are captured by Arab slave traders. Her father will pay anything for her rescue. The heroics fall to a U.S. cavalry officer (Lorenzo Tucker) loaned to the African republic.

All this, however, would have to be realized on a rock-bottom budget. Micheaux had to trick up a faux Africa inside a studio, and shoot his aerial scenes over Long Island. "We spent hours taking off and landing in those old biplanes," recalled Tucker. "It was dangerous, but it was exciting too. And we flew all over Long Island, as another plane followed alongside us with a camera and shot us looking over the side, like we were searching the jungles below."

A Daughter of the Congo was shot at warp speed and then propelled into theaters in the spring of 1930. Micheaux was desperate to pump up his cash flow, now down to a trickle. He was also desperate to circumvent the hassles of censorship. Censorship entailed costs, delays, and inevitable deletions of the very un-Hollywoodlike highlights that Micheaux had embedded in the African film, to stir what he liked to call "mouth to mouth advertising": the scene straight from Downing's novel, for example, where the mulatto and her friend take a dip in a jungle pool, "with breasts unduly exposed," in the words of the eventual censorship report.

The opening was set for April 5 at the Renaissance, the only major Harlem theater run by black men, the Charity brothers. But state censors shut the picture down after two days, insisting that *A Daughter of the Congo* did not have an up-to-date approval seal. In fact, the new film was

affixed with a seal left over from *The Millionaire;* Cleo Charity, the theater's manager, claimed that Micheaux had assured him that the correct seal was forthcoming.

The morning after *A Daughter of the Congo* was pulled, agents for the state censorship board arranged to meet with Micheaux at the Renaissance. The race-picture pioneer "admitted that he rented this picture to Mr. Charity, and also admitted freely that he was entirely in the wrong in having rented for exhibition this picture before it was licensed. He and Mr. Charity agreed to take the picture from the screen that day."

When the suspicious agents returned later in the afternoon, however, *A Daughter of the Congo* was still on the marquee, and still playing to audiences. This time, when they tracked Micheaux down, he claimed that he'd spoken personally with the head censor in Albany, who gave him special permission for temporary exhibition. The agents tried to contact the head censor, who was on a train, incommunicado. They didn't sort it out until April 10, and when they did they concluded that Micheaux never had spoken with the censor.

The unlicensed film was ordered withdrawn, and Micheaux was forced to make cuts. In the meantime, *A Daughter of the Congo* had sold to capacity in Harlem for five days.

Audiences lapped it up, but this time the critics ganged up on Micheaux with a vengeance, calling his latest production cheapjack and humdrum. The black press charged that *A Daughter of the Congo* fell down on all levels, from its story elements to the "part-talkie" technology to its cultural sensitivity. In their eyes, the film lagged far behind the burgeoning achievements of Hollywood, and they blamed the lapse on Micheaux.

"Most of the actors overact, and Mr. Micheaux has succeeded again in distorting a story so that intelligent continuity is destroyed," wrote John Mack Brown in the *Norfolk Journal and Guide.* The musical turn of Daisy Harding, a soprano familiar at Harlem church functions, was singled out by Brown as the film's "one bright spot."

The widely read Theophilus Lewis was even more scathing in the *New York Age,* one of Harlem's two principal newspapers. Though he'd been impressed by Micheaux's previous productions as "the work of a man of remarkable personal ability, handicapped only by a lack of financial resources," Lewis noted, he had been brought up short by the "unpardonable" offenses of *A Daughter of the Congo.*

"The picture is thoroughly bad from every point of analysis," wrote Lewis, "from the continuity, which is unintelligible, to the caption writing, which is a crime."

The crowd scenes were directed as though the performers "had been cautioned to be careful and not knock the camera over," Lewis said. He offered some praise for the intelligent emoting of Salem Tutt Whitney, but dismissed the overall production quality as vastly inferior to Hollywood.

Far worse, according to Lewis, were the racial transgressions in Micheaux's film. The *New York Age* columnist scorned *A Daughter of the Congo* for its "persistent vaunting of interracial color fetishism," raising the issue, like other critics before him, of the director's "artificial association of nobility with lightness and villainy with blackness." Making his own informal tally of the skin colors of Micheaux's characters, Lewis found the balance skewed. "All the noble characters are high yellows; all the ignoble ones are black," he wrote. "Only one of the yellow characters is vicious, while only one of the black characters, the debauched president of the republic, is a person of dignity."

Micheaux's Africans behaved as though they were "preposterously stupid," Lewis complained, whereas even "white movie magnates" in Hollywood had become more "Negro-conscious" lately. Major white-studio productions such as *Three Feathers*, *Thunderbolt*, *Hearts in Dixie* and *Hallelujah!* had made earnest and "honest efforts to present Negro character as faithfully as they present Caucasian character," according to Lewis.

Lewis wrapped up his scolding on a mildly forgiving note. "Every man, no matter what line he works in, has at least one bad job under his hat," the *New York Age* columnist concluded. "Perhaps *A Daughter of the Congo* was the one bad production Mr. Micheaux was booked to make. Now that he has got it out of his system, let us hope he will return to form and repeat his sound work of earlier days."

Micheaux had been accused of many things in his career, but this was the first time he was accused of being shamelessly slapdash. It was a charge that lingers with some critics today—but one that overlooks the sheer force of Micheaux's will power, which kept him going even when dire circumstances threw off his artistic barometer.

Whether *A Daughter of the Congo* was truly wretched, or whether the few who saluted Micheaux's African flight of fancy (the *Pittsburgh*

Courier hailed the picture as "tensely realistic") were more on target, will never be known, unless, by some miracle, a print of the "lost" work should materialize today. Perhaps the only film that could truly measure up to its notoriety would be a documentary about its *making.* "The Making of *A Daughter of the Congo*": That would be a record of daring, ingenuity, chicanery, and tenacity.

Micheaux had made two dozen motion pictures since *The Homesteader.* Barely solvent, he took a thorough drubbing by censors and critics for this pair of "part-talkie" films. Few expected him to rise from the mat.

Micheaux had compounded his problems with his usual ballyhoo, releasing "all-talking" advertisements for *Easy Street* and *A Daughter of the Congo* when the films were really only "part-talkies." *Hallelujah!* and the other recent Hollywood pictures cited by Theophilus Lewis were exciting largely because they were indeed "all-talking, singing, and dancing." Not all members of the black press hailed such major white-studio productions as social advances, however; historian Donald Bogle has pointed out the contrast between white and black journalists' reactions. Many of the latter found fault with the stereotypes in *Hallelujah!,* especially the "spiritual-singing, crap-shooting characters."* But *Hallelujah!* was handsomely produced, using the latest technology—and, indisputably, offered more black faces than usual on the screen.

Most theaters in black neighborhoods wanted to book the latest Hollywood "all-talkies." Many that couldn't afford the changeover to sound simply went bust. According to one report, at one time there were as many as fifteen "race moving picture managers and proprietors" in Washington, D.C. By 1930, there were two.

As "talkies" boomed, race pictures shriveled, and by 1930 there were

* There were reports in the black press that the *Hallelujah!* cast challenged the "objectionable phrases" in the Hollywood script and that their salaries were "one-fifth to one-tenth of what they should have been" for white actors. According to a July 15, 1930 piece in *The Baltimore Afro-American,* one-time Micheaux actor William E. Fountaine had a scene in which he was supposed to call a black character a "big coon." "O, my God!" he complained aloud, "you don't mean for me to say that, I know. Not me. Why, man, I wouldn't dare go back to Harlem."

more black theaters in Washington, D.C. than there were race picture producers in the entire country. The white Southerner Richard E. Norman; the Johnson brothers, Noble and George; Harry Gant and Ira McGowan's short-lived Los Angeles company; Robert Levy's high-minded Reol Productions; the Royal Gardens of Chicago; the Maurice Film Company; and the Colored Players Corporation of Philadelphia—all these and many others gave up the ghost, their fleeting existence all but forgotten today.

Having spurred a gold rush, race pictures left behind a ghost town. One newspaper columnist wrote that the famous race-picture pioneer Oscar Micheaux had fallen on "evil days." And though he was no longer universally regarded as "great," by the early 1930s Micheaux was for all intents and purposes "the only." In a list of Christmas wishes for 1930, the *Pittsburgh Courier's* Floyd G. Snelson Jr., published this wish for Micheaux in his column: "Some new hits for his moving pictures."

Micheaux was proud of living in Harlem, and in his novels he derided certain luminaries of the Harlem Renaissance who chose to live in New York's more upscale neighborhoods. So it must have been humbling for this distinguished citizen to walk the streets of Harlem in that winter of 1930, when the newspapers were writing his obituary. One might imagine him as a figure out of one of his stories, bowing his head, holding onto his hat, trailing his long Russian coat behind him—Czar Oscar leaning into the whipping wind and snow.

For all his sociability and communication skills, however, Micheaux was a solitary, private man, who never quite fit into the Harlem Renaissance. In most ways, the Renaissance passed him by. Indeed, Micheaux only half-lived in Harlem; he was always on the run, hopping trains in and out of town, seldom intersecting with the intellectual ferment of the time.

By 1930 the Renaissance was at its zenith. Yet Micheaux and his films came in for "profound silence and neglect from his intellectual contemporaries," as film historian Clyde Taylor has noted. Though Micheaux personally knew some of the poets, artists, and writers who dominated the cultural movement that celebrated black life in Harlem

and America—people like Langston Hughes, Countee Cullen, Richard Wright, and Zora Neale Hurston—Micheaux didn't hold membership in the same social, political, or intellectual circles.

They were middle-class, college-educated; Micheaux was low-born, a primitive. They were modernists—some of them militants—who repudiated authors like Charles W. Chesnutt and Henry Francis Downing, dismissing their novels about "passing" as quaint.* These Harlem literary lights enjoyed close connections with New York's best publishing houses; Micheaux was a self-published novelist, whose fiction was intended for ordinary folk. Those who registered his work at all looked down on his "execrable" English, in the estimate of Alice Dunbar-Nelson, the widow of poet Laurence Dunbar, who met Micheaux in Pennsylvania in the 1920s. (Even Micheaux's film scenarios reeked of "bad English," Dunbar-Nelson thought.)

Among Harlem's cultural leaders, Micheaux was alone in preferring motion pictures as a medium. In 1967, when Langston Hughes cowrote a book called *Black Magic*—"A Pictorial History of the Negro in American Entertainment"—film was treated almost as an aside. Micheaux himself was mentioned noncommittally, as part of a sweeping single sentence covering race cinema.

Writer Carlton Moss recalled talking about Micheaux and race pictures with Hughes, James Weldon Johnson, Rudolph Fisher (author of the first black detective novel), Renaissance chronicler Arna Bontemps, and other Harlem eminences, but what he discovered was that they considered Hollywood a cultural junkyard, and race pictures just more garbage for the heap. "They saw Micheaux as an illiterate person," recalled Moss. "And this they could not accept. Because the big thrust at that time was to prove that you were as literate as whoever the accepted figure was on the national scale."

"Those circles," said Moss on another occasion, "never took Micheaux efforts seriously. One prominent writer was known to be working on a play about Micheaux. He called it, 'Let's Make Movies.' It was a *comedy* on Micheaux's filmmaking. Few who criticized him, admitted to ever having *seen* his films."

* Henry Francis Downing was a relatively obscure author, better known in London than America, and by 1928, the year Charles W. Chesnutt received the NAACP Spingarn Medal for his lifetime of literary accomplishment, his books were out of print.

Nor did Micheaux care to develop a circle of his own. He was, as ever, a lone wolf who slipped in and out of circles. Among his friends were a few loyalists, actors like Lawrence Chenault, William E. Fountaine, or Lorenzo Tucker. But in the dark winter of 1930—no darker, Micheaux would have said, than his loneliest time on a South Dakota homestead— he trusted one person alone: Alice B. Russell, his pillar of constancy and resolve. In films he sometimes idealized women as intelligent, beautiful, ladylike, moral exemplars. Mrs. Micheaux seemed that ideal sprung to life.

From her he drew strength and purpose. As had become his custom, Micheaux spent Christmas of 1930 and the week leading up to the New Year and his forty-seventh birthday with the Russell family, dividing the holiday season between their 48 Morningside Avenue flat in Harlem and his wife's family's house on Greenwood Avenue in Montclair, New Jersey. The ex-homesteader had dubbed the Greenwood Avenue place "The Homestead."

But his death notices were premature. Micheaux had been building a life-line to new angels, and in January 1931 he reincorporated in Albany with unlikely partners—Leo Brecher and Frank Schiffman. They took his name off the masthead, and renamed his company Fayette Pictures. Micheaux was listed as the nominal president ("titular head," according to the publicity), with Brecher as vice-president, Schiffman as secretary.

Brecher and Schiffman, white and Jewish, were exactly the type of pro-ducers Micheaux had railed against for meddling in race pictures. But seen from another angle, they were logical saviors. Under Brecher's principal ownership, Schiffman ran the Lafayette, the New Douglas, the Roosevelt, and the Odeon theaters, the four biggest movie houses in Harlem. (For years they had been trying to buy a fifth, the Renaissance). They invested in all-black stage shows that traveled outside New York and were thinking of branching into race-picture exhibition in other East Coast cities.

In one fell swoop, Micheaux was now able to boast "new capital" for production, and prime bookings in Harlem. He would use the new cap-ital to bankroll the first true "race talkie." "From now on the product will be all-talking pictures," the company's initial press release boasted, "and will be produced on a larger and more expensive scale."

The black press gave the news big coverage. "Due to lack of funds," according to one account, "Micheaux has heretofore played a lone hand in the making of his pictures. The difficulties of creating talking pictures were so great, however, that he was hardly able to get started." Now he planned to make "one or two each month."

Fayette Pictures announced lofty if familiar ambitions: Micheaux's first sound picture would have a "tryout on Broadway" before gracing Harlem theaters; the pioneer would produce "a couple of short subjects" to accompany the tryout; and the film's general distribution would be preceded by "a special road show engagement in a large number of key cities."

As though in tacit rebuttal to Theophilus Lewis, Micheaux made sure the new company's press release pointedly mentioned two of the "Negro-conscious" Hollywood pictures the columnist had cited: *Hearts in Dixie* and *Hallelujah!* Micheaux emphasized that *his* "talkies" wouldn't indulge in nostalgia for the Old South, like the most recent Hollywood fare. Where *Hearts in Dixie* and *Hallelujah!* "had their settings in the South and dealt with the Negro in his native state," Micheaux intended to fill a void by setting his stories among modern blacks in the big Northern cities. "Micheaux contends that since there are more than 4,000,000 Negroes in the North, he feels that a public is in position to possibly appreciate a theme dealing and laying somewhere among these 4,000,000"

Fayette Pictures took a lease on space at the Metropolitan Studios in Fort Lee. In mid-January, Micheaux declared, he would commence photography on "the first all-black talkie" (a claim that pointedly dismissed *Hearts in Dixie* and *Hallelujah!,* which Hollywood had promoted in similar terms). His financing even afforded him time to prepare his cast. His actors had already had been "in rehearsal for some time," one article in the black press noted. After "five weeks of intensive rehearsal," said another, "all the dramatic artists entered the studio the day the shooting was scheduled to begin, knowing every word of their parts."

Though separated by twelve years, *The Homesteader,* the first feature-length silent race picture, and *The Exile,* the first all-black talkie directed by a black man, sprang from the same source material: Micheaux's own life story. After *The Homesteader,* Micheaux had incorporated versions of his autobiography into several silent pictures, and that habit would con-

tinue into the sound era. *The Exile* was Micheaux's latest reworking of his homesteading saga, divided between Chicago and South Dakota, but spiced up with underworld vice, a vamp's murder, and song and dance numbers.

Once again, the hero of the tale was the Micheaux alter ego Jean Baptiste, a young, self-righteous man who finds himself at odds with decadent Chicago. Jean Baptiste is besotted with Edith Duval, who is determined to become the "Queen of Chicago's Negro Underworld." Edith dwells in a South Side mansion formerly owned by a wealthy meatpacker, but "deserted by his heirs who fled, frightened and terrified," according to a title card, "by the sight of an endless stream of Negroes, brought North to supply labor demands for the war."

Baptiste and Duval eventually quarrel over her plans to turn her mansion into a "social club" with recreational activities for the criminal element. Indignant, she brands him a sissified "Goody Man." Armed with a land deed, the hero heads west. When the story picks up five years later, Jean Baptiste has established himself as a successful homesteader in South Dakota. Among the other settlers he is sometimes mistaken for white, though he doesn't hide his true identity and always tells the truth about himself.

One of his friends knows that Jean Baptiste is "colored," but wonders about his relatively light complexion. "I understand that nig—colored people are smoky," the friend stammers. "That is—black, you understand?"

"Yes, that is true," Jean Baptiste answers, his reply summarizing the insistent problem of many Micheaux films, "but if you are part colored and part white it is all the same—you are considered all colored."

Against his better judgment, Jean Baptiste falls in love with the daughter of a neighbor—still a Scottish girl from Indiana. He and the neighbor's daughter have the usual tortured romance, one that on the surface seemed to be an "egregious violation of racist guidelines concerning miscegenation," in the words of scholar J. Ronald Green, "laid down by contemporary censorship boards throughout the United States."

Jean Baptiste flees the prairie, returning to Chicago, again falling under the spell of Edith Duval. Her mansion is now a thriving cabaret complete with house band and nightly entertainers, frequented by drunks, reefer smokers, and gamblers.

When the vice queen is murdered, Jean Baptiste is arrested for the

crime. After a time, the real culprit is revealed, and when Jean Baptiste emerges from the D.A.'s office a free man, he finds the Scottish girl waiting for him, with news she has learned from her father: her mother was "of Ethiopian extraction." The couple takes the train back to South Dakota, entwined in each other's arms, facing a bright future together.

The leading roles went to a set of fresh faces. Stanleigh Morrell, who portrayed Jean Baptiste, had played a small part in the Broadway musical *Green Pastures* (while also understudying the lead). Micheaux had first seen Morrell act (and play stomp piano) onstage at the Alhambra at 126th and Seventh in the 1920s, when that vaudeville and movie house hosted a stock company. Nora Newsome, portraying the Scottish daughter, was probably from Great Bend, Kansas; another Newsome from that family tree would figure significantly in later Micheaux pictures. Newsome was cast mainly for her creamy skin, which added credibility to her character's ability to "pass," and for her long wavy tresses, which Micheaux photographed with a pre-Raphaelite luminosity.

Another newcomer to film, Carl Mahon, had a pivotal scene, playing the distraught former lover spurned by Edith Duval; when he threatens suicide, she hands him a gun, and instead he shoots her. Eunice Brooks played Edith, and the large supporting cast included Micheaux veterans A. B. DeComathiere, Lorenzo Tucker, and Katherine Noisette. Charles "Daddy" Moore even returned to reprise the role he had originated in *The Homesteader:* the white-haired Rosebud neighbor from Indiana who is slow to inform his daughter she is of mixed race.

Some of the actors tucked in their roles for Micheaux between performances in *Green Pastures,* which had opened to resounding acclaim on Broadway the previous February and was still drawing packed audiences. Many in the cast of *Green Pastures*—from Richard B. Harrison and "Daddy" Moore to J. Homer Tutt, Salem Tutt Whitney, Mercedes Gilbert, and Susie Sutton—were already well-known to fans of Micheaux films.

With the biggest, most secure budget of his career, Micheaux felt flush. This time his glee was genuine. He splurged on the singing-dancing se-

quences, bringing Leonard Harper and Donald Heywood to Fort Lee to stage the film's cabaret interludes, and to help out with *Darktown Revue,* a short subject to accompany the feature.

Harper, a former vaudeville dancer, had become the premier choreographer of the stage spectacles at Connie's Inn, where he was the house producer. His revues were always fast-paced and witty; they boasted headliners, but were equally renowned for their skimpily clad chorus lines of young no-names. (Preachers, law enforcement officials, and puritanical critics regularly mounted attacks on Harper's risqué shows.) Along with his genius for staging musical numbers, Harper brought his "Hot Chocolates" over from Connie's Inn.

Early in his career, Heywood, a composer, lyricist, and playwright from Venezuela, had composed music for the Smart (and Smarter) Set companies. He wrote prolifically for Harlem and Broadway musicals; one of his hit songs, "I'm Coming, Virginia," became a standard among jazz artists, and was recorded by Sidney Bechet, Bix Beiderbecke, Art Tatum, and Artie Shaw, among others. For *The Exile,* Micheaux asked for an overture of spirituals (to underscore the opening images of the film, a shimmering montage of Chicago buildings and street life) and dance music for the club scenes ("searing quotations of hot jazz," in the words of J. Ronald Green). Heywood brought his own choir and band to the studio, and even appeared on-screen conducting the orchestra.

Micheaux's films abounded with performers obscure to white America, who were celebrities on the black show business circuit. During the silent era he had drafted the Lafayette Players and other stage idols and introduced them to big-screen audiences. In the sound era, his films were chock-full with black singers, musicians, cabaret entertainers, specialty acts, and kooky comedians who never hopped the Hollywood gravy train; these included every type of tap-dancer: twins, kid tappers, "muscle dancers," dancers who tapped while jumping rope.

The highlight of *The Exile*'s filming was the extended nightclub sequence from which Micheaux would carve out acts to interlard the story. The ruthless interspersing of these acts would become a fixture of his sound-era features: He'd cut to his leads sitting at tables for a brief exchange of dialogue, then back to the parade of performers.

Among the marvels in *The Exile* were Roland Holder, a buck-and-wing specialist, and Louise Cook, a sparkler from Connie's Inn, singing "Make Hay While the Sun is Shining" while doing her shimmy and

kootch. Leonard Harper's tap-dancing chorus girls took over here and there, exploding before the cameras with their big smiles, slivered outfits, and long legs. Nothing in Hollywood movies compared with the "Hot Chocolates" at their hottest: Micheaux knew he'd have to shuffle this sexy footage when facing the censors later.

Some of the best music and funniest comedy was squeezed into the two-reeler, *Darktown Revue*, which spotlighted Donald Heywood's Harlem Choir, lustily belting out their numbers around a piano. The small chorus was elegantly dressed, the tone was high-class and solemn. But there was also a mock spiritual, and songs ranging from "Watermelon Time" to "Jazz Grand Opera."

High art often fused with low in a Micheaux production, and the choral concert was interrupted by the "coon comics" Andrew Tribble (from *Blackbirds of 1928*) and Tim Moore (later the Kingfish of television's *Amos 'n' Andy* series). The two rambled on-screen to discourse on work and ignorance (swiping "at the U.S. cult of personality and myths of upward mobility and individual self-reliance," as film scholar Arthur Knight has observed). Their sidesplitting satirical exchange devolved into a lengthy haunted house anecdote.

Continuing the general heresy, Amon Davis materialized in blackface to deliver his uproarious send-up of a digressive, sanctimonious preacher, full of hot air and weird malapropisms.

Micheaux may have been the odd man out among his intellectual contemporaries, but "if one wants to get some idea of what the Harlem Renaissance looked like in motion," in the words of film historian Clyde Taylor, for dance, music, and rough comedy, "Micheaux's movies are among the best sources available."

It's likely that *The Exile* boasted two cameramen, because Micheaux had to divide the schedule around actors appearing nightly on Broadway. He had a fondness for newsreel photographers, because they came at a discount and weren't ruffled by mishaps. His team for *The Exile* was Lester Lang, who'd been shooting low-budget material in New York since the early 1920s, and Walter Strenge, a newsreelist who proved himself during a long career by winning Emmys and an Academy Award nomination, ultimately serving as president of the American Society of Cinematogra-

phers. Both cameramen would work on Micheaux films intermittently throughout the 1930s.

If any proof is needed that Micheaux was *cinematic* when he had the means and opportunity, *The Exile* is Exhibit A; the film would boast a textbook array of shots and angles, and an intimacy in the staging that benefited from superior studio lighting. Micheaux used smoke and mirrors cleverly. And unlike most Hollywood directors, who were forever relegating musicians to the background of club scenes, diminishing their numbers by excerption, he showcased his performers' at length, with attentive framing.

The filming was over by the end of February; thanks to Micheaux's rejuvenated finances, his editing bills were paid ahead, and *The Exile* was completed by mid-March. A special midnight preview was planned for the Odeon, with *Darktown Revue* to be screened as a prologue. The advance publicity stirred anticipation in Harlem, and the full house for the preview included members of the national black press.

The midnight audience enjoyed a production that was sumptuous by previous race-picture standards. The detail lavished on the decor and costumes was extraordinary, the musical sequences extended and vibrant. If the story was improbable, it was also deeply sincere and steadily involving, entertaining even as it touched astutely on sensitive issues—prejudice (in the character of a nefarious homesteader from Arkansas who brags that he doesn't like "coloreds"), intermarriage between the races, even "white flight" before that phrase existed.

True, some of the dialogue seemed to be spoken in slow motion—partly because Micheaux wrote speeches that spelled out every hint of meaning, and partly because the actors, unaccustomed to microphones, were overenunciating their every syllable. And, true, some of the novice players—particularly Nora Newsome—seemed inept. But Micheaux's casting was hardly infallible, and wordy scripts and clumsy technology also were common among many Hollywood studio films, during the bridge years of sound.

Micheaux's preview was greeted as "a wonderful effort" by George Tyler in *The Afro-American*. "Some good acting is done in this picture," Tyler noted, while also praising *Darktown Revue*. The *New York Age*, as usual, offered a more measured reaction. "It is by far the best picture Mr. Micheaux has ever turned out," wrote W. E. Clark in the *Age*, "genuinely entertaining in spots." Nevertheless, he found that *The Exile* evinced

"many obvious faults," especially weak acting by the female leads.* And Micheaux couldn't hope to woo New York sophisticates, Clark tsk-tsked, when he used "the outside of the famous Charles W. Schwab mansion on [New York's] Riverside Drive as a notorious house in the Windy City."

The Exile wouldn't have its official premiere for another two months, suggesting that there may even have been extra in the budget for fine-tuning after previews—another Micheaux first. But the dream of opening one of his films in a theater on the aptly named Great White Way was still elusive.

Instead, *The Exile* opened at the Lafayette in May 1931—to overflow crowds and triumphant notices. The "first Negro all-talking picture" was completely ignored by the white press, but covered as an historic occasion in papers like the *Pittsburgh Courier,* which hailed the story, acting, musical sequences, and a "portrayal of Negro life in a city that no one but a Negro, who has traveled and lived in cities, could tell."

Micheaux immediately hit the road, traveling to black theaters in the major markets of Pittsburgh, Philadelphia, Baltimore, Washington, D.C, and Chicago to personally arrange key bookings. Everywhere he went, he met with the press. He couldn't be blamed for sounding a note of vindication in his interviews.

In a career of switchback reversals, *The Exile* was the miracle comeback, a rebound for the ages. "Micheaux studied hard and waited a long time for the breaks," declared the *Pittsburgh Courier;* "his *Exile* now is a credit to him." No other race -picture producer from the silent-film era— not a single one—broke through all the barriers and crossed over into the sound age. Micheaux was the first and only.

* Lorenzo Tucker said Micheaux himself thought there was weak acting by the novice male lead. Tucker "insisted that a second version of the film [*The Exile*] was made shortly after the first version," wrote Richard Grupenhoff in his biography of the actor, "because Micheaux was unhappy with the performance of Stanley [Stanleigh] Morrell in the title role. Tucker said that numerous scenes were shot over with him in the lead role, which probably accounts for the posters that announce him as a leading player. If Micheaux did make another version of *The Exile* it has been lost, or else he abandoned the idea of completing the second version."

CHAPTER FOURTEEN

1931–1935
JEWS WITH
MONEY

They were white and Jewish—Jews with money that Micheaux desperately coveted.

An Austrian immigrant, Leo Brecher was the man with the deep pockets. Frank Schiffman, from the Lower East Side, was Brecher's manager and enforcer. Together they were the gods of Harlem show business.

Brecher and Schiffman ran the Odeon, the Roosevelt, the Douglas, and the Lafayette theaters. Brecher was also the landlord of the Cotton Club, upstairs from the Douglas. In 1934 the partners would launch the Apollo. In 1935, when they finally succeeded in buying the Renaissance from its black owners, they controlled Harlem's five largest theaters, offering movies and live entertainment to a combined capacity of 6,700 people. With four shows at each theater, they catered to a paying public of more than 25,000 customers daily.

Brecher and Schiffman also had theater interests in other East Coast cities—Philadelphia, Baltimore, Washington, D.C.—so performers in the popular Lafayette revues always followed up their Harlem engagements with a bus trip "Round the World," as the circuit was called, before returning to rehearse the next show.

The balding, bespectacled Schiffman was the hands-on man who interacted with the public and the performers. Some who worked for Schiffman called him "Pops," considering him a generous man who befriended black people and donated to Negro causes and benefits. Before the partners took over the Lafayette in 1925, after all, black customers

had been consigned to the famous theater's "nigger heaven," just as they were in most places in America—even in Harlem.

According to "local legend," on one occasion Schiffman even defended Micheaux's civil rights. "Frank was personally responsible for breaking down the color barrier that existed in many of the stores and restaurants on 125th Street well into the 1940s," wrote Ted Fox in *Showtime at the Apollo*. "As the story goes, he and black film producer Oscar Micheaux went into Frank's Restaurant, a well-known Greek-run steak house, and ordered two steaks. When Micheaux's came smothered with pepper, Schiffman exchanged dishes with him, ordered another, and told the waiter if he ever tried that again, he'd have a hell of a fight on his hands."

To others, however, Schiffman was no saint. By 1931 he was already a controversial power broker in Harlem—regarded by his detractors as a tough, cheap son of a bitch, a cutthroat who delighted in putting rival theaters out of business and blacklisting entertainers who accepted gigs from competitors. Record producer John Hammond, who knew Schiffman well from their mutual dealings with musicians, recalled Schiffman "talking about Negroes and using the word *shvartzer*," a Yiddish pejorative.*

Micheaux eschewed pejoratives, but he harbored ambiguous feelings about Jews and a suspicious attitude toward Jewish producers of black stage shows and race pictures. But he had dealt with Jewish theater owners throughout much of his career, and was open-minded when it came to taking money from willing backers. And he was a magician with money.

Wags on Harlem streets gave the partnership long odds, and the wags were right.

What happened next can be pieced together from court records and newspaper items. *The Exile* may have been a hit in Harlem theaters, but the picture (especially the dancers' skimpily costumed scenes) rang the

* Leo Rosten's reliable *The Joys of Yiddish* lists several definitions for "shvartzer," including, simply, "black," and "unskilled," while noting that the term and its variants were " 'inside' words among Jews—cryptonyms for Negro servants or employees." Rosten wrote: "Since the growth of the civil rights movement, these uses have declined."

usual censorship alarm bells, and the returns were slow from outside New York. Still, Micheaux had a line of credit from his well-heeled partners, and he was the new Fayette Pictures man on the road dunning theaters. He'd been skilled at knockdowns since his Pullman porter days, and for years he'd been juggling banks, lawyers, and debts in cities all over the country. It would take Schiffman at least a year to realize all the ways in which his money could be magicked.

During which time, incredibly, Micheaux would squeeze out five more productions.

The coming of sound offered many filmmakers an excuse to revisit their hits or favorite stories from the silent era, to remake and tinker with cherished ideas. What was true of John Ford, Howard Hawks, and nearly every important Hollywood director was also true of Micheaux. Remaking a silent picture took less time and money than creating an entirely new film, since the story was already largely conceptualized, a basic script in hand. Micheaux's first "talkie" was *The Homesteader* redux. Now, after *The Exile,* he'd remake *The House Behind the Cedars.*

Never mind the minor detail that Micheaux had never made that last rights payment to Charles W. Chesnutt for his 1926 version. This time, instead of using Chesnutt's title, he would simply lift a different title from another source: *Veiled Aristocrats,* a 1923 "passing" novel by Milwaukee author Gertrude Sanborn, another story of interracial romance set partly in Chicago's Black Belt.

Never mind that Micheaux had no marquee name to play Rena, the young "bright mulatto" whose life takes a fateful turn when her brother persuades her to "pass" for white. Shingzie Howard, who had portrayed Rena in Micheaux's silent version, had starred in a couple of race pictures for other producers before quitting to become a schoolteacher. His latest "virgin star," Nora Newsome, had been excoriated by critics for her weak performance in *The Exile* and never acted in another motion picture. Micheaux may have thought wistfully of Evelyn Preer, but the actress was far away in Los Angeles, pregnant with her first child. So while in Chicago for screenings of *The Exile* in mid-1931, the director attended a talent parade at the Regal Theatre on the South Side, and from the contestants chose Lucille Lewis as the next Rena.

He cast Lorenzo Tucker as Rena's brother John, and Laura Bowman as Mrs. Walden, Rena's mother. Carl Mahon, who had acquitted himself admirably in *The Exile,* would play Frank, the childhood friend in love

with Rena. Lawrence Chenault would play the white judge and benefactor of the family; nightclub singer-dancer Barrington Guy would portray Rena's white suitor.

Frank Schiffman couldn't have been pleased with Micheaux's new project. Fayette Pictures had pledged to make Northern Black Belt stories. But the Fayette banner didn't last much beyond the first Brecher-Schiffman-Micheaux production, and Schiffman himself was swiftly sidelined: One "A. Burton Russell," also known as Mrs. Micheaux, would be credited as the producer of *Veiled Aristocrats*.* If Schiffman wanted to cut studio costs on a production for which he had little enthusiasm, Micheaux would find ways to cope: the "house behind the cedars" of the remake was actually the Homestead on Greenwood Avenue in Montclair, where Micheaux did most of the filming in the summer of 1931.

Micheaux's silent film script was hastily rewritten, substituting dialogue for intertitles. Although some in the ensemble, like Lucille Lewis, were amateurs, even the professionals were flustered by how fast Micheaux worked once he had a semblance of financing. "Sometimes we would get on the set and Micheaux would hand out scenes that he had written only the night before," Tucker recalled, "so we had to memorize it quickly." And of course there was never time or money for "cue cards," which Hollywood actors took for granted.

Tucker and Micheaux didn't always get along. At times his mentor treated him in a fatherly fashion, but when they were with others on the set Micheaux would sting Tucker, calling him derisive nicknames like "Big Boy" or "Useless." Like one of Micheaux's later actors, Carman Newsome, Tucker was handsome enough, but Micheaux sometimes found his performances lacking, especially in the strong jaw and backbone department. "When you finished you'd think he'd say to you, 'That was wonderful,'" said Tucker. "Never. He'd look at you and say, 'Huumpf! You hammed that one up for me.'"

With the silent era over and Rudolph Valentino long dead, Micheaux had to update his promotional strategies: Now Tucker would be billed as "The Colored John Gilbert." At times the actor felt exploited. "I can remember going up to his apartment to see if he [Micheaux] had any work

* Some filmographies indicate that Mrs. Micheaux took this producing credit on several of her husband's last silent films before surrendering it briefly on *The Exile*. Interestingly, the "A. Burton Russell" allowed theater owners and managers to assume Micheaux's producer was a man.

for me," Tucker reminisced in the Grupenhoff biography. "He showed me his next script. 'My name's not in the cast,' I said. 'I know,' he replied, and said nothing more. Later, when I got up to leave, he said, 'Take a script on the way out—you're playing the lead.' That way he always had me at his mercy. 'I made more money with you as my leading man than anybody else,' he once told me, but that's as far as he would go. He always paid me on time, and he even loaned me money at times, but he would never let me get too big."

In any event, Micheaux's leads during the sound era were sometimes upstaged by the musical acts he shoehorned into the films. The singers and dancers were intended to leaven the drama, but they sometimes took over like houseguests who refused to leave, proving more engaging than the main story. One highlight of *Veiled Aristocrats* was an extended sequence at Rena's brother's house, when the homeowner's absence affords the maid, the cook, and the chauffeur an opportunity to break out in a little scat singing and tap dancing. (The full orchestra of *The Exile* was reduced here to a quintet for one party scene, and solo piano to accompany the servants).

Fayette Pictures' "larger and more expensive scale" of production swiftly went the way of the company name. Only a deformed version of *Veiled Aristocrats* survives today, but the indoor scenery is spartan, with the actors statically posed around sofas or pianos in sparsely decorated rooms. Academy Award-winning cinematographer Haskell Wexler, who began his career as a lowly film processing assistant on a Micheaux project in Chicago in the late 1930s, marveled at the man's expedience in such circumstances.

"I remember the exact expression he used, because I say it sometimes to myself nowadays, when people in show business are trying to do something cheap," Wexler recalled. "He'd say, 'Okay, boys, change the pictures on the walls!' Then they'd leave the lighting the way it was and move some of the furniture around—maybe put a piece of plastic on a chair or sofa to make it look different from the other apartment—while a guy changed the pictures.

"I remember [thinking], 'Gee, this is *really* low-budget.'"

As was true of many early Hollywood talkies, the acting in *Veiled Aristocrats* ranged wildly. Laura Bowman declaimed to the rafters; Lucille Lewis floundered about with no discernible technique. Yet the outdoor scenes had an arresting beauty, the well-knit story still carried a wallop,

and, as contemporary critic Richard Corliss has written, "there's truth, power, and hurt—a hint of Emily Dickinson with a case of the emotional vapors—in Rena's big speech about passing for white while with her fiancé and his friends." Writing in the *Chicago Defender* in 1931, Barbara Llorayne saw the same virtues in the picture, hailing *Veiled Aristocrats* as "far better than many [films] we have been asked to view and review the past season."

Charles W. Chesnutt's daughter viewed the unauthorized remake at a Washington, D.C., theater in April 1932. "Rena, her brother, and Miss Molly took their parts very well," Mrs. Ethel Williams reported in a letter to her father. "It was not artistic, like the story, however. Your beautiful English and the soul of the tale were lacking. It was a speaking movie, and the actors' voices were all harsh, as they probably are naturally. It was not so bad," she added, "when you consider the handicaps colored actors have."

Still, Chesnutt was incensed. If the Micheaux company had produced a talking remake of *The House Behind the Cedars*—without clearance, credit, or compensation—that was "rank plagiarism, and they would be liable in a civil action," the author replied to his daughter, "if I had the money to bring one, and they had anything which I could collect."

But Chesnutt had neither the means nor the opportunity: Broke and in frail health, he died later in 1932.

After finishing *Veiled Aristocrats,* Micheaux waited about five minutes before embarking on his next production. Schiffman's money burned a hole in his pocket. For the next year his speed would be frenetic.

The next was another "ghost film," this one even sporting a ghost in its title. *The Phantom of Kenwood* was a perfect-murder mystery starring Frank Wilson, a sometime Lafayette Player and a well-known writer and director of Harlem plays; Babe Townsend, another Lafayette member who had triumphed as Mephisto in the company's production of Goethe's *Faust;* and Bee Freeman, the contralto whose first break had been in *Shuffle Along* (in which her signature tune was Sissle and Blake's "If You've Never Been Vamped by a Brown Skin, You've Never Been Vamped at All"). *The Phantom of Kenwood* was certainly produced; it was screened once or twice for the press, then disappeared like the ghost film it was.

After another five-minute break came *Harlem After Midnight* (a story "built around Negro gangsters who kidnap a wealthy Jew," as one review put it), starring Lorenzo Tucker, Lawrence Chenault, A. B. DeComathiere, and, again, Bee Freeman. There was also a pretty newcomer (Dorothy Van Engle) and a savvy old-timer (Rex Ingram from *Green Pastures).* Micheaux himself played "a clever sleuth" who "breaks up the racket." *Harlem After Midnight* was definitely filmed, circulated to some black theaters, reviewed in a few places, then "lost," probably left behind at the last Midwest theater where it was booked.

The third quickie of 1931–1932 (the only one of the three that survives) was the big-city anthology *Ten Minutes to Live,* whose title was drawn from the second of two or three stories interwoven by a motif of vengeance.*

The main character in the first story is a screen producer named Marshall, who visits a cabaret called "The Lybia," scouting talent for his next movie. An obvious Micheaux surrogate (even his name "sounds somewhat like Micheaux," as J. Ronald Green has noted), Marshall admires one young performer and offers her a plum part in his next picture. The job "doesn't pay much," he admits, only $3.50 a day—art imitating life—but is she interested? "How would I like to go to heaven without dying?" she replies, batting her eyelashes. "You don't realize how happy this makes me."

The first story's in-joke playfulness is continued when Alice B. Russell shows up at The Lybia, portraying a hate-driven woman determined to kill the louse who long ago spurned and murdered her best friend. Nightclubs would become the hub of all the plotlines in Micheaux's sound pictures, and soon enough The Lybia welcomes another stranger, a young woman sitting nervously at a table with her boyfriend. The woman is delivered an anonymous note, warning her that she has only "ten minutes to live." Then, out of the blue, comes a title card. "What mystery here?" it asks. "Why has this beautiful girl been put on the spot? Let's go back . . ."

Yes, a title card: Long after switching to sound, Micheaux made use of intertitles as an inexpensive way to bridge continuity gaps (and censors' excisions), even to save money on sound recording. In *Ten Minutes to*

* The third story in *Ten Minutes to Live* may well have been recycled from *Harlem After Midnight,* which also makes mention of the kidnapping of "a wealthy Jew" and has Micheaux acting a law-enforcement role.

Live, for example, the nervous young woman is being stalked by a felon who happens to be deaf and dumb—a character who scribbles his words, allowing Micheaux to limit his dialogue to intertitles!

While the woman awaits her fate at The Lybia, the vengeful felon breaks into the house where she has been staying (lingering on the porch steps, the camera catches the house number "55"—The Homestead in Montclair). That is when the ex-con learns (preposterously, from a telegram sent by his mother: an excuse for another intertitle) that he is being surrounded by police. The felon looks out the window to see if the bad news is true. There, glaring back at him, is none other than the hatted Oscar Micheaux, once again playing a detective. *Ten Minutes to Live* was a Micheaux "home movie" in every sense, with A. Burton Russell once more listed as producer.

A. B. DeComathiere made his final appearance for Micheaux in the film, playing Marshall, the producer. Lawrence Chenault sat at a table in the nightclub throughout the story, observing the action and commenting drolly; it would be his last Micheaux production, too. The sinister-looking William A. Clayton Jr., from the silent-era Micheaux pictures *The Broken Violin, The Wages of Sin,* and *When Men Betray,* played the embittered felon.

Donald Heywood, uncredited, emceed and orchestrated the nightclub numbers, which included Ralph Brown, the tap-dancing soloist for Cab Calloway's orchestra; this was the first of Brown's fiery tap exhibitions in several Micheaux pictures of the 1930s. If the chorus line looked a little weary, perhaps it was because the dancers were working second shift after their regular stint at Connie's Inn. "We'd make these scenes at night," recalled Lorenzo Tucker. "After they [the dancers] finished work and the cabaret closed, he would have a bus to bring them all to the set."

If Micheaux had one inarguable genius, it was for using the world around him as his rent-free set. He'd put cameras across from police stations as the cops came off duty, and photograph his uniformed actors walking in and out of the station doors. "In railroad stations he had a trick that I'm telling you was terrific," recalled Tucker. "He would have the cameraman set up in a telephone booth, and coming off the train or going on the train he got his crowds." Impromptu, the director also used to steal "a lot of scenes in Bronx Park," according to the actor, "and the police would come and run Mr. Micheaux out of there."

The "stolen" footage was the highlight of *Ten Minutes to Live.* In one

sequence the endangered ingenue (Willor Lee Guilford) arrives at an eerily deserted Grand Central Station, hails a cab, and rides through city streets on a drawn-out taxi ride that is part newsreel, part Alice through the looking glass. There is no dialogue, only Micheaux's pictorial travelogue and a soundtrack punctuated by the "intrusive blare of car horns," in the words of J. Ronald Green, and a "surrealistically serene music track that modulates into Beethoven's Fifth Symphony."

In the early talkie days, there was a distinct changing of the guard among Micheaux's regular actors. Lorenzo Tucker had come to feel frustrated with Micheaux; the jobs were erratic, his parts in some films like *Ten Minutes to Live* trivial. The new, fair-haired kid was a handsome West Indian, Carl Mahon, who got all the hand-holding scenes with the girl with "ten minutes to live."

Another newcomer was Carlton Moss, from Newark, New Jersey. A theater graduate of Morgan College, Moss was a smart, ambitious young man already carving out a reputation for himself in radio and theater circles. Alice B. Russell, who knew the Moss family, arranged for him to audition for a small acting role in *The Phantom of Kenwood*. "Displaying an attitude of a man who puts great dependence on his wife's opinions," Moss remembered, "Micheaux looked me up and down and nodded his approval." The race-picture pioneer took the young man under his wing, even taking him along to New York City's downtown film laboratories, where Moss was acutely aware that they were the only black people in the building. Still, Moss was impressed by how Micheaux commanded respect when he walked into the labs. Everyone snapped to attention, watching him with respect and none of the usual side-of-the-mouth racism.

Moss admired Micheaux, but not his movies—at least not the ones Moss himself acted in, which were made during this hectic period. He thought one of the films' problems was the white cameramen Micheaux hired at the lowest available rates, cameramen who were "declassed, meaning nobody else wanted them," who had contempt for the stories they were filming, and who started drinking in the afternoons and lost discipline.

Micheaux was feeling challenged by the new generation; youngsters

like Moss didn't really appreciate his stature, kowtow to his wishes, or accept his long experience as wisdom. Moss had written some radio scripts, but when he told Micheaux that he wanted to write film scripts, Micheaux "made it clear that he wrote his own scripts and wasn't interested in what anyone else wrote." He was "in absolute control of every facet of his productions," Moss recalled, and "would not listen to any suggestions or changes from anyone, except Mrs. Micheaux."

To Moss, Micheaux's scripts seemed prolix, the language frequently tangled, or ungrammatical. But only Alice B. Russell dared criticize her husband's scenarios. "She'd edit [the scripts] by being in the rehearsal," recalled Moss, "and [while] we're playing the scene [she'd say], 'Dad, I think it'd be proper to say . . .'"

Moss found Micheaux easily drawn into conversation, or argumentation, on the subject of their shared race, and during the making of *The Phantom of Kenwood* and *Ten Minutes to Live* they held long talks.

"He saw the black population as two groups," Moss recalled years later. "He would say, 'The better class makes a strenuous effort, a strenuous effort to take advantage of the opportunity in America for those who are willing to work. Businessmen like C. C. Spaulding of the North Carolina Insurance Company, [Alonzo] Herndon of Atlanta Mutual Insurance Company, Jesse Binga's Bank in Chicago—doctors and lawyers all over the country, real estate people—they all own nice homes and acres of good farm land.

"'Now the other group, the rougher set. They ain't got sense enough to come in out of the rain. They have no conception—hear what I say— no conception, of what it takes to succeed, to acquire, to have or to hold. They want ease, privilege and luxury without any great effort on their part. All they can do is hold on to the timeworn cry of 'no opportunity.'"

Some discussions, however, Micheaux would not countenance. According to Moss, by the early 1930s the race-picture pioneer was a different man from the fearless, smiling entrepreneur of the years after World War I, who had leapt over so many hurdles and edged sideways around others. Now Micheaux seemed coiled tight, burdened by pressures from without and within. He seemed paranoid about ceding any power to outsiders. "The actors pleaded with him to let them rerecord words they felt they had mispronounced, or lines they thought were hurried," Moss recollected. "The technicians complained they weren't given the time to focus properly; that rushed scenes would reflect in faulty composition on

the screen, and the lighting equipment was inadequate for scene changes. I constantly pointed out that he was making character changes that weren't consistent with what had already been filmed.

"It all fell on deaf ears," Moss continued. "Micheaux allotted a certain amount of film footage for each scene. There was no extra—there were to be no 'retakes.' If he decided a scene couldn't be used, which was seldom, he would fill in with a musical sequence from a former film."

One day Moss demanded to know why all the camera, sound, and lighting people behind the scenes were white (the "most obvious incongruity" of Micheaux's operation, in Moss's words). "He said that if a black man came to him with a skill," recalled Moss, "he would hire him. But he didn't have time to go running all over Harlem, trying to find somebody who wanted to learn how to operate the camera. He said, 'That's the trouble with colored people, they always want someone giving them something—I'm running a business, not a school.' "

By mutual consent, *Ten Minutes to Live* was Carlton Moss's last film with Micheaux.

In the summer of 1932, Mr. and Mrs. Micheaux headed south for a wide-ranging trip, leading a skeleton cast and crew in a small caravan of cars. One person who wasn't along for the ride was Frank Schiffman: The boss was left behind in the dark in Harlem, fuming and preparing legal action against his partner gone wild.

Micheaux planned to use the traveling time to sketch out his next picture—his fifth since *The Exile*—while arranging bookings and collecting fees for his quickie productions from theater owners south of the Mason-Dixon line. These days, however, bookings were sought with an urgency bordering on mania, so much so that Micheaux placed a rare advertisement in the 1932 *Film Daily Yearbook*, Hollywood's annual directory of motion picture personnel, something he had never done before. Along with a stern, glaring photograph of himself, Micheaux issued a shrill challenge to black theater owners and managers: "GET A LOAD OF THIS, MR. EXHIBITOR: Poor attendance is due, in some measure, to the fact that your patrons are 'fed up' on the average diet you are feeding them daily and are crying for 'something different.' Why not give them one of our Negro features as a change? Many theatres are doing

so—and with gratifying success. They are especially good for midnight shows. Modern in theme, which pleases your flapper patrons—each picture has a bevy of Creole beauties—with bits of the floor shows from the great nightclubs of New York, with singing and dancing as only Broadway Negro entertainers know how to deliver—try one!"

His survival instincts told him that his nightclub spectacles sold better in the South, where they were like a cheap ticket to Harlem. Northeastern audiences were blasé and needed more in the way of meaty drama. Films *about* the South also pleased Southern audiences, though they didn't do as well in the North. Often Micheaux cheated with the title, changing the name of the film as it traveled around, deleting or emphasizing the "Harlem."

Micheaux saw value in all kinds of stories—Northern urban dramas, Southern melodrama, realistic preachments, and musical cavalcades alike—but he felt obliged to defend the commercially weaker strain. "Personally," he told one *Chicago Defender* columnist during a car ride back from a booking foray to Detroit, "I think *Veiled Aristocrats* by far the greater production, but it doesn't begin to draw as my latest one [*Ten Minutes to Live*]."

The trick, he always thought, was in the mix. The best solution was to mingle Northern and Southern locales and preferences in the same picture. That was the goal of his next remake, this time of his 1926 film, *The Spider's Web*. And so Micheaux steered his caravan toward Batesville, a sleepy cotton town in northeast Mississippi.

Like the original *Spider's Web*, this new sound version would be an attack on the evils of crooked gambling. Micheaux's updated script followed "a dashing young Secret Service agent" named Alonzo White (Carl Mahon), who arrives in "Batesburg" to investigate a shady plantation owner named Jeff Ballinger (John Everett). Ballinger exploits his workers and abuses his paramour Liza Hatfield (Grace Smith). The agent lodges with Mary Austin (Eunice Brooks) and befriends her pretty young niece Norma Shepard (Starr Calloway), "a recent graduate of high school" who has just been hired as a schoolteacher. After the agent arrests Ballinger, Liza flees from her unhappy past, becoming a nightclub singer in Harlem. Norma and Mary also head to Harlem, with Alonzo trailing be-

hind. Mary is soon corrupted by the "numbers" game; she wins big, but when she tries to collect her money she ends up falsely arrested for the murder of the chief racketeer (Juano Hernandez). Alonzo sets a trap for the real culprit aboard an ocean liner and corners Liza into confessing. Mary is saved from execution, and the film ends in Micheaux-fashion with Alonzo and Norma's embrace.

Pleasant weather accommodated the sweetly romantic scenes between Mahon and Calloway, which were filmed in Batesville's town square and city parks. The nightclub and other interiors were shot later, some at the Homestead in Montclair, with the furniture and paintings switched around for different scenes. The outdoor photography (by newsreel cameraman Sam Orleans) was as lyrical as the indoors scenes were dim and poorly lit.

Micheaux was working frantically, aware of the disaster awaiting him back in New York. Mahon struggled with pages of cumbersome dialogue handed to him at the last minute. At one point in the finished film, the director can be heard off-camera, urging Mahon to hurry as the actor waves him off. At the end of another scene, Micheaux shouts "All right, cut!" But he couldn't lose the take without forfeiting the dialogue, so into the picture it went. Such crudeness in technique—along with awkward plot contrivances—had become all too common in recent Micheaux films.

Got to keep going!

He finished up back in New York, packing a remarkable half dozen musical acts into the Harlem half of the film, which takes place at "The Radium Club." Micheaux's fast-fading budget limited him to tight shots of a quintet and a mere handful of extras. The entertainers included the top-hatted Tyler Twins, who execute a sly shadow dance. But the performers were sprinting, the chorus girls trying to synchronize their kicks with fur-and-fabric costumes pasted all over their bodies, a hedge against the censors. It was a far cry from the full-throttle Harlem of *The Exile*.

"Harlem and the good times!" reads the intertitle, when the story shifted to the capital of black America. Yet for the picture's main title, Micheaux looked in a different direction: since the no-good Liza turns out to hail from his old stomping ground, Micheaux decided to retitle his remake *The Girl from Chicago*. The last production under the Brecher-Schiffman regime, it was barely released to the public; the few reviews were harsh, and what critics there were belittled the "misleading" title.

Nineteen thirty-two was the year Micheaux touched bottom. His litany of misfortune began with the death in Great Bend, Kansas, of his 85-year-old father. Calvin Swan Micheaux passed away in late January, from the lingering effects of a paralytic stroke. "A hardworking, industrious man, and a good citizen," read his obituary in the *Great Bend Tribune*. "He was the father of a large family, and he had the joy in his late years of knowing that each son and daughter had received a good education, and were successful, prudent, and saving."

Juggling so many problems in New York, Micheaux couldn't even afford the trip to his father's funeral. Ever since his bankruptcy in 1928, he had been racing—lurching, some might say—from picture to picture. His business dealings were a rickety house of cards. In 1932, the whole house caved in beneath a series of lawsuits, some more crushing than others.

Among the first to sue was a married vaudeville team known as Hooten and Hooten, who filed papers against Micheaux in Baltimore in late 1931. The duo charged that Micheaux had stolen their well-established comedy shtick, "The Alphabet Sermon," recycling it as preacher Amon Davis's hilarious sermon in *Darktown Revue*.*

In May 1932, he was sued by a real "girl from Chicago." Lucille Lewis, the virgin star Micheaux had "discovered" for *Veiled Aristocrats*, had never been paid for her emoting in the film. Lewis filed in court to halt the screening of future Micheaux movies in Chicago, and the *Chicago Defender* reported that "other creditors" were lining up behind Lewis.

Micheaux had long since learned how to evade attorneys, and even in New York it took a while for his chief financier, Frank Schiffman, to catch up to the race-picture pioneer with a lawsuit of his own. Charging angrily that his partner had "collected money which he failed to turn into the company offices," and continually "issued checks without permission,"

* While *The Afro-American* was sympathetic to the complaints of the hometown vaudevillians, the Baltimore paper acknowledged, when reporting the lawsuit, that "act-lifting is one of the most overworked practices of the stage," and that Micheaux was hardly alone if he indulged in such borrowings.

Schiffman first filed suit early in the fall of 1932. Micheaux simply ignored the claim, skipping the court hearing.

But on November 26, 1932, around the time he was finishing *The Girl from Chicago*, Micheaux was arrested and arraigned in a Washington Heights courtroom on charges of "petty larceny." The complaint alleged that Micheaux had stolen $83.91 from Schiffman, who added that "this is but one of a series of larcenies totaling several thousand dollars." Micheaux borrowed five hundred dollars for bail, jumped the bond, and then promptly ignored a series of court dates.

Almost a full year went by before the system finally caught up with him. In October 1933 Schiffman instigated another arrest, and this time his complaint was joined by the bondsman whose security Micheaux had forfeited. His bail was set at $2,500: Now Schiffman had Micheaux in a vise.

Micheaux became a fixture of the tiny-print proceedings and judgments itemized in the *New York Times*. (Ironically, this was the first time he was ever *mentioned* in the *Times*, which had never reviewed any Micheaux book or film. As far as the "paper of record" was concerned, race pictures didn't exist.) The levies against Mr. and Mrs. Micheaux, who was named as a co-defendant, ranged above $3,000.

More humiliating was the headline coverage given to Micheaux's lawsuits, arrests, and downward spiral of legal entanglements in the black press. Even some usually friendly critics piled on with their grievances. Ralph Matthews of *The Afro-American* had been a Micheaux enthusiast, but he was repulsed by *The Phantom of Kenwood* when it was screened for him in May 1933, and over time his misgivings had mounted. "I admire your determination to pioneer in your chosen field," Matthews addressed Micheaux in the Baltimore-based newspaper, which circulated widely in black belts throughout the East, "but, sir, I confess I abhor your technique."

The Phantom of Kenwood "seemed to lack direction," Matthews wrote. "It seemed jumpy and undecided as to whether it wanted to move forward or backward, and your actors seemed to be held in check. Their actions were too studied, the natural spontaneity seemed suppressed."

Matthews made it clear that he had followed Micheaux's career from the start, and with appreciation; his astute analysis of the filmmaker's auteurist body of work led him to a stern critique of its repetitive nature.

"Forget for awhile that colored gentlemen go West, or North, or to

South America, and become millionaires," Matthews urged Micheaux. Forget the "social justice" crusades, too, and the obsession with "passing" and miscegenation. "Not every black man wants to cross the [color] line to get a wife," Matthews wrote. He pleaded for Micheaux to consider scripts by other writers once in a while, to find urgent material in real-life news events, for instance. He asked for stars who could really act, role models audiences could "imitate and emulate."

"You have plugged away where others have tried and failed," Matthews ended his column. "You have striven to succeed where others have retreated in despair. Your future, sir, lies with the youth, both in the studio and in the box-office. They are pulling for you. Give them themes they can take to their hearts."

Yet Micheaux was in no position to reply. It would be at least a year before he made another picture—the first in fifteen without a Micheaux production. Instead he spent this ghost year drifting in and out of court-rooms, seemingly defeated.

Micheaux eventually paid his court fees and fines, as well as the money he owed Frank Schiffman. But his pictures were henceforth banned from the Brecher-Schiffman empire—the five largest theaters in Harlem, the city within a city where Micheaux lived, the nation's single most concen-trated market for race pictures.

This was the blow that should have destroyed him. But what had Booker T. Washington said? That it was good to start from the bottom of life? Belief was willpower, and Micheaux swore by the words of the Great Educator. He had scraped through before. It was good to start from the bottom.

He was an expert at many things, and among them were destitution, deprivation, and ignominy. He had been fired for thievery as a Pullman porter, and then learned to be a frontiersman the hard way, dragging a plow through acres and acres of tough ground in South Dakota. His baby had died in childbirth; his wife had left him; his personal humiliation had made headlines in Chicago; even his land had been stolen out from under him. The banks had reclaimed his beloved homestead. Censors had mu-tilated and repossessed his films. Critics of his own race had savaged some of his best creations. His own brother had betrayed him. Some of the pic-

tures he had worked hardest to produce had been frozen in labs, sold at auction. Everywhere he went, he was trailed by lawsuits.

Through it all, he had had to contend with racism and segregation and Jim Crow.

Through it all, America's mainstream film industry remained oblivious to his work.

Yet Micheaux's motivations as a filmmaker went beyond those of his Hollywood counterparts, and this extra dimension compelled him to persevere. Film was a storytelling medium, but for Micheaux it was also a pulpit. He wanted to show life the way he alone saw it. He was determined to bear witness, to *testify.* "He was zealous, full of zeal," recalled Shingzie Howard. "He wanted to get across a message."

And so, slowly, Micheaux began to reinvent his future. He reached out to new investors and collaborators, talking up his ideas the way he always had. He found friends at the Empire Laboratories in Closter, New Jersey, one of the key plants serving the Fort Lee constellation of studios. The Empire Lab owners were willing to let Micheaux's processing bills slide in exchange for a percentage of anticipated returns on his next films. Then he wangled a substantial production investment from Sack Amusement Enterprises, a San Antonio, Texas, company that wanted a steady flow of race pictures for its small theater chain in the Southwest.

The South and Southwest were increasingly important to Micheaux now that he was blackballed in the major Harlem theaters. The West also held promise, and Sack Amusement Enterprises was exploring the market in California. In early 1934, Micheaux himself traveled to the West Coast. From his earliest correspondence with the Johnson brothers and the Lincoln Motion Picture Company, Micheaux had aspired to make a race picture in or around Hollywood. Over the years he had continued to float this dream in publicity releases. But Micheaux never found the means or opportunity, and this was probably his first and last visit to America's screen capital.

Micheaux had maintained a correspondence with the capable actor Clarence Brooks, one of Lincoln's founders. Brooks had developed a solid Hollywood career, recently playing a high-profile role in John Ford's adaptation of Sinclair Lewis's *Arrowsmith.* Fifth-billed, Brooks portrayed a Howard University–educated doctor who aids the hero, Ronald Colman, in fighting disease on a West Indies island. Brooks's part made the picture a resounding success in black theaters, and his breakthrough was

widely heralded in the black press as "the most dignified part given a Negro in the films to date," in the words of the *Atlanta Daily World*.

Brooks met with Micheaux in California, and made a handshake agreement to star in the director's next two productions, the first to be shot back East. Micheaux also met with theater owners in central Los Angeles, which had a booming black population, taking pledges for the planned projects starring Brooks.

Micheaux's visit wasn't mentioned in the Hollywood gossip columns; nor did he apply for work at the major studios, where, he knew all too well, a man of his race was barred from *any* employment behind the camera. Film historian Donald Bogle cited these statistics from 1930: Of 4,451 actors in Hollywood, 128 were black. Of 2,909 actresses, 85. Of 1,106 "directors, managers, officials," just three were black, none of course writers, directors, or producers. Micheaux couldn't have gotten a job operating the clapboard on a Hollywood set.

Yet would Micheaux have left California without stopping for a glimpse of one of the legendary studios, maybe MGM, not far away in Culver City? He loved motion pictures, he watched Hollywood movies whenever he could, and these days some of his old leads even had small roles in them. Sitting in a car outside a studio like MGM, his motor idling, Micheaux would have stared out at a mysterious, sprawling jumble of buildings, a foreign country for which he had no passport. The guard at the gates giving him the once-over would have seen nothing but a well-dressed, middle-aged Negro—a gawking tourist, not the pioneering director of African-American film.

Staring past the gates, only Micheaux could have imagined what he might have done at such a lavish studio, with all the budgets and personnel and opportunities a contract afforded. And only a man like him could have shrugged it all away, putting his car in gear and driving off, thinking: *It is good to start from the bottom.*

Micheaux was accompanied by Clarence Brooks on a train heading East. They took their time, got off at points, hopped into a car and strayed from a direct route, staying overnight with sympathetic newspaper editors and theater managers, talking up their plans. Adding this stint to towns and cities visited later, when their film was released, a national

black-press columnist estimated the two covered 26,000 miles and 37 states, collecting bookings and earnest money.

While en route Micheaux polished the script he was tailoring for the actor, the first scenario he'd been able to schedule for filming in a year. In his lost year he'd had time for reflection, a luxury he rarely indulged. His next picture would be intricately wrought and deeply felt, with a superior script and cast. It would be his first masterwork of the sound era.

At this major crossroads, after having just been flogged by a Jewish backer in the New York courts, Micheaux returned to the true-life Deep South mystery that ended with a prominent Jewish businessman convicted of the slaying of a young white woman, on the testimony of a menial black worker.

Drawing on his 1915 book *The Forged Note* and his 1921 silent film *The Gunsaulus Mystery,* Micheaux plunged into an allegorical reexamination of the 1913 Mary Phagan slaying in Atlanta, and the conviction of factory-owner Leo Frank—a murder case that stuck in his craw.

He would bring audiences into the story using a detective as his alter ego, just as he had in his earlier versions of the story. But in the remake, *Lem Hawkins' Confession,* the Micheaux analogue (who pays his way through law school by selling his novel door-to-door) is named Henry Glory, not Sidney Wyeth. Henry is reluctant to admit that he's the "anonymous" author of the novel he's hawking, even after striking up a relationship with a polite and pretty young customer named Claudia Vance. Yet Claudia lives next door to a vamp, and a series of elaborate misunderstandings separates her from Henry before their friendship can ripen.

The script would open with the murder, with this backstory tucked into a flashback. Years after Henry and Claudia first meet, her brother Arthur, a night watchman, is arrested for the killing of a young woman at a chemical factory. (The victim, Myrtle Gunsaulus in the silent film, is Myrtle Stanfield here.) Henry is now an attorney, and Claudia hires him to defend her brother and track down the true culprit.

Henry and Claudia set a trap for a dubious witness, a lowly factory worker named Lem Hawkins, who has implicated her brother. The trap works: Hawkins reveals that he has been coerced by Brisbane, the head of the factory, into lying. Hawkins believes that Brisbane himself is guilty of the crime, but when Hawkins is dragged into court to refute his previous affidavits, the real killer is revealed through a series of interconnected flashbacks.

As he had in the silent-era version, Micheaux set his latest exploration of the Frank case in Harlem. But he drew the dialogue between Brisbane (the Leo Frank character) and Lem Hawkins (based on janitor Jim Conley) from press accounts and trial transcripts. Many details of his script were extracted "almost verbatim" from the facts of the case, as scholar Matthew Bernstein has pointed out.

Here, as Bernstein reported in his study of *Lem Hawkins' Confession*, is Conley's actual testimony from the trial, recounting a conversation he claimed to have had with Frank on the day young Mary Phagan was slain:

> CONLEY: After I got to the top of the steps, he asked me, "Did you see that little girl who passed here just a while ago?" and I told him I saw one come along there and she come back again, and then I saw another one come along there and she hasn't come back down, and he says, "Well, that one you say didn't come back down, she came into my office awhile ago and wanted to know something about her work in my office and I went back there to see if the little girl's work had come, and I wanted to be with the little girl, and she refused me, and I struck her too hard and she fell and hit her head against something, and I don't know how bad she got hurt." . . . He asked me if I wouldn't go back there and bring her up so that he could put her somewhere, and he said to hurry, that there would be money in it for me.

In a parallel scene in *Lem Hawkins' Confession*, the Brisbane and Hawkins characters recount that same sequence of events, which is visualized in one of the film's flashbacks:

> BRISBANE: Did you see that little girl who came up here a while ago?
>
> HAWKINS: Yas suh, uh, I seen one come up here and she done come back down. And then I seen a . . . a . . . another one come up, but, she ain't come back down yet.
>
> BRISBANE: Well, the one that didn't come back down, came into my office and then went into the stock room where I followed her. I . . . I wanted to make love to the little girl, but she refused me. We got to scuffling and she got her fingers in my face and eyes, and I . . . I had to hit her to make her turn loose. I . . . I don't know how hard I hit her, but she . . . she fell down and hit herself against something and got hurt. I don't know how bad she's hurt. I want you to go back there and bring her

here so we can put her somewhere. Hurry up, Lem! Hurry up! There's money in it for you!

HAWKINS: Yassuh.

Although the remake would be pointedly situated in the present day ("I'm going to run so fast that Ralph Metcalfe can't catch me," exclaims Hawkins, in one of the script's contemporary references),* everything else about *Lem Hawkins' Confession*—from its central characters to minor details—was constructed as an obvious parable of the "familiar, if decades old, public controversy," in Bernstein's words.

Yet one of the beauties of the script was how Micheaux managed to borrow so closely from the history of the case—and then, in unexpected ways, ultimately diverged from its verdict.

Though critics sometimes chided Micheaux for playing to stereotypes, he had a real, underrated, talent for casting. He was cunning about launching veterans of the black stage and vaudeville into motion pictures; he often countercast actors resourcefully, and sometimes made in-jokes with his choices; and he had a solid track record for discovering newcomers.

In Clarence Brooks, Micheaux had an established actor whose name would guarantee bookings and crowds. But a leading lady was equally vital to his success, and finding the right actress had proven elusive for some time.

The great Evelyn Preer was lost to him forever: The pioneering star of Micheaux's best-known early films had passed away at age thirty-six in November 1932. Bulletins of her death from double pneumonia interrupted radio shows. "The statement could hardly be believed," wrote Harry Levette, a Hollywood correspondent for black newspapers. Thousands of shocked fans lined the sidewalks and crowded the Independent Church of Christ at her funeral.

Katherine Noisette, who had played important roles in recent

* A product of Chicago's Black Belt, Ralph Metcalfe was a storied sprinter, a record-holder in college, who finished third in the 200-meter dash in the 1932 Summer Olympics and second in the 1936 Summer Olympics (behind Jesse Owens). He earned a gold medal as part of the 4-by-100-meter relay team that set a world record in 1936. Later, Metcalfe became a Chicago city councilman and U.S. congressman.

Micheaux pictures, also underwent a tragic reversal of fortune. After a messy public divorce, she suffered a nervous breakdown and was institutionalized at Bellevue Hospital; in 1936, she died at twenty-nine. Stardom in black show business demanded talent, but also an iron constitution that could endure the relentless work and stoic drive required to offset the pervasive inequities of racism. The prejudices drove many to drink, despair, or early death.

Nora Newsome and Starr Calloway had fizzled. Lucille Lewis had sued Micheaux before vanishing. But one fair-skinned young actress had impressed Micheaux as a supporting player in *Harlem After Midnight* and *Ten Minutes to Live*. Dorothy Van Engle was a Harlem native who grew up in the same 145th Street apartment building as Lena Horne. Her stepfather, Arvelle "Snoopie" Harris, played saxophone in Cab Calloway's band. Though she had a fleeting career as a model, Van Engle wasn't glamorous; she had a delicate beauty, a modest, unaffected manner, and a keen intelligence. (She was also a talented seamstress, who designed her own wardrobe.) Micheaux cast her as Claudia Vance, billing her as "The Creole Constellation."

Brisbane and Lem Hawkins were the other two major parts. For Brisbane—the Leo Frank character, his Jewishness disguised but implicit—Micheaux turned to Andrew Bishop, the veteran who had anchored several of his best silent films. There is no better example of Micheaux's cross-casting: once a Lafayette Players heartthrob, Bishop would now give life to the lecherous, pale-skinned factory-owner of *Lem Hawkins' Confession.*

Micheaux's casting for Hawkins was also inspired. Roly-poly Alex Lovejoy was a first-rank showman. He had been on the stage since the age of thirteen, playing in the occasional Broadway show but touring widely with revues throughout Europe and America. Lovejoy was celebrated for his vernacular comedy, though his English was perfect off-stage, and Micheaux had written this enigmatic aspect of the real James Conley into the Hawkins character.

Rounding out the principals was the smouldering singer-dancer Bee Freeman, late of *The Phantom of Kenwood* and *Harlem After Midnight,* as Claudia Vance's vampish neighbor. And, following his now-standard procedure, before the cameras rolled at Fort Lee studios in the fall of 1934, Micheaux filled out the cast with a host of musical entertainers and cabaret performers.

Even the song and dance numbers climbed a notch. In one mesmerizing number, Freeman—decked out in a fishnet costume—sold "Harlem Rhythm" before lacing into a wild tap and shimmy. (The cameraman pulls back so quickly to capture her sinuous moves that the boom mike can be glimpsed dangling overhead; Micheaux's films are not for perfectionists.)

Donald Heywood had moved on, but to replace him Micheaux had enlisted Clarence Williams, a prolific composer and musician who had collaborated with Louis Armstrong, Bessie Smith, Jelly Roll Morton, Fats Waller, Sidney Bechet, and W. C. Handy. When not writing or recording his own music, Williams was A&R director for Okeh Records, one of the premier race labels of the era. He also ran the "largest Negro music publishing house of the nation," specializing in spirituals, blues, and jazz.

Fiery jazz, sexy chorus girls, silky tap dancers, and comedy cutaways enlivened the extended scenes set at "The Midnight Club," where Claudia Vance has her crucial rendezvous with the chameleonic Lem Hawkins. Vance pretends to flirt with Hawkins, plying him with drink until he becomes thoroughly soused and blabs his "confession." In this lengthy, stellar sequence, Hawkins betrays his contradictory selves: a man of some erudition known to his cronies as "The Professor," he is also a low-life character who knows how to play the fool. (Micheaux makes this patently clear in one flashback, revealing Hawkins's "coon act" with Brisbane as a masquerade.)

Micheaux had made of Hawkins a character who cannot quite be believed, or trusted—but who is also fundamentally human beneath the charade, who is plainly deeply moved and shaken when he first spies Myrtle Stanfield's dead body. Van Engle and Brooks, who ooze with decency, have relatively thankless roles in the movie. But Alex Lovejoy is a revelation, alternating broad humor with a perverseness and inscrutability that made him a ringer for the actual Jim Conley, as described in accounts of the Frank trial.

Another standout was the usually suave Andrew Bishop as the despicable factory owner. Although Bishop had acted for Micheaux as early as 1924, *Lem Hawkins' Confession* is the first of his performances to survive for viewing today. For most of the story, the audience is led to believe that Brisbane murdered Myrtle Stanfield, just as Micheaux long believed that Leo Frank killed Mary Phagan. But the ending delivered a startling twist: In a flashback, we learn that Brisbane indeed made sexual advances to-

ward Myrtle, but the girl stumbled and fell while fending him off, striking her head. In a panic, Brisbane rushed off to secure Hawkins' help, setting the cover-up in motion. But we also learn that Myrtle's white boyfriend has been hovering outside the room in a mounting rage, sure that Myrtle is flirting with Brisbane.

As Myrtle lies unconscious, the boyfriend steals into the room, strangles her, and slips away unnoticed. It's an ingenious twist, one that leaves both Brisbane and Hawkins with good reason to believe that Brisbane caused Myrtle's death, while placing the real responsibility on the shoulders of another.

In the end, the white boyfriend is implicated by his own mother (played by Laura Bowman). He becomes the object of a manhunt, but even then Micheaux is reluctant to hand the perpetrator over to police. A newspaper clipping reports he has been slain outside a prison, while trying to aid the escape of ne'er-do-well friends.

Thus, regardless of his own conflicts with Jews, and in spite of the ordeal he had just gone through at the hands of Frank Schiffman, Micheaux had found an imaginative explanation for this crime that still troubled him, and a dramatic solution for *Lem Hawkins' Confession* that steered clear of anti-Semitism. He still didn't accept that Hawkins/Conley committed the murder, but he had come around to believing in the possible innocence of Brisbane/Leo Frank.

One of Micheaux's later novels, *The Case of Mrs. Wingate,* published during World War II, concerned American blacks who align themselves with the Nazi cause. The black Nazi sympathizers try to recruit Sidney Wyeth, the surrogate Micheaux character, into making an anti-Semitic film. They feel confident that the unemployed Wyeth will accept their offer to bankroll an anti-Semitic tract, considering his reputed antipathy toward Jews.

But Wyeth protests that his feelings about Jews have been misunderstood by the black Nazis. When grumbling about Jews, he explains, he doesn't mean to sound prejudicial. "I just have a way when I refer to certain people by emphasizing their race," he says. True, some Jewish producers had treated him badly in his career; yet Wyeth felt indebted to others, "rich but kindly Jews" who treated him well. "I don't hate Jews," he insists. "I don't hate anybody." In the end Wyeth refuses the Nazi money, sticking to books.

Micheaux did brood about Jews, but with *Lem Hawkins' Confession*

he also found reason for a change of heart. One factor may have been the influence of a new set of "rich but kindly Jews" in his career. The brothers who operated Sack Amusement Enterprises in Texas, Alfred N. and Lester Sack, were Jewish, and Alfred, who ran the company, was no Frank Schiffman–style bully. He would serve as Micheaux's partner and producer for the rest of the decade, allowing him to make seven more films over the next seven years, far more discreetly and helpfully than Schiffman.

Lem Hawkins' Confession ought to have resurrected Micheaux's career. Yet most of the big-city critics simply ignored Micheaux's comeback film— the first signal that his time had passed. Worse yet, in Harlem, where the Schiffman ban had limited him to brief, unadvertised bookings in small theaters, the movie was lambasted. The reviewers rejected Micheaux's zigzagging narrative structure; after screening the picture in April, one complained that he couldn't follow a story with so many flashbacks. "The continuity has again been ignored," wrote the critic for the influential *New York Amsterdam News*. And apart from Clarence Books and Alex Lovejoy, the paper jibed, the acting was "decidedly overdone."

One remarkably deft scene also drew brickbats from Harlem critics, not on technical grounds, but once again for Micheaux's stubborn effort to write low-life characters who used the n-word. Lou Layne devoted much of his column in the *New York Age* to berating Micheaux, highlighting this offending scene, in which Brisbane forces Hawkins to scribble a note that will pin suspicion for Myrtle's murder on the factory watchman, Claudia Vance's brother. The interplay between the two characters highlighted the devious, jester side of Hawkins, who shuffles and *yassuh*s while scheming to undercut his boss.

"He tell me lie down like a night witch," Brisbane commands Hawkins to write, telling Hawkins to add that a "Negro" did the killing. Micheaux based this exchange on one of two actual notes found near Mary Phagan's body—"the case's most enigmatic pieces of evidence," in the words of author Steve Oney.* According to Conley's testimony, Leo

* The actual note in the case contained similar language and colloquialisms and misspellings: "he said he wood love me and land doun play like night witch did it but that long tall black negro did buy his slef."

Frank forced his black employee to write the two notes. Micheaux had Lem Hawkins balk at the word "Negro," because it would have sounded wrong to Conley's ears. "Four times Lovejoy made it 'nigger,' in the last instance actually spelling the word so that there might be no mistake," complained Layne.

Micheaux's subtle gesture of authenticity was wasted on Layne. "Perhaps the sequence was included in *Lem Hawkins' Confession* to create a laugh," wrote Layne, "but to many who viewed the film it brought only feelings of extreme disgust." Misinterpreting the scene, Layne chastised Micheaux for his "poor judgment."

Once upon a time Micheaux might have been driven to respond in public. He had made a practice of showing up at newspaper offices to shake the hands of his critics, before engaging them in spirited debate. Every now and then he'd pen an open declaration and have it read out before showings of controversial productions. But he'd been wounded and scarred by his troubles in the last few years, and he knew that he'd sometimes made himself too easy a target for his enemies. In the future he'd give fewer interviews, issue no manifestos; he'd let his films and novels speak for themselves.

The best prospects for *Lem Hawkins' Confession* lay outside the East, where it was retitled *Murder in Harlem*. Micheaux and Clarence Brooks barnstormed the South, staying overnight with local theater managers in Atlanta, Knoxville, Chattanooga, and St. Louis, while the Sack brothers scoured the Southwest and tried to make inroads across the Rockies. *Murder in Harlem* became the first Micheaux picture to be shown in Los Angeles and its Black Belt neighborhood, Central Avenue, first at the Tivoli in June 1934, then at the Rosebud as part of a double bill.

Yet things were slowing down. Micheaux's second Clarence Brooks vehicle never materialized. With his characteristic optimism, the race-picture pioneer announced a program of exciting new projects for the future, films that would continue to bring Southern and Northern experiences together into the same story, "a mixture of the old and new Negro." He intended to create race pictures that would be welcomed by "capacity houses in Dixieland as well as on Broadway."

But the talk of Broadway was a flash of the old bravado, when in truth Micheaux had begun to lower his expectations. Race pictures, even he recognized, were an endangered species.

1936–1940 REAPING AND SOWING

By the mid-1930s it was obvious that the New Deal was the same old Bad Deal for black Americans, who still bore widespread unemployment, dwelled in inferior housing, and got the worst of every social index, including the nation's highest mortality rate. North and South, they endured nearly universal discrimination and led generally downtrodden lives.

In Harlem there was growing unrest over the soured promise of President Franklin Delano Roosevelt's reforms. The bitterness peaked in March 1935 with a riot. Following rumors that a black youth, accused of stealing a knife from a store, had been beaten by police, some ten thousand Harlemites went on a rampage, looting and destroying neighborhood businesses. Often enough the targets were Jews, who were among Harlem's chief landlords and merchants. Before the National Guard could quell the disturbance, three black citizens had been killed and seventy-five people (mostly black) arrested; property damages soared above $200,000.

Many Harlemites, including many theater and music artists, were politicized by the Depression at home, and by the rise of fascism abroad. Some found an outlet for their activism as members of the U.S. branch of the Communist Party. A small number were drawn to Nazism and Hitler. Indeed, during this time Harlem produced a homegrown "Black Hitler," the fiery labor and religious leader Sufi Abdul Hamid, whose streetcorner harangues decrying the millions of dollars poured into white businesses in Harlem were suffused with anti-Semitism. A convert to Islam, Abdul Hamid brought thousands of Harlemites into the Islamic faith and led a

controversial boycott of Harlem merchants, before he was sued, dragged into court, and jailed. In 1937, he was killed in an airplane crash.

As the mood of black America swung from lassitude and despair to a heightened pride and militance—especially in the Northern cities—there was one surprising side effect: the race picture industry caught a second wind. Film scholar Clyde Taylor has described the mid- to late 1930s as a resurgent period for race pictures, one that saw an escalation in both quality and quantity. Even as the term "colored" gave way to "Negro" in general parlance, "about this time the very name 'race movies' began to disappear," wrote Taylor. Some called them "sepia pictures" now.

In the mid-1930s, Hollywood itself gave rise to a flurry of new pictures geared to black audiences. They were modest films, arguable advances, but the times were calling for change, and Hollywood took note. The major studios always had followed the race-picture business, coveting its talent, its ideas, its audience.

One of the Hollywood breakthroughs, for example, was a "passing" story given the four-handkerchief treatment. *Imitation of Life,* made in 1934, starred Louise Beavers as a self-sacrificing "Mammy" whose light-skinned daughter is tormented by her racial identity. Its undeniable success spurred a few "all-Negro" projects, like the screen version of *The Green Pastures* in 1936. Unique personalities like the dumb-comic Stepin Fetchit and dancer Bill "Bojangles" Robinson suddenly became Hollywood royalty, given marquee roles in major studio productions.

Most of the new "sepia pictures" were also being made in Hollywood, but on the fringe, where shoestring producers, often white Jewish men who were aloof from the big studios, cranked out formulaic all-black programmers for predominantly black audiences. Not bad films, either: Light-skinned Ralph Cooper, disqualified as a "typical Negro" for Hollywood roles, became a crime-buster in a slew of "sepia pictures," while a former jazz crooner named Herb Jeffries metamorphosed into a singing cowboy and single-handedly revived the all-black Western.

Outside of Hollywood, only a few lonely outposts of race picture-making endured. One was in Dallas, where Spencer Williams, a stocky, resourceful actor who had dabbled in writing and directing motion pictures, often without credit, since the silent era, was turning out interesting all-black films for Sack Amusement Enterprises.

Always a category unto himself, Micheaux remained in the East long after his many rivals and colleagues in the field had quit, or gone to Hol-

lywood. The leading name in race pictures (he was slow to embrace the term "sepia") still made his home in Harlem. But Micheaux and Spencer Williams shared an angel: the Jewish Texan Alfred N. Sack, who helped give Micheaux's career rare stability through much of the 1930s.

Like Micheaux, Alfred N. Sack was a born salesman. The son of a Greenville, Mississippi, merchant, he moved with his family to San Antonio as a boy. After high school, Alfred tried college in St. Louis before returning to San Antonio, where he published the local *Jewish Record*. As an officer of his temple, he hosted amateur plays and road shows, and it was there that he fell in love with show business.

Sack bought his first theater in San Antonio in 1920, when he was only twenty years old. He and his brother Lester soon began buying other movie houses in the South and Southwest, often in Mexican or black neighborhoods, and by 1922 they had theaters in Texas, Oklahoma, Arkansas, and Mississippi. The Sack theaters offered race pictures and touring plays, but the brothers also cultivated civic relations by making the theaters available to local "colored" clubs, sororities, fraternities, and charitable organizations. By the mid-1920s Alfred Sack was putting money into the occasional low-budget Spanish-speaking, Yiddish, all-black, or educational picture. In 1929 he produced *St. Louis Blues*, a musical short with blues singer Bessie Smith, shot in New York City.

The bespectacled Sack was very much a Southerner—soft-spoken, laidback, courtly. He didn't pretend to be a creative producer; rather, he was an investor in the creativity of others, and a salesman of the product. Like Micheaux, he made it a point of honor to travel his circuit, which included much of the Deep South and Southwest, getting to know the theater managers and making good on his agreements.

Moving to Dallas in 1936, Sack decided to expand his operations, adding theaters and boosting his investment in race-picture production. He signed distribution contracts with every producer he could find, and handled the "sepia pictures" of most of the newest Hollywood companies. He opened branch offices of Sack Amusement Enterprises in Chicago, Atlanta, and on Seventh Avenue in New York. His press releases vowed to book future Micheaux productions into white theaters. For the first time, he created color brochures and even trailers for upcoming

Micheaux titles. And, as another point of honor, the Sack firm hired "an increased number of colored assistants, agents, and other attachés."

The budgets for Micheaux's productions were still stingy: Regardless of the Depression, the filmmaker was still held to a $15,000 limit—the same amount he had budgeted for his first silent picture, *The Home-steader*, in 1918. His stars might earn $100 to $500 per picture, but most of the other actors were paid ten dollars a day. (Even so, actors' salaries added up to less than 10 percent of the total budget.)

But the Sack money was steady and reliable, and Micheaux could get his movies pre-booked into the company's string of black theaters in the South and Southwest. Sack even took care of Micheaux's distribution problems in Harlem and elsewhere in the boroughs of New York City, by making local exhibition arrangements with the RKO chain.

In his publicity materials, Micheaux acknowledged that times had changed, while slyly clinging to ideas that had worked for him so often in the past. No longer would audiences tolerate "Southern hymn singing and portraying of Mammys with handkerchiefs on their heads," he was quoted as saying. The changing times called for modern race dramas, urban and edgy and suffused with "a faster tempo, night clubs, hot orchestras, pretty chorus girls." The most marked change would be in the number of white actors Micheaux intended to sprinkle into small parts ("not as buffoons as we are used in Hollywood," as he explained, "but in exactly the same spirit we would like them to use us"), and in the new orchestras and floor shows he would use, sometimes drawing the performers, now, from midtown clubs.

Micheaux's new race dramas would be set in Harlem or Chicago, or sometimes—like *Temptation,* the first film he officially produced under the Sack umbrella—both in the same story.

Temptation was shot in mid-1936. The film itself is "lost," but its plotline can be pieced together from press notices: A beautiful young Chicagoan wanders into a notorious nightclub and finds herself in deep trouble, getting mixed up with a gangster on the lam from Harlem. A government agent rescues her in the nick of time. It was the usual Micheaux setup, except for this extraordinary fillip: the girl is an artist's model ("with the fig-

ure of a goddess"), accustomed to posing in the nude. The men she meets just don't understand the artistic nature of her profession.

Micheaux needed a handsome actor to play the undercover agent, but he was fresh out of leading men. Lorenzo Tucker had gotten married and quit acting in favor of a regular paycheck, starting a painting and home improvement business on Long Island. He still stayed in touch with Micheaux, who treated him like a wayward son. "I used to go to their house some evenings," Tucker recalled, "and I was actually hungry between pictures, because things were tough in those days. I used to sit down at the table, and eat with them. Incidentally, I was accused of eating up all the props when we made the pictures and we had dining room scenes . . ." Micheaux offered Tucker the undercover agent role.

Then he went after another regular who had left acting behind: Andrew Bishop had moved to Cleveland, where he worked for the city administration. Bishop's successful shady-character turn in *Lem Hawkins' Confession* inspired Micheaux to think of him for the gangster-louse in *Temptation*. After a series of phone calls and letters, Micheaux managed to woo Bishop away from Cleveland, and the filming was arranged around his August summer vacation. Bishop drove East in the new Hudson he had bought on his city salary.

The mood was more lighthearted on the sets of the films Micheaux made for Sack Amusement Enterprises in the mid-1930s. Having been through the worst, Micheaux had come to see his job more philosophically. Many of the actors seemed to realize that it was the last hurrah for race pictures, and there was a kind of "Let's enjoy ourselves while we can" atmosphere on the set, an echo of the "family feeling" that had prevailed during Micheaux's time in Roanoke. Now and then Micheaux played practical jokes on the cast members, and they took their revenge with elaborate spring-traps of their own. When he wasn't looking, they even did hilarious impressions of him, mocking his pompous pronouncements.

Micheaux felt, sometimes, that there was a little too much fun going on. "The big problem is getting these artists to work in the morning," he complained in one interview. "High-priced technical men must frequently be paid for hours while some person necessary to a scene is quietly snoozing at home after a night's jamboree. Things like this run the cost of production up."

Tucker and Bishop, especially, made a "pair of wastrels" during the film-

ing of *Temptation*. More than once they materialized late, or inebriated. One day the friends fell to drinking together in Harlem, and then got into a car accident while crossing the George Washington Bridge on their way to Fort Lee. By the time they finally arrived at the studio, an angry Micheaux had already started without them. The two curled up behind some flats, thinking it might be wise to avoid the boss until they had sobered up.

"Where the hell have you been?" Micheaux demanded when they eventually crawled out.

Bishop muttered something about falling asleep behind the flats.

"Micheaux didn't believe us," recalled Tucker, "and he never forgave us for that one."

The nude artist's model was the most important character in the story, and once again Micheaux had to mold a novice into a marquee attraction. He chose Ethel Moses, a newcomer to the screen with sultry, Latin-tinged looks, who had va-va-voom to spare. The daughter of a minister, Moses had been a chorine with Florence Mills and won a Harlem beauty contest that broadcast her vital statistics: height: 5'4½", bust: 32, waist: 27, hips: 37. She had performed in cabarets and road shows. Micheaux promoted Moses as "The Negro Harlow," and advertised *Temptation* as "Adults Only" in some venues, with pinups of Moses half-nude from behind, or cupping her bare breasts.

The film's nudity might have hampered it in states with vigilant censors, but *Temptation* circulated well in Sack theaters; and in the East, Moses made personal appearances at the largest venues. One such event, at Brooklyn's Regent Theatre in April 1938, reportedly drew five thousand people. After the Micheaux picture was shown, hundreds rushed backstage for autographs and police had to be summoned.

With Alfred Sack's money behind him, Micheaux was back up to speed. His next film, *Underworld*, was shot the same year, in late 1936.

Once again Micheaux chose Chicago as the main setting for a story about humble, decent folk who get mixed up with jazz and low-life criminals. This time, however, Micheaux based his script on someone else's story: "Chicago After Midnight" by Edna Mae Baker, who wrote for *Abbott's Monthly*, a literary offshoot of the *Chicago Defender*.

The story began "somewhere in the Southland," with establishing

shots of Fisk University in Nashville, where a new graduate (Sol Johnson) is invited to Chicago by a smooth-talking racketeer (Alfred "Slick" Chester), hiding out from police. The two descend on the Black Belt, and the graduate loses himself (and his money) in a binge of crap games, speakeasies, and pawnshops. He develops a crush on a vamp (Bee Freeman) who is already juggling two men—the racketeer and an abusive husband (Oscar Polk).

Micheaux was capable of writing nice guys who could win a stupid contest, and Johnson's character was one. The real spitfire of the film was Bee Freeman, who had appeared in *The Phantom of Kenwood, Harlem After Midnight,* and *Lem Hawkins' Confession.* Her part in *Underworld* was her biggest yet, as the hostess of a roadhouse called "The Red Lily." At first her character shows some sincere affection for the educated Southerner, but after they quarrel over ethics and another woman, she conspires with the racketeer to rob the college kid. The robbery goes awry, the graduate is drugged into a stupor, and the vamp's jealous husband, guided by detectives who have been paid to trail her, shows up unannounced, threatening retaliation. The racketeer, always hovering about, shoots the husband.

When the graduate wakes up, Freeman tells Johnson that *he* murdered her husband. The police arrest him, but Freeman's maid (Amanda Randolph) knows the truth—a threat the vamp eliminates by strangling her. But then Freeman's head fills with accusing voices; insane with guilt, she drives her car into a speeding train.

It's a riveting scene, albeit low-budget. And Freeman acts her convoluted character to the hilt. *Underworld* had its share of such compelling moments, and when the action started to lag, the director waved on a kickline, a vocal trio of sisters, a rope dancer (tap-dancing as he twirls a rope), and the otherworldly hoofer Stringbean, whose loose-limbed footwork ranks among the weirdest spectacles in Micheaux's films.

Micheaux's weakness for such distractions confounded some of his players. "I said to him once, 'Why are you doing that? It has nothing to do with the story,'" remembered Lorenzo Tucker, whose role in *Temptation* was his most minuscule yet. "He said, 'The poor guys down South want to see some pretty legs—dancing and beautiful girls. We've got to satisfy them.'"

For *Underworld,* Micheaux bypassed Connie's Inn in favor of a dance band and floor show imported from the Kit Kat Club on East Fifty-fifth Street. Freeman was billed as "The Sepia Mae West," and Oscar Polk ad-

vertised as "Angel Gabriel from *Green Pastures*" (he'd go on to Hollywood and play a servant in *Gone With the Wind*). Ethel Moses, the sexy star of *Temptation,* this time took the role of the good-girl, a beauty parlorist who saves the college man from a life of decadence.

"One of the most stirring and unusual stories" of the year, wrote Hugh Thornton in the *Chicago Defender.* But Moses kept her clothes on, and *Underworld* didn't draw quite the same crowds as *Temptation.*

When Micheaux wasn't filming, as always he was traveling and selling his films. Heading to South Carolina by train in the mid-1930s, the young artist Elton Fax sat down beside a man "dramatic looking" and "dramatic in his manner." The man leaned over and introduced himself as Oscar Micheaux. Fax was awed; he had enjoyed *The House Behind the Cedars* and other Micheaux pictures during his Baltimore childhood. Micheaux started in talking—about his latest film, and his next film, and the one he planned after that. "You couldn't sit near Micheaux without his talking," recalled Fax. "He talked and talked and talked. That's where I first saw him and got the feel of his personality. He was a supersalesman of his own wares, and, I was thinking to myself, something of a Phineas T. Barnum in general manner—bombastic."

But the supersalesman needed to sell to theaters, not fellow train passengers. And the number of theaters for "sepia pictures" wasn't mushrooming. In 1937 Sack Amusement Enterprises released a list of "Movie Theaters Catering to Negroes," identifying 389 in the United States: 142 in the South Atlantic States, 68 in the Middle Atlantic, 54 in the East North Central and West South Central, 47 in the East South Central, 16 in the West North Central, with the remaining fifty-plus strung out in the Mountain and Pacific states.

That was "about 400 of the 16,000 movie houses" in America, according to *Time* magazine.

The *New York Amsterdam News* said the number of "so-called Negro theaters" was always inflated, "owing to certain competitive theaters that squawk about first-run pictures." These theaters refused to exhibit a "sepia picture" if they couldn't claim exclusivity; the same self-destructive competitive spirit prevailed that Richard E. Norman and George P. Johnson had bemoaned in the 1920s. The *Pittsburgh Courier* put the national

total at closer to 270, once the houses in major cities that welcomed a "mixed population" (that is, mixed-neighborhood theaters willing to play a few race pictures, usually at midnight shows) were eliminated.

One persistent problem was that fewer than half the Negro or "mixed population" theaters boasted black managers, and still only a fraction were owned by black people. Micheaux, who was banned from the Brecher-Schiffman theaters in Harlem, depended increasingly on a group of theaters controlled by black businessmen in Washington, D.C., Baltimore, Philadelphia, and Pittsburgh. In burgs like Elyria, Ohio or Monessen, Pennsylvania, he had to settle for the one-shot end-of-day showings dubbed "Midnight Rambles."

To shore up his bookings, Micheaux took scouting trips with a new Man Friday, Carman Newsome. Born in Kansas, Newsome was the grandson of a freed slave, an elderly rancher who had long been a neighbor of the Micheaux family. As a teenager in the 1920s, Newsome had moved with his family to Ohio, enrolling in Central High School, a black school famed as a hotbed of musical prodigies. Newsome taught himself to play the tenor saxophone and clarinet and formed his own big band, leading a shifting aggregation that, at one time, featured trumpeters Freddie Webster and Harry "Pee Wee" Jackson, both of whom later played with jazz great Jimmie Lunceford. Cleveland was one of those cities Micheaux passed through regularly, and on one trip in the mid-1930s he encountered the young musician leading the house band at the Cedar Gardens.

Micheaux told Newsome to look him up if he ever came to Harlem. When Newsome moved there in 1936, he found the music competition fierce and took the sales job offered to him by the race-picture pioneer.

Despite his traveling tutorials from Micheaux, Newsome, the world's most mild-mannered personality, didn't turn out to be much of a salesman. But Micheaux was keeping an eye on him for other reasons. The light-skinned Newsome was so tall and handsome, so physically striking that wherever he went, women fluttered and swooned. Micheaux was half irritated by his Man Friday's easygoing charm, and wrote him into his 1946 novel *The Story of Dorothy Stanfield* as his "Clark Gable–looking" employee Carter Thompson. "He didn't have two ounces of brains," Micheaux wrote ungenerously of Thompson/Newsome.

But by the time Lorenzo Tucker quit again after *Temptation*—his tenth or eleventh Micheaux film, and his last—the newest graduate of Micheaux's school for stars would be ready for his close-ups.

Remarkably, in the following year Micheaux would dash off three more pictures: *Swing!, God's Stepchildren, Birthright.*

Swing! was a diverting piffle largely designed to launch Carman Newsome as "The Dark Gable." The tale, which shifted between Alabama and Harlem, followed the fortunes of a goodhearted cook named Mandy (Cora Green), who is much in demand among white households but also dishes up "Chitlin' Suppers" for the Alley C and South Highlands neighborhood of Birmingham. Her husband is a hustler, chronically out of work. He's been two-timing Mandy with a "high yaller" named Eloise, who is cuckolding her own husband, a fireman. When Mandy finally figures out her husband's unfaithfulness, she abandons him for new horizons in New York.

Micheaux refocused the Harlem half of the story on an alter ego who reflected his own artistry and preoccupations: the tall, good-looking impresario Ted Gregory (played by Newsome). Ted is trying to launch a new musical revue, aided by his loyal secretary Lena (Dorothy Van Engle). The "high yaller" from Birmingham materializes as the show's lead, though, like certain actors Micheaux could mention, she "drinks like a fish" and has a habit of missing rehearsals. Something interesting happens with the casting when the action shifts north: Though the "high yaller" and her firefighter have different names in the Harlem scenes, both couples are played by Helen Diaz and Alex Lovejoy, and they seem to be the same characters.* Whether Micheaux was playing a "doubling" game with audiences, or simply giving two favorite actors a chance to "double" their performances (and low salaries), is unclear—but the double-casting adds to the fun.

The conflicts and crises continue. While inebriated, the "high yaller" breaks her leg, and without a guaranteed headliner the "colored" producers pull out of the show, plunging the impresario into despair. "This show can't get to first base with a Blues singer, a Mammy lead," Ted says, voicing a Micheaux plaint on the history and pitfalls of black show business. "They look for it in this type of show . . . Of all the Colored shows that have gone by the boards, no Negro has ever produced one. From

* Hazel Diaz plays Eloise in Birmingham and Cora in Harlem, while Alex Lovejoy is Lem in the South and "Big Yellow" in New York. The name "Lem" might remind audiences of Lovejoy's starring role in a previous Micheaux production, *Lem Hawkins' Confession.*

Williams and Walker to *The Green Pastures,* they've all been sponsored by white men. No Negro has ever been in on the money, or the profits."

Lena, who knows Mandy from Birmingham, finds her a job, sewing costumes. While Mandy is inept at costuming (most of the actual sewing is being done by Lena, played by the expert real-life seamstress Van Engle), she can torch-sing with the best of them. Lena urges Ted to take a chance on Mandy. Ted finds a rich white backer who agrees to fund a Broadway opening with Mandy as the star, and the show goes on—a quintessential Micheaux pipedream.

Newsome and Van Engle made a charming couple. The petite, dynamic Green, who played Mandy, had been in vaudeville since she was a teenager; during the making of *Swing!* she was being showcased in Leonard Harper's latest revue at Connie's Inn, where her act (just as in the film) combined comedy and torch songs. Hazel Diaz, the "high yaller," was a nightclub singer turned actress. Micheaux filled out his cast with the usual parade of chorus girls, street-urchin tap dancers, a female trombonist, and muscle dancer Consuelo Harris, whose specialty was an acrobatic and licentious bump-and-grind.

"We don't have the money to spend on big sets and many retakes," Carman Newsome, Micheaux's "road" ambassador and new leading man, told the Cleveland *Plain Dealer,* somewhat defensively, on a publicity visit to his hometown. "We mostly shoot with one 'take' but if it isn't good or isn't what our director wants we have gone as high as seven 'takes' for one scene. We try to make the very best pictures we can."

Besides all the self-references, *Swing!* was sprinkled with Micheaux's social criticism, especially in the form of disapproving portraits of shiftless men, two-timers, gamblers, and welfare bums. And, if nothing else, the 1938 film is still worth watching today for a last look at the sweetly affecting Dorothy Van Engle, who got married, became a librarian, and never acted again.

As always Micheaux followed Hollywood trends, closely watching the movies that poached on his territory, sometimes reacting adversely to their fallacies, sometimes creating his own all-black variants. The self-important *Imitation of Life,* nominated for a Best Picture Oscar in 1934, particularly incensed him, as its story—about a lovable Mammy's daughter running

away from her true skin color—stole his "passing" theme and ideas and turned them around into a sheeny Hollywood soap opera. Not only was *Imitation of Life* more technically proficient than Micheaux could dream to afford, by the end the film had turned into a bathetic weeper.

Micheaux realized that he could turn a profit by making an imitation of *Imitation of Life*. After all, wasn't he the legitimate master of that theme? Weren't his films the most authentic account of the realities and texture of black America?

He would envision his next project, *God's Stepchildren,* as the ultimate "passing" story, reworking and critiquing the Hollywood clichés from his own unique perspective. Micheaux wasn't shy about citing the negative inspiration of *Imitation of Life,* identifying the 1934 film in the Sack Amusement Enterprises trailer for *God's Stepchildren* as one of two acclaimed and successful studio productions that had influenced his latest movie. The other was a product of white Hollywood that had nothing to do with race, a William Wyler picture from 1936 called *These Three,* based on Lillian Hellman's celebrated play, *The Children's Hour.*

On crucial matters Mrs. Micheaux always concurred with her husband. And the script for *God's Stepchildren* was based on an unpublished short story, "Naomi, Negress," again written by someone other than Micheaux. The publicity and advertising were coy about its source, but in one interview Carman Newsome allowed that the author was none other than Alice B. Russell, the first and only time she penned the story for a Micheaux film. *God's Stepchildren* would become a summary achievement for husband and wife.

The first part of *God's Stepchildren* was a riff on the Hellman play, which concerned a group of teachers whose lives are ruined by malicious students spreading lesbian gossip about them (the Hollywood version avoided censorship by leaving the lesbian undertones ambiguous). The Micheaux script would similarly start with "these three": a middle-aged, upstanding seamstress named Mrs. Saunders; a distraught stranger trying to abandon her unwanted mixed-race baby; and the mixed-race infant girl, whom the seamstress agrees to adopt.

The adopted child grows into a beautiful lightskinned mulatto, who agonizes over the fact she has been adopted into a Negro family. This is "Naomi, Negress," whose racial identity is betrayed only by the color of her eyes. ("Over in the shadows, they seem to be blue," says Mrs. Saunders, the seamstress. "But here in the daylight they're brown. That's the

Negro in her.") Naomi could easily "pass" for white. Herself a stepchild, she sneers at other black people as "God's stepchildren." Though the Saunders family lives in "Coloredtown," Naomi refuses to mingle with black children and tries to sneak into the whites-only school across town. Her black teacher tries to nurture her, but a hostile Naomi spreads rumors about the teacher's intimacy with another instructor, causing a community uproar. Her stepmother and Naomi's older brother Jimmie, realizing Naomi is mentally imbalanced, defuse a riot of parents by telling the truth about her. Naomi is sent away to a convent.

Cut to ten years later: Jimmie has grown into an honest, handsome fellow; working as a Pullman porter, he has saved thousands of dollars and dreams of buying and farming land. His sweetheart is the daughter of the goodhearted schoolteacher from the first half of the story. Jimmie resists the efforts of a ne'er-do-well friend to persuade him to invest his earnings in a "numbers" racket. Instead, he becomes Micheaux's spokesman for "our group," voicing disdain toward fellow members of his race who have drifted into a lazy or criminal life.

"Their idea of success is to seek the line of least resistance," Jimmie tells his girlfriend. "A Negro hates to think. He's a stranger to planning."

Along comes the seemingly angelic Naomi, "cured" by her convent term. Yet Naomi nurses a strange crush on her handsome older brother, and she resists her stepmother and brother's well-intentioned efforts to marry her off to Clyde, a family friend. "Nice fellow, industrious," argues her stepmother. But Naomi, who is filled with self-loathing and still phobic about race, finds the dark-skinned Clyde "funny-looking," with his flat nose and other "typical Negro" features. Jimmie spurns Naomi's weird advances. Clyde hears voices inside his head (Naomi is tricking him from a hiding place), but marries Naomi anyway.

The opening scene is replayed at the end of the story, when Naomi walks out on Clyde and her newborn, giving over her baby boy to her own stepmother, Mrs. Saunders. Naomi has cast her lot with white people. "I'm leaving the Negro race," Naomi tells the self-sacrificing seamstress. Though hurt and astonished, Mrs. Saunders replies sympathetically, "I did the best I could, but I failed . . . Now I can only say I'm sorry for you, Naomi. Sorry from the bottom of my heart, and I pray the Lord to forgive you and guide you to God knows whatever."

Naomi is unfazed. "If you see me, you don't know me, even if you pass me on the street . . ." she declares—a powerful line lifted almost directly

from the similarly climactic final encounter between the pale-skinned daughter (Fredi Washington) and her "Mammy" (Louise Beavers) in *Imitation of Life*. The Hollywood picture had concluded with Mammy's death and the daughter sobbing her repentance—a mildly uplifting finale. But in his best films Micheaux was an unblinking realist, and his response to *Imitation of Life* was his toughest ending.

Years pass in *God's Stepchildren*. Jimmie marries the schoolteacher's daughter, they raise a family. Naomi's little boy grows up as one of their extended brood, a reality of black America that was often honored in Micheaux pictures. Jimmie and Mrs. Saunders love and care for Naomi's little boy as their own.

True to her vow, Naomi has cut off all contact with those who love her, but can't find happiness with white people. (Surviving records indicate that censors struck a violent scene in which the audience would have learned that Naomi has gotten married to a white husband, who beats and deserts her when he discovers she is a "Negress.") Homeless and destitute, she takes to lurking outside the Saunders' house, peeking in the windows for a glimpse of her lost child. Like characters in other Micheaux pictures, the boy possesses extrasensory perception; one night he insists that he spies a strange but familiar face outside the windows. Jimmie and Mrs. Saunders rush onto the porch to search around, but when they get there Naomi is gone.

Gone to a bridge overlooking a rushing river, where the film concludes with a stunning montage. Happy images of the intergenerational Saunders family are intermingled with shots of Naomi's sad fate. The tortured "Negress" is glimpsed under glowering skies, teetering on a bridge railing, then plunging into the waters, her hat swirling past in the current. The final title card quotes Galatians 6:7: "As ye sow, so shall ye reap."

Louise Beavers's Hollywood "Mammy" had been a stereotype, however subtly written and performed. Micheaux steered clear of caricature with his version of *Imitation of Life*, making Mrs. Saunders a powerful, positive woman who works hard for her livelihood and independence. It's no accident that this key character has a profession, seamstress, in common with his wife's mother; no accident, either, that Mrs. Micheaux wrote herself into the role.

Indeed, Alice B. Russell was at the center of this extraordinary project in several ways. She had long been a reliable performer in Micheaux's films, but *God's Stepchildren* would be anchored by her rueful smile and Zen-like presence. Besides writing "Naomi, Negress," she also starred in the film, and was credited as the producer.

Apart from Carman Newsome (as Jimmie) and Ethel Moses (as the schoolteacher/daughter), the cast included Charles "Daddy" Moore, whose many appearances for Micheaux had begun with *The Homesteader;* Moore played the school principal in the first half of the story. Alex Lovejoy was Jimmie's gambler-friend, Jacqueline Lewis played Naomi as a girl, and Gloria Press was the adult Naomi.

The plethora of outdoor scenes suggests that parts of *God's Stepchildren* were photographed in a rural locale, perhaps near Dallas, Texas, where the Sack brothers had invested in a low-budget production facility used by Spencer Williams. But the bulk of the movie was shot in New York and New Jersey in the summer of 1937, with a cobbled-together white crew including editors Leonard Weiss and Patricia Rooney from West Coast Service Studio on Fifty-seventh Street and Recording Laboratories of America on Thirty-eighth Street, respectively; and sound engineer Ed Schabbehar from Producers Service Studio in Ridgefield, New Jersey. Lester Lang was back as Micheaux's director of photography.

Micheaux took as much time as he could shooting *God's Stepchildren,* and then he refused to rush the editing of this important "preachment" film—one of two or three pictures, in any event, that he was editing simultaneously.

The third project produced during this impressive spurt, the sound version of *Birthright,* was shot in late 1937.

This was another remake of a silent hit, and likely another film for which Micheaux appropriated the rights. His fondness for T. S. Stribling's novel was bolstered by his nostalgia for Evelyn Preer, whose acclaimed performance as Cissy, the good soul mired in "Niggertown," had helped make the silent picture a hit. Casting Ethel Moses as Cissy in the remake was a testament to Micheaux's belief in her budding talent and drawing power. The versatile brothers J. Homer Tutt and Salem Tutt Whitney weren't available for the other two main characters, but Alex

Lovejoy would play "Tump" Pack, the returned World War I veteran who makes trouble for Cissy and the idealistic Harvard graduate Peter Siner; and Peter Siner himself would be portrayed by Carman Newsome.

The Sack years were characterized by gradual budget tightening, and *Birthright* is the first of Micheaux's three 1937 productions to look sorely pinched for funds. It's not clear if *any* of the movie was shot in the South; press items reported filming in "the heart of South Jamaica," between 109th and 110th Avenues, with immigrant Jamaicans standing in for Southern blacks. However, the photography had a vitality as well as austere beauty, thanks to cameraman Robert J. Marshall, who also shot low-budget Yiddish features for Edgar Ulmer.

Others in the acting ensemble included Hazel Diaz and Alice B. Russell, who was again credited as the film's producer. The musical sequences were humdingers. And though Stribling's story was streamlined by the script, though looks and likability were Carman Newsome's main attributes, Micheaux's perspective on Jim Crow practices and the squalor of Southern segregation was still unique, still bracing. He might have soft-pedaled such issues in his "gat-gam-and-jazz" musicals for much of the 1930s, but in *God's Stepchildren* and *Birthright,* Micheaux evoked the fire and brimstone of old.

Swing!, God's Stepchildren, and *Birthright* all appeared in theaters in 1938, a "Banner Year for Negro Movie Industry," according to a headline in the *Pittsburgh Courier.* As film scholar Clyde Taylor has noted, though, 1938 was also a crisis year: Another headline—the Communist *Daily Worker's* warning, "Negro Films Must Tell the Truth"—suggested "the opposing perspectives, the boosterism and the skepticism" that greeted each new "all-Negro" film. The skepticism came largely from urban dwellers, which included a burgeoning number of black members of the Communist Party of the U.S.A. Their sweeping social critiques extended to the world of cinema.

Micheaux considered himself apolitical, in part because he resisted being pigeonholed. Though Booker T. Washington had long since disappeared from the walls of the homes of characters in all his films, he still revered the Great Educator. But he was as mixed and catholic in his politics as he was interested in nearly every category of show business and lit-

erature and the arts. He briefly admired Marcus Garvey's back-to-Africa movement, expressed support for Liberia, and at different times in his book and film work he had championed W. E. B. DuBois.

America's black Communists, however, were too extreme for him—too orthodox, too downbeat. Micheaux found U.S.-style Communism a "crazy ideology" that thrived on "hard luck and discontent." True, the Party supposedly made a priority of fighting for equality and justice for minorities. But Micheaux suspected that many overeducated black men were becoming Communists simply in order to marry the rich, white, often Jewish women, who dominated Party circles in New York. (When musing about Communism in his novels, Micheaux often used *Native Son* author Richard Wright—a one-time Communist who was married to a white woman, and lived downtown, not in Harlem—as a negative example.) Yet Communism was no mere abstraction for Micheaux; some of his Harlem acquaintances, including certain actors in his productions, were Communists, and some of them he liked personally.

No doubt his hostile attitude toward Communism was exacerbated by the surprisingly antagonistic reception the U.S. branch of the Party, and affiliated left-wing groups, accorded one of his prize films: *God's Stepchildren*.

Micheaux's answer to *Imitation of Life* opened quietly in mid-1938 at an RKO theater, the Regent at 116th Street and Seventh Avenue in Harlem. Critics largely ignored the race-picture pioneer's new film, but ticket sales were brisk—and the audiences included Harlem Communists who had been tipped off in advance. The Harlem Communists were affronted by the characters of Jimmie, who denounces lazy members of the race ("One Negro in a million tries to think"), and Naomi, who is so consumed with self-hatred that she deserts her baby and commits suicide. After the manager of the Regent met with a delegation of outraged viewers, but refused their demand to withdraw the picture, "a storm of protest" erupted (in the words of the *New York Age*), with members of the National Negro Congress, the Frederick Douglass Club, the Harlem Teachers Union, the International Workers Order, the American Youth Congress, the Young Communist League, the Workers Alliance, and the Harlem Committee for Better Pictures for Children assembling to picket the Regent and threaten any theater that dared exhibit the picture.

When Micheaux consented to meet with the protestors, he was called on the carpet by none other than Angelo Herndon, one of the Party's

most popular black leaders. Herndon was only nineteen in 1932 when he organized a massive rally of the jobless in Atlanta, a largely peaceful demonstration that alarmed local officials because of the biracial turnout and Herndon's avowed Communism. Herndon was arrested and charged with inciting insurrection, a capital crime; after being found guilty he was sentenced to eighteen to twenty years on a Georgia chain gang.

The Herndon case, like that of the "Scottsboro boys" rape trial in Alabama that same year, was such a notorious example of Jim Crow injustice that his cause stirred support throughout the United States. In 1937 the Supreme Court threw out his conviction, declaring the Georgia insurrection statute a violation of the Fourteenth Amendment. Herndon was mobbed as a hero in New York and feted at a Group Theatre benefit.

Now, behind closed doors at the Regent, Herndon and other Communist spokesmen sternly lectured Micheaux. Beatrice Goodloe of the Young Communist League warned the press that the "all-star colored" film "slandered Negroes" by "holding them up to ridicule, playing light-skinned Negroes against their darker brothers." The New York Communists demanded that Micheaux withdraw *God's Stepchildren,* or delete the degrading scenes.

Here was a new form of censorship, one that Micheaux had not expected or encouraged. Surely he was taken aback to be confronted by the heroic Herndon, whose battle with Southern injustice was known to every man and woman in Harlem. The RKO management buckled, promising to withhold *God's Stepchildren* until Micheaux altered the film. Then the race-picture pioneer met with reporters, according to the *New York Age,* and announced that he would delete "offensive portions" of *God's Stepchildren* and preview his next two pictures to "representatives of all the protesting groups" before releasing them to theaters and the general public.

Then *God's Stepchildren* jumped to the Apollo, the Tompkins, and Subway theaters in Brooklyn, probably benefiting from the controversy. And perhaps Micheaux did tinker with the "offensive portions" of the New York prints, but probably not, as evading any kind of censorship was his specialty.

Distribution of *God's Stepchildren* continued in any case, and when the Micheaux picture was advertised for the Ritz Plaza Hall in Boston later in 1938, it was the same original version, uncut and uncensored. The local alliance of the New England Congress for Equal Opportuni-

ties, New England Congress of Colored Youth, the South End Progressive Club, and South End Educational Committee called on the Ritz Plaza Hall management to cancel the engagement. The theater owner demurred. The New Englanders picketed and passed out flyers.

"No favorable publicity was given Mr. Micheaux," according to a press account. "Contrary to all speculation, however, the picture found many colored patrons anxious to judge it for themselves."

That was true wherever *God's Stepchildren* was shown in 1938.

Another Micheaux film had benefited from headlines, and indeed *God's Stepchildren* became one of the director's most reliably popular films, cropping up intermittently in theaters nationwide until his death.

And *God's Stepchildren* has stood the test of time. After racism and financial problems, censorship was probably Micheaux's worst enemy, and the politically motivated censors of 1938 misjudged the movie.

Technically, it's one of Micheaux's most accomplished sound-era films, with a style that is a triumph over budgetary restraints. The outdoor sequences are lyrical: groaning trees, rustling wind, gathering storms that echo people's inner turmoil. The interiors are spare, but even here extra care was taken in the decor and lighting, with people tightly silhouetted against walls, or sometimes trapped in a car next to each other, having troubling talks.

The principals gather at intervals at "The Raccoon Club." "Let's set aside our cares and watch this number," says Jimmie (Carman Newsome) at one point, a typical cue for Micheaux to bring on his potpourri of acts. But for once, even the musical numbers take a backseat to the ideas, and Naomi's story unfolds with a grim inevitability. Micheaux invested a lifetime of his concerns and craft in this intense tragedy of a mixed-race woman who is torn apart by her identity crisis—her story singular, like his, but with lessons for all. *God's Stepchildren* can be seen as his ultimate "passing" film, condemning racial categorization as a social madness.

As J. Hoberman of the *Village Voice* has written, the Communists couldn't appreciate the film's complexity without an awareness of Micheaux's lifetime of work. Part of the greatness of *God's Stepchildren*, Hoberman noted, was that it made "overt the formula" of his long career, unleashing "the full force of Micheaux's racial neurosis." Another prominent white film critic, *Time*'s Richard Corliss, has also hailed the picture as brilliant, synoptic Micheaux, "everything to condemn and cherish"

about his unique oeuvre in one concise package. "The twisted melodrama of his plots reveal the social anguish of his characters," Corliss argued. For Corliss, the race-picture pioneer was a master of his métier, and *God's Stepchildren* his true "masterpiece."

Nineteen thirty-eight was a watershed for the race picture business, its last banner year. All-black films would fill a void and persist with occasional surges into the early 1950s, but the "Golden Age," if it ever existed, was over.

Sack Amusement Enterprises had made little headway pushing Micheaux films into white theaters. Still, even the managers and owners of black theaters (who were overwhelmingly white) preferred to book the latest Hollywood movie with seamless production values and big-name stars. Micheaux's all-black films were routinely "nixed" by the biggest Harlem theaters, according to Dan Burley, the Showlife editor of the *New York Amsterdam News,* "in favor of pictures made by white concerns."

Clarence Muse, one of the most famous black actors in Hollywood movies (he had started out with the Lafayette Players) and a leader of the Hollywood branch of the NAACP, devoted an installment of the column he wrote for a string of black newspapers to Micheaux. He praised the veteran as a "BROTHER of the RACE," a "HERO," who had devoted his career to race pride. But Micheaux, Muse wrote, was having a harder and harder time getting his pictures into "SOME theaters in LARGER cities, particularly in NORTHERN cities." Muse added, "Of course, in our survey, we FIND that has never occurred in HOUSES owned and OPERATED by NEGROES."*

Though there were still numerous small theaters and eager audiences for his films throughout the South and Southwest, Micheaux couldn't hope to make up what he was steadily losing in the Northeast and Midwest.

As the end closed in, Micheaux only intensified his work on a new script. *Lying Lips,* another story in the nightclub-musical vein, started filming in February 1939 at the former Biograph Studios in New York.

Micheaux could turn any cow's ear into a silk purse, and he cast one

* The capital letters are Muse's stylistic device in his original column.

leading role in unique fashion. A prizefighter from Mississippi, a rising
star in boxing, had knocked out a rival in a Harlem bout; his photo had
appeared in the black press, fiercely looming over his slumped victim.
That is when the prizefighter, afraid he might kill his next opponent, quit
the ring. He decided to try acting, and his first job was as Joe Louis's spar-
ring partner in *The Spirit of Youth,* a "sepia biopic" of Louis, the reigning
heavyweight champion, produced in 1937.

When Micheaux recognized the ex-boxer from Mississippi among the
picketers outside a New York theater showing *God's Stepchildren,* he asked
him if he wanted to play a Joe Louis–type boxer in a future picture he was
planning. First, the former fighter could try a secondary role in *Lying
Lips.* The anti-Micheaux picketer said yes; his name was Robert Earl
Jones, and he was the father of the deep-voiced actor James Earl Jones,
well known to audiences today.*

For his leading lady Micheaux chose Edna Mae Harris, daughter of a
well-known Harlem family. Her mother ran a boardinghouse for per-
formers near the Lafayette Theatre, and several of the Harris girls went
into show business. The dark-eyed Edna Mae catapulted to fame as
Zeba in *Green Pastures* on Broadway before going to Hollywood and re-
creating her role in the 1935 film. She lingered in Hollywood, playing
small parts in studio pictures like *The Garden of Allah* and *Bullets or Bal-
lots.* Harris was another alumna of *The Spirit of Youth,* where she played
opposite Joe Louis. These days she danced, sang, and made patter onstage
at Connie's Inn.

The tough-talking villainess with lying lips would be portrayed by
Frances Williams, who came from Cleveland's prestigious Karamu The-
atre. Williams may or may not have been picketing alongside Robert Earl
Jones, but everyone knew how she lined up politically; she was among the
stream of sympathetic black artists and intellectuals, including Paul
Robeson and Langston Hughes, who visited the Soviet Union in the
1930s.

Micheaux's story centered on good-girl Harris's attempt to steer clear
of anything but her entertainment obligations while working at a night-

* Jones the son is well known to film fans for playing Darth Vader in the *Star Wars* series. Since
the late 1950s, he has had a long, high-profile career on Broadway and in other media, playing
everything from leads in Shakespeare to recurring roles in television series. His famous voice is in-
stantly recognizable in commercials or, for example, as the call-out of CNN. Jones wrote about
his father and Micheaux in his autobiography *Voices and Silences.*

club owned by underworld figures. The owners of "The Poodle Dog Cafe" are white, but day-to-day management of the club is left to Carman Newsome, once again playing Micheaux's nice-guy hero. Newsome quits his post when his bosses try to pressure Harris into trysts with the clientele.

Newsome has been studying to be a private detective, however, which comes in handy when a mysterious murder occurs and Harris is framed for the slaying of her heavily insured aunt. Robert Earl Jones plays the police officer who subscribes to Harris's innocence and teams up with Newsome to prove the facts of the murder. A series of linked flashbacks reveal complicated motives rooted in past relationships and the Deep South.

"Micheaux was really struggling," Harris recalled. The budget was stretched. It was a running joke in Micheaux's circles that he always paid his actors last. "He *would* pay you," Harris insisted loyally. "He had a good word." Yet his leads were still making the same money they were paid twenty years earlier. "Ten dollars a day," Harris remembered. "That was good for the time." (She got only $75 a week in Hollywood for her billed appearance in *Green Pastures*.)

In the early 1930s, amid bankruptcy and battles with Frank Schiffman, Micheaux had made movies like a man running from a subpoena, which he was. His good humor suffered, and so did the films.

Now, in the late 1930s, the filming was still hurried and the bills as worrisome as ever. But Micheaux seemed more comfortable with circumstances, at ease with himself. By and large, the cast liked and empathized with him. "He was very nice," Harris recalled. "He didn't holler at actors. He humored you."

"I've always been impressed with large gentleman who are gentle," echoed costar Frances Williams. "I can see that slow smile of his now and that twinkle in his eye. He was a very charming man. I never saw him upset."

Alice B. Russell was always close by—"big woman, tall, very neat, very nice and proper," in Harris's words. "He loved her and she was beautiful," agreed Williams. Mrs. Micheaux helped with the ladies' casting; she'd organize the wardrobe (out of the actors' closets) and "show the other actors how to make up," said Harris.

One of her important jobs on the set was to hold the script and make sure her husband's lines were followed precisely. After a short rehearsal, Micheaux would announce, "Now this is for real. This is a take . . ." Even

then, despite the pace they were forced to keep (Harris jokingly recalled that *Lying Lips* was shot in only "three days"), Micheaux sometimes called for retakes. "Oh, if you made a mistake, you had to do it over again," Harris said.

Most of *Lying Lips* was simpleminded, even preposterous. Even though Harris was playing the young innocent in the story, Micheaux kept her busy undressing, or lolling in the bathtub (talking aloud to herself to prolong the shot), for sexy highlights that were intended to have an Ethel Moses–like effect on audiences.

The only message of *Lying Lips* was entertainment; the "preachment" was minimized. But Micheaux planned a comic scene that turned on the idea of lynching, something he had done as far back as *The Symbol of the Unconquered* in 1920.* In his original script, the detectives (Newman and Jones) stage a mock lynching of the villainess's brother, forcing him to confess. But a comic lynching, predictably, was too much for the New York censors. Micheaux was forced to revise the idea, dashing off pages of palaver and refilming the scene with the two threatening their victim (Cherokee Thornton) with a visit to a haunted house. But the jokes are funny and full of Micheaux self-references (allusions to "The Ghost of Tolston Manor" and "A Fool's Errand," among other "ghost films").

Lying Lips was in the editing room by late March 1939, in theaters by May. The leads jumped into Micheaux's automobile and traveled from city to city promoting the picture, even handing out flyers in a few cities down South. But theaters were increasingly scarce, and so were reviews. Wherever the latest Micheaux production played, however, some critics—like Lynette Dobbins of the *Chicago Defender*—overlooked its flaws and found it "praiseworthy and commendable."

By now, Micheaux was desperate for a lifeline.

On paper, Colonel Hubert Fauntleroy Julian might have looked like

* Although lynchings understandably haunt the African-American psyche to this day, in truth, lynchings had become more aggressively publicized and prosecuted, and by the end of the 1930s there was a decline in their frequency across America. Lynching statistics are notoriously unreliable, but data kept by the Tuskegee Institute shows a drop-off beginning in 1936.

Micheaux's newest savior. But Julian was neither a creative artist nor a financial wizard. His fame was as an aviator, and the bankrolling of his disparate flying adventures was sometimes as nebulous as Micheaux's. His main attraction as a partner was his publicity value.

Born in Trinidad, Julian had emigrated as a student to England, then moved to Canada, before finally settling in Harlem. Dating from the early 1920s, when flying was young and as subject to Jim Crow restrictions as every other major occupation and industry—black pilots were extremely rare—Julian staged many bravura air demonstrations and parachute jumps into public arenas. He had made an unsuccessful attempt to be the first man to fly from the United States to Africa, and even served a spell in Abyssinia as Haile Selassie's personal pilot.

Julian was a front-page favorite of America's black press, which avidly followed his stunts and pioneering, dubbing him "The Black Eagle of Harlem." He even infiltrated white newspapers and national magazines like *Time* and *American Mercury.* Tall and prepossessing, the Black Eagle affected a monocle and bowler, wore a Savile Row suit decorated with a boutonniere, and carried a briefcase attached by chain to his belt.

Somewhere along the way, Micheaux and Julian had struck up a friendship, and now it seemed possible that Julian could serve as a conduit to fresh money and publicity. His name might help Micheaux obtain bookings in Harlem as well as on Broadway, and once again the press releases hyped the hope of slipping Micheaux films into white theaters nationwide. The new partners announced their intention to manufacture short subjects about black newsmakers, too. Their first feature would be an ambitious boxing saga starring Robert Earl Jones.

Micheaux had been making films for the same dirt cost, flirting with courts and collapse, for twenty years. In that period he had managed to write, direct, and produce at least forty films—more than any number of famous directors doing the same job in all-expenses-paid Hollywood; more, for example, than Cecil B. DeMille.

The Notorious Elinor Lee would hark back to one of Micheaux's first pictures, 1921's milestone black vs. white boxing film *The Brute*. Where *The Brute* had traded on the mystique of Jack Johnson, *The Notorious*

Elinor Lee would make its allusions to the currently reigning heavyweight champion, Joe Louis.

Once an amateur pugilist (if the Rosebud stories were true), and always a knowledgeable fan of boxing, Micheaux had followed Louis's career from the start, exulting when the "Brown Bomber" was crowned champion of the world in 1937. In one novel Micheaux offered high praise for Louis, not only as a tough fighter, famed for his stunning knockouts, but as a role model for the race, a black man who wasn't afraid to boast his greatness.

Micheaux would pluck several cast members from the rival "sepia picture" *The Spirit of Youth,* in which Louis had acted his own life story. Like *The Brute,* however, *The Notorious Elinor Lee* would be set mainly in Chicago, Micheaux's home of the heart. "A Chicago girl, huh?" one of his characters asks another in the script. "By adoption, yes," she replies. "Most of us over twenty, likewise," the first comments knowingly.

Micheaux's script would weave topical, autobiographical, socially critical, and folkloric elements into an alternative Joe Louis "biopic," complete with musical numbers. The hero of *The Notorious Elinor Lee* was Benny Blue, known as "The Bombshell," whose boxing contract has been taken over by the crooked Elinor Lee. Unbeknownst to Blue, Elinor Lee has made a pact with gangsters, promising to build Blue up into a contender for the championship. But when he fights for the heavyweight crown, the match will be secretly rigged in favor of organized crime.

Blue stacks up the wins, and his popularity soars. Success goes to his head; he neglects his old friends and is beguiled by a mystery girl named Fredi (her name intentionally evoking Fredi Washington, the actress who "passed" in *Imitation of Life*). Fredi is reluctantly working off an obligation to Elinor Lee, a relative. She is trying to leave behind a checkered past that includes shoplifting and a prison stint. Fredi hails from Paducah, Kentucky (across the Ohio River from Micheaux's birthplace) and is the daughter of the notorious "Stacker Lee," who made headlines by killing a person during a crap game, with a talking parrot as his only eyewitness.*

Blue's manager is the honest and educated Haywood ("he has just been graduated from the University of Chicago"), who has his hands full

* The "talking parrot" was Micheaux's curious grace note, but the main reference is to the blues song "Stagger Lee," which is based on the myth of "Stacker Lee."

trying to shield the fighter from corrupting influences. "The Bombshell" has a white archnemesis, a German Superman named Max Wagner (read: Max Schmeling), who fights in a "funny sideways" manner and harbors an implicitly racist disdain and fear of Blue. The two slug it out early in the story, but Wagner wins (as happened to Joe Louis, when he fought Schmeling for the first time in 1936). When the rivals meet again for the championship, Blue is told to take a fall, or else.

True to his word, Micheaux gave Robert Earl Jones the starring role as Benny Blue. Carman Newsome would play Haywood. Edna Mae Harris, appearing in her second Micheaux film, was Fredi, while Gladys Williams portrayed Elinor Lee. There were never very many white performers in Micheaux films, but the number multiplied in the late 1930s, peaking at "18 whites" for *The Notorious Elinor Lee* (an exact number supplied to *Time* magazine by Hubert Julian). Most of the colorful types in *The Notorious Elinor Lee* came straight from the boxing world—among them Harry Kadison, a former Golden Gloves boxer turned character actor, who had the most substantial white part as the German Superman.

The Notorious Elinor Lee was shot mainly in and around Chicago's Black Belt in the fall of 1939. Micheaux was able to draw on his connections with local hangouts and boxing personalities.

Haskell Wexler, who would go on to become an award-winning Hollywood cinematographer, was working at the time as a teenage assistant in the processing laboratory of a cheap Prairie Avenue studio, where Micheaux was filming the interiors. The Prairie Avenue facility was used mainly for industrial filmmaking, not feature motion picture production, and the developing rooms shared a wall with the principal sound stage; the chemical smell of nitrate film was constantly wafting onto the stage where Micheaux was working.

The race-picture pioneer had turned fifty-five in January 1939. These days he eschewed hard liquor, but ate profusely. As he wrote of Sidney Wyeth, his alter ego in his 1945 novel *The Case of Mrs. Wingate,* "When he [Wyeth/Micheaux] goes to dinner, he goes to eat. Throws formality and ostentation out the window, eats his fill and enjoys it." In his fifties his weight ballooned ominously. Now it was Micheaux's size and girth, as much as his commanding air and charisma, that awed people.

Though he looked like a ponderous giant, Micheaux was still a man with energy to burn. As always, he was a speed demon on the job, scrambling all over the set, climbing ladders to check on lights. He'd strut and

bop along with the musical numbers, or watch the actors from his chair, his body twisting in anguish if he didn't like what he heard or saw.

Micheaux exuded the firepower of youth, Haskell Wexler recalled. The handful of crew members, all white, hustled to follow his barking orders. His speed was amazing. "Change the pictures!" rumbled between scenes.

The principal photography was completed by Christmas, and the postproduction that followed was a whirlwind.

Micheaux and Hubert Julian pulled out all stops for the mid-January 1940 "world premiere" of *The Notorious Elinor Lee*, which took place at RKO's Regent Theatre on Seventh Avenue and 116th Street in Harlem.

Julian mailed out gold-embossed "free" invitations with "semiformal" dress and R.S.V.P. advised. The general public paid as much as forty cents, or as little as twenty ("the last eight rows in the balcony"), for tickets. An hour before the first show, "hundreds of curiosity seekers crowded around the roped-off, spotlighted square," according to one account, with arc lights and a camera trained on a hired master of ceremonies.

At 7:15 P.M., a siren-blaring police radio car escorted the arrival of a shining black Cadillac. Out stepped the film's associate producer, Colonel Hubert Julian, magnificently adorned in top hat, tails, white silk gloves, and an Inverness opera cape draped around his neck and secured with a silver chain.

The Black Eagle spoke briefly into a microphone. "I am proud to be associated with Mr. Micheaux, veteran motion picture producer, who has gone through twenty years of personal sacrifice to give Negroes good, clean entertainment." Promising an excellent film, Julian added cautiously, "Don't expect the perfection of a Hollywood picture." Micheaux also briefly addressed the crowd, which was dotted with Harlem celebrities like jazz virtuoso Louis Armstrong, recording artist Maxine Sullivan, and the black magistrate Vernon Riddick.

Before the screening Julian hosted the gold-invitees in private in the manager's office, where he served "the choicest" of champagnes, scotches, ryes, cognac, and port, according to one press account. "This is the greatest thing that has ever been done in Harlem!" the beaming theater manager, Max Mink, told reporters.

At the appointed hour Micheaux and Julian took the stage together to introduce *The Notorious Elinor Lee*. Micheaux said little, deferring to the Black Eagle, who basked in the attention. "Darken the theater, and on with the show," Julian finished his short speech, to cheers and applause. "Let joy be unconfirmed!"

Micheaux liked to sit off to the side when watching his own movies with the general public. He spent part of the show pacing around the lobby. Inside, the crowd talked back to the screen, laughing and applauding, by all evidence enjoying themselves immensely. *The Notorious Elinor Lee*, wrote the representative of the *New York Amsterdam News* afterward, "was really something to see." "It was colossal," the white columnist H. Allen Smith of the *New York Herald Tribune* chimed in (perhaps tongue in cheek; one never knew with him). "It was very gripping and held the interest, and I laughed until I got a pain in my side."

After twenty years in the limelight, explaining and defending his pictures, Micheaux seemed content in Julian's shadow. The partners and special guests celebrated into the wee hours that night, backstage in the manager's office. Even Micheaux, a virtual teetotaler at this point, may have joined in the champagne toasts to the future. Julian kept proclaiming they were entering a new golden era of Negro moving pictures. "My life work in aviation is done," he told *Time*. "I am going to devote my life now to improving the place of the Negro in motion pictures." According to his authorized biography, "For weeks the film played to packed audiences."

In reality, however, the film played to few audiences outside of Sack theaters, and the partners were broke on opening day. *The Notorious Elinor Lee* could barely claim to exist. "After we made all these pictures we had no place to show them!" recalled Edna Mae Harris, years later. Robert Earl Jones never got his salary.

CHAPTER SIXTEEN

1941–1947
THE WIND FROM
NOWHERE

The theaters were slipping away. After *The Notorious Elinor Lee,* Micheaux even lost the Sack chain in the South and Southwest.

Alfred and Lester Sack had seen the handwriting on the wall: *Elinor Lee,* they told Micheaux, would be their last race picture. They would no longer be investing in production, and they were getting out of the distribution end entirely. Sack Amusement Enterprises had quietly begun to sell off its theaters, keeping only select houses in Dallas, where the company switched to showing foreign-language films.

As he recounted in his 1945 novel *The Case of Mrs. Wingate,* when Micheaux learned this news he had several future scripts prepared, with two actually rehearsed and ready to go before the cameras. The first would have been expensive: a sweeping biographical picture, this time with Micheaux's partner Hubert Julian, the pioneering aviator, playing himself. "It will tell the story of my career," Julian informed *Time* magazine, "my crackup when I tried to fly to Europe, my parachute jumping over the city, and my triumph in getting the Army to have Negro aviators."

Then Sack Amusement Enterprises pulled the plug on the budget, and Micheaux made a decision. "I don't feel like going out here begging a lot of Jews to put up money to make pictures with, any more. Just don't feel like it." Or at least that's the explanation given by Sidney Wyeth, Micheaux's alter ego, in *The Case of Mrs. Wingate.*

The Sack brothers' desertion revived Micheaux's lifelong struggle to come to terms with his feelings about Jews. And yet he had to admit that

it was another group of Jews—other prosperous acquaintances—who quickly stepped up to replace the Texans, advancing the relatively small sums of money Micheaux needed to forge a new path.

In truth, it was an old, familiar path, requiring less investment and risk: Micheaux would return to self-publishing. He would convert his unfilmed scripts, and other, earlier projects, into novels. At least a part of each of the four novels he wrote after the failure of *The Notorious Elinor Lee* would be, in some sense, a "remake."

He might miss filmmaking, but really, he wouldn't miss the *ordeal* of filmmaking.

"There is hardly enough money in it [producing race pictures] to justify the cost and effort," Wyeth/Micheaux muses in *The Case of Mrs. Wingate*. Though at times he had managed to live well and maintain a few regular employees—always a secretary and sometimes a driver—Wyeth/Micheaux admitted that he never made any "Big Money" in all the twenty years he'd been writing, directing, and producing films.

In *The Case of Mrs. Wingate,* Micheaux offered a sophisticated analysis of why race pictures were dying while Hollywood got richer and richer all the time. "Publishing a book is simple, a simple procedure compared with making pictures," Wyeth/Micheaux explains. "The major picture business has long ago been taken over by Wall Street. It is a huge and gigantic industry and trust, operated through about a half dozen or more what you call 'major' film companies, who own or control all the best theatres not only in this country, but in Europe, especially England and South America. These big film companies reciprocate their pictures with each other. 'I'll play your pictures, in the theatres we control' they say, in effect, to each other, 'If you'll play ours in those you control.' And so it goes. If I spent a million dollars to make a colored picture and if it was as good as the best picture ever made, I couldn't play it anywhere except in what they call Negro theatres, unless I could persuade one of the major companies to release it, and they're not that interested that much in Negroes. . . ."

He wouldn't abandon the field entirely. He'd continue to book his old pictures into theaters whose owners he could count on; the best-known Micheaux films would crop up across America throughout the 1940s. And as he worked to circulate his old pictures, he indulged his life-long love of travel, crisscrossing the land, researching his books, visiting friends and old haunts. Ernest Jackson, one of the three wheeler-dealer brothers who had shown him generosity in his homesteading years, was

by now living in Chicago, and the two men had stayed in touch. Back in South Dakota, they heard tell that the ex-homesteader was shuttled back and forth between Harlem and Chicago in a sixteen-cylinder car driven by a white chauffeur. By this point Micheaux weighed "over 300 pounds," reported the *Sioux Falls Daily Argus-Leader* in 1940.

Most of the time, however, Micheaux could be found in New York, living a more settled life. From his small office in Harlem, he concentrated on setting up his new business and writing his first novel in over twenty years. He wrote, as he had always done, in longhand on a cheap lined tablet. (Later, his secretary would do the typing.) He tried writing "a little every morning, a chapter mostly," as Wyeth/Micheaux puts it in *The Case of Mrs. Wingate.* "On Sunday, I try to write more."

Though he welcomed visitors, and never skipped a meal, Micheaux worked hard at constructing a novel based on a story he believed was tried and true, a story he felt he still could improve, but which still had the power to inspire his race. *The Wind from Nowhere* would "remake" two previous Micheaux novels: *The Conquest* and *The Homesteader,* which had also been the basis of his first silent and sound pictures.

His life story: the wellspring of all his stories.

By the day of infamy—the bombing of Pearl Harbor in 1941—he had finished a solid draft. Following his longstanding practice, he then delivered it to "some highly educated person," as Wyeth/Micheaux conceded, whose job it was to comb the pages "sentence by sentence," editing his sometimes ungainly prose into "perfect rhetoric and grammar."

That was Alice B. Russell, Mrs. Micheaux, the One True Woman.

The Wind from Nowhere had a more evocative title and was more smoothly written than its predecessors. The basic plot remained the same, varying only in its nuances. This time, those nuances revealed a man still searching the betrayals of the past for an answer to the quandaries of the present day. The humor of his early novels, in which a young man commented wryly on himself from the sidelines, was replaced by a lack of irony, a solemnity.

Micheaux's title was clever, a play on the grandiose Hollywood movie that sentimentalized the Old South at the time of the Civil War, which had just swept the box office and won the Oscar for Best Picture of 1939. He

even borrowed the phrase "gone with the wind" in the novel itself, wield-
ing it in a scornful aside aimed at certain people and American cities,
which he had come to see as cesspools. On a trip to Harlem, his alter-ego
homesteader stands outside Marcus Garvey's headquarters and reflects on
the failed promise of Garvey's crusade, and of Harlem in general. The
hopeful, exciting Harlem of old, he muses, was now "gone with the wind."

This time Micheaux christened his alter ego Martin Eden, in tribute to
Jack London, whose rugged individualism had inspired him as a young
man. Micheaux's Eden is "virile and a hard worker with a definite objective
in life." Reminiscing warmly about the white homesteading community,
Micheaux wrote that Martin Eden had "almost never heard the ugly word
of 'nigger.'" Indeed, just about the only person to use that word in the
novel is his wife's malicious younger sister, who sneeringly informs Linda
Lee (the Orlean McCracken character) that Martin Eden is "your niggah."

Micheaux assigned most of the wrongdoing to the younger sister, who
grew more demented in each successive version of his life story. Martin
Eden's wife, Linda, became a confused, sympathetic victim, who would
never have forsaken her husband if her family hadn't kidnapped her and
taken her back to Chicago. Her father, the Reverend Newt Lee in this
telling, is still "vain to the core and full of ostentation" but not really evil
or blameworthy. "Years later," Micheaux wrote ruefully, Martin Eden
"was sorry he had not been a bit more patient with the Elder."

With each rendition, Micheaux further exaggerated his climactic en-
counter with his wife and her father in Chicago. In this third novel about
his homesteading struggles, he really punishes the Lees/McCrackens:
Near the end of the story, when Linda finally realizes how much suffering
she has caused poor Martin, she grabs a long-bladed knife, stabs her fa-
ther to death, stumbles outside her house in a dazed state ("in her orange
colored negligee, spattered with blood, her brindlelike hair disarranged"),
and is run over by a car.

Micheaux's most wishful addition to *The Wind from Nowhere* was his
baby son, who, in this final version of long-ago events, survives childbirth
and is spirited away to the Black Belt by the wife's meddling family. All
along Martin Eden has been struggling with his affection for the appar-
ently white Scottish girl, who is his neighbor on the Rosebud. As in *The
Homesteader*, the Scottish girl follows Martin Eden to Chicago, where she
meets up with her own relatives on Vernon Avenue and learns that she is
a "bright mulatto." Then, after Linda's death, she and Martin Eden re-

claim his baby. They rush back to South Dakota in time to defeat a crooked banker and take up residence on their rightful land—where, conveniently, valuable manganese ore has just been discovered.

The Wind from Nowhere was self-published in early 1943, with The Book Supply Company reincorporated at Micheaux's 40 Morningside Avenue apartment in Harlem. But the Harlem press, which had treated Micheaux's race pictures as beneath notice for most of the preceding decade, sniffed at his first novel since 1917. Constance Curtis, the book editor of the *New York Amsterdam News,* told friends, "I've reviewed a lot of books, but I've never reviewed one more aptly titled than *The Wind from Nowhere.*"Indeed, reviews of any kind were hard to come by, which infuriated Micheaux.

But the self-publisher advertised the book heavily in black newspapers and magazines throughout America, and it sailed through multiple editions, selling a reported 30,000 copies. That would have qualified *The Wind from Nowhere* for the bestseller lists, if Micheaux hadn't been working outside the mainstream New York publishing industry. "Undoubtedly," conceded Carlton Moss, hardly a member of Micheaux's fan club, "he placed more books by a black author in more black homes in America, than any other fiction writer."

Micheaux also traveled widely to promote the book in bookstores and libraries and schools, and as usual in person he was an irresistible salesman of his stories and ideas. Micheaux enjoyed his time on the road, giving talks and selling *The Wind from Nowhere* right out of his suitcase. He liked to inscribe copies: "To one of our group . . ."

While on the road, Micheaux always found spare time for reading and thinking. In 1943 the papers were filled with war news, and now the reborn novelist started jotting down ideas for his next book, one that would mingle autobiography with a modern plot—something to jolt his readers, remind them of Pearl Harbor, and rally black people to the urgency of World War II.

Micheaux spent the next two years selling *The Wind from Nowhere* and writing *The Case of Mrs. Wingate,* which evolved into Micheaux's most elaborate and audacious novel, taking his longtime bugaboos about politics, Jews, and intermarriage, and weaving a pitched melodrama exploring "Nazi activity inside black America."

Borrowing, liberally, from W. E. B. DuBois's *Dark Princess*—which at one time he had considered adapting into a film—Micheaux offered a story full of interweaving subplots and shifts in time and place.

Its true beginning was in the South, in Atlanta ("easily one of the freest towns in the South for a Negro"), where the reader was introduced to a young, college-bound black man named Kermit Early, who since high school has been pursued by a well-bred, coquettish white Southern classmate. After marrying a rich white man, this flirtatious woman, now known as Mrs. Wingate, stops by Kermit's shoeshine stand; as he polishes her shoes, she deliberately spreads her lower limbs and shows him her private parts. Though he tries to dodge her persistent sexual advances, she doesn't give up; she is drawn to the taboo of having sex with a black man. She successfully schemes to get Kermit into a spare room in her suburban home, then into her bed as her lover.

Mrs. Wingate tells Kermit that her husband (like Leo Frank) is "not a normal man" when it comes to sexual relations. (Then, for several pages, Micheaux reflexively revisits the true-life case that compelled his attention in a book and two films: *The Forged Note, The Gunsaulus Mystery,* and *Lem Hawkins' Confession*. Whether or not Frank was guilty, Micheaux in the end endorsed Negro janitor James Conley's views about the factory-owner's stunted sexuality. Frank could only be sexually aroused by having "unnatural relations" with women, Micheaux wrote; the Jewish factory-owner wasn't "built like other men" and "went down on women.")

You'd think Micheaux would approve of a shoeshine boy with aspirations toward higher education, but his storytelling was iconoclastic to the end. Kermit goes on to college and life in Chicago, but Micheaux portrays him as weak-willed and pathetic. Despite his degree, Kermit becomes a "kept man" for Mrs. Wingate. His airy liberal education never leads him to meaningful employment, much less an ability to cope with the real world.

Kermit soon falls under the spell of a subversive group, operating out of Chicago and Milwaukee, which is building a fifth column of Negro Nazis who blame Jews for the problems of black America. Moving to New York, Kermit is assigned by his pro-Nazi handlers to approach the pioneering race-picture producer Sidney Wyeth, whose differences with Jewish producers and theater owners are widely known. Wyeth, by now, has gone broke making race pictures and retreated to writing fiction. As part of a pro-Nazi propaganda campaign planned for the United States,

Kermit offers to arrange funding for Wyeth to make a comeback, if he will agree to make a "hate movie" inciting Negroes to riot against Jews.

Micheaux's story skitters all over the map—from Atlanta to Chicago and New York, from Memphis to Nashville and Louisville, touching down aboard a luxury liner bound for Bremen and visiting Berchtesgaden in Germany, where Hitler is busy delivering a speech berating Jews and describing the lynching of Negroes as America's "national pastime." (A Japanese ambassador, looking on, smiles in agreement.) In Germany, readers meet a brother and sister of the Negro race, though half-German and light-skinned, who are dispatched to America to aid the subversion. The sister becomes conflicted by her assignment when she falls in love with Wyeth.

The New York chapters are sprinkled with autobiographical allusions and glimpses of Wyeth/Micheaux's daily routine. Minor characters in the novel are based on the multitalented Donald Heywood, and on Irving Miller, a noted producer of black theatricals, whose wife, a dancer, had a small role in Micheaux's 1923 film *Deceit.*

The most intriguing aspect of *The Case of Mrs. Wingate* is Micheaux's continuing colloquy on Jews, a fellow oppressed minority, but a group whose members had too often rubbed him wrong. In fiction and films he was an early voice in the difficult history of black and Jewish relations in America, but in the end his message was complex.

At first, Micheaux's alter ego Wyeth is bemused by the Nazis' offer and stalls his reply. Ultimately, however, Wyeth/Micheaux rejects the "hate movie" proposition, saying that he is content as an author. Besides, his attitude toward Jews has been misunderstood. At this peak of anti-Semitic tragedy in the world, Micheaux's alter ego waves an olive branch, insisting that he doesn't hate Jews.

"After all they did to spoil your business?" the unsympathetic Kermit prods.

"They didn't go into it to hurt me; to put me out of business. They went into it on the theory that they could make some money. They had a right to," Wyeth/Micheaux replies phlegmatically.

So Kermit heads to Buenos Aires, another old Micheaux haunt, from the days when he was portering for white bigwigs on South American excursions. There Kermit tracks down the genuine article, an ex-Hollywood German émigré filmmaker, who is willing to take up the gauntlet. When the hate tract premieres in Harlem, riots break out and vandals run wild, destroying "mostly Jewish owned" businesses and merchandise.

In the meantime, the white Mrs. Wingate has become Mrs. Kermit Early. Disapproving of her black husband's corrupt brand of Americanism, she exerts her will and he quits the subversive organization. Mrs. Early then arranges for her husband to become editor and publisher of "a struggling Negro magazine," and they drop out of the narrative. While Kermit is never treated less than skeptically, by the end of his book Micheaux has developed a grudging admiration for his purposeful white wife—the closest he ever came to condoning the early temptation he had always condemned in his fiction: intermarriage.

The story speeds to a supercharged end, à la *Dark Princess,* with the remaining pro-Nazi black Americans hatching a plot to assassinate the First Lady (i.e., Eleanor Roosevelt) and plant a bomb aboard a train.

Elton Fax, the young man who had endured Micheaux's memorable monologue on a train trip years before, learned around this time that the Harlem author was looking for an artist to create a dustjacket for his new novel. By now an established illustrator and artist for magazines and books, Fax made an appointment to visit Micheaux. "I was kind of thrilled again to meet him and see this man, genuinely so," recalled Fax.

Now, the great man was massive and stooped and gruff. His winning smile had "gone with the wind." Micheaux didn't mention whether he remembered Fax from that train ride, a decade earlier; probably not.

The illustrator was disconcerted when Micheaux offered him "$35 or something ridiculous" for his artwork. Moreover, Micheaux demanded ownership of the piece in perpetuity, whereas the accepted practice in commissioning such illustrations was to pay for one-time use only. Still, Fax admired Micheaux, and he accepted the job, crafting "a beautiful black and white drawing," which the author paid for and accepted. Then, to the artist's astonishment (and without his permission), Micheaux embellished Fax's drawing with "abominable" colors intended to evoke his glory years as a race-picture pioneer, ". . . the same yellows, the same blues, the same reds that went into those old lobby cards" for his many films, according to Fax. "That was his [Micheaux's] bag," said Fax. "That is what he knew."

But Micheaux knew his audience, and the "colorized" Elton Fax cover helped make *The Case of Mrs. Wingate* a windfall success. The "mouth by mouth advertising," as Micheaux liked to put it, made up for the paucity

of reviews. Inside of a few years, with orders generated by mail, or by the author himself brandishing copies on the road, the second Micheaux novel since his return to fiction had sold a remarkable 55,000 copies: "the biggest single success" of his literary career, according to the *New York Amsterdam News.*

That was almost twice the profits of *The Wind from Nowhere.* Micheaux had learned a lot since his early self-publishing days, and now he was supplementing his company income by distributing other titles besides his own. Among them were substantial works, including *New World A'Coming: Inside Black America* by Roi Ottley, a former *Amsterdam News* staffer, whose investigative report on the condition of blacks in America incorporated research he had supervised as an editor of New York's Federal Writer's Project. Another work the Book Supply Company made available to stores and mail-order buyers was *Strange Fruit* by Lillian (Eugenia) Smith, a controversial first novel by a white Southerner about an interracial romance, a murder, and a lynching.

Between working on his novels, and traveling and selling his own books and those written by others, the World War II years elapsed swiftly and not unpleasantly for Micheaux. "His friends think he's all through because he has suspended making pictures," Micheaux wrote of Sidney Wyeth in *The Case of Mrs. Wingate,* "but he is doing far better, for himself, in the present business than he ever did in making pictures."

Micheaux dedicated his next novel, his sixth, "To Mary J."—Mary J. Russell, his wife's unselfish, hardworking mother—"Whose faith and confidence in the writer has always been a source of inspiration."

The Micheauxes stayed close to their Montclair "Homestead" while living an increasingly quiet, insular life in Harlem. People who visited their Harlem flat recall the furnishings as simple and unassuming, though Elton Fax said that Micheaux "didn't live like a pauper by any means." He continued to dress well and dine to satisfaction, and he still had a chauffeur on call, but the couple had few of the material trappings of affluence.

Actor Lorenzo Tucker, faithful to the mentor who had launched him into race pictures as "The Colored Valentino," often dropped by to say hello, finding his once-energetic employer now staid and stolid with age. Micheaux was afflicted by arthritis and hypertension. "Instead of calling

him Mr. Micheaux in later years," Tucker remembered, "I called him Doc, and I called my stepfather the same thing—so he was like a father to me."

He was "Dad" to his spouse of twenty years, Alice B. Russell. She tried to superintend his health, coaxing Micheaux into taking the occasional break from his routine. They enjoyed day trips to Long Island or to the Catskills, longer trips to the Adirondacks, driven by their chauffeur while the couple nestled in the backseat.

By early 1945, "Dad" had put the finishing touches on his third novel of the World War II years: *The Story of Dorothy Stanfield.* The title echoed that of the successful *Mrs. Wingate,* and so did the novel's byzantine construction. But the new book was a puzzle-work, whose pieces—some clearly left over from Micheaux films—didn't fit together with the same fluidity as *The Case of Mrs. Wingate.*

For the story's centerpiece, Micheaux concocted a central romance between a mysterious Memphis woman and a lovelorn private eye ("New York's ace Negro detective"), who is chasing a dangerous criminal cross-country. He threw in an illegal abortion and undertaking scandal in Memphis, an upstate New York rape case, a Harlem murder with Leo Frank echoes.

For the last time, Micheaux brought back his shadow self, Sidney Wyeth, who was still brooding about Jews and blacks. He included some winking autobiographical touches. Micheaux even has his characters praise Wyeth/Micheaux's own films and books repeatedly ("A corking good story!")—a joke that wears thin, but must have entertained his longtime readers.

But Micheaux had begun to fester. Creeping age and jealousy colored his onetime optimism and outlook on racial issues. In *The Forged Note,* Micheaux had included a fleeting portrait of Memphis's Beale Street, a quarter "entirely occupied by Negroes," but not a terrible place despite its juke-joint ways. In *The Story of Dorothy Stanfield* it's full of "bums and whores and hustlers." Whatever its drawbacks, Chicago had always been a city of hope; now, in both *The Case of Mrs. Wingate* and *The Story of Dorothy Stanfield,* the Black Belt where Micheaux once lived seemed a hotbed of Nazis, Communists, and criminals.

The shifting of emphasis from Leo Frank's Jewishness to his sexuality was indicative of another trend in Micheaux's work. He had always treated sex and nudity adventurously in his films, but never so crudely as in his World War II novels. When the ace race detective in *The Story of Dorothy Stanfield* gazes at the title character, "at her rounded breasts which seemed to extend straight out and hang down," he has to wonder

if she is wearing a girdle; he stares as "her teaties rose and fell as she breathed." In the novel's potboiling climax, when the black killer known as Scarface catches his lover in bed with a rich white man, he says his first impulse is "to tell you to go to the bathroom and wash your dirty ——" Then this phrase appears: "(word used censored by the author)."

The book's attacks on fellow black authors "Frank Knight" (i.e., Richard Wright) and "Ora Thurston" (i.e., Zora Neale Hurston)—who figure into the story because both had Memphis backgrounds—were gratuitous, mean-spirited.

"The best known and the most read of Negro writers," according to Micheaux, Knight/Wright wrote "very interesting" books, but he was nevertheless a hypocrite. First, he was once a Communist; second, he was married to a Jewish woman ("most Jews at heart are Communists"); and third, he lived downtown, eschewing black Harlem. Sidney Wyeth, on the other hand, "is married to a girl of our race," Micheaux wrote of himself. "They live in Harlem and go around among Negroes and are seen walking and riding up and down the streets of Harlem."

Thurston/Hurston had social advantages that Wyeth/Micheaux never had; after all, her father had been a public figure (a preacher and elected mayor). And none of her books "ever got out of the first edition, which means that they did not sell well." Her main accomplishment, he wrote, has been "getting money to live on from white people."

Gone with the wind was Micheaux's ability to write about himself with genuine good humor, as he had in *The Conquest*. Now he wore bitterness on his sleeve. In a foreword to *The Story of Dorothy Stanfield*, Micheaux claimed that *The Case of Mrs. Wingate* had been ignored by the press because he treated "race-mixing" differently from other writers; where most novelists saw to it that such intermingling ended tragically, he had dared suggest a workable marriage between a millionaire white woman and her "colored lover." "Being plain and frank about it, such stories are against the 'pattern' as designed for Negroes and writers pretty well understand that 'thou shalt not' write such books," he wrote.

"Eighty-five per cent of the daily newspapers and magazines that received copies [of *The Case of Mrs. Wingate*] for review ignored the book and made no mention of even having received it," Micheaux griped. "A few gave fine reviews and praised the book highly."

Elton Fax was asked to contribute another dustjacket illustration for *The Story of Dorothy Stanfield*, and with a sinking feeling he went to meet

with Micheaux. They argued about his fee; later they argued about one of Fax's sketches before Micheaux would approve it. Fax was embarrassed to hear Micheaux, with his genteel wife standing nearby, exhorting him to sex up the drawing, to lower the female figure's cleavage. "Look here," Micheaux demanded, "show some titties!"

Fax did his best to compromise, but that "cured me of dealing with Micheaux," he reflected years later. Growingly isolated, the race-picture pioneer had become "a super exploiter," Fax thought, "a supreme egotist."

Micheaux picked up a little money and publicity with a condensed se-rialized version of his novel in the April 1946 *The Negro*. But despite Elton Fax's artwork, sales of the peculiar, grumpy, sensationalistic *The Story of Dorothy Stanfield* slumped far below *The Case of Mrs. Wingate* and *The Wind from Nowhere*.

Micheaux's World War II novels inevitably sold through their early print-ings, and then orders declined. The effort to reprint and continue pro-moting the books was too much for Micheaux, a "one-man corporation" with growing health concerns.

And whatever was happening inside Micheaux deepened, worsened.

After *The Story of Dorothy Stanfield*, he would write only one more novel: *The Masquerade*, published in early 1947.

On the face of it, this new book, his fourth since he quit making movies, was an homage to Charles W. Chesnutt and the "passing" novel *The House Behind the Cedars*, which Micheaux had always loved and ad-mired: Chesnutt—the acclaimed, elegant writer, whose interest in the theme of "passing" was intensely personal, as it had always been with Micheaux; *The House Behind the Cedars*—a "passing" masterpiece of the sort Micheaux always wished to achieve for himself.

Micheaux's ingenuous foreword to *The Masquerade* explained that he had decided to write "an historical novel." Then, digging through "my old file of motion picture scenarios," he had alighted on his script for Chesnutt's story, which he had filmed once in the silent era and again with sound. He'd always felt that *The House Behind the Cedars* needed more of the "turbulent, grave and exciting" pre–Civil War context, he wrote, the kind of history that inspired his own family's migration north, and thus was an untold part of his own life story. Reworking Chesnutt's

novel, emphasizing historical personalities and events, would permit him to depict the momentous Dred Scott Decision, the Lincoln-Douglas debates, the abolitionist John Brown, and other background leading up to the War Between the States. "I am very happy, in the meantime, for the privilege of having known Mr. Chas. W. Chesnutt, who died in 1932, and acknowledge with gratitude, the assistance provided by his book of that period," Micheaux wrote.

Indeed, the first half of *The Masquerade,* the American history that forms a prelude to the fictional narrative, is the most interesting, with Micheaux ennobling Abraham Lincoln and the Abolitionists (John Brown is described as "an artist at dying"). But readers also get a hint of things to come in these early chapters, where Micheaux reprinted full pages of direct transcription from the Lincoln-Douglas debates of 1858 and Lincoln's 1861 presidential inaugural address.

When Micheaux shifts the story to Chesnutt's "Fayetteville,"* the reader is introduced to the characters from *The House Behind the Cedars,* with only slight variations on the names given them by the original author. As he had in both screen versions, Micheaux dropped the chunk of flashback in the middle of the novel that described life "under the old regime," instead leading the sequence of events with the backstory of Rena's mother. Again, as with both films, Micheaux radically altered Chesnutt's ending—the very last chapter of the book.

To the rest of what Chesnutt had written, Micheaux added tiny bits at the beginning and end of some (not all) chapters, and made interpolations (especially in the Southern vernacular), cuts, minor supplements and word changes. But otherwise—in his story sequence, characters, and virtually all of his dialogue—Micheaux replicated Chesnutt's novel exactly. Micheaux's Chapters 26 through 48 correspond directly with Chesnutt's 9 through 33. Virtually all the language is identical.

Out of four hundred pages of *The Masquerade,* Micheaux copied nearly two hundred from Chesnutt's novel, almost line for line.

As one small sample, consider Rena's eloquent letter to George Tryon, her tortured white suitor, after he finds out that she is teaching in a nearby school. When Tryon writes to ask her if they might meet and discuss "what has passed between us," Rena sends this response:

* Chesnutt's hometown in North Carolina, disguised with another name in *The House Behind the Cedars,* is expressly identified by Micheaux in *The Masquerade.*

CHESNUTT'S VERSION

GEORGE TRYON, ESQ.

Dear Sir,

I have requested your messenger to say that I will answer your letter by mail, which I shall now proceed to do. I assure you that I was entirely ignorant of your residence in this neighborhood, or it would have been the last place on earth in which I would have set foot.

As to our past relations, they were ended by your own act. I frankly confess that I deceived you; I have paid the penalty, and have no complaint to make. I appreciate the delicacy which has made you respect my brother's secret, and thank you for it. I remember the whole affair with shame and humiliation, and would willingly forget it.

As to a future interview, I do not see what good it would do either of us. You are white, and you have given me to understand that I am black. I accept the classification, however unfair, and the consequences, however unjust, one of which is that we cannot meet in the same parlor, in the same church, at the same table, or anywhere, in social intercourse; upon a steamboat we would not sit at the same table; we could not walk together on the street, or meet publicly anywhere and converse, without unkind remark. As a white man, this might not mean a great deal to you; as a woman, shut out already by my color from much that is desirable, my good name remains my most valuable possession. I beg of you to let me alone. The best possible proof you can give me of your good wishes is to relinquish any desire or attempt to see me. I shall have finished my work here in a few days. I have other troubles, of which you know nothing, and any meeting with you would only add to a burden which is already as much as I can bear. To speak of parting is superfluous—we have already parted. It were idle to dream of a future friendship between people so widely different in station. Such a friendship, if possible in itself, would never be tolerated by the lady whom you are to marry, with whom you drove by my schoolhouse the other day. A gentleman so loyal to his race and its traditions as you have shown yourself could not be less faithful to the lady to whom he has lost his heart and his memory in three short months.

No, Mr. Tryon, our romance is ended, and better so. We could never have been happy. I have found a work in which I may be of service to others who have fewer opportunities than mine have been. Leave me in peace, I beseech you, and I shall soon pass out of your neighborhood as I have passed out of your life, and hope to pass out of your memory.

Yours very truly,

ROWENA WALDEN

Here is the version Micheaux published as his own work, with the slight variations from Chesnutt's wording marked in bold:

MICHEAUX'S VERSION

GEORGE TRYON, ESQ.

Dear Sir:

I have requested your messenger to say that I will answer your letter by mail, which I shall now proceed to do. I assure you that I was entirely ignorant of your residence in this neighborhood, or it would have been the last place on earth in which I should have set foot.

As to our past relations, they were ended by your own act. I frankly confess that I deceived you; I have paid the penalty and have no complaint to make. I appreciate the delicacy which has made you respect my brother's secret, and thank you for it. I remember the whole affair with shame and humiliation, and would willingly forget it.

As to a future interview, I do not see what good it **will** do either of us. You are white and you have given me to understand that I am black. I accept the classification, however unfair, and the consequences, however unjust, one of which is that we cannot meet in the same parlor, in the same church, at the same table, or anywhere, in social intercourse; upon a steamboat we would not sit at the same table; we could not walk together on the street, or meet anywhere publicly and converse, without unkind remark. As a white man this might not mean a great deal to you; as a woman, shut out already by my color from much that is desirable, my good name remains my most valuable possession. I beg of you to let me alone. The best possible proof you can give me of your good wishes is to relinquish any desire or attempt to see me. I shall have finished my work here in a few days. I have other troubles, of which you know nothing, and my meeting with you would only add to a burden which is already as much as I can bear. To speak of parting is superfluous—we have already parted. It **was** idle to dream of a future friendship between **two** people so widely different in station. Such a relation, if possible in itself, would never be tolerated by the lady whom you are to marry, with whom you drove by **the** schoolhouse the other day. A gentleman so loyal to his race and tradition as you have shown yourself, could not be less faithful to the lady to whom he has lost his heart and his memory in three short months.

No, Mr. Tryon, our romance is ended, and better so. We could never, **under the circumstances later discovered,** have been happy. I have found a work in which I may be of service to others who have fewer opportunities than mine have been. Leave me in peace, I beseech you, and I shall soon pass out of your neighborhood as I have passed out of your life, and **as I** hope to pass out of your memory.

Yours very truly,

ROWENA **NORTHCROSS**

Micheaux did make one meaningful change in the story, replacing Chesnutt's tragic ending with the happy finale he had used in both film versions. In the last chapter of *The Masquerade*, Rena would recover from her debilitating illness (fatal in Chesnutt's novel), with her childhood friend Frank waiting by her bedside. Frank proposes, and after marriage, like many black people of the post-Reconstruction Era—including Micheaux—they will leave Fayetteville for "a booming and growing town called Chicago." Frank plans to go into construction, with Rena as his bookkeeper.

Micheaux has Rena's uncomprehending white suitor, George Tryon, arrive in town just in time for Rena and Frank's wedding. A neighbor informs George, who is standing outside her house, that Rena is marrying a childhood sweetheart. He rides away, stunned, and muttering, "Childhood sweetheart . . . ," consoling himself with the thought that "if she was marrying a childhood sweetheart, she must have been in love before she ever met him."

Not a terrible ending, but in the context, it hardly mattered. The first half of the book and last chapter notwithstanding, *The Masquerade* was a blatant piracy of Charles W. Chesnutt's work. After years of adapting it to his own ends, Micheaux had finally assimilated Chesnutt's masterpiece as his own.

Of all the questionable things he had done to survive and keep going, this was the worst. He had often borrowed from other produced or published works. He had frequently used material transcribed from courtrooms or newspapers. He had flirted blithely with copyright infringement. He had dodged subpoenas and shaved the law. But until *The Masquerade*, his own creativity had never been in doubt.

It was a bizarre act, one for which there is no simple excuse, or easy explanation. Unless Micheaux had been struck down by some kind of silent illness, a stroke, something that diminished his capacity. Unless he sat at his desk in a stupor while writing *The Masquerade*, laboriously copying out another author's words. Perhaps Micheaux was unaware of what he was doing, or only half-aware; strong, independent man that he'd always been, perhaps he was unwilling or unable to confess his frailty.

He seemed in fair fettle in March 1947, signing autographs at publication parties hosted by two Harlem bookshops, the National Memorial Bookstore at 2107 Seventh Avenue, and the Washington Bookstore at 2084 Seventh Avenue, and then traveling to Washington, D.C., for an NAACP luncheon feting authors. But *The Masquerade*, even in several

editions, wouldn't sell more than fifteen thousand copies, according to Micheaux's own numbers. This time the paucity of reviews was a blessing; no one noticed the rank plagiarism. Indeed, it has escaped most scholars, as the book is rare, out of print, and almost universally ignored.

"I wouldn't be quite so critical about it," said sympathetic scholar J. Ronald Green, "given Micheaux's general naïveté and unprivileged background in intellectual matters. I would tend to look at it as a major folk artist being drawn repeatedly to a story and accomplishment that he admired, but wanted to do some work on."

By the spring of 1947, Micheaux was telling his wife that the book business appeared to have bottomed out, and he thought he should attempt "to get back into pictures as soon as possible," in Alice B. Russell's words.

As always, once decided, he took action. Once committed, he began planning his moves.

Most of his old associates were out of the race picture business. It would take forever to drum up investors. He would have to keep the budget down and pay all the upfront costs himself, drawing from his savings. He could limit expenses by shooting the entire film in Chicago, lots of exteriors, mostly with amateur actors.

There was one story no one could accuse him of stealing. For his final fling at filmmaking, Micheaux chose the subject most familiar and natural to him. His own life story had been the basis of his first novel way back in 1913, then the first motion picture he wrote, directed, and produced, and other films and books in the years since. Now he would make a movie of *The Wind from Nowhere:* his "one man's story" and its lessons for the race, his tale of struggle and conquest, of trust and innocence betrayed.

His 1943 novel had been characterized in publicity as a prospective "stage play," so it is possible that a script already existed and all Micheaux had to do was rewrite it as a motion picture. Visitors to 40 Morningside Avenue found Micheaux nursing his weight and health, and snapping his fingers with ideas. He wasn't exactly up and dancing, but the old bustle and ebullience was back.

It was true that Micheaux would be taking a tremendous risk with this venture, using up all his "little money" on the production's operating

budget. And he wouldn't be able to go out on the road, selling the new movie like he used to. Still, he knew how to sketch and describe air castles. This was going to be his greatest film, one of epic length and unlimited box-office potential. As he had since his very first picture, Micheaux planned "a big plot and long story," the most super of all his super-productions: "Like *Gone With the Wind*," he kept saying. Micheaux found a New York distributor willing to stake a Broadway premiere, and after the opening, black theaters coast to coast would clamor for the picture. Maybe, finally, white audiences would show up, too.

Lorenzo Tucker stopped by one day, and Micheaux confided part of his dream had always been "to have this thing so I can sit in my office and just ship these things out. That's the way the boys do it out on the coast!"

Late in the summer of 1947 the race-picture pioneer left for Chicago, accompanied by his wife, who would help him finalize the script, make arrangements with a studio and laboratory, scout locations, and cast the film.

World War II changed prospects for the Negro in America. Black Americans had served dutifully and with distinction, and they came back from the war a force for social progress. They were being employed and educated as never before under government grants. They were slowly moving into all sectors of the economy, agitating for equality.

Race pictures had long since been relegated to a worse than ever marginal existence, in part—ironically—because the war had helped to raise Hollywood's consciousness. Soon Hollywood would embark on a new round of earnest antiprejudice pictures like *Pinky* (about "passing") and *Intruder in the Dust* (about lynching), co-opting subject matter—and, in the latter case, lead actor Juano Hernandez—from Micheaux and the handful of producers still stubbornly turning out race pictures. To some, these postwar Hollywood "preachments" would seem weak tea; others would see them as auguries of better things to come.

Feature-length motion pictures were no longer produced in post–World War II Chicago. The old Essanay Studios had been whittled away and long abandoned. The only technical work was in advertisements, industrials, local radio, or a few fledgling television operations. Show business venues had dwindled in the city's Black Belt, and local

black entertainers were struggling harder than ever to carve out remunerative careers. The sound and lighting and camera unions were lily-white.

Most of the professionals Micheaux had known in the late 1930s, during his last fling of film activity, were retired or deceased. Robert Abbott, publisher of the *Chicago Defender*, had passed away in 1940. Nahum David Brascher, the onetime head of the Associated Negro Press, whose column in the *Defender* had long been friendly to Micheaux, died in 1945, leaving Micheaux with no up-to-date contacts at the still-thriving black newspaper.

In bygone days, Micheaux's activities had rated front-page coverage. His current stature was such that the *Defender* carried only a small item in its "Swinging the News" column, noting that the race-picture producer was in town "seeking talent for the 20–reel movie epic" he was planning "to be filmed here and"—the old ballyhoo—"in Hollywood."

Mr. and Mrs. Micheaux found quarters in a comfortable hotel on Fifty-first Street on the South Side, along with their chauffeur and "odd jobs" man. The chauffeurs were always temporary hires; people who encountered Micheaux on this trip recall that this one was a black gentleman named Obie, who drove them everywhere in Micheaux's ebony limousine.

Micheaux made arrangements with a South Side community center that was willing to donate rehearsal space. He leased a studio at a former radio news station on Twenty-ninth Street, ordered sets built and equipment brought in. Who can guess at his thoughts as he toured his old Black Belt neighborhood, and picked out two or three brownstones that might stand in for the residences of the major characters in the story, characters and places that evoked bittersweet memories of Chicago before World War I?

He engaged a local assistant director, a black college graduate with a broadcasting résumé. The audio and camera crew he hired were, by necessity, white—members of the all-white local, which enforced union employment. That included the director of photography, a man named Marvin Spoor, whom everyone called Major Spoor. Spoor was related to George K. Spoor, who had founded Essanay in Chicago at the turn of the century, though these days the Major mostly shot television, commercials, and industrials.

When it came time to cast his new production, Micheaux put out feelers and flyers to black churches, high schools, colleges. The majority

of the cast, as it ended up, hailed from Chicago; nearly all were making their first—in most cases, only—screen appearances.

A local girl, Verlie Cowan, was picked to play Linda Lee, the preacher's daughter who marries the homesteader. Her hellcat sister, Terry, would be played by Yvonne Machen, a Chicagoan with New York experience; she had been part of the replacement cast of *Anna Lucasta* on Broadway. Harris Gaines, a son of prominent Chicago civil rights activists, had done some radio work in New York; he would play the Reverend, in this rendition called Doctor Lee. Alice B. Russell, who also served as producer, would portray the Reverend's wife.

It was Mrs. Micheaux who found Myra Stanton, phoning her mother to tell her that Mr. Micheaux wanted to consider her daughter for the part of Deborah Stewart, the Scottish girl with Negro blood. "How he found out about me we never knew," Stanton recalled. Micheaux might have seen Stanton's photograph in one of the magazines of the *Ebony* empire, the black-owned Johnson Publishing Company, which was headquartered in Chicago. Stanton was a local model but also a college student, brainy as well as pretty.

Twenty-two-year-old Leroy Collins Jr. was attending nearby Roosevelt University on the GI Bill. A varsity football player in high school, Collins had also done a little acting in school and community groups before his army service, and he looked the part: a blend of athlete, soldier, and movie star, tall, well-built, dreamily handsome, with an intelligent face and a warm smile. Collins and his fraternity brothers heard about an all-black movie being shot in Chicago and they went over to the studio where interviews were being held to look for summer jobs as stagehands. Collins was standing in line, hoping for any kind of work, when the assistant director tapped him on the shoulder and beckoned him into another room to meet two people.

Barely into his teens when the director had made his last picture in 1940, Collins had never heard of Oscar Micheaux, had never read his novels or recalled seeing any of his movies. The man he was introduced to was in his sixties, tall, heavyset, and balding, with salt and pepper tufts of hair, dressed in suit and tie. They shook hands. Close by was a lighter-skinned woman in her late fifties, slender, well-dressed, cultivated.

Micheaux asked Collins a few introductory questions and then briefly outlined the story of the picture—his own life story, he said, fictionalized. Then to his astonishment, Micheaux handed the college student a thick

script and asked Collins to read a scene in which he would be playing Martin Eden, the lead character.

"Just read it in your own style," the director encouraged him.

So Collins read a page, as Micheaux stared at him. Then another page. Finally, after a few more, Micheaux glanced over at his wife and said, "I think this is the one." And Alice B. Russell nodded her approval.

"You are Martin Eden," Micheaux explained, "and Martin Eden was me."

Micheaux's assistant director later informed Collins that many people, including prominent professionals, had been auditioned for the lead role, "people like Oscar Brown, a writer, singer, and all-around entertainer," in Collins's words. "But I got the part because I looked like Oscar Micheaux wanted me to look."

Leroy Collins *was* Martin Eden: not only in the story, but also in Micheaux's eyes. The director never addressed the college student as Leroy, or Roy, as his friends called him. Instead Micheaux always called him "Martin," just as he always called Myra Stanton "Deborah."

"Never in his life did he call me by my real name," Collins marveled years later. "From the first moment he laid eyes on me he didn't call me anything other than the name of the character in his book."

Micheaux, by this point, was walking with a slight limp, using a cane. He took pills at intervals, and once in a while smoked a cigar. But people associated with the director's last film production don't remember him having any obvious health concerns. In rehearsals and on the set he radiated strength and authority.

The same could be said of his methods. Though his budget was as feeble as ever, he was imaginative about making do with what he had. Again and again, surviving eyewitnesses have contradicted the legend that Micheaux was an intentionally cheap, fast, and shoddy director: the mistaken notion that the partial remains of his censored, maltreated films represent a deliberate "style." When Micheaux found the money and time—and, most important to this last project, the willpower—he worked hard, from read-throughs to "dailies" and retakes.

In August the cast gathered at the community center, sitting in a circle of chairs in a big room. Besides the principals, there were about

twenty other actors with speaking parts, an assemblage that in some ways epitomized Micheaux's casting over the years. Quite a few were college students from Roosevelt. Micheaux recruited favorites from earlier films, like Edward Fraction from *The Symbol of the Unconquered* (a quarter of a century ago) to play the old grandfather, and Gladys Williams from *The Notorious Elinor Lee;* he even flew one veteran character actor in his sixties out from Hollywood. Chicago calypso dancer and choreographer Vernon B. Duncan, the son of the man who had played the Reverend McCracken character in *The Homesteader,* played one of the unscrupulous lawyers trying to rig the betrayal of Martin Eden.

Always dressed formally, Micheaux sat to one side during the initial read-throughs, while the actors with the lengthiest dialogue scenes stood up in front. Most of the scenes were overlong, Leroy Collins thought, and *talky.* The script seemed as long as a telephone book, and Martin Eden was in over 70 percent of the scenes.

Micheaux would volunteer little suggestions. "Speak up." Or: "Try reading it a different way." Though he was addressing a room full of amateurs, he rarely expounded on acting; instead he offered valuable camera-specific tips, such as never to look directly at the lens. "He wanted to get it down to a fine point before you got in costume," recollected Collins, "because he was spending a great deal of his own fortune to do this movie."

Mrs. Micheaux was at all the rehearsals, reading her own part or holding the master script. The couple had silent ways of communicating. As the actors spoke their parts, Mrs. Micheaux made sure they were tracking her husband's written lines, and quietly consulted with her husband about necessary small changes.

The script was a strange mix, mingling some archaic language (as though it were recycled from silent-era intertitles), with modern slang and innuendo. Micheaux was still willing to test the censors, with lines like "How's your hammer hanging?" and "You might be able to 'make' her," that the local authorities in some parts of the country were bound to notice. But he bowed to postwar sensibilities by stopping short of using the n-word, long a point of pride in his populist approach. The word had been conspicuous in the novel on which the script was based, but whenever the film's characters started to utter the slur, they were inevitably cut off in mid-syllable.

The time frame of the story was curiously jumbled. At one point, for instance, the self-referential Micheaux couldn't resist having Martin Eden

mail a copy of *The Case of Mrs. Wingate*—a book Micheaux published thirty years *after* his homesteading—to his neighbors.

If the director was anxious about spending so much of his own money, he didn't show it during the three or four weeks set aside for rehearsal before the actual filming. If the actors became comfortable with their parts, then the production would go more smoothly and Micheaux would save on film stock and studio time. The crew was small, but Micheaux had his bases covered. He even sprang for costume fittings and makeup artists. All the actors except Leroy Collins wore makeup. "He stipulated that at no time was I ever to use any makeup," Collins said. "I guess he wanted me to look more rugged, like he was as a young person."

The all-white crew was paid union scale. But the cast of mostly young amateur unknowns felt grateful for their decent compensation. Their checks were handed over to them on time, weekly, by Micheaux himself.

After rehearsals had run their course, the cast moved into the Twenty-ninth Street studio for two or three weeks of interior photography. His spirits lifted by the work, Micheaux scurried around, scrutinizing the set and lighting. He gave exacting instructions to the cameraman, sometimes peering through the lens himself. He blocked the actors' movements, and perched on a stool to watch intently as the scenes unfolded.

There was no money in the budget for the elaborate musical sequences of old, but then again, Micheaux was no longer the nightclub aficionado he once had been. Yet Micheaux did find a way to weave favorite music into the story, using the jazz standard "Sweet Georgia Brown," which he whistled to work, recurrently in the background of several scenes.

Micheaux's directing style was courtly, though he could be gruff and blustery with some of the amateurs, the men more than the women. "He never shouted at me, not once," recalled Collins. "He was gentle with me, and the leading ladies, and two or three other ladies. I think he was quite the guy with the ladies, at one time." He was also gracious with Jesse Johnson, one of Collins's fraternity brothers, who played a small part as Martin Eden's white homesteader friend. At a certain point, Johnson got up the courage to ask Micheaux for additional work as a "a go-fer on a part time basis," carrying klieg lights and other equipment during the

filming. Johnson was trying to pay for night school. Micheaux said sure. "Three or four hours a day," recalled Johnson gratefully. "Twenty five bucks a week. Back in 1947, without a part-time job, that was a fortune. I did that until they wrapped up the movie."

One performer who got under Micheaux's skin was Yvonne Machen, whose temperament mirrored the character she was playing. Machen was a spitfire, always challenging Micheaux, wanting to try scenes *her* way. He'd shout at Machen worse than he shouted at the men, and she'd shout back.

Another actor who got on his nerves was Harris Gaines, who was playing Doctor Lee, the McCracken-devil incarnate. Gaines had grandiose show business aspirations, and in his death scene Micheaux thought he was dragging things out, hamming it up. The angry director kept yelling at him, "C'mon, you black Barrymore, die!"

Such tense moments were sometimes broken up by Micheaux's chauffeur, Obie, who was always hanging about. Although he didn't have any official status on the production, Obie wasn't shy about offering his own opinions, at times even disagreeing audibly with his boss. "Obie, you don't know what you're talking about!" they heard Micheaux snap back, to their amusement. "Aw, shut up, Obie!"

As she always had, Alice B. Russell did her share, watching over the script during scenes, taking her husband aside for whispered words, making suggestions and solving small problems. Micheaux pieced off the tricky emotional scenes to his wife, for extra rehearsal. One of them was a big moment between Collins and Myra Stanton, when the two are drawn closer and closer—while reciting the Lord's Prayer—until their characters finally kiss. Flustered, Stanton kept forgetting the words to the prayer, screwing up the take. "Damn it, Deborah!" Micheaux swore, calling her by her character's name.

The young leads weren't sure how real the kiss should be. Mrs. Micheaux took additional time with them, showing them how screen actors "phony-kiss" with their lips to the side, so that the camera angle makes it look real. "She was quite dynamic" and helpful, Jesse Johnson recalled, from watching the rehearsals.

The worst sin for any Micheaux actor was to deviate from the dialogue in the master script. Micheaux wanted each and every word he had written clearly enunciated, and if the words weren't registered he'd call for retakes.

Again, the sole exception was Collins. Though dramatically un-trained, Collins felt "pretty much natural in the part." Still, at times he would say to himself, "I can't talk that way. It's not me." And then he would improvise a few words, change the dialogue a little, trying for a more organic quality. He was the one actor Micheaux never interrupted or chastised. Collins could tinker, "but he didn't let the others improvise" any lines.

"The dialogue just didn't come natural to a lot of the characters," Collins mused. "It was like someone saying, 'Here is my philosophy, here is how I feel, and I'm going to say it all through this character, all at once, right now.' I had taken speech classes, and I had some success at speech-making, and even I knew that the dialogue could be improved."

The cast and crew gathered every night after filming to watch the pre-vious day's rushes. Micheaux had to be satisfied before they could move on. "If he saw something there he didn't care for, we'd reshoot it," said Collins. "It could be reshot the next day, while the costumes and actors were still there."

A seventy-page "dialogue sheet" of Micheaux's script for *The Betrayal* sur-vives in the New York state archives. Scene by scene, it was the old famil-iar story he'd already told in several books and films—ending, as in *The Wind from Nowhere*, with the homesteader, the mixed-race Scottish girl, and Martin Eden's rescued baby all returning to the Rosebud just in time to save their land. (For movie purposes, this involved a frantic train ride, a speeding car trip, and a perilous trip across a cloudburst-swollen river on horseback.) They arrive to discover that mineral riches have been found on their claim, guaranteeing a future of wealth and happiness—the fairy-tale ending Micheaux had sought all his life.

Of course Micheaux wasn't going to do any filming in Hollywood; that was merely hooey for the press. Nor was there enough budget for any trip to South Dakota. Micheaux used farms in southern Wisconsin and fields in Michigan to simulate the Rosebud, with Leroy Collins plowing like a madman, or riding a horse in full cowboy regalia.

They'd be driving along a country road, a convoy of open-topped cars with Micheaux and the cameraman in the lead, looking for a farmhouse for an establishing shot. Suddenly Micheaux would order Obie to pull

over, gesturing at a picturesque house over on a slight rise. All the other cars would swing over to the side of the road, while Micheaux hopped out, telling the cameraman where to set up. The curious residents of the farm would trickle onto the porch, or peer through their windows at the strange sight of the cars, the camera, and the tall, husky, white-haired black man standing in front of their home and stabbing his finger in their direction. Without so much as a hello, Micheaux would wave angrily and shout: "Get out of the way of the shot!"

And then the farm folk'd skedaddle. "He could put the scare into people," Collins recalled.

The more freewheeling scenes were out of doors. If the actresses and romantic touches were more Alice B. Russell's bailiwick, Micheaux handled the manlier scenes himself. One time, Jesse Johnson was playing a scene where he plunges into a fistfight with another white homesteader who makes prejudicial comments about Martin Eden. Johnson was supposed to slug the other actor hard enough to knock him to the ground. The two amateur actors tried faking it one way, then another and another. "We faked it and faked it and faked it," Johnson recalled.

"Aw, it looks phony!" Micheaux shouted at the young actor. "Go on, hit him, Johnson!"

"I can't, Mr. Micheaux," Johnson apologized.

"Well, you're not faking it too well," Micheaux complained, not unkindly. "At least fake it better!"

So the director himself stepped in and showed Johnson how to punch and feint more credibly. "We finally did it to his liking," Johnson recalled. "We did it a half dozen times, trying it until he liked it."

The scene where the preacher's daughter Linda (Verlie Cowan) stumbles out into traffic and is run down by an automobile was a rare stunt job for Obie, Micheaux's chauffeur. With the cast and crew lined up to watch from the sidelines, Micheaux took his time setting up the important shot, advising his chauffeur where to aim and angle the car—Micheaux's own black limousine—for the maximum visual effect. Obie got behind the wheel, Micheaux called action, and the car shot forward like a missile, so fast that everyone had to leap out of the way.

"The car missed her, but it was very close," Myra Stanton remembered, laughing. "Mr. Micheaux had a fit. 'You almost hit Linda! We almost had a fatal accident with that gal!' He was so angry with Obie."

Micheaux splurged for wind machines for the signature sequence in

the film, where Martin Eden, living forlornly on his homestead, is suddenly attacked by "the wind from nowhere." Huge fans were set up to blow great gusts of air against Collins, pushing him back, impeding his progress—just as nature and society had always tried to keep Micheaux from achieving his life's goals. To Collins it seemed an extremely realistic and effective scene, with the tornadolike wind whirling him about and slamming him repeatedly to the ground.

Most of the photography was done in the month of September, inside of three weeks. Micheaux left Chicago soon thereafter, taking the footage with him. Most of the crew and cast never laid eyes on him again.

Even so, there was a footnote: Despite all the read-throughs, the rehearsals, dailies, and retakes, this was Micheaux's last chance to tell his life story, and he was determined to get it right. Late in the fall he sent orders from his New Jersey editing room: The race-picture pioneer wasn't satisfied with the coverage. He needed more retakes. He sent pages of instructions to his assistant director, who took the cameraman and some of the actors out and supervised a little reshooting.

CHAPTER SEVENTEEN

1947–1951
AHEAD OF TIME

Back east by November 1947, Micheaux launched into postproduction. He would take as much care with the editing and polishing in Fort Lee as he had with the preproduction in Chicago. After three months of cutting and splicing, Micheaux had *The Betrayal* down to twenty-four reels, or just over three and a half hours. Declaring a temporary halt, he called in some favors and loans before continuing. After "days of virtual amputation," in his words, he had a release version ready—at three hours and fifteen minutes.

He still had to raise five hundred dollars to "start matching the negative so he can get a print for screening" to stimulate booking contracts, according to his wife, Alice B. Russell. In the meantime, he mocked up "some of his advertising matter," in the words of Mrs. Micheaux, who sent the "Program" to a sister-in-law in Great Bend, Kansas. "So you can see, dear," her accompanying letter said, "he is doing a big job and he is doing it alone. Isn't that wonderful?"

But finances weren't the only reason that the postproduction bogged down. Micheaux himself was physically spent.

"Dad has arthritis all over his body," Mrs. Micheaux wrote to her sister-in-law. "I have to help him put on his clothes and take them off. And I have to help him take a bath. His hands are slightly swollen, and he can't grip or hold anything tightly, but as I said, he keeps on working. It is better for him to keep busy as long as he can, because he is so restless he couldn't stand not being able to go where he wanted to go."

"Dad's books are still selling," her letter closed, "but nothing like in the past."

* * *

Astor Pictures, a distribution company on West Forty-sixth Street in Manhattan, had been in existence since the mid-1920s; by the late 1940s the firm had twenty-six offices in key cities around the country. Astor's main business was circulating reissues of A pictures relinquished by major Hollywood studios; most of its business came from RKO. But after World War II, the Southern-born head of Astor, R. M. Savini, announced a plan to produce "dignified, entertaining Negro pictures" for the now estimated 678 American theaters said to welcome a mixed or substantial black clientele. Yet the first film it produced—*Beware,* starring the boogie and blues bandleader Louis Jordan—wasn't especially profitable, and Astor's first fully financed "Negro picture" was also its last.

Still, Astor agreed to distribute Micheaux's comeback, starting with a June 24, 1948, premiere at the Mansfield Theatre on Forty-seventh Street, at last fulfilling the race-picture pioneer's lifelong dream of opening one of his films on Broadway. Ticket prices for the three hour and fifteen minute version of the film sold from ninety cents to $1.80. "The Greatest Negro Photoplay of All Times," raved the advertisements, and the "Longest Picture Since *Gone With the Wind.*" Micheaux placed ads beyond Harlem, even in New York's white newspapers.

Micheaux was rolling the dice with this final variation on his life story. But starting with its blunt retitling—the evocative *The Wind from Nowhere* became the bitter-sounding *The Betrayal*—he gambled badly. The reviews, which called *The Betrayal* obvious and tired and old-fashioned, might as well have been aimed at the man himself.

The white New York newspapers, which had long ignored Micheaux but now profited from his advertisements, published devastating notices. "It is not a professional production," said the New York *Daily News.* "It is even difficult to class as amateur. The characters religiously interpret Oscar Micheaux's poor script with the stilted movements and hesitations associated with grade school plays. Flimsy and without purpose, the plot offers neither argument nor substantial material for discussion of any kind."

"A preposterous, tasteless bore," echoed the *New York Herald Tribune.* The *New York Times,* which had never reviewed a single one of

Micheaux's more than forty previous pictures, dismissed *The Betrayal* as "confusing," "gauche," poorly photographed and "consistently amateurish." Even the show-business bible *Variety*, which had neglected Micheaux's productions for thirty years, critiqued the race-picture pioneer's final testament, calling it "overlong," "dull," and "stilted and artificial."

Though most simply overlooked *The Betrayal*, the black press was hardly kinder. The *Chicago Defender*—which had boosted him in the past—reprinted the New York barbs; then staff writer Al Monroe, who knew Micheaux's history full well (he'd been writing for Chicago's black press since the 1920s), piled on, lambasting the "poor" continuity, the "ill-timed and tasteless" dialogue, and the directing, "faulty to say the least."

Leading man Leroy Collins watched the movie with his fraternity brothers in a packed audience at the Chicago premiere. As the film dragged on, he slunk down in his seat, seeing his worst fears come to life on the screen: the wooden acting, the long-winded speeches, the interminable convolutions, all leading to the revelation of the Scottish girl's "one drop of Negro blood," an outdated climax that hardly carried the same impact for young, post–World War II audiences.

"It was *long*," Collins reflected ruefully.

Astor might have handled the distribution, but Micheaux was as ever the chief hawker of his own wares. Ignoring the reviews, he tweaked his sales pitch: a year later he was trumpeting *The Betrayal* as the "Greatest Picture of Its Kind Since *Imitation of Life* and *Lost Boundaries* [a 1949 Hollywood film about the perils of 'passing']." He tried mounting a pseudo-"road show" to enhance bookings, adding short subjects and special showtimes while charging higher prices. Though his various afflictions now restricted him to Harlem, he sat at his desk, sending out circulars and ads exhorting others to share his enthusiasm.

"We colored people, 15,000,000 of us, don't like to be monkeyfied," he told theater managers in his circulars. "Nor do we like attempts to flatter us by making us, on the screen, what we are not in everyday life. And we don't like being pushed off the screen altogether as the major producers seem to be doing, to appease the South. We want to see our lives dramatized on the screen as we are living it, the same as other peoples, the world over.

"That, my dear exhibitor," his statement continued, "explains why I am returning to the production of motion pictures after an absence of seven years, during which time I wrote and published four novels."

From Harlem, he would use mail, telegram, and telephone to make one last stand against censorship. *The Betrayal* might have been an overly familiar story to many, but the white censorship board of Pennsylvania still found it an exceptionally violent drama about a black man who appeared (throughout most of the story) to be romancing a white woman. Times might be changing in postwar America, but not that fast, at least not in Pennsylvania. No doubt Micheaux gave a snort of familiar indignation when *The Betrayal* was "condemned in toto" there; he may also have felt perversely vindicated by the censors' dismissal, which confirmed that miscegenation was still a hot-button issue. Then, reaching into a bag of tricks as old as his first silent film, he rounded up prominent local black citizens to appear before the board and successfully demand that the ruling be overturned.

Yet the censors weren't Micheaux's only problem. More than anything, it was the *Gone With the Wind*-like length of *The Betrayal* that put off theater managers, forcing Micheaux to recut the picture. He tried a compromise, offering to divide the film into "three installments." "Like a serial, you'll say," Micheaux explained in one circular. "Please do not confuse this as any serial. It was not conceived as a serial and will not be exhibited as such. It is simply a super-feature, too long to be shown in all theatres, as is, at one time, so we're offering to let you run it in three installments . . .

"Incidentally, the installment prints run 3 hours and 24 minutes, 9 minutes longer than the road show prints.

"Before arguing that no picture has ever been shown this way," Micheaux continued oddly, "recall that no country had ever employed the Atom-bomb until we dropped two on Japan—and ended a destructive and costly war right quick."

The circular ended with this salutation, "Kindly get in touch with us—and let's make some money—yeah man!"

Some black theaters in eastern cities agreed to book the picture for one- or two-day stints. Most took a pass. *The Betrayal* found more receptive venues in the South and West, where "Direct from Broadway!" became part of the sell. "When they showed it throughout the South, the theaters were packed," Collins insisted. "I saw pictures of the theaters

with lines going down for blocks. It was accepted by the black audience. They wanted to see it."

Whether or not *The Betrayal* truly broke "attendance records" at spots like the El Rey Theatre in Oakland, where it played for two weeks in August 1949, or whether this was boastful publicity—no one can say.

Whether *The Betrayal* was abysmal, as the critics claimed, or whether the packed audiences in the South and Oakland suggest that the old master was still in touch with a segment of his audience—no one can say. It's unlikely that more than two or three prints of Micheaux's last picture were ever struck, and like two-thirds of the movies he wrote, directed, and produced, his last film is "lost" today. Astor, which had gone into the "Negro picture" business with such fanfare, got out of it quietly but speedily and altogether.*

The failure of *The Betrayal* crushed Micheaux financially. It was no secret in Harlem that the race-picture pioneer was broke. But he also disappeared from the streets. The failure had finally ruined his health.

Actor Lorenzo Tucker still visited occasionally, and "around 1949 or so" he stopped by to see the man who had launched him into motion pictures, who had mentored him, whom he thought of as a second father.

The tough body that had tamed the Rosebud was gone with the wind. Tucker found the once-strapping Czar Oscar shrunken, folded into a wheelchair. The vigor was gone, but more surprising, so was the zeal to reclimb the mountain. Micheaux knew that he had reached the bottom, not Booker T. Washington's bottom rung—always a good place to start— but the deep bottom of ending, and never-ending.

Yet Micheaux was religious at his core, and he believed in the inevitable bottom. He had always been an idealist on behalf of his race, but a realist when it came to his own fortunes. He sold illusions to inspire others, while living a hard-luck life of heartbreak and disappointment himself.

* Like Sack Amusement Enterprises before it, Astor went over to foreign-language films almost entirely, and subsequently achieved tremendous success, in the early 1960s, as a distributor of Italian and French New Wave films, bringing *La Dolce Vita* and *Last Year in Marienbad,* for example, to American moviegoers.

"I don't go out now," Michaux told Tucker matter-of-factly, his once-fiery eyes now stoical. "He rolled his chair from his desk to his dining room," Tucker recalled, "and I had something to eat with him, and that was the last time I saw him."

There was still business to attend to: Even from his wheelchair, Micheaux arranged bookings here and there for his most durable old films, and filled the small number of mail-order requests for his books. Ironically, his reputation as a novelist was on the rise in Harlem, even as he was being written off as a race-picture artist. In 1948, Hugh M. Gloster's *Negro Voices in American Fiction* rated Micheaux alongside the luminaries of the Harlem Renaissance. Gloster devoted four pages to Micheaux's pre-filmmaking novels, finding them "unimpressive in technique," but graced with characters, settings, and situations "far removed from the well-trod paths of American Negro fiction."

For its fortieth anniversary edition, the *New York Amsterdam News* featured a roundup of significant black writers of the twentieth century, and whether book editor Constance Curtis had changed her mind about Micheaux, or felt compassion for his sorry circumstances, she ran his photograph at the top of the page, where it shared space with the portraits of such eminences as W. E. B. DuBois, Countee Cullen, Zora Neale Hurston, and the NAACP leader Walter White. True, Micheaux had not won "critics' acclaim" with his books, but they appealed "to the public," she wrote. And he was "still writing books," reported the *Amsterdam News*.

This belated recognition might have given him solace, but it's unlikely that Micheaux really was still writing books, or much else. A shadow spread over him in his twilight years, as his arthritis, hypertension, and arteriosclerosis advanced. His feeble health is one reason to question the widespread belief, based on a brief clipping in the *Charlotte Observer*, that in the winter of 1951 the filmmaker became ill "while here selling books and making a tour of the South." Yet it is a fact that around that time Micheaux ended up in Good Samaritan Hospital in Charlotte, North Carolina.

Some rumors suggest that Micheaux may have ended up at the Good Samaritan after a car accident. Whatever the case, Micheaux was hospitalized there for six weeks, before passing away on Easter, March 25, 1951. He was sixty-seven years old.

Neither advertisements placed in the *Charlotte Post*, the city's black newspaper; nor repeated requests for information posted in the *Charlotte Observer*, the largest city daily; nor a search of medical and police records by local officials, has been able to establish the true circumstances of Micheaux's death. Not a single person could be located who claimed to have met Micheaux, or who knew what he was doing in Charlotte on that final trip.

One likely scenario is that the race-picture pioneer journeyed with his wife to North Carolina, where she had relatives, to find refuge at Good Samaritan (today part of Carolinas Medical Center), an historic black hospital said to be the first in the United States operated exclusively for African-Americans. Mrs. Micheaux, with whom he had just celebrated twenty-five years of marriage, was at his bedside when he died. Dr. Allen Atkins Wyche, a black physician who was a pioneer in the treatment of heart disease, signed the death certificate.

The day after his death, Micheaux's body was shipped back to Kansas for a family funeral; after the service he was buried in an unmarked grave in a Great Bend cemetery.

As far as can be determined, Oscar Micheaux's obituary was not reported in any white newspaper in America. The *Chicago Defender* gave Micheaux's death three paragraphs on page one, with no mention that he had ever lived in Chicago or produced some of his best-known films there. The *New York Amsterdam News* announced his death on the front page with a long article, hailing him as "one of Harlem's most distinguished citizens."

No will has ever been probated. Perhaps, in spite of the many bank accounts that Micheaux had strewn across America, in spite of all the money that had passed through his hands, there was nothing left to be declared.

In the month that Micheaux died, one of his masterpieces, *Harlem After Midnight*, was playing at the Ambassador Theatre in Kingston, Jamaica; another, *God's Stepchildren*, was hopping around theaters in the Deep South. Not long after, these and other Micheaux pictures disappeared into seeming oblivion.

* * *

Micheaux's widow, Alice B. Russell, wasted no time in vacating Harlem and moving back to New Jersey, where she lived close to family members, determinedly out of the public eye. As far as is known, she never gave a single interview. Bitter over her husband's destiny, according to some accounts, Mrs. Micheaux burned all his business papers and filmmaking memorabilia and junked the remaining prints of his pictures.

Alice B. Russell Micheaux outlived her husband by nearly thirty-five years, but was indigent for the last twelve, a senile ward of the state at the Woodland Nursing Home in Rye, New York. When she died of a heart attack on New Year's Day, 1985, at ninety-five, her occupation was listed on the state certificate of death as "Vocalist." Micheaux's faithful and loving partner was buried as a pauper at Greenwood Union Cemetery, "So. Acre W/19 Lot 31, Grave #6," an unmarked site that can be found only by consulting records in the cemetery office.

Unmarked gravestones wouldn't be the last bleak image if this were a film written, directed, and produced by the great and only. Even Micheaux's bleakest film productions—*Within Our Gates* or *God's Stepchildren*—held out hope for future generations.

For twenty years after his death, Micheaux was largely forgotten. Unlike Hollywood films, his weren't shown routinely on television, weren't available for rental in 16 mm format; they vanished from public consciousness, and many of them were lost altogether. His novels went out of print. All of this during a time when America was galvanized by the Civil Rights movement, a time when black history and heroes were avidly being rediscovered and reclaimed.

The rediscovery of Micheaux began, fittingly, in South Dakota in the late 1960s, when local historians began to research and write about the black pioneer whose first novel had been such an authentic account of the homesteading experience. The excitement spread to film circles in the early 1970s, when a handful of black show business historians started writing about race cinema and Micheaux's accomplishments in that arena. As part of their research, scholars and documentary filmmakers

initiated valuable interviews with the last surviving actors and personnel who had worked with Micheaux. When these first pieces about race cinema were being published, only a handful of Micheaux's films were known to have survived, all in poor condition; it would take time, luck, and persistence to reintroduce his best work to audiences.

Micheaux's 1925 film *Body and Soul,* for example, was located in the late 1960s, on deposit at the George Eastman House in Rochester, New York. Transferred to 16 mm, the picture, featuring Paul Robeson in his impressive dual roles, was publicized as part of Pearl Bowser's Black Historical Film Series at the Jewish Museum and Brooklyn Academy of Music in 1970, though it had to be pulled from the series at the last moment. Bowser began showing it in Paris in 1981, and then as part of her "Black Independent Films: 1920–1980" program that toured the United States. *Body and Soul* was meticulously restored in 1986, and a high-quality tape was made available to the general public in 1998 for the Robeson centennial. At the New York Film Festival in 2000, the silent film was presented with a newly commissioned orchestral score by jazz trombonist Wycliffe Gordon.

Detective work abroad has affirmed the international distribution of some Micheaux pictures. A print of *Within Our Gates* was located by Thomas Cripps in the Cineteca Nacional in Madrid, Spain, in the spring of 1979, shortly after he completed his distinguished black film history *Slow Fade to Black.* The 1919 production, which had overcome opposition by a group of Chicago ministers, bore the Spanish title *La Negra.* Another decade passed before a swap could be arranged with the Library of Congress: *La Negra* for a print of the 1931 version of *Dracula* starring Bela Lugosi. By 1995, *Within Our Gates* had been restored and made widely available by Smithsonian Video.

In 1983, a Southern Methodist University archivist named G. William Jones received a phone call from a superintendent who was clearing out a building in Tyler, Texas, about eighty-five miles east of Dallas. Jones was guided to "a stack of octagonal steel film cans ten feet high, ten feet deep and ten feet wide sitting in a corner" of a warehouse used by the long-defunct Sack Amusement Enterprises. The piles of film-footage cans yielded more than one hundred short and feature films, including twenty-two separate "black-audience" pictures. "Some of these films were on pre-1950 nitrate stock, and were already in a state of decomposition," wrote Jones in his book *Black Cinema Treasures: Lost and Found.* But among the

treasures was a good-condition copy of *Murder in Harlem* (the Southern retitling of *Lem Hawkins' Confession*), Micheaux's 1935 restaging of the Leo Frank case.

The Symbol of the Unconquered, Micheaux's fourth silent feature, which had been presumed lost, surfaced at the Cinématique Royale in Brussels in the late 1990s. Advised by Jane Gaines and Charlene Regester, the coeditors of the *Oscar Micheaux Society Newsletter,* Turner Classic Movies (TCM) undertook restoration of the 35 mm print with translation of the French and Flemish intertitles. The recovered version of Micheaux's 1920 homesteading picture, with its anti-Ku Klux Klan theme, had its television premiere in midsummer 1998, along with a New York City unveiling at the Apollo Theater. Jazz drummer and composer Max Roach provided a new musical score.

These rediscovered gems alone would confirm Micheaux's greatness as a filmmaker, even before one considers the novels and larger body of work he created—and the unique struggle of his life and career.

In the late 1980s, Micheaux's relatives in Great Bend, Kansas, took up his cause. Spearheaded by a local white attorney, Martin Keenan—a one-man Micheaux booster who whipped up the enthusiasm of everyone he met—they collected enough donations to pay for a headstone to adorn his grave in the Rose Cemetery in Great Bend. The headstone reads:

<div align="center">

Pioneer Black Film Maker & Author

OSCAR MICHEAUX

Jan. 1, 1884

Mar. 25, 1951

A MAN AHEAD OF HIS TIME

</div>

The recognition, long overdue, started to snowball. *The Conquest* and *The Homesteader* were republished by the University of Nebraska Press. General reference encyclopedias (like the three-volume *The American Negro Reference Book* of 1966) that once had ignored Micheaux now made ample space for him in their updated editions. Micheaux was missing from mainstream film reference books like the four-volume *Magill's Survey of Cinema,* or the first edition of Ephraim Katz's inclusive *Film En-*

cyclopedia, both from 1980, but the editors scrambled to give him long appreciative essays in later editions.

By the turn of the millennium, distinguished historians like Henry Louis Gates Jr. and Cornel West were routinely citing Micheaux among the one hundred most influential African-Americans of the twentieth century. Awards were created in his name, film festivals in his honor; college courses sprang up by the dozens, devoted to race cinema and his films; original lobby cards for Micheaux movies and first editions of his books sell for thousands of dollars on eBay.

Today, as film scholar Charlene Regester has noted, there is almost a "mad dash to honor Oscar Micheaux."

Even Hollywood, prodded by black activists in the film industry, got into the act. In 1986, Micheaux was voted a Golden Jubilee Special Award for lifetime achievement from the Directors Guild of America (DGA). Federico Fellini and Akira Kurosawa had been similarly honored in the past, but Micheaux was the first director to receive the award posthumously. In presenting the award to Micheaux's niece, Verna Crowe, Sidney Poitier described the race-picture pioneer as an "enormous genius," a "role model by which we can sculpt our future in the American film industry." President Ronald Reagan sent a telegram declaring that Micheaux "stands tall in the history of the cinema—for the obstacles he overcame, and for the obstacles nobody in his day could overcome. Nothing daunted him, and his work remains as a testament to courage and artistic excellence."

The following year, Micheaux got his own star on Hollywood's Walk of Fame, near those of actress Dorothy Dandridge and entertainer Harry Belafonte. The Walk of Fame honors are always "sponsored," and the cost of his honor was underwritten by the Educational and Benevolent Foundation of the DGA, which also pays for the upkeep of D. W. Griffith's gravesite in Crestwood, Kentucky. Micheaux would have savored that irony.

In 1996, the Producers Guild of America established an Oscar Micheaux Award for an individual or individuals whose contributions to the profession of producing had been made despite tremendous odds. The honorees to date have included celebrated photographer Gordon Parks, musician Quincy Jones, and actor-director Tim Reid.

It's easy to be cynical about Hollywood, which has lagged behind every

major industry in America, in some ways reacting to the Civil Rights movement as though it were running away in slow motion from a monster in a horror movie. Black actors have made huge strides, actresses less so; inside the studios and behind the cameras, discrimination persists and inequality reigns. Film and television are the subject of a yearly report by the National Association for the Advancement of Colored People, and annually the NAACP denounces the industry's "token gestures of opportunity." Representation among writers, directors, and producers is still a disgrace.

When Micheaux was honored by the Directors Guild, Saundra Sharp wrote in the *Black Film Review,* "He probably would have been too busy to come. He would have been filming in Chicago, or editing in New York, or in Oklahoma petitioning a theater owner to show his next film. Oscar Micheaux would have been at work."

True enough:

> Got to keep going!
> Make something out of it!
> Let's make some money—yeah man!

The realist would have been busy. But the idealist would have welcomed the almost happy ending.

WORKS BY OSCAR MICHEAUX

BOOKS

The Conquest: The Story of a Negro Pioneer (Lincoln, Nebraska: Woodruff Press, 1913)

The Forged Note: A Romance of the Darker Races (Lincoln, Nebraska: Western Book Supply Company, 1915)

The Homesteader (Sioux City, Iowa: Western Book Supply Company, 1917)

The Wind from Nowhere (New York: The Book Supply Company, 1943)

The Case of Mrs. Wingate (New York: The Book Supply Company, 1945)

The Story of Dorothy Stanfield (New York: The Book Supply Company, 1946)

The Masquerade (New York: The Book Supply Company, 1947)

FILMOGRAPHY

All films are black and white. All produced before 1930 are silent. *A Daughter of the Congo* and *Easy Street* are part-silent. *The Exile* is the first of Micheaux's sound films. Cast and crew are listed in the original order their names appeared on the screen, where possible. "Unbilled" players and technical personnel are added, where they can be reasonably documented. Various websites—for example, the Internet Movie Database (www.imdb .com)—feature credits for Micheaux films with arguable discrepancies, including spellings. Curiously, many of Micheaux's actors had spellings that varied with their billings in different films, or changed slightly from their billing onstage. For example, Grace Smith was billed sometimes as "Grace Smythe," Alex Lovejoy as "Alec Lovejoy."

The extant films (which vary in their quality and running times) are noted with an asterisk (*). The "ghost" films are noted with two asterisks (**). The films are listed according to their "year of release," but even this varies according to filmographies in other books.

1919

THE HOMESTEADER
As writer, director, and producer.
Sc: Based on the Micheaux novel.

Cast: Charles D. Lucas (Jean Baptiste), Evelyn Preer (Orlean McCarthy), Iris Hall (Agnes Stewart), Charles Moore (Jack Stewart), Inez Smith (Ethel McCarthy), Vernon Duncan (N. Justine McCarthy), Trevy Woods (Glavis, Ethel's husband), William George (Agnes's white lover), Bill Prescott.

> "... *the greatest of all Race productions ... a remarkable picture both as a story and photography ... It takes eight splendid reels of gripping interest to tell it all, and those who are able to witness the running of it should take full advantage."*
>
> *Chicago Defender,* February 22, 1919

1920

WITHIN OUR GATES*
As actor, writer, director, and producer.

Cast: Evelyn Preer (Sylvia Landry), William Starks (Jasper Landry), Mattie Edwards (Jasper Landry's wife), Grant Edwards (Emil Landry), E. G. Tatum (Efrem, Gridlestone's faithful servant), Charles D. Lucas (Dr. V. Vivian), Flo Clements (Alma Prichard), Jack Chenault (Larry Prichard), S. T. Jacks (Reverend Wilson Jacobs), Grant Gorman (Armand Gridlestone), Ralph Johnson (Philip Gridlestone), James D. Ruffin (Conrad Drebert), Bernice Ladd (Mrs. Geradine Stratton), Mrs. Evelyn (Mrs. Elena Warwick), William Smith (Philip Gentry, the detective), LaFont Harris (Emil as a young adult), Jimmie Cook, Oscar Micheaux.

> *"Despite some aspect to ratio problems,* [Within Our Gates] *was an amazing thing to experience. The film covers a lot of thematic ground, but the section that deals with a lynching is quite disturbing. It was interesting to watch a film by a black director that dealt with lynching at a time that it was a commonplace occurence. Micheaux was commenting on contemporary events and using a*

mixed race cast to do it. Within Our Gates *also made fun of black preachers, looked at the class and color divide among black folk, and ridiculed black sell-outs to boot."*

<div align="right">

Nelson George, commenting on a screening of *Within Our Gates*
at the Lake Placid Film Festival, June 7, 2004,
posting at info@nelsongeorge.com

</div>

THE BRUTE
As writer, director, and producer.

Cast: Evelyn Preer (Mildred Carrison, the mistreated wife), A. B. DeComathiere/Comathiere ("Bull" Magee, the brute), Susie Sutton (Aunt Clara), Lawrence Chenault (Herbert Lanyon, the lover), Alice Gorgas (Margaret Pendleton, the vamp), Sam Langford (prizefighter Tug Wilson), Marty Cutler (prizefighter Sidney Kirkwood), Laura Bowman (Mrs. Carrison), Mattie Edwards (a guest in "The Hole"), Virgil Williams (referee), Flo Clements (Irene Lanyon), Lewis Schooler ("Klondike"), E. G. Tatum, Harry Plater, Al Gaines.

> *"Plot good. Dramatic action good. Settings poor in all but one scene. Photography poor. Stars work good but not up to former work. Support good for novices. Comedy very good. Appeal, special to sporting element. Sam Langford work fair, fight spoiled by poor light. Sam Langford and fight best publicity. Paper good. Titles good. Picture as a whole best he's [Micheaux] produced."*

<div align="right">

From George P. Johnson files, with notation:
"Witnessed Nov. 3, 1920 at Diamond Theatre, Omaha"

</div>

THE SYMBOL OF THE UNCONQUERED*
As writer, director, and producer.

Cast: Iris Hall (Evon Mason), Walker Thompson (Hugh Van Allen), Lawrence Chenault (Jefferson Driscoll), George Catlin (Dick Mason), Edward E. King (Tom Cutschawl), Mattie Wilkes (Driscoll's mother), E. G. Tatum (Abraham), Leigh "Lee" Whipper (Tugi Boj, the Indian Fakir), Edward Fraction (Peter Kaden), Lena L. Loach (Christina), Louis Dean, James Burris.

> *"In* The Symbol of the Unconquered, *Micheaux not only exposed the economic underpinnings of the hooded night riders, the Ku Klux Klan on the frontier . . . he also addressed important discourses on racial identity and preference from within the Black community. The color line was both the subtext and the context . . ."*

<div align="right">

Pearl Bowser and Louise Spence, "Oscar Micheaux's *The Symbol of the Unconquered:* Text and Context," *Oscar Micheaux & His Circle*

</div>

1921
THE GUNSAULUS MYSTERY
As writer, director, and producer.
Ph: Leonard Galezio.

Cast: Evelyn Preer (Ida May Gilpin), Ed "Dick" Abrams (Sidney Wyeth), Lawrence Chenault (Anthony Brisbane), Louis DeBulger (Lem Hopkins), E. G. Tatum, Mattie

Wilkes, Bessie/Bessye Bearden, Ethel Williams, Edward "Eddie" Brown, Mabel Young, Hattie Christian, Ethel Watts/Waters, George Russell, W. D. Sindle, Alex Kroll, Inez Clough.

> "This is the story based on the Leo Frank case. It is one of the most mysterious murder cases on record. The evidence shows that Leo Frank committed the crime and got a COLORED MAN to help him dispose of the body. And then tried to blame the crime on the COLORED MAN."
>
> Micheaux advertisement for *The Gunsaulus Mystery*

1922

THE DUNGEON
As writer, director and producer.

Cast: William E. Fountaine, Shingzie Howard, William B. F. Crowell, J. Kenneth Goodman, Earle Brown "Carl" Cooke, Blanche Thompson.

> "The film is of such a character that, in the opinion of the Commission, it is 'inhuman,' 'immoral' and 'would tend to corrupt morals' and 'incite to crime.' "
>
> New York Motion Picture Commission, May 20, 1922
> letter to Micheaux disapproving *The Dungeon*

THE VIRGIN OF SEMINOLE
As writer, director, and producer.

Cast: William E. Fountaine, Shingzie Howard, William B. F. Crowell.

> "A daring, powerful, and thrilling drama interwoven with a beautiful love story. There is a climax to tighten your breath, to keep you on edge, with restless eagerness, for it is a climax which bares the soul of a woman. Elaborate settings with an excellent supporting cast. This is one of the season's greatest successes."
>
> *Philadelphia Tribune*, May 8, 1926

1923

JASPER LANDRY'S WILL**
(aka CASPER OLDEN'S WILL)
As writer, director, and producer.

Cast: William E. Fountaine, Shingzie Howard, William B. F. Crowell.

> *No conclusive evidence of completion or exhibition.*

A FOOL'S ERRAND**
As writer, director, and producer.

Cast: William E. Fountaine, Shingzie Howard, William B. F. Crowell.

> *No conclusive evidence of completion or exhibition.*

DECEIT

As writer, director, and producer.

Ph: Leonard Galezio.

Cast: Evelyn Preer (Doris Rutledge/Evelyn Bently), Norman Johnstone/Johnston (Alfred DuBois/Gregory Wainright), A. B. DeComathiere (Rev. Christian Bently), Cleo Desmond (Charlotte Chesboro), Louis DeBulger (Mr. Chesboro), Mable Young (Mrs. Levine), Cornelius Watkins (Gregory Wainright, as a boy), Mrs. Irvin C. Miller (Mrs. Wainright), Ira O. McGowan (Mr. Wainright), Lewis Schooler (actor/waiter), Jerry Brown (Actress), James Carey (a crooked banker), Viola Miles (Teacher), Mary Watkins (Teacher), N. Brown (Teacher), J. Coldwell (Preacher), F. Sandifier (Preacher), Jessie R. Billings (Preacher), Allen D. Dixon (Preacher), Leonard Galezio (Censor), Sadie Carey (Censor), William Patterson (Censor and Member of Rescue Party), Milton Henry (Member of Rescue Party).

> "The plot of this film closely parallels the events which occurred when Micheaux's
> Within Our Gates was brought before the Chicago Board of Censors for approval."

> Henry T. Sampson, *Blacks in Black and White:*
> *A Source Book on Black Films*

1924

BIRTHRIGHT

As writer, director, and producer.

Sc: Based on the novel by T. S. Stribling.

Cast: Evelyn Preer (Cissie Deldine), J. Homer Tutt (Peter Siner), Salem Tutt Whitney (Tump Pack), Callie Mines (Aunt Caroline), E. G. Tatum (The Persimmon), Ed Elkas (Sheriff A. Dawson Bobbs), Alma Sewell (Old Rose), Lawrence Chenault (Henry Hooker/Captain Renfrew), William B. F. Crowell.

> "Micheaux has made a really great picture. It is a modern Uncle Tom's Cabin and
> may not be popular in some quarters, a fact that will but confirm its value. It was
> apparently not intended for colored audiences alone. Its brutal frankness hurts,
> and some of the titles put a sting into the evening's entertainment, and just because
> it has been so well done every one should see it. The film has comedy, pathos, and
> gripping interest, and should play to packed houses, and if one appreciates naked
> truth, it should make you think—and think constructively."

> J. A. Jackson, *Billboard*, January 26, 1924

1925

A SON OF SATAN

(aka THE GHOST OF TOLSTON'S MANOR)

As writer, director, and producer.

Sc: Based on Micheaux's unpublished story "The Ghost of Tolston's Manor."

Cast: Andrew Bishop (the Sea Captain), Lawrence Chenault, Shingzie Howard, Edna Morton, E. G. Tatum, Walter Robinson (the father), Dink Stewart, Ida Anderson, Monte Hawley, William B. F. Crowell, Olivia Sewell, Emmett Anthony, Evelyn Ellis,

Marie Dove, Blanche Thompson, Margaret Brown, Professor Hosay, Mildred Small-wood (dancer), Flournoy Miller, Aubrey Lyles, and the "Shuffle Along" chorus.

> *"Some may not like the production because it shows some of our Race in their true colors. They might also protest against the language used. I would not endorse this particular part of the film myself, but I must admit that it is true to nature, yes, I guess, too true. We have got to hand it to Oscar Micheaux, when it comes to giving us the real stuff."*
>
> D. Ireland Thomas, *Chicago Defender,* January 31, 1925

THE HOUSE BEHIND THE CEDARS
As writer, director, and producer.
Sc: Based on the novel by Charles W. Chesnutt.

Cast: Shingzie Howard (Rena Walden/Warwick), Andrew Bishop (George Tryon), Lawrence Chenault (John Walden/Warwick), Alma Sewell, William B. F. Crowell, Douglas Griffin, Oliver Hill.

> *"Whereas Chesnutt's Rena dies, sadder and wiser for her travails, Micheaux's Rena survives, happier and wiser for her experiences. Significantly, contrary to Holly-wood's version of the 'passing' film in which the offending black or mulatto had to be humiliated for daring to affect whiteness, Micheaux rewards Rena for reasserting her black heritage."*
>
> Barbara Tepa Lupack, *Literary Adaptations in
> Black American Cinema: From Micheaux to Morrison*

MARCUS GARLAND**
As writer, director, and producer.

Cast: Salem Tutt Whitney, Amy Birdsong.

> *"Though listed as a Micheaux film by various sources, little else is known about it. James Nesteby* [Black Images in American Film, 1896–1954] *referred to it as a burlesque of Marcus Garvey. Bernard Peterson* ["The Films of Oscar Micheaux" in *The Crisis*] *reported it to be a melodrama based on Garvey's life."*
>
> Earl James Young Jr., *The Life and Work of Oscar Micheaux*

THE DEVIL'S DISCIPLE
As writer, director, and producer.

Cast: Evelyn Preer, Edward Thompson, Lawrence Chenault, Percy Verwayen/Verwayne.

> *"The picture is really the first story of Negro night life in Harlem ever brought to the screen. Every scene is taken in the locality and every one will recognize the land-marks that are familiar to us. The story centers about a beautiful but vain girl who falls in love with a degenerate. She tries to reform him but fails miserably, and is in turn dragged down and down. Besides being intensely gripping and dramatic, the picture contains a good moral lesson for our stage struck sisters."*
>
> *New York Age,* October 24, 1925

BODY AND SOUL*
As writer, director, and producer.

Cast: Paul Robeson (Rev. Isaiah T. Jenkins/his brother Sylvester), Julia Theresa Russell (Isabelle, the Girl), Mercedes Gilbert (Martha Jane, her Mother), Lawrence Chenault (Yellow Curly Hinds), Marshall Rodgers (Speakeasy Proprietor), Lillian Johnson (Sister Ca'line), Madame Robinson (Sister Lucy), Chester A. Alexander (Deacon Simpkins), Walter Cornick (Brother Amos), Tom Fletcher.

> *"The two sides of the preacher's personality are symbolized by the cover of a* Police Gazette *that hangs on the wall of the preacher's speakeasy hangout, contrasted with a portrait of Booker T. Washington that gazes from the matron's wall as she refuses permission for her daughter to marry* [Paul] *Robeson. But Micheaux, using a contrived ending, has the young girl awaken from a nightmare, which the audience has been watching, and marry the now pious preacher. The film becomes at once a trick played on an audience expecting to see another white man's Negro, and a symbolic turning away from those stereotyped traits."*
>
> Thomas R. Cripps, "Paul Robeson and Black Identity in American Movies," *Massachusetts Review* (Summer 1970)

1926
THE CONJURE WOMAN
As writer, director, and producer.
Sc: Based on the book by Charles W. Chesnutt.

Cast: Evelyn Preer, Lawrence Chenault, Percy Verwayen, Mattie Wilkes, Alma Sewell, Sidney Easton.

> *"This may not have been a very successful film."*
>
> "An Oscar Micheaux Filmography," *Oscar Micheaux & His Circle*

1927
THE SPIDER'S WEB
As writer, director, and producer.
Sc: Based on Micheaux's unpublished story "The Policy Players."

Cast: Evelyn Preer (Norma Shepard, the niece), Lorenzo McLane (Elmer Harris, the detective), Edward Thompson (Martinez, a Cuban numbers banker), Henrietta Loveless (Mary Austin, a widow), Grace Smith/Smythe (Madame Boley), Zodie Jackson, Marshall Rodgers, Billy Gulfport, Cy Williams, Josiah Diggs, Cincinnatus Major (the lawyer), Edna Barr (Creole belle), Palestine Delores Williams, Dorothy Treadwell.

> *"How the guilty parties are at last discovered and brought to justice makes up as interesting a story of Negro life as one can wish to see."*
>
> *Chicago Defender,* January 15, 1927

THE MILLIONAIRE
As writer, director, and producer.

Cast: Grace Smith (Celia Wellington), J. Lawrence Criner (Pelham Guitry), Lionel Monagas (The Lizard), Cleo Desmond, William Edmondson, Vera Bracken, S. T. Jacks, E. G. Tatum, Mrs. and Mr. Robert S. Abbott (editor-publisher of the *Chicago Defender*).

> *"This unusual story is about a Negro soldier of fortune in South America. After years of working and accumulating his fortune he returns to America, where he meets a young lady. Unfortunately, the woman he likes is part of a crime family."*
>
> *Philadelphia Tribune*, November 24, 1927

1928
THIRTY YEARS LATER
As writer, director, and producer.
Sc: Based on the Henry Francis Downing play *The Racial Tangle*.

Cast: William Edmondson (George Eldridge Van Paul), A. B. DeComathiere (Habisham Strutt), Ardelle Dabney (Clara Booker), Gertrude Snelson (Mrs. Van Paul), Barrington Carter, Madame Robinson, Arthur Ray, Ruth Williams, Mabel/Mable Kelly (Hester Morgan).

> *"This picture is based on the famous Alice-Kip Rhinelander case and has attracted wide attention among both races throughout the country. It is a remarkable film and filled with heart, interest, and truths of interest to the race."*
>
> *Kansas City Call*, April 13, 1928

THE BROKEN VIOLIN
As writer, director, and producer.
Sc: Based on Micheaux's unpublished novel "House of Mystery."
(Presented by Frank G. Kirby for Micheaux Productions)

Cast: William A. Clayton Jr., Ardelle Dabney, Salem Tutt Whitney, J. Homer Tutt, Alice B. Russell, Ethel Smith, Ike Paul, Daisy Foster, Gertrude Snelson, Boots Hope, William "Pickaninny" Hill.

> *"A race drama of intense interest and thrillingly dramatic episodes. The continuity is well established and the interest sustained. The artists for the cast were carefully selected."*
>
> *Pittsburgh Courier*, August 25, 1928

1929
THE WAGES OF SIN
As writer, director, and producer.
Sc: Based on Micheaux's unpublished story "Alias Jefferson Lee."

Cast: Lorenzo/AlonzoTucker (Winston Le Jaune), William A. Clayton Jr. (Jefferson Le Jaune, aka Jefferson Lee), Katherine Noisette, Rudolph Hind, Ardelle Dabney, Bessie Gibbens, Sylvia Birdsong, Alice B. Russell, William Baker, Gertrude Snelson.

"Has to do with the life of two brothers, one of whom goes straight while the other goes wrong, led on by wild life. Thrills and heroism make this an unusual production."

New York Amsterdam News, January 30, 1929

WHEN MEN BETRAY
As writer, director, and producer.

Cast: Katherine Noisette, William A. Clayton Jr., Bessie Gibbens, Gertrude Snelson, Lorenzo Tucker, Ethel Smith, Alice B. Russell.

"An absorbing tale, teeming with action though bitter with tragedy, a tale that is brutally frank, but true to the phase of life it portrays."

The Afro-American (Baltimore), August 3, 1929

1930
EASY STREET
As writer, director, and producer.
Sc: Based on Micheaux's unpublished story "Caspar Olden's Will"
(Produced by A. Burton Russell for Micheaux Pictures)

Cast: Richard B. Harrison, William A. Clayton Jr., Lorenzo Tucker, Alice B. Russell, Willor Lee Guilford.

"It shows the 'inside actions' of city slickers in their attempt to swindle an old man of honestly earned money. It's a plot sensational with surprise, action, love, suspense, and intrigue."

Pittsburgh Courier, August 6, 1930

A DAUGHTER OF THE CONGO
As writer, director, and producer.
Sc: Based on the Henry Francis Downing novel *The American Cavalryman: A Liberian Romance.* Theme song: "That Gets It," composed by Roland C. Irving and Earl B. Westfield.
(Produced by A. Burton Russell for Micheaux Pictures)

Cast: Katherine Noisette (Lupelta), Lorenzo Tucker (Captain Paul Dale), Salem Tutt Whitney (Kojo, the rumhound President), Roland C. Irving (Lieutenant Brown), Joe Byrd (Whereaboe), Wilhelmina Williams (Ressha), Clarence Redd (Lodango), Alice B. Russell (Miss Pattie), Charles Moore (John Calvert), Gertrude Snelson (Calvert's sister), Percy Verwayen (Pidgy Muffy), Madame Robinson (Lobue), Daisy Harding (singer), Willor Lee Guilford (Hulda), "Speedy" Wilson (Mwamba), Rudolph Dawson (tap dancer), Sylvia Birdsong, Ida Forsyne, Jennie B. Hillman.

Received "coverage in the Negro World, *as it held political implications for [Marcus] Garvey's movement. The newspaper covered Micheaux's film primarily because the lead actor, Roland C. Irving, had toured Africa where the film had been set and because the story, at least, was in the interest of Garvey's back-to-Africa movement."*

Charlene Regester, "The African-American Press and Race Movies: 1909–1929," from *Oscar Micheaux & His Circle*

1931

THE EXILE*
As writer, director, and co-producer.
Sc: Based on *The Conquest*.
Ph: Lester Lang, Walter Strenge. Dances and Ensemble Staging: Leonard
Harper. Musical Score: Donald Heywood.

Cast: Eunice Brooks (Edith Duval), Stanleigh Morrell (Jean Baptiste), Celeste Cole
(Singer), Katherine Noisette (Madge), Charles Moore (Jack Stewart), Nora Newsome
(Agnes Stewart), George Randol (Bill Prescott), A. B. DeComathiere (Outlaw), Carl
Mahon ("Jango," an Abyssinian student), Lou Vernon (District Attorney), Roland
Holder (Tap Dancer), Louise "Jota" Cook (Dancer), Lorenzo Tucker, George Cooper
Sr., Norman Reeves, Inex Persaud, Donald Heywood's Band and Chorus, Leonard
Harper's Connie Inn's Chorus.

> *"While it has many obvious faults, it is by far the best picture Mr. Micheaux ever*
> *turned out. It has a fairly good plot, continuity, and is genuinely entertaining in*
> *spots."*
>
> W. E. Clark, *New York Age*, May 23, 1931

DARKTOWN REVUE*
(short subject)
As director and producer.
Songs by Donald Heywood: "Is That Religion?" "Watermelon Time," "Blow,
Bugle Blow," "Mister Trouble," "Ain't It A Shame," "Jazz Grand Opera," "Satan
Is a Devil."

Cast: Amon Davis, Andrew Tribble, Tim Moore, and the Donald Heywood Choir.

> *"A succession of apparently discrete musical and comedy numbers stuck together.*
> *What makes* Darktown Revue *interesting is that its succession is carefully pat-*
> *terned by a series of contrasts—contrasts which at first appear simple, but built*
> *until finally they become complex, critical, and interconnected."*
>
> Arthur Knight, *Disintegrating the Musical*

1932

VEILED ARISTOCRATS*
As writer, director, and producer.
Sc: Based on the Charles W. Chesnutt novel *The House Behind the Cedars*.
Songs include: "River, Stay Away from My Door."
(Produced by A. Burton Russell for Micheaux Pictures)

Cast: Lucille Lewis (Rena Walden), Walter Fleming (John Walden), Laura Bowman
(Molly Walden), Lawrence Chenault (Judge Straight), Lorenzo Tucker (John War-
wick), Carl Mahon (Frank Fowler), Barrington Guy (George Tryon), Willor Lee Guil-
ford (Miss Waring), Bernardine Mason (Singer), Aurora Edwards (Cook), Mabel
Garrett (Maid), Arnold Wiley (Driver), A. B. DeComathiere, Katherine Noisette,
Donald Heywood.

"It may have been whittled to bits by censors, exhibitors, projectionists, angry patrons . . . but what's left of Aristocrats is choice: off-putting, unsettling, staggering toward emotional profundity."

Richard Corliss, "An Oscar for Micheaux" (*Time* online)

HARLEM AFTER MIDNIGHT
As actor, writer, director, and producer.
Sc: Based on Micheaux's unpublished short stories.

Cast: Lorenzo Tucker, Bee Freeman, Alfred "Slick" Chester, Rex Ingram, Lionel Monagas, Babe Townsend, Dorothy Van Engle, Lawrence Chenault, A. B. DeComathiere, Pearl McCormack, Alice B. Russell, Carlton Moss, Sam Patterson, Sol Johnson, Count LeShine, Oscar Micheaux.

"The story is built around Negro gangsters who kidnap a wealthy Jew and just about get away with it, until Micheaux, in the role of a clever sleuth, breaks up the racket."

Atlanta Daily World, September 9, 1934

TEN MINUTES TO LIVE*
As actor, writer, director, and producer.
Sc: Based on Micheaux's unpublished short stories.
("Producer's Note: This photoplay is adapted from the following short stories of Negro night life in Harlem: Story No. 1: 'The Faker'; Story No. 2: 'The Killer'; Story No. 3: [Unknown Title.]")
Ph: Lester Lang. Asst Dir: A. B. DeComathiere. Music: Donald Heywood.
(Produced by A. Burton Russell for Micheaux Pictures)

Cast: A. B. DeComathiere (Marshall, the producer), Alice B. Russell (the killer), William A. Clayton Jr. ("The Escape King"), Willor Lee Guilford (wronged wife/Letha), Carl Mahon (Anthony), Lawrence Chenault (Harold Stokes), Lorenzo Tucker (Nelson Gentry), Laura Bowman, Clementine Phelps, Mabel Garrett, Tressie Mitchell, Walter Fleming, Ethel Smith, Galle De Gaston, Tressie Mitchell, George Williams, Dixie Serenaders, Donald Heywood, Oscar Micheaux.

"Calling into question the Western metaphysical dualism which associates whiteness with purity and blackness with taint, the subtext of Micheaux's seemingly simple melodrama interrogates internalized racism and the color caste system."

bell hooks, "Micheaux: Celebrating Blackness,"
Black American Literature Forum (Summer 1991)

THE GIRL FROM CHICAGO*
As writer, director, and producer.
Sc: Based on Micheaux's unpublished story "Jeff Ballinger's Woman."
Ph: Sam Orleans. Asst Dir: Vere E. Johns. Recording Engineer:
Richard Halpenny.
(Produced by A. Burton Russell for Micheaux Pictures)

Cast: Carl Mahon (Alonzo White), Starr Calloway (Norma Shepard), Alice B. Russell (Miss Warren), Eunice Brooks (Mary Austin), Minta Cato (Her Sister Minnie), John

Everett (Jeff Ballinger), Frank Wilson (Wade Washington), Cherokee Thornton (A Snitch), Grace Smith (Liza Hatfield), Erwin Gary (Numbers Collector), Juano Hernandez (Gomez), Alfred "Slick" Chester, Chick Evans with Bud Harris's Rhythm Rascals Orchestra.

> "Lying Lips *and* The Girl from Chicago . . . *are not among black pioneer film-maker Oscar Micheaux's better films, to put it kindly. Melodramas with musical interludes, awkwardly constructed and amateurishly acted, they yet are stirring expressions of middle class aspirations. The first exposes the predicament of nightclub entertainers who are expected to prostitute themselves after hours, while the second condemns the numbers racket.*"
>
> Kevin Thomas, *Los Angeles Times*, April 26, 1990

1933

THE PHANTOM OF KENWOOD
As writer, director, and producer.
(Produced by A. Burton Russell for Micheaux Pictures)

Cast: Frank Wilson, Bebe Townsend, Bee Freeman, Pearl McCormack, Carlton Moss.

> "*Deals with the theme of a perfect murder and in telling how it is solved holds intense and intriguing moments from start to finish.*"
>
> *Philadelphia Tribune*, May 4, 1933

1935

LEM HAWKINS' CONFESSION*
(aka MURDER IN HARLEM)
As actor, writer, director, and producer.
Sc: Based on Micheaux's unpublished story "The Stanfield Murder Case."
Ph: Charles Levine. Original Music and Cabaret Sequences: Clarence Williams.
Songs include: "Harlem Rhythm Dance" (sung by Eunice Wilson). Art Dir: Tony
Contineri. Production Manager: Charles P. Nason. Sound: Harry Belock,
Armand Schattini.
(Produced by A. Burton Russell for Micheaux Pictures)

Cast: Clarence Brooks (Henry Glory), Dorothy Van Engle (Claudia Vance), Andrew Bishop (Anthony Brisbane), Alex/Alec Lovejoy (Lem Hawkins), Laura Bowman (Mrs. Epps), Bee Freeman (The Catbird), Alice B. Russell (Mrs. Vance), Lorenzo McClane (Arthur Vance), Lionel Monagas, Sandy Burns, Lea Morris, Joie Brown, Jr., Henrietta Loveless, Helen Lawrence, David Hanna, Alfred "Slick" Chester, Byron Shores, Roland Smith, Eunice Wilson (singer), Clarence Williams, Oscar Micheaux.

> "*Micheaux attempted something quite ambitious, and in the history of representations of the Mary Phagan/Leo Frank story, quite unusual. By using as a narrative structure a series of interrelated, often contradictory, confessions and testimonies that fit neatly into a detective story genre, he is insisting that we move beyond the bifurcated accusations of the Leo Frank trial in which blatant antisemitism and racism shape the arguments. By introducing the plot twist of a third possible*

*killer—indeed, the one who really is guilty—he ostensibly breaks the racially
fraught African-American/Jewish tension in the story . . . And, as his narrative
structure proves, truths are always more complicated and subjective than they may
first appear.*"

Michael Bronski, "The Return of the Repressed:
Leo Frank Through the Eyes of Oscar Micheaux,"
Shofar: An Interdisciplinary Journal of Jewish Studies (2005)

1937

TEMPTATION

As writer, director, and producer.

Cast: Ethel Moses (Helen Ware), Lorenzo Tucker (Robert Fletcher), Andrew Bishop
(Kid Cotton), Alfred "Slick" Chester, Larry Seymour, Hilda Rogers, the Pope Sisters,
Lillian Fitzgerald, Dot and Dash, the Six Sizzlers, Taft Rice, Bobby Hargraves and his
Kit Kat Club Orchestra.

"A sophisticated sex drama in the De Mille vein."

Donald Bogle, *Toms, Coons, Mulattoes, Mammies & Bucks*

UNDERWORLD*

As writer ("adaptation and dialogue"), director and producer.
Sc: Based on Edna Mae Baker's story "Chicago after Midnight."
Ph: Lester Lang. Ed: Jack Kemp, Nathan Cy Braunstein.
(Alfred N. Sack Presents for Sack Amusement Enterprises)

Cast: Bee Freeman (Dinah Jackson), Sol Johnson (Paul Bronson), Alfred "Slick"
Chester (LeRoy Giles), Ethel Moses (Evelyn Martin), Oscar Polk (Sam Brown),
Lorenzo Tucker, Larry Seymour, Amanda Randolph, Anna May Fritz, Bernice Gray,
Eddie Matthews, Mitchell Modeste, Willie Kew, Dorothy "Dot" Salters, Raymond
Collins (Rope Dancer), Carrie Bell Powell, Stringbean, The Pope Sisters, Harlem Sepia
Chorus, Six Sizzlers, The Girls from Nagasaki, Bobby Hargraves and his Kit Kat Club
Orchestra.

*"A stirring and highly dramatic film, one that should not be missed. The All-
Colored cast is one of the finest ever assembled in one production."*

The Philadelphia Tribune, January 6, 1938

1938

SWING!*

As writer, director, and producer.
Sc: Based on Micheaux's unpublished story "Mandy."
Ph: Lester Lang. Ed: Patricia Rooney. Sound: Edward Fenton,
E. A. Schabbehor.
Musical Dir: Leon Gross. Songs include: "Bei Mir Bist Du Schoen."
(Produced by A. Burton Russell for Micheaux Productions)

Cast: Cora Green (Amanda "Mandy" Jenkins), Larry Seymour (Cornell Jenkins),
Hazel Diaz (Eloise Jackson/Cora Smith), Alex Lovejoy (Lem Jackson/"Big Yellow"

Jones), Carman Newsome (Ted Gregory), Dorothy Van Engle (Lena Powell), Mandy Randolph (Liza Freeman), Trixie Smith (Lucy), Nat Reed (Sammy), Sammy Gardiner (Taylor), Columbus Jackson (A Hustler), George R. Taylor (Theatrical Backer), Trumpet Player (Doli Armena), Tyler Twins (Tap Dancers), Muscle Dancer (Consuelo Harris), Leon Gross and his Orchestra.

> *"The night life scenes are set in bright and flashing style, with colorful clubs and glamorous girls. The film at no time spares the stark and realistic side of life, bringing a vivid picture of a woman who loves not too wisely—but too well. Her unfaithful man is portrayed in every sordid trait. Seldom has a production with this compelling human interest power carried such a lighter side."*

> *The Afro-American* (Baltimore), October 1, 1938

GOD'S STEPCHILDREN*
As writer, director, and producer.
Sc: Based on Micheaux's and Alice B. Russell's unpublished story "Naomi, Negress"
Ph: Lester Lang. Ed: Patricia Rooney, Leonard Weiss. Sound: Ed Fenton, Nelson H. Minnerly, E. A. Schabbehor, George Wicke. Music: Leon Gross. (Produced by A. Burton Russell for Micheaux Productions)

Cast: Alice B. Russell (Mrs. James Saunders), Trixie Smith (visitor), Jacqueline Lewis (Naomi, as a child), Charles Thompson (Jimmie, as a child), Ethel Moses (Mrs. Cushinberry, the teacher/Eva, her daughter), Carman Newsome (Jimmie, as an adult), Gloria Press (Naomi, as an adult), Alex Lovejoy (Cowper, a gambler), Columbus Jackson (hustler), Laura Bowman (Aunt Carrie), Sam Patterson (banker), Charles Moore (Superintendent of Schools), Cherokee Thornton (Clyde Wade), Consuelo Harris (muscle dancer), Tyler Twins (tap dancers), Sammy Gardiner (tap dancer), Leon Gross and his Orchestra.

> *"For viewers inclined to dislike Micheaux's style, disagree with his ideology, or distrust his loyalty and character, this film might cinch the case; yet for viewers who celebrate or can get beyond his unorthodox, insouciant, and improvisatory style; who support his ideology (or find it at least reasonable); and who respect his integrity and his character, this film may be his best. It is certainly one of his most fascinating."*

> J. Ronald Green, *With a Crooked Stick— The Films of Oscar Micheaux*

BIRTHRIGHT*
As writer, director, and producer.
Sc: Based on the T. S. Stribling novel.
Ph: Robert Marshall. Sound: George Wickmer, Wickmer Noiseless Recording. (Produced by A. Burton Russell for Micheaux Productions)

Cast: Carman Newsome (Peter Siner), Alex Lovejoy (Tump Pack), Trixie Smith (Caroline Siner), Ethel Moses (Cissie Dildine), Hazel Diaz (Ida May), C. R. Chase (Henry Hooker), Herbert E. Jelly (Sheriff Dawson Bobbs), Alice B. Russell (Nan Berry), Har-

lan Knight (Tomwit), Ida Forsyne (Old Rose), George E. Lessey (Captain Renfrew), Harry Moses (Dr. Jallup), Robert Alderdice (Sam Awkright), John Ward, Columbus Jackson, Tom Dillon, Allen Lee, Leon Gross and his Orchestra.

> *"A very unusual film of colored life. Some patrons who have seen it have praised it for its frankness, while others have said that it is too daring a subject that should not be brought to the screen."*
>
> Philadelphia Afro-American, March 11, 1939

1939

LYING LIPS*

As writer, director, and producer.
Sc: Based on Micheaux's unpublished story "The Story of Elsie Bellwood."
Ph: Lester Lang. Ed: Leonard Weiss. Dialogue Dir: John Kollin.
Night Club Sequences: Charlie Davis. Musical Dir: Jack Shilkret.
Recording: Nelson H. Minnerly.
(Alfred N. Sack Presents for Sack Amusement Enterprises)

Cast: Edna Mae Harris (Elsie Bellwood), Carman Newsome (Benjamen Hadnott), Robert Earl Jones (Detective Wanzer), Frances Williams (Elizabeth Landry Green), Cherokee Thornton (John Landry), Slim Thompson (Clyde Landry), Gladys Williams (Aunt Josephine), Juano Hernandez (Rev. Henry Bryson), Henry 'Gong' Gines (Ned Green), Don DeLeo (Farina), Charles LaTorre (Garotti), Robert Paquin (District Attorney), George Reynolds (Lt. Donovan), Amanda Randolph (Jail Matron), Teddy Hale (Young Boy), Frank Costello, J. Lewis Johnson.

> *"It's about a beautiful girl who is led astray because she wants beautiful things . . . You see, I am trying to build up the morals of my race."*
>
> Colonel Hubert Fauntleroy Julian, Time magazine, January 28, 1940

1940

THE NOTORIOUS ELINOR LEE*

As writer, director, and producer.
Associate Producer: Hubert Julian. Ph: Lester Lang. Ed: Leonard Weiss.
Recording: Nelson Minnerly. Dialogue Dir: John Kollin. Music: Jack Shilkret.
Songs: Sally Gooding, Ellen May Waters.
(Alfred N. Sack Presents for Sack Amusement Enterprises)

Cast: Gladys Williams (Elinor Lee), Robert Earl Jones (Benny Blue), Carman Newsome (Norman Haywood), Edna Mae Harris (Fredi Welsh), Vera Burrelle (Sherry Johnson), Eddie Lemons (Brownlee), Columbus Jackson (Cracker Johnson), Laura Bowman (Benny's Mother), Madeline Donagan (Mary), Amanda Randolph (Mary's Mother), Robert Paquin (Reporter), O. W. Polk (Blakely), Charles LaTorre (Farbacher), Don DeLeo (Feretti), Abe Simon (Hererra), Sandy McDonald (Bradley), Harry Kadison (Max Wagner), Lew Hearn (Joe Grim), Jack Effrat (Chief Reporter), Harry Ballou (Announcer), Sam Taub (Commentator), Lew Goldberg (Referee),

Juano Hernandez (John Arthur), "Rubberneck" Holmes and Ralph Brown (dancers), Frances Williams, Kenn Freeman, Sally Gooding, Ellen May Waters, with Fred Palmer and his Orchestra.

> *"Benny Blue's win is not just a 'class act,' it is a successful class action by the best elements of the black community, and it results in class advancement on a broad front. The still-long-overdue need for African-American economic progress on a broad front is, of course, what Martin Luther King, Jr. was forcing upon the national agenda when he was assassinated a quarter-century later; Micheaux's portrayal of economic rights as inseparable from the praxis of civil rights was right on target."*

<div align="right">

J. Ronald Green, *With a Crooked Stick—*
The Films of Oscar Micheaux

</div>

1947

THE BETRAYAL

As writer, director, and producer.

Sc: Based on Micheaux's novel *The Wind from Nowhere*.

Ph: Marvin Spoor.

Cast: Leroy Collins (Martin Eden), Myra Stanton (Deborah Stewart), Verlie Cowan (Linda Lee), Harris Gaines (Dr. Lee), Yvonne Machen (Terry Lee), Alice B. Russell (Mary Lee), William Byrd (Jack Stewart), Frances De Young (Hattie Bowles), Arthur McCool (Joe Bowles), Vernon Duncan (Duval), David Jones (Crook), Edward Fraction (Nelson Boudreaux), Lou Vernon (Ned Washington), Vernetties Moore (Eunice), Jesse Johnson (Preble), Barbara Lee (Jessie Brooks), Gladys Williams (Mrs. Dewey), Richard Lawrence, David Jones, Curley Ellison, Sue McBride.

> *"There before her at last stood grandpa Boudreaux, the first time she'd ever seen him—and she was shocked! For he was a—colored man! She realized in that moment then, that she was not a white girl—and never had been; that she was colored too, colored—just like him!"*

<div align="right">

Newspaper advertisement for *The Betrayal* at the
Bill Robinson Theatre, Forty-third and Central,
Los Angeles Sentinel, November 24, 1949

</div>

ACKNOWLEDGMENTS

Any book about Oscar Micheaux or race cinema or the history of African-Americans in Hollywood must begin, somewhat defensively, with an explanation of the skin-color terminology of the past. This issue is especially relevant to Micheaux, as in his films he belittles clear-cut identification (or categorizations) of race. He himself used a variety of terms, sometimes even wielding the n-word in his scripts and being attacked for it. One hundred years ago, when Micheaux was entering manhood, "black people" (a common phrase today) didn't call themselves "black people." Some people of African or slave descent called themselves "Ethiopians" or "Abyssinians." Already there was a vigorous debate over whether the best progressive term was "colored" or "Negro," or "negro" with a small *n*, which Micheaux favored in his earliest novels. (I have tried to preserve his spellings as well as his varying terminology.)

A single passage from the autobiography of famed bandleader Cab Calloway, roughly Micheaux's contemporary, illustrates the problem and contradictions. "Our people were colored or Negro, never black," mused the fair-skinned Calloway in *Of Minnie the Moocher and Me* (coauthored with Bryant Rollins and published by Crowell in 1976). "To call somebody black was an insult; and, of course, to call me black, light-skinned as I was, was a triple insult . . .

"Even black people have given me a hard way to go sometimes. They've called me dirty yeller and poor white. That went on for years in the thirties and forties. Some people were bothered bcause they couldn't classify me easily; they thought I was Cuban or Puerto Rican. It's a horrible thing when people want to classify you or resort to name calling, but I've come through it because I've always known . . . hell, I'm a nigger and proud of it."

All these terms crop up in my book. I have done my best to keep true to Micheaux's vernacular, or the language of the times in context, and I apologize in advance to anyone who prefers contemporary expressions. To some extent, this is a continuing debate, and even "African-American" is questioned nowadays by people without clear or direct African ancestry.

Also, any book about Oscar Micheaux must begin by paying tribute to the authors and scholars who have gone before. This book stands on their shoulders. Alphabetically the list would begin with "Bowser, Pearl," whose research, many articles, public appearances, interviews, several books, and documentary film have led the reappraisal of Micheaux's life and work; she was honored with the Jean Mitry Award for her role in the rediscovery of Micheaux by the world's silent film community at the annual *Le Giornate del Cinema Muto* in Sacile, Italy, in 2001. This book couldn't have been written without the benefit of Bowser's oral history interviews with Elton Fax, Shingzie Howard, Carlton Moss, and Edna Mae Harris. I was privileged to meet her, hear her speak about Micheaux, and gain her trust and encouragement. Others, especially the members of the Oscar Micheaux Society, whose published works I have cited, have dug into many facets of Micheaux's life, and spread appreciation of his work.

In previous accounts of his career, Micheaux's silent film work has attracted the most attention, and two earlier biographies had understandable limitations. When Micheaux died in 1951, he left no archives of his papers, not having access to the privilege extended to most important Hollywood directors (whose professional files were generally compiled and preserved by the studio system from which Micheaux was barred). Anyone who knew Micheaux well and who wasn't quite out of their teens at the time of his death would now be in their late seventies. I've never done fewer primary-source interviews for a book. But the first one—with Leroy Collins—was substantive: Micheaux had been on my list of possible subjects for a long while when, out of the blue, Martin J. Keenan—a Micheaux champion who lives in Great Bend, Kansas—called and urged me to get off my duff and get down to Chicago to talk to Leroy Collins, the star of *The Betrayal,* Micheaux's last motion picture. That is what I did, and publishing that interview was my first step toward this project. (Collins was an invaluable resource throughout the job.) Still, Keenan wouldn't leave me alone; he talked my ear off (by phone, e-mail, and letter), insisting that I proceed with a full-fledged biography.

When I wasn't traveling to places where Micheaux lived, I spent my time reading other people's articles and books; communicating with archivists and librarians in cities where Micheaux had lived or worked; searching out land deeds, court records, and government documents; and reading on microfilm the muzzy print of the black press of Micheaux's era. Many people warned me, "A biography of Micheaux is impossible. He was too much of a liar. Too secretive. There aren't enough records." That challenge intrigued me. I did my best to double-check and honor the earlier research. I focused on gaps and did my utmost to contribute some modest discoveries. I made guesses here and there (it is surely impossible to reconstruct accurately the actual sequence of production and release, much less a precise filmography, for Micheaux). Of course, I always have my own ideas, my own preoccupations, and point of view. In the end I lined up everything chronologically and tried to understand the "life" and tell the "story." I hope it winds up as Micheaux would have liked, with a strong plot, a meritorious theme, at least one true woman, and a strong-jawed hero overdue for acclaim.

Thank you Matthew Bernstein, Pearl Bowser, Leroy Collins, J. Ronald Green, Karen P. Neuforth, Jacqueline Najuna Stewart, Betti Carol VanEpps-Taylor, and Dana F. White for reading the work-in-progress and making sharp criticisms and worthwhile suggestions. Of course, no one but myself is to blame for any errors of fact or interpretation.

SOURCES

INTERVIEWS: Leroy Collins, Jesse Johnson, Myra Stanton Miller, Haskell Wexler.

CORRESPONDENCE, ADVICE, AND ENCOURAGEMENT: Robin Bachin, Ed Barnettt, John Baxter, Stephen J. Bourne, Pearl Bowser, Martha Boyle, R. L. Burns, William Cahill, Earl Calloway, Thomas Cripps, James Curtis, Duane DeJoie, Scott Eyman, Paul Fellows, Kathryn Frye, Jane Gaines, Charles Hensey, Stephen Goldfarb, J. Ronald Green, Richard Grupenhoff, James V. Hatch, Charles Higham, Val Holley, Martha Hunter, Helen Imburgia, Martin J. Keenan, Richard Koszarski, Jerren Lamb, Julius Lester, Anne Martin, Fern McBride, Joseph McBride, Grace McLain, Joe Mosbrook, Charles Musser, Karen P. Neuforth, Richard Papousek, James Robert Parish, Richard Porton, Marty Rubin, Nat Segaloff, Anthony Slide, Jacqueline Najuma Stewart, Peter "Hopper" Stone, Michael Tapper, Sister Francesca Thompson, David Thomson, Lawrence Toppman, Richard Vacca, Dana F. White, Allen Woll.

ESPECIALLY: Matthew Bernstein, who stayed loyal and responsive to my every query; and Alice Veren, who coaxed me to visit South Dakota and the Micheaux Film Festival.

RESEARCH ASSISTANCE: Brigitte Burkett, Richmond, Va.; Alfred Patton Davidson, York, Penn.; Bill Fagelson, Austin, Tx. and New York; Sherry Foresman, Des Moines, Ia.; Will Gartside, Madison, Wis.; Elizabeth A. Lane, Atchison, Kans.; Mary Troath, London, U.K.; Sam West, Lumberton, N.C.

ESPECIALLY: Regula Ehrlich, who "covered" New Jersey, helping to fill in my portrait of Alice B. Russell—every bit as elusive as Micheaux—and offering her insights as well as research.

SCRIPTS AND SCREENINGS: Pearl Bowser; The Micheaux Film Festival, Gregory, South Dakota; Motion Picture Commission Scripts and Censorship Files, New York State Archives, Albany, New York; Scott McGee, Turner Broadcasting System; *Lying Lips* courtesy of the Kenn Freeman papers, Schomburg Center for Reseach in Black Culture, New York Public Library.

ARCHIVES AND ORGANIZATIONS: *Alabama*: Yvonne Crumpler, Birmingham Public Library; *California*: Octavio Olvera, George P. Johnson Negro Film Collection, Department of Special Collections, Charles E. Young Research Library, University of California at Los Angeles (UCLA); Alva Moore Stevenson, UCLA Oral History Program; Denise Meyer, Contra Costa Public Library; *Delaware*: Sandi Pisarski, Delaware Division of Corporations, Dover; Renee Gimski, Wilmington Public Library; *Washington D.C.*: Jean Currie Church, Chief Librarian, and Joellen ElBashir, Curator of Manuscripts, Moorland-Spingarn Research Center, Howard University; George Diez,

Archives, Department of Education; Robert Ellis, Judicial Records, Old Military and Civil Records, National Archives and Records Administration (NARA); Richard Fusick and George R. Shaner, Old Military and Civil Records, Textual Archives Services Division, NARA; Maryellen Holley, Executive Director, Washington Press Club Foundation; Washingtonian Division, Washington, D.C., Public Library; *Georgia*: William A. Montgomery, Georgia Local and Family History Department, Atlanta-Fulton Public Library, Ga.; *Illinois*: John Reinhardt, Supervisor, Inventory Control Section, Illinois State Archives; Pat Nunley, Illinois Regional Archives Depository, Special Collections, Morris Library, Southern Illinois University, Carbondale; Jan Miller, Carbondale Public Library; Martha Briggs and JoEllen Dickie, The Newberry Library, Chicago; Earl Calloway, *The Chicago Defender;* Yvette Richards, Archives, Clerk of the Circuit Court of Cook County, Richard J. Daley Center, Chicago; Jay Satterfield, Special Collections Research Center, University of Chicago Library; Microforms and Special Collections, The Chicago Public Library; "Ask a Librarian!", Chicago Public Library; Kathleen E. Bethel, African-American Studies Librarian, Northwestern University Library, Evanston; Sandra Barnhill and Lisa Monkman, Massac County Unit School District; Paul E. Fellows, Local Historian, Metropolis; Jackson County Historical Society; Marilyn Manning, Robinson Public Library, Robinson; Tom Huber, Map Librarian, Illinois State Library, Springfield; John Vincent Franch, Special Collections, University of Illinois, Urbana-Champaign; *Indiana*: Anthony Tedeschi, Richard E. Norman Collection, The Lily Library, University of Indiana, Bloomington; *Iowa*: Helen Dagley, Iowa State Library, Des Moines; Jeffrey L. Dawson, Iowa State Archives and Records Bureau, Iowa Department of Cultural Affairs; Rosie Springer, State Historical Society of Iowa, Des Moines; Bonnie Barkema, Stubbs Memorial Library, Holstein; David Mook, Sioux City Public Library, Sioux City; Grace E. Linden, Curator of History, Sioux City Public Museum; *Kansas*: Bev Schmeidler, Barton County Records Department, Barton County; Lori Hopp, Hutchinson Public Library; Dr. John A. Horner, Kansas City Public Library; *Louisiana*: E. J. Carter, East Baton Rouge Parish Library; Wayne Everard, New Orleans Public Library; Larry Foreman, Ouachita Parish Public Library, Monroe; P. F. Ferguson, Shreve Memorial Library; Dr. Orella Brazile, Southern University, Shreveport; *Maryland*: Daniel L. Shiffner, African-American Department, Enoch Pratt Free Library, Baltimore; John K. Vandereedt, Textual Archives Services Division, Records of the Freedman's Savings and Tust Company, NARA, College Park; Aaron McWilliams, Maryland State Archives; *Massachusetts*: John Joseph Devine Jr., Boston Public Library; *Missouri*: Patti Barsch, St. Joseph Public Library; Noel Holobeck, St. Louis Public Library; *Montana*: Terri Bakken and Catherine Carlisle, Public Records and Information Services, Bureau of Land Management, Montana State Office, Billings; *Nebraska*: Eric Bittner, Archivist, Bureau of Land Management; Bennett Martin Public Library, Lincoln; Dan Nieman, South Sioux City Library; *New Jersey*: Catherine S. Medich, Archivist, State of New Jersey; Robert W. Stewart, Asbury Park Public Library; Doris Murphy, Reference/Serials Librarian, New Jersey State Library, Trenton; *New York*: Joan Romano, Bureau of Resources, Department of Social Services, State of New York; Carey Stumm, Cataloguing and Research, American Museum of the Moving Image, Astoria; John Carter, Deputy Registrar, Columbia University; Steven G. Fullwood, Manuscripts, Archives, and Rare Books, Schomburg Center for Research in Black Culture, New York Public Library; Ruth A. Carr, Local History and Genealogy, New York Public Library; James B. Hatch, Hatch-Billops Collection, N.Y.C.; Jane

Klain, Museum of Broadcasting, N.Y.C.; Richard Gelbke, Archives Specialist, NARA, Northeast Region, N.Y.C.; Mary Welsh, New Rochelle Public Library; Glen Island Care Center (formerly Woodland Nursing Home), New Rochelle; George T. Davis Funeral Home, New Rochelle; Greenwood Union Cemetery, Rye; *North Carolina*: Sheila Bumgarner, Charlotte-Mecklenburg Public Library, Charlotte; Robert Johnson, the *Charlotte Post*; Lois D. Peterson, Clerk of Superior Court, Charlotte; Pat Taylor, Medical Records Department, Carolinas Medical Center, Charlotte; Lawrence Toppman, the *Charlotte Observer;* Marylyn L. Williams, Charlotte-Mecklenburg Police Department; Robeson County Public Library, Lumberton; Jane B. Hersch, Maxton Historical Society, Maxton; Information Services, State Library of North Carolina; *Ohio*: Anne Salsich, Western Reserve Historical Society Library and Archives, Cleveland; Evelyn M. Ward, Cleveland Public Library; John Ransom, Rutherford B. Hayes Presidential Center, Fremont; Gail D. Lash, Registrar, and Jacqueline Brown, Archives, Wilberforce University, Wilberforce; *Pennsylvania*: John J. Slonaker, Pennsylvania State Archives; Patrick Connelly, Archives Specialist, NARA, Philadelphia; *South Carolina*: Marianne Cawley, Charleston County Public Library, Charleston; Susan Thoms, Spartanburg County Public Libraries, Spartanburg; *South Dakota*: Marvene Riis, South Dakota State Historical Society Archives, Pierre; Clerk of Courts, Tripp and Todd counties; Kristi Kafka, South Dakota Oral History Center, Institute of American Indian Studies, University of South Dakota; *Tennessee*: Edwin J. Best Jr., Research Library, Tennessee Valley Authority, Knoxville; Danette Welch, Calvin M. McClung Historical Collection, Knox County Public Library System, Knoxville; Doris R. Martinson, Knox County Archives, East Tennessee Historical Center, Knoxville; Darla Brock, Archivist, Tennessee State Library, Nashville; *Texas*: Penny Clark, Tyrrell Historical Library, Beaumont; Carol Roark, Texas/Dallas History and Archives Division, Dallas Public Library; Lisa K. Meisch, Sam Houston Regional Library and Research Center, Liberty; Clarissa Chavira, San Antonio Public Library; *Virginia*: Motion Picture Censorship Board Records, Archives Research Services, The Library of Virginia, Richmond; Brenda A. Finley, Roanoke Public Library; *Wisconsin*: The Milwaukee Public Library; Angie Cope, American Geographical Society Library, Golda Meir Library, University of Wisconsin, Milwaukee; The University of Wisconsin Library, Madison; Wisconsin State Historical Society, Madison.

All along I heard reports that the *Chicago Defender* was going to be historically indexed electronically, and indeed, after the final draft of this book was completed, Chicago's black newspaper, from 1910–1975, was made available online by the Black Studies Center via ProQuest. I picked up addditional detail and information at the eleventh hour from this invaluable resource.

ESPECIALLY: Brenda Mizell of the Metropolis Public Library patiently responded to my endless questions, and guided me to people and places when I visited Micheaux's hometown. Finally, I couldn't have written this book without the resources and services of my home library at Marquette University. I would especially like to acknowledge the repeated assistance of the John P. Raynor Library Information Desk and Joan Sommer and her Interlibrary Loan staff.

It may seem a formality to thank my agent and editor, but Gloria Loomis has been representing me, staunchly, for as long as Calvert Morgan Jr. has been guiding and improving my books—going on twenty years.

And my family—my wife Tina, and three sons, Clancy, Bowie, and Sky—they are staunch, improving guides too.

CHAPTER NOTES

My sources were numerous, and often they were itty-bitty items from this or that local library (or George P. Johnson's files). My itemization is selective. The emphasis is on primary sources, especially quotations from Micheaux or his correspondence. I haven't noted all the many snippets from film reviews or columns (Charlene B. Regester's book keeps track of entertainment-related items in four leading African-American newspapers), and scholars in general are cited from their listed articles or books.

The following published works and produced films were indispensable. Whether or not they are mentioned in the text, I referred to them again and again. The authors of these books and other listed articles pioneered the research, influenced my thinking, and inspired my task. I recommend these books for anyone interested in deeply studying Micheaux's films.

BOOKS: Donald Bogle, *Toms, Coons, Mulattoes, Mammies and Bucks* (Viking, 1973); Pearl Bowser and Louise Spence, *Writing Himself Into History: Oscar Micheaux, His Silent Films, and His Audiences* (Rutgers University Press, 2000); Pearl Bowser, Jane Gaines, and Charles Musser, eds., *Oscar Micheaux & His Circle* (Indiana University Press, 2001); Thomas Cripps, *Slow Fade to Black: The Negro in American Film, 1900–1942* (Oxford University Press, 1977); Jane Gaines, *Fire and Desire: Mixed-Race Movies in the Silent Era* (University of Chicago Press, 2001); J. Ronald Green, *Straight Lick: The Cinema of Oscar Micheaux* (Indiana University Press, 2000); J. Ronald Green, *With a Crooked Stick—The Films of Oscar Micheaux* (Indiana University Press, 2004); Bernard L. Peterson, Jr., *Profiles of African-American Stage Performers and Theatre People, 1816–1960* (Greenwood Press, 2001); Mark Reid, *Redefining Black Film* (University of California Press, 1993); Charlene B. Regester, *Black Entertainers in African-American Newspaper Articles, Volume 1* (McFarland, 2002); Henry T. Sampson, *Blacks in Black and White: A Source Book on Black Films* (Scarecrow Press, 1995); Betti Carol VanEpps-Taylor, *Oscar Micheaux . . . Dakota Homesteader, Author, Pioneer Film Maker* (Dakota West, 1999); Earl James Young Jr., *The Life and Work of Oscar Micheaux* (KMT Publications, 2002).

DOCUMENTARY FILMS: *In Black & White* (writers, Russ Karel, Gordon Parks; director, Russ Karel, 1992); *Midnight Ramble* (writer, Clyde Taylor; directors, Bestor Cram and Pearl Bowser, 1994); *Oscar Micheaux: Film Pioneer* (Carol Munday Lawrence, writer and producer; director Robert N. Zagone, 1981).

CHAPTER ONE: 1884–1900

My portrait of Oscar Micheaux (OM) and his early life, up through chapter 8, relies heavily on his quasi-autobiographical novels: especially *The Conquest: The Story of a Negro Pioneer,* but also *The Forged Note, The Homesteader,* and *The Wind From Nowhere.* This may be an arguable approach, but again and again, cross-referencing the novels with my own research to compare and overlap his story with history and events (right down to incidental detail mentioned in passing), I found that his fictional versions conformed to the known facts.

Karen P. Neuforth of Great Bend, Kansas, is the acknowledged expert on OM's geneaology. I drew on her article "GENERATIONS: The Family and Ancestry of Oscar Micheaux," available on the excellent Micheaux website www.shorock.com— maintained by Don Shorock—and on findings that she is constantly updating. Right up to the end of my work she was correcting errors and assumptions and providing new detail. Her recent exhumation of OM's World War I draft registration records, for example, supplied not only another document to affirm the existence of "Sarah Micheaux," but also pinpointed the color of OM's eyes (brown).

It should be noted that an official birth certificate for OM has never been located, which is curious, considering that the births of other Micheaux children are registered on the county level in Illinois. I turned the pages of musty record books in the Massac County courthouse without finding his name in any variant spelling. (Remembering that OM was born the day after the New Year, perhaps his mother was visiting relatives in Kentucky over the Christmas holidays when she gave birth.) Indeed, his year of birth varies in early records. His WWI draft registration, for example, states that he was thirty-eight in 1918, suggesting that he was born in 1880, not 1884. Some sources give his middle name as "Devereaux," but, to the best of my knowledge, that name does not appear on any known legal, government, or employment record.

"Could quote profusely from [Booker T.] Washington . . ." is Carlton Moss (CM) from "Remembering Oscar Micheaux," Souvenir Program, the 13th Black Annual Filmmakers Hall of Fame Oscar Micheaux Awards, 1986. Moss is quoted principally from this essay and Pearl Bowser's oral history, though he was also interviewed for Earl James Young Jr.'s book.

"Chocolate-colored" is from "Hollywood in the Bronx," *Time* (January 29, 1940). "His tongue was so red . . ." is Agnes Becker from the Institute of American Indian Studies, the South Dakota Oral History Project (June 18, 1973, interview by Steve Plummer). "A Negro . . . unmistable [sic: unmistakably] so" is George P. Johnson (GPJ) from one of the undated "Oscar Mitcheux" synopses among his voluminous papers.

Other articles and books: T. V. Glass, *Metropolis City Directory and Business Advertiser for Southern Illinois for 1870, With a Brief History of Metropolis City* (Robert Clarke & Co.,1870); George W. May, *Historical Papers on Massac County, Illinois* (Turner, 1990); George W. May, *Massac Biographies* (Bookmasters, 1998); Robert L. McCaul, *The Black Struggle for Public Schooling in Nineteenth-Century Illinois* (Southern Illinois University Press, 1987); Claude F. Oubre, *Forty Acres and a Mule: The Freedmen's Bureau and Black Land Ownership* (Louisana State University Press, 1978); O. J. Page, *History of Massac County, Illinois, With Life Sketches and Portraits* (Journal-Republican, 1900); O. J. Page, Superintendent, "Read, Reflect, Preserve. Metropolis High School

Course of Study, 1896–97" (Journal-Republican, 1896); Edgar F. Raines, "The Ku Klux Klan in Illinois, 1867–1875," *Illinois Historical Journal* (Vol. 78, No. 1, 1985); Joshua M. Reynolds, County Superintendent, "1899 Annual Report of the Condition of the Common Schools in the County of Massac."

CHAPTER TWO: 1900–1904

The Pullman Company archives are on deposit at the Newberry Library in Chicago. The librarians seemed faintly amused at my hope that I might stumble upon OM's ancient personnel records—the proverbial needle in a haystack of microfilm—but luck was with me. I am grateful to Martha Briggs of the library for helping to interpret the sometimes obscure company notations.

Other articles and books: Robin F. Bachin, *Building the South Side: Urban Space and Civic Culture in Chicago, 1890–1919* (University of Chicago Press, 2004); St. Clair Drake, *Black Metropolis* (Harcourt, 1945); Glen E. Holt and Dominic A. Pacyga, *Chicago: A Historical Guide to the Neighborhoods* (Chicago Historical Society, 1979); Jack Santino, *Miles of Smiles, Years of Struggle* (University of Illinois Press, 1989).

CHAPTER THREE: 1904–1906

Much of the hard grind of perusing vintage Gregory and Tripp counties newspapers and microfilm, pinpointing mention of OM, and correlating his homesteading experiences with local events and citizens was done for earlier papers, articles, or books by South Dakota historians and Micheaux scholars, including (among others) Lee Arlie Barry, Leathern Dorsey, Chester J. Fontenot Jr., Richard Papousek, Betti Carol VanEpps-Taylor, and Joseph Young.

VanEpps-Taylor's exceptional 1991 biography of the race-picture pioneer, which concentrates on the prefilm years and especially on the South Dakota period of OM's life, broke all kinds of ground in terms of sources and background. As for groundbreaking, literally, I would know very little about different kinds of soil, blades, plows, or horses, without the benefit of her book. I also drew from her supplemental paper "A View from the Catbird Seat: Oscar Micheaux and the Opening of the Rosebud," delivered at the Oscar Micheaux Film Fesitval in 2004, where I had the pleasure of meeting VanEpps-Taylor. We kept in touch, and she was gracious enough to read drafts of early chapters of this book, offering pointers.

All land data and description of OM's South Dakota holdings comes from Department of the Interior records held by the National Archives and Records Administration.

"The soil of these plains . . ." is Lewis and Clark as quoted in Doane Robinson's informative *A Brief History of South Dakota* (American Book Company, 1905).

As far as I know, there is no book on the Jackson patriarch—onetime Iowa governor Frank D. Jackson—or his three sons. But the Jackson brothers turn up in many South Dakota chronicles, including the ones listed here; my account of the Jacksons, especially Ernest Jackson, as their lives overlapped OM's, is patched together from the South Dakota histories listed here and scattered newspaper items. I learned about

Marvin Hughitt from H. Roger Grant's article in *The Encylopedia of American Business History and Biography* (Keith L. Bryant Jr., ed., Facts on File, 1988).

"You can't find a better metaphor . . ." is Don Coonen from a letter quoted in Janis Hebert's excellent "Oscar Micheaux: A Black Pioneer," *South Dakota Review* (Winter 1973–74).

Other articles and books: Opie Chambers, "The Early History of Rosebud County," *A Rosebud Review* (July 1984); "Dallas, South Dakota: The End of the Line," which includes "Oscar Micheaux" by Lee Arlie Barry (Dallas Historical Society, 1977); Arlene Elder, "Oscar Micheaux: The Melting Pot on the Plains," *The Old Northwest* (September 1976); *The Gregory Advocate*, "Special 2004 Double Issue: The First Hundred Years," Number One: 1904–1914, and Number Two: 1915–1924; Adeline S. Gnirk, *The Saga of Ponca Land* (Gregory County Historical Society, 1979); *The History of Tripp County, South Dakota* (Pine Hill Press, 1984); Ried Holien, "The Homesteader," *South Dakota Magazine* (July/August 1998) F. H. Jackson, "Homesteading on the Rosebud," *A Rosebud Review* (July 1984); Gladys Whitehorn Jorgensen, *Before Homesteads in Tripp County and The Rosebud* (Pine Hill Press, 1974); Paula M. Nelson, *After the West Was Won: Homesteaders and Town Buildiers in Western South Dakota, 1900–1917* (University of Iowa Press, 1986); "Tripp County, South Dakota, 1909–1984, Diamond Jubilee" (Pine Hill Press, 1984).

CHAPTER FOUR: 1906–1908

"He'd say 'Nope', he wouldn't . . ." is Dick Siler from the Institute of American Indian Studies, the South Dakota Oral History Project (July 27, 1973, interview by Steve Pummer). "Eight horses pulling . . ." is Don Coonen from *South Dakota Review*.

CHAPTER FIVE: 1908–1909

"Colorful character . . . etc.," the anecdotes about OM's grandmother and sister, are credited in a footnote of VanEpps-Taylor's biography to an item in the *Gregory Times Advocate* (January 20, 1910), from a paper presented by Richard Papousek at the 1998 Micheaux Film Festival.

OM'S "WHERE THE NEGRO FAILS . . ." is on the front page of the *Chicago Defender* (March 19, 1910). This is the first conspicuous public use of the spelling "Micheaux," which the entire family also adopted around this time. When the *Gregory Times Advocate* reported Micheaux's marriage, just a month later (see chapter 6), it used the new spelling. There are any number of possible explanations: "Micheaux" may have been the correct spelling all along, for example, but simply misspelled by indifferent white record-keepers; or it's also possible that the family had talked it over and decided to agree on a new spelling, which harked back either to forebears or its slaveholding past. This is one of many mysteries about Micheaux that persists. In any case, it seems clear he added the *e*, and adopted the new spelling, while a homesteader in 1910.

The *Chicago Defender* reported the marriage of OM and "Miss Orlean Mc-Cracken, daughter of Elder McCracken" on April 23, 1910.

For background on the *Chicago Defender* and its publisher I referred to Roi Ottley's *The Lonely Warrior: The Life and Times of Robert S. Abbott* (Regnery, 1955).

For Lew Dockstader and minstrelsy I consulted John Strausbaugh's thoughtful

Black Like You: Blackface, Whiteface, Insult & Imagination in American Popular Culture (Jeremy P. Tarcher/Penguin, 2006).

CHAPTER SIX: 1909–1912

"A happy journey . . ." is from the *Gregory Times Advocate* (April 27, 1910). "MR. OSCAR MICHEAUX IN CITY . . ." is from the front page of the *Chicago Defender* (April 29, 1911), and "COLORED AMERICANS TOO SLOW . . ." is from the front page of the *Defender* (October 28, 1911).

For background on Dr. U. G. Dailey, I read *The Scholar and the Scalpel: The Life Story of Ulysses Grant Dailey* by Donald Preston (Afro-Am Publishing, 1966).

CHAPTER SEVEN: 1912–1914

"I personally wrote the Chapter V . . . etc.," is from "an original copy of the first printing of *The Conquest,*" in the possession of Micheaux Film Festival founder Richard Papousek, according to a footnote in *With a Crooked Stick—The Films of Oscar Micheaux.*

For background on the Woodruff Press I consulted the book compiled by the Nebraska Writers' Project, *Printing Comes to Lincoln* (Woodruff Printing, 1940).

"Meeting with great success . . ." and "Heartily recommend it . . ." are from the *Gregory Times Advocate* (April 3, 1913). "A few advance copies . . ." and "The book has had a wonderful [advance] sale . . ." are from the *Gregory Times Advocate* (April 9, 1913). "Oscar, accept our congratulations" is from the *Dallas News* (December 12, 1912). "The book is entitled *The Conquest* . . ." is from the *Gregory Times* (March 20, 1913).

"My folks knew him and liked him . . ." is Merrit Hull of Crane, Montana, from a letter to the editor in the October-November 1966 *Frontier Times.*

"REV. M'CRACKEN SUED FOR $10,000 . . ." is from the front page of the *Chicago Defender* (August 2, 1913). "Patrons jumped up and shouted . . ." is from "Foster's R. R. Porter" in the *Chicago Defender* (November 22, 1913). "The distribution and sales operation . . ." is from *With a Crooked Stick—The Films of Oscar Micheaux.*

Dana F. White graciously shared his paper "Oscar Micheaux's Atlanta Connections," written for the Society for Cinema and Media Studios, March 4, 2004, and then answered my follow-up questions about OM's purported stay in Atlanta. For information and perspective on the "Leo Frank films" (*The Gunsaulus Mystery* and *Lem Hawkins' Confession*) I relied heavily on Matthew Bernstein's "Oscar Micheaux and Leo Frank: Cinematic Justice Across the Color Line" from *Film Quarterly* (Summer 2004). Bernstein has updated his research and analysis for his book *They Haven't Forgot: Leo Frank on Screen* (University of Georgia Press, 2007). I also cited from "'Is the Jew a White Man?': Press Reaction to the Leo Frank Case, 1913–1915" by Eugene Levy in *Strangers and Neighbors: Relations Between Blacks and Jews in the United States,* Maurianne Adams and John Bracey, eds. (University of Massachusetts Press, 1999). Although I consulted many factual sources on the Leo Frank case, I fell back repeatedly on Steve Oney's comprehensive *And the Dead Shall Rise: The Murder of Mary Phagan and the Lynching of Leo Frank* (Pantheon, 2003).

CHAPTER EIGHT: 1914–1918

"We are always caricatured . . ." is from OM's article "The Negro and the Photo-Play" in *The Half-Century Magazine* (May 1919). "Certainly aware" and "Of the repeated calls . . ." are from J. Ronald Green's "Micheaux v. Griffith" in *Griffithiana* (October 1997).

"The injection of the white girl who in the end . . ." is from OM's June 25, 1918, letter to the Lincoln Motion Picture Company which, like all his correspondence to the Lincoln company or its representatives (including the Johnson brothers and Clarence Brooks), is part of the George P. Johnson (GPJ) collection. That collection also includes numerous clippings and press material and memorabilia pertaining to OM, or race films in general, which provided rich background and detail for this book. GPJ himself considered writing a book about OM, and there are synopses for this project among his papers, including differing versions of the one titled "Oscar Mitcheux."

The death of Orlean McCracken was reported on the front page of the *Chicago Defender* (August 18, 1917). Circumstances of the deaths of Veatrice and Bell Gough Micheaux were described by Karen P. Neuforth in her "GENERATIONS" genealogy.

"The first Negro postal clerk . . ." and "As a side issue . . . showing the Lincoln films . . ." are from GPJ's oral history transcript, which is part of the UCLA collection.

"Limited to 3 reels, whereas I am sure . . ." is from OM's May 13, 1918, letter to the Lincoln Motion Picture Company. "A perfect set-up for my brother . . ." is GPJ in "Oscar Mitcheux." "The incidents seemed most natural to him . . . ," "The only Ethiopian . . . ," and "To treat of the inter-marriage . . . etc.," are from GPJ's May 31, 1918, letter to OM. "I agree with you . . . ," "Assist in general with the direction . . . ," "the evil N. Justine McCarthy," "You might write your brother . . ." and "To do this, of course, will require time . . ." are from OM's June 3, 1918, letter to GPJ and the Lincoln Motion Picture Company. "Most of your plays were written . . ." is from OM's June 25, 1918, letter to the Lincoln Motion Picture Company.

"The heart of the Colored population . . ." is from "The Negro and the Photo-Play."

"Join forces" and "Into a Negro film . . ." are from "Oscar Mitcheux." "Expect to send my wife to her home . . ." is from OM's June 9, 1918, letter to GPJ and the Lincoln Motion Picture Company. "Because Micheaux not only had no [film] experience . . ." and "The film bug" are from "Oscar Mitcheux." "Saw Johnson kill a dozen . . ." is from OM's June 9, 1918, letter to GPJ. "Have you had any word from Noble . . ." and "I have been soliciting subscriptions to the capital stock . . ." are from OM's August 11, 1918 letter to Clarence Brooks (CB). "The hero in this production . . . ," "I feel I can collect more complete talent . . . ," and "Although Sioux City is mentioned as the office city . . ." are from an undated letter from OM to GPJ.

OM's company prospectus and earliest publicity material are in the GPJ collection. "Two weeks, this I will perhaps write . . . ," "It is necessary to get these scenes . . . ," and "Since Ringling Bro's [sic] will be here . . ." are from OM's August 11, 1918, letter to CB.

Background on the Pekin Theatre was culled from programs and clippings in Special Collections at the Chicago Public Library, but the Pekin Players have also been written about extensively in other key sources listed for this book. For background in general on early African-American theater and film in Chicago I referred to Jacqueline

Najuma Stewart's excellent *Migration to the Movies: Cinema and Black Urban Modernity* (University of California Press, 2005). Jerry Mills "is well versed in the theatricals . . ." is from OM's September 15, 1918, letter to CB. The early participation of Mills and William Dean Foster in *The Homesteader* is mentioned in unsourced clippings in the GJP collection. "Sweet, tender, vivacious and clever" and OM's other comments on the casting of *The Homesteader* also come from his September 15, 1918, letter to CB.

My chief source on Evelyn Preer, Edward Thompson, and the Lafayette Players is the essays of Sister Francesca Thompson, including "The Lafayette Players, 1917–1932" from *The Theater of Black Americans* (Errol Hill ed., Applause Books, 1987); "From Shadows 'n Shufflin' to Spotlights and Cinema: The Lafayette Players, 1915–1932" in *Oscar Micheaux & His Circle*; and "Evelyn Preer: Early Dramatic Film and Stage Star" from *Black Masks* (July/August 2002). Sister Francesca also graciously answered my e-mail queries about her mother and father. I also consulted LeRoi Antoine's *Achievement: The Life of Laura Bowman* (Pageant Press, 1961), the closest thing to a memoir by one of the Lafayette Players. (Bowman, along with her husband Sidney Kirkpatrick, also acted in Micheaux films.)

Other articles and books: Alex Albright, "Micheaux, Vaudeville & Black Cast Film," *Black Film Review* (Vol. 7, Issue 4); Arnie Bernstein, *Hollywood on Lake Michigan: 100 Years of Chicago and the Movies* (Lake Claremont Press, 1993); Douglas Gomery, *Shared Pleasures: A History of Movie Presentation in the United States* (University of Wisconsin Press, 1992); Daniel J. Leab, *From Sambo to Superspade: The Black Experience in Motion Pictures* (Houghton Mifflin, 1976); Richard Schickel, *D. W. Griffith: A Life* (Simon and Schuster, 1984); *Simms' Blue Book and National Negro Business and Professional Directory* (J. N. Simms, 1923); Anthony Slide, *American Racist* (University Press of Kentucky, 2004).

CHAPTER NINE: 1919–1921

The "A Good Old Darkey" anecdote is from "The Negro and The Photo-Play."

To learn about Chicago's race riot during the summer of 1919, I consulted the Chicago Commission on Race Relations, *The Negro in Chicago* (University of Chicago Press, 1922).

Corey K. Creekmur ("The only black character . . .") is quoted from "Telling White Lies: Oscar Micheaux and Charles W. Chesnutt" in *Oscar Micheaux & His Circle*. Besides decoding and analyzing *Within Our Gates,* this essay delves deeply into the connections between OM and author Charles W. Chesnutt, the films made by OM from CWC's fiction, and the relationship between the Micheaux film version and the Rhinelander divorce case.

"More versatile than any girl . . ." is OM quoted in "Death of a Famous Actress a Shock to New York Friends" from the *New York Age* (November 26, 1932). All quotes from Evelyn Preer ("This scene I consider the best . . . , etc.") are culled from her series of first-person articles in the June 11, 18, and 25, 1927, *Pittsburgh Courier.*

"You did not take enough of the second reel [of *Within Our Gates*] out . . ." is from GPJ's August 10, 1920, letter to OM. "It is true that our people do not care . . ." is from OM's August 14, 1920, reply to GJP. "A very dangerous picture . . ." is from a police captain's March 19, 1920, letter to a Superintendent of Police in New Orleans, part

of the GPJ collection. "The picture is a quivering tongue of fire . . ." is from Chicago schoolteacher Willis N. Huggins's letter to the *Chicago Defender* (January 17, 1920). I quote Pearl Bowser in this chapter partly from her e-mail correspondence to me about *Within Our Gates*.

"Of finish and high aspiration" and "Race filmdom" are from an October 6, 1920, letter to GPJ from the Micheaux Film Company (unsigned). "Has made nothing for himself . . ." is from GPJ's July 19, 1920, letter to Robert L. Vann (RLV), marked "confidential." "Produced at a loss . . ." is from GPJ's March 27, 1920, letter to RLV. "I know and you know . . ." is GPJ to OM from an undated letter in the Johnson collection.

"I am expecting phenomenal business . . ." is from OM's August 14, 1920, letter to GPJ. "Stack them out" and "We opened in New York City . . ." are from Swan E. Micheaux (SEM)'s September 17, 1920, letter to GPJ.

Lester A. Walton wrote about *The Brute* in the *New York Age* (September 18, 1920) and Sylvester Russell wrote about *The Brute* in the *Indianapolis Freeman* (August 28, 1920).

"He probably regretted that decision . . ." is from the chapter on *The Symbol of the Unconquered* in *With a Crooked Stick—The Films of Oscar Micheaux*. "Of the Micheaux films that have survived . . ." is from Arthur Knight's *Disintegrating the Musical: Black Performance and American Musical Film* (Duke University Press, 2002). "A film dramatically different . . ." is from Jane Gaines, "Within Our Gates: From Race Melodrama to Opportunity Narrative," *Oscar Micheaux & His Circle*. "Moving pictures have become one . . ." is from OM's address as quoted in *The Competitor* (January–February, 1921).

Other articles and books: Mary Carbine, " 'The Finest Outside the Loop': Motion Picture Exhibition in Chicago's Black Metropolis, 1905–1928," included in *Silent Film* (Richard Abel, ed., Rutgers University Press, 1996); Anna Everett, *Returning the Gaze: A Geneaology of Black Film Criticism, 1909–1949* (Duke University Press, 2001); Jane Gaines, *"The Birth of a Nation* and *Within Our Gates:* Two Tales of the American South," from *Dixie Debates: Perspectives on Southern Cultures,* (Richard H. King and Helen Taylor, eds., Pluto Press, 1996); Wallace Thurman, *Negro Life in New York's Harlem* (Haldeman-Julius Publications, 1928).

CHAPTER TEN: 1921–1922

"By no means a comparison . . ." is from GPJ's December 30, 1927, letter to C. Boney.

All the Micheaux-Richard E. Norman (REN) correspondence is from the Norman Collection at the University of Indiana. "Some Jews," "Appears to draw [audiences] very well . . . ," "We could help them a great deal . . . ," and footnote ("To the use of . . .") are from OM's August 7, 1926, letter to REN.

All the Micheaux-Chesnutt correspondence is from the Charles W. Chesnutt (CWC) collection at the Western Reserve Historical Society in Cleveland. (Some but not all of these letters appear in *Letters of Charles W. Chesnutt, 1906–1932,* edited by Jesse S. Crisler, Robert C. Leitz II, and Joseph R. McElrath Jr., Stanford University Press, 2002).

"A mature gentleman . . ." is from OM's January 29, 1921, letter to CWC. "Mine own people" and "Like myself . . ." and "My favorite child" are from CWC's June 16, 1930, letter to John Chamberlain, intended for publication in *The Bookman*.

"Any story that deals with the relation . . . ," "In the last few years . . . ," "Understand me . . . ," "This is a very strong start . . . ," "Would require a great many people . . . ," "Shortly after the Civil War . . . ," "I would make the man Frank . . . ," "Colored people whom we must depend . . . ," "Visualize just how . . . ," "Stronger, and while good . . . ," and "Out of the theater with this story . . . ," are from OM's January 18, 1921, letter to CWC.

"I have no doubt that you will make it . . ." is from CWC's January 27, 1921, letter to OM. "Better than nothing . . ." and "More or less, and probably change the emphasis . . . etc." are from CWC's January 20, 1921, letter to William B. Pratt of Houghton Mifflin. "It is not, when writing directly . . . ," "Run to conversation" and "Bear this in mind . . . , etc." are from OM's January 29, 1921, letter to CWC.

Details of the Atlanta censorship of *The Gunsaulus Mystery* come from Matthew Bernstein's "Oscar Micheaux and Leo Frank: Cinematic Justice Across the Color Line," which cites news items from the *Atlanta Journal* and *Atlanta Constitution.*

"I visited the theatre . . ." is from CWC's September 23, 1921, letter to SEM. "Depression in business . . . ," "Each month until . . . ," and "To go farther . . ." are from SEM's June 17, 1921, letter to CWC. The anecdote about Micheaux in Petersburg, Virginia, is from "Eject Movie Producer From Southern Cafe," *Chicago Defender* (May 21, 1921).

All the quotes and anecdotes from Elcora "Shingzie" Howard McClane come from Pearl Bowser's 1988 interview with the actress, which is part of the Museum of the Moving Image oral history collection. Howard is also interviewed in *Midnight Ramble*.

I am grateful to Roanoke architect Ed Barnett for clippings and background on OM's filmmaking partners in Roanoke, especially the undated local news items about C. Tiffany Tolliver.

"We have been disappointed . . ." and "One or two of these . . ." are from SEM's September 19, 1921, letter to CWC. "Laid off six months . . ." and "Contemplated filming . . . etc." are from OM's October 30, 1921, letter to CWC. "Pressing obligations . . ." and "I will be very glad . . ." are from CWC's October 10, 1921, letter to SEM "As a whole, I prefer stories . . . ," "Write the case of the man and woman . . . ," and "In the next five years . . ." are from OM's October 30, 1921, letter to CWC. "Three of the best . . . etc." and "Succeeding so well . . ." are from OM's November 13, 1921, letter to CWC. "A couple of tropical productions . . ." is from OM's January 15, 1922, letter to CWC. "Owing to the hatred . . . etc." and "I am compelled to ask . . ." are from OM's February 28, 1922, letter to CWC.

D. Ireland Thomas's column about *The Dungeon* is in the *Chicago Defender* (July 8, 1922). "If you were [inordinately] black you couldn't get any work . . ." is Bee Freeman from "We Were Stars in Those Days," a lengthy feature article by Clinton Cox in the March 9, 1975, New York *Daily News Magazine.* "Personally edited . . ." is from Thomas's September 9, 1955, obituary in the Charleston, S.C., *News and Courier.*

"There are about 354 Negro theaters . . ." and "Opposition and petty jealousy" is REN as quoted in Matthew Bernstein and Dana F. White's " 'Scratching Around' in a 'Fit of Insanity': The Norman Film Manufacturing Company and the Race Film Business in the 1920s," in *Griffithiana* (May 1998).

"Pack them in" and "And the reason is . . ." are from REN's September 2, 1922, letter to his brother Bruce Norman (BN). "Chicago is a dead one" is OM as quoted in RN's September 2, 1922, letter. "Was not a Negro theater . . ." and "It is a hard propo-

sition . . ." are from REN's September 7, 1922, letter to BN. "Negro pictures have lost . . ." and "I am good and tired . . ." are from REN's September 10, 1922, letter to BN. "He was playing *The Dungeon* . . ." is from REN's September 15, 1922, letter to BN.

"Not make another bad deal . . ." is from D. Ireland Thomas's "Motion Picture News" column in the *Chicago Defender* (March 29, 1924). "One good releasing organization . . ." is from GPJ's March 1, 1922, letter to REN.

"The young white lover . . ." is from CWC's May 16, 1932, letter to his daughter Mrs. Ethel Chesnutt Williams. "The present day . . . ," "We are not financially able . . . ," and "In the meantime . . ." are from OM's October 7, 1922, letter to CWC.

Charlene B. Regester is an authority on Micheaux and censorship and has led the way in documenting his struggles with different state commissions. She has also written extensively about his financing and promotional strategies, especially regarding *The House Behind the Cedars* and the publicity tie-ins to the Rhinelander divorce case. While I explored censorship archives for my own biographical purposes, I repeatedly referred to information in her pioneering essays. They include "Black Films, White Censors: Oscar Micheaux Confronts Censorship in New York, Virginia, and Chicago," in *Movies, Censorship, and American Culture* (Francis G. Couvares, ed., Smithsonian Institution, 1996); "Headlines to Highlights: Oscar Micheaux's Exploitation of the Rhinelander Case," *The Western Journal of Black Studies* (Fall 1998); "Lynched, Assaulted, Intimidated: Oscar Micheaux," *Popular Culture Review* (February 1994); "Oscar Micheaux on the Cutting Edge: Films Rejected by the New York State Motion Picture Commission," *Studies in Popular Culture* (Spring 1995); "Oscar Micheaux, The Entrepreneur: Financing *The House Behind the Cedars,*" *Journal of Film and Video* (Spring/Summer 1997); and "The African-American Press and Race Movies, 1909–1929" in *Oscar Micheaux & His Circle.*

Other articles and books: Arna Bontemps, *The Harlem Renaissance Remembered* (Dodd, 1972); Herb Boyd, ed., *The Harlem Reader* (Three Rivers Press, 2003); Dave Findlay, "Mrs. Sewell Recalls Filming of Pictures Here . . ." in the *Roanoke World* (October 29, 1942); Susan Gilman, "Micheaux's Chesnutt," *PMLA* (October 1999); James Weldon Johnson, *Black Manhattan* (Knopf, 1930); Phylis R. Klotman, "Planes, Trains and Automobiles: *The Flying Ace,* the Norman Company and the Micheaux Connection," in *Oscar Micheaux & His Circle;* Richard Koszarski, *Fort Lee: The Film Town* (John Libbey Publishing, 2004); David Levering Lewis, *When Harlem Was in Vogue* (Random House, 1981); Claude McKay, *Home to Harlem* (Harper, 1928); Claude McKay, *Harlem: Negro Metropolis* (Dutton, 1940); Stephen F. Soitos, *The Blues Detective: A Study of African-American Detective Fiction* (University of Massachusetts Press, 1996).

CHAPTER ELEVEN: 1923–1924

"On August 1 a big white association . . ." is from *Billboard* (May 5, 1923).

All T. S. Stribling quotes are from his autobiography *Laughing Stock,* posthumously edited by Randy K. Cross and John T. McMillan (St. Luke's Press, 1982). From an edifying biography of the author, *T. S. Stribling: A Life of the Tennessee Novelist* by Kenneth W. Vickers (University of Tennessee Press, 2004), comes this footnote summarizing the film rights transaction for Micheaux's version of *Birthright,* as documented in Stribling's papers: "A royalty statement from the Century Company dated 30 Sep-

tember 1924 bears the only correspondence concerning the film. It carries the caption '¾ amount received—Micheaux Film Co. $94.75.' " This suggests, rather strongly, that Micheaux contracted the rights for approximately $125, and then, perhaps, as in the case of *The House Behind the Cedars,* skipped the last payment.

"According to a contract . . . etc.," is from D. Ireland Thomas's "Motion Picture News" column in the *Chicago Defender* (December 1, 1923).

Micheaux's statement at the Cleveland premiere of *Birthright* is from a Dec. 29, 1923, press release in the CWC archives. (Other versions were published in the black press.) "It was very well done . . ." is from CWC's January 29, 1924, letter to OM. "Many comments were uttered [by the audience] . . ." is from Walley Peele's review of *Birthright* in the *Philadelphia Tribune* (November 29, 1924).

The Virginia Motion Picture Censorship Board has records of all the correspondence pertaining to the disputed exhibition of *Birthright.* "Many objectionable features" and "Is an audacious violation . . ." are from a March 3, 1924, letter from the Chairman of the Censorship Board to the Chief of Police in Roanoke. C. Tiffany Tolliver is reported as denying "any present connection" to Micheaux in a March 13, 1924, memo of a Board of Censors meeting on the situation, which also contains "It touches upon . . ." OM's lengthy response of October 14, 1924 to the censorship board chairman is in the State of Virginia archives. The censorship board chairman's reply to OM ("Fails to excite commendation . . .") came on October 21, 1924, and the board's final report on the matter, in the form of a letter to the state auditor ("Somewhat pathetic story," "A sort of sop to conscience" and "At best can hope . . ."), is dated November 10, 1924.

"As wholesome and entertaining . . ." is from the *Norfolk Journal and Guide* (November 1, 1924). "Some may not like this production . . ." is from D. Ireland Thomas's column in the *Chicago Defender* (January 31, 1925).

For my information and perspective on *Body and Soul,* I am indebted to Charles Musser and especially his provocative essay "To Redream the Dreams of White Playwrights: Reappropriation and Resistance in Oscar Micheaux's *Body and Soul*" in *Oscar Micheaux & His Circle.* I also consulted Thomas Cripps's "Paul Robeson and Black Identity in American Movies," *The Massachusetts Review* (Summer, 1970); Martin Bauml Duberman's *Paul Robeson* (Alfred A. Knopf, 1988); *Paul Robeson Speaks: Writings, Speeches, Interviews* (Philip S. Foner, ed., Citadel Press, 1978); and, with the assistance of the Special Collections librarians at Moorland-Spingarn Research Center, Howard University, Eslanda Goode Robeson's diary. The casting of Robeson and Julia Theresa Russell is mentioned on the front page of *Variety* (November 26, 1924).

Versions of Micheaux's public statement at the premiere of *The House Behind the Cedars* were published in different newspapers. The one quoted here ("I have been informed that my last production . . .") is from a "signed," complete version reprinted in the *Pittsburgh Courier* (December 13, 1924). "I recall the thrill . . ." and all subsequent Elton Fax material comes from Pearl Bowser's interview with the artist-illustrator in the Museum of the Moving Image oral history collection.

"Very well done, but . . ." is from CWC's May 16, 1932, letter to his daughter. "Distorted and mangled . . ." is CWC from "The Negro in Art: How Shall He Be Portrayed: A Symposium," *The Crisis* (November 1926).

CHAPTER TWELVE: 1925–1927

Scholar Richard H. Broadhead is quoted from the Introduction to his edited volume of Chesnutt's *The Conjure Woman, and Other Conjure Tales* (Duke University Press, 1993).

A letter writer denounced *Body and Soul* as "filth" in the *Chicago Defender* (January 22, 1927). Maybelle Crew wrote about *Body and Soul* in her "Along the White Way" column in *The Afro-American* (September 11, 1926).

William Foster is quoted in *Migration to the Movies: Cinema and Black Urban Modernity.* Romeo L. Dougherty's column on Micheaux being "passé" is in the *New York Amsterdam News* (December 23, 1925). "A pimple on a bedbug's hindparts" is Lorenzo Tucker from "We Were Stars in Those Days." "Now showing the poor pictures . . ." is from Sylvester Russell's column in the *Pittsburgh Courier* (March 26, 1927).

Details of Robert Burton Russell's life and death proved maddeningly elusive. As far as I can determine, there are no archival copies of *The Maxton Blade* and no extant issues of *The Scottish Chief* from the time Russell was involved with the newspaper. I could not locate his death certificate (there are few North Carolina death records prior to 1909), and a local researcher tramped around area cemeteries without pinpointing his grave. I was aided by items from a "Maxton Area Centennial" booklet (published in 1974), some court and deed records, and context and information supplied by North Carolina historians Sam West, Charles Hensey, and Jane B. Hersch.

"Alice was so damn polished . . ." is from Pearl Bowser's 1988 interview with Carlton Moss in the Museum of the Moving Image oral history collection. "Pretty and charming" is from George Berkin's profile of "Hortense Tate, 104 Montclair Activist," in the *Newark Star-Ledger* (September 10, 2003). "I liked his approach . . ." is Bee Freeman from *Oscar Micheaux: Film Pioneer.*

"It was quite a social event . . ." is from the *Chicago Defender* (National Edition, April 3, 1926).

"Seven-thousand mile trip by auto . . . etc.," is from the *Chicago Defender* (September 24, 1927).

"It was the dawn of a new day . . ." is Ina Duncan in the *Pittsburgh Courier* (August 12, 1930). Ida Anderson's rejection of Richard E. Noman's salary offer is cited in "Planes, Trains and Automobiles: The Flying Ace, the Norman Company, and the Micheaux Connection." "If you could get $45 . . ." is Leigh Whipper from "We Were Stars in Those Days."

Myrtle Gebhart's article about the new "ebony heroes" of Hollywood "talkies" was in *Extension* magazine (November 1929). Evelyn Preer was profiled by Dorothy Manners in "Enter the Dixies," *Motion Picture Classic* (February 1929).

"The [race-picture] game is too fast . . ." is from the *Chicago Defender* (April 10, 1920).

My account of the Micheaux brothers' split, and the imbroglio over *The Millionaire,* is drawn largely from documents in the motion picture script files of the New York State archives One of the best accounts of OM's bankruptcy filing is in *The Afro-American* (February 25, 1928).

CHAPTER THIRTEEN: 1928–1931

"Why does the heroine . . ." is from Obie McCollum's "Things Theatrical" column in *The Afro-American* (May 5, 1928).

My chief source on Lorenzo Tucker (LT) is Richard Grupenhoff's invaluable *The Black Valentino: The Stage and Screen Career of Lorenzo Tucker* (Scarecrow Press, 1988), which reports the actor's life story and film career in detail. Tucker was extensively interviewed by Grupenhoff (a transcript of which was published as "Lorenzo Tucker: The Black Valentino," in *Black Film Review*, Spring 1988), although he was also interviewed for other books and documentaries. Except where I cite other sources, I am quoting Tucker from the Grupenhoff book.

"If you passed him [Micheaux] on the street . . ." is from "We Were Stars in Those Days." "Reminded me of a symphony orchestra leader . . . ," "Any time any other company . . . ," the "What's wrong with you . . ." anecdote and "In those days, Rudolph Valentino . . ." are from *Oscar Micheaux: Film Pioneer*. Chappy Gardner wrote about Micheaux in his January 5, 1929, column, and about black actors "too white" for Hollywood in his January 12, 1929, column, both in the *Pittsburgh Courier*.

Theophilus Lewis criticized *A Daughter of the Congo* in his "The Harlem Sketch Book" column in the *New York Amsterdam News* (April 16, 1930). "They saw Micheaux as an illiterate . . ." is CM from Clyde Taylor's illuminating "Oscar Micheaux and the Harlem Renaissance," in *Temples for Tomorrow: Looking Back at the Harlem Renaissance* (Geneviève Fabre and Michel Feith, eds., Indiana University Press, 2001). (A footnote cites the quote from a "transcript of Carlton Moss's interview, in author's private possession.") "Those circles never took Micheaux . . ." is CM from "Remembering Oscar Micheaux."

Other books: Alice Dunbar-Nelson, *Give Us Each Day, The Diary of Alice Dunbar-Nelson* (Gloria T. Hull, ed., W. W. Norton, 1984); Langston Hughes and Milton Meltzer, *Black Magic: A Pictorial History of the Negro in American Entertainment* (Prentice Hall, 1967).

CHAPTER FOURTEEN: 1931–1935

John Hammond wrote a glowing introduction to Jack Schiffman's biography of his father, but had more measured words, including recalling Frank Schiffman "talking about Negroes . . ." in *Showtime at the Apollo*.

"Rena, her brother, and Miss Molly . . ." is from Mrs. Ethel Williams's undated 1932 letter to CWC. "Rank plagiarism . . ." is from CWC's May 16, 1932, reply to his daughter.

"Sometimes we would get on the set . . . ," "When you finished . . . ," "We'd make these scenes at night . . . ," and "In railroad stations he had a trick . . ." are LT from *Oscar Micheaux: Film Pioneer*. "A lot of scenes in Bronx Park . . ." is LT from "We Were Stars in Those Days."

"Displaying an attitude of a man . . . ," "Made it clear that he wrote . . . ," "He saw the black population as two groups . . . ," "The actors pleaded with him . . . ," and "He said that if a black man . . ." are CM from "Remembering Oscar Micheaux." "Declassed, meaning . . ." and "She'd edit [the scripts] . . ." are from Pearl Bowser's interview with CM in the Museum of the Moving Image oral history collection.

"Personally, I think *Veiled Aristocrats . . .*" is from the *Chicago Defender* (June 18, 1932).

The Lucille Lewis lawsuit is reported in the *Chicago Defender* (May 21, 1932). The Hooten-Hooten lawsuit is chronicled in *The Afro-American* (October 3, 1931). Micheaux's first arrest in the Schiffman court action ("Collected money which he failed to turn into the company offices . . . ," etc.) is recounted in the *Chicago Defender* (November 26, 1932), while his second is reported in *The Afro-American* (October 7, 1933). Ralph Matthews wrote "An Open Letter to Mr. Oscar Michaux [sic]" in *The Afro-American* (May 20, 1933).

Donald Bogle's 1930 statistics of black employment in "white" Hollywood are from *Bright Boulevards, Bold Dreams: The Story of Black Hollywood* (Ballantine, 2005).

The dialogue transcript from *Lem Hawkins' Confession* and the testimony from Leo Frank's trial are culled from longer excerpts in "Oscar Micheaux and Leo Frank: Cinematic Justice Across the Color Line." Lou Layne wrote about *Lem Hawkins' Confession* in his "Moon Over Harlem" column in the *New York Age* (May 25, 1935). "A mixture of the old and new . . ." and "Capacity houses in Dixieland . . ." are from the *Atlanta World* (May 7, 1934).

Other articles and books: Michael Bronski, "The Return of the Repressed: Leo Frank Through the Eyes of Oscar Micheaux," *Shofar* (Summer 2005); Ted Fox, *Showtime at the Apollo* (Holt, Rinehart and Winston, 1983); Rusty E. Frank, *Tap! The Greatest Tap Dance Stars and Their Stories, 1900–1955* (Morrow, 1990); Jack Schiffman, *Apollo Uptown: The Story of Harlem's Apollo Theatre* (Cowles, 1971); Jack Schiffman, *Harlem Heyday* (Prometheus, 1984).

CHAPTER FIFTEEN: 1936–1940

The backstory of the Sack brothers was compiled from local clippings from the Dallas and San Antonio public libraries, including many small items from the *San Antonio Jewish Weekly* and *Jewish Press*. The statistics about black theaters came from various news items and also from "Hollywood in the Bronx," *Time* (January 24, 1940).

"Southern hymn singing . . ." and "A faster tempo . . ." are from the *Atlanta World* (May 7, 1934). "Not as buffoons . . ." is from "Col. Julian Outshines *Elinor Lee* Premier" in the *New York Amsterdam News* (January 20, 1940).

"I used to go to their house . . ." and "I said to him once . . ." are LT from *Oscar Micheaux: Film Pioneer.* "The big problem is getting . . ." is from Ralph Matthews's "Mixing Sex, Rhythm and Romance Is Job of Pioneer Producer of Sepia Film" in *The Afro-American* (February 27, 1937), an article that also specifies some costs of production of Micheaux's 1930s films. The anecdote about the "pair of wastrels" Andrew Bishop and Lorenzo Tucker comes from the Grupenhoff book.

I am indebted to Joe Mosbrook's "Jazzed in Cleveland," a special WMV Web News Cleveland series at www.cleveland.oh.us.wmv_news/jazz, for details of the musical career of Carman Newsome. "We don't have the money to spend . . ." is from W. Ward Marsh's "Colored Star Brings His Own Films Here; Shows First at Globe Theater" in the *Cleveland Plain Dealer* (October 19, 1938). This is the interview with Newsome that credits the authorship of "Naomi, Negress" to Alice B. Russell.

The filming of *Birthright* in "the heart of South Jamaica" comes from a rare on-set glimpse of Micheaux at work in the *New York Amsterdam News* (November 6, 1937).

The Harlem protests against *God's Stepchildren* were chronicled in "Motion Picture Is Withdrawn After Protest in New York" by John Harding in the *New York Age* (May 28, 1938). The Boston protests were reported in "Show *God's Stepchildren* in Boston Despite Protests" in the *New York Amsterdam News* (December 9, 1938).

"Nixed . . . in favor of pictures . . ." is from the *New York Amsterdam News* (September 30, 1939). Clarence Muse wrote about Micheaux in his "What's Going on in Hollywood" column in the *Chicago Defender* (February 24, 1940).

"Only three days" is Edna Mae Harris as interviewed by Delilah Jackson in the Hatch-Billops archives; the Edna Mae and (her sister) Vivian Harris interviews were published in *Artist and Influence 1991, Volume X,* James V. Hatch and Leo Hamalian, eds. (Hatch-Billops Collection, 1991). Other quotes from Harris are drawn from Richard Grupenhoff's interview with the actress in the Museum of the Moving Image oral history collection. Harris is also interviewed ("After we made all these pictures . . .") in Pearl Bowser's film *Midnight Ramble.* Frances Williams is quoted from Pearl Bowser's interview with the actress in the Museum of Moving Image collection.

The story of Micheaux and Hubert Julian's partnership is derived from the following main sources: the page-one article "Col. Julian Outshines Elinor Lee Premiere" in the *New York Amsterdam News* (January 20, 1940); "Hollywood in the Bronx" in *Time* (January 29, 1940); Julian's memoir (as told to John Bulloch), *Black Eagle: Colonel Hubert Julian* (The Adventurers Club, 1965); and H. Allen Smith's column as reprinted in *Low Man on a Totem Pole* (Doubleday, 1944).

Other articles and books: "The Celluloid Sister: (Mis) Representation of the Black Female On Film," *Michigan Citizen* (July 31, 1999); Richard Corliss, "Black Cinema: Micheaux Must Go On," series of web-exclusive articles for www.time.com in May-June, 2002; M. Green, "Harlem's Fabulous Flyer," *American Mercury* (February 1941); J. (James) Hoberman, "A Black Pioneer: The Case of Oscar Micheaux," *No Rose* (Fall, 1976); James Earl Jones (with Penelope Niven), *Voices and Silences* (Scribner's, 1993); Charles H. Martin, *The Angelo Herndon Case and Southern Justice* (Louisiana State University Press, 1976); Clyde Taylor, "The Crisis of 1937–1939: Crossed Over & Can't Get Black," *Black Film Review* (Vol. 7, Issue 4); Wilson Record, *The Negro and the Communist Party* (Atheneum, 1971).

CHAPTER SIXTEEN: 1941–1947

Details of Micheaux's life as a writer in the early 1940s are drawn from his novels, especially *The Case of Mrs. Wingate* and *The Story of Dorothy Stanfield,* both of which feature his alter-ego character, the "former" race-picture producer Sidney Wyeth. I was guided by fingerpoints in the "Biographical Backstory" of *With a Crooked Stick—The Films of Oscar Micheaux.*

"It will tell the story . . ." is from *Time* (January 29, 1940). Micheaux's ("Over 300 pounds") continuing friendship with Ernest Jackson is reported in "Negro Who Homesteaded in Rosebud Now Big Man in U.S. Moving Pictures" in the *Sioux Falls Daily Argus-Leader* (March 4, 1940). "I've reviewed a lot of books . . ." is Constance Curtis as quoted by Elton Fax in the Bowser interview.

"Undoubtedly, he placed more books . . ." is CM from "Remembering Oscar Micheaux." "The biggest single success" is from Micheaux's obituary in the *New York*

Amsterdam News (April 7, 1951). "Instead of calling him Mr. Micheaux . . ." is LT from *Oscar Micheaux: Film Pioneer.*

I have quoted J. Ronald Green on Micheaux's "plagiarism" of *The House Behind the Cedars* from my e-mail correspondence with him on the subject.

"To get back into pictures . . ." and all subsequent quotes from Alice B. Russell (Mrs. Oscar Micheaux) are from her January 7, 1948, letter to "my dear sister Ethel," one of Micheaux's sisters, living in Kansas. This letter was obtained by Richard Grupenhoff during his researches and published in its entirety as part of his article "The Rediscovery of Oscar Micheaux, Black Film Pioneer," *Journal of Film and Video* (Winter 1988). "To have this thing so I can sit in my office . . ." is from "We Were Stars in Those Days."

CHAPTER SEVENTEEN: 1947–1951

The postproduction of *The Betrayal* ("days of virtual amputation") is described from publicity material courtesy of Leroy Collins. This material includes " 'The Negro and the Photoplay,' a statement by Oscar Micheaux, author and producer of the superproduction, *The Betrayal.* "

"Around 1949 or so" and "I don't go out now . . ." are from "We Were Stars in Those Days." Micheaux's achievements as a novelist were highlighted in Constance Curtis's article, "Novelists As Part of Past Forty Years," in the *New York Amsterdam News* (December 10, 1949).

There is some ambiguity about the date of Micheaux's death, even. His death certificate says March 25, 1951, which was Easter Sunday. The *New York Amsterdam News* account of his death says he died on "Easter Monday." The Great Bend funeral card for his memorial services says March 27, 1951. Until further evidence emerges, scholars have agreed on March 25, 1951—which is inscribed on his tombstone.

My information on the rediscovery and restoration of Micheaux's films comes principally from issues of the *Oscar Micheaux Society Newsletter* and G. William Jones's book *Black Cinema Treasures: Lost and Found* (University of North Texas Press, 1991).

Other articles and books: David T. Friendly, "An Overdue Honor for Film Pioneer," *Los Angeles Times* (May 17, 1986); Richard Gehr, "One-Man Show," *American Film* (May 1991); National Association for the Advancement of Colored People, "Out of Focus, Out of Sync, Take 3," A Report on the Film and Television Industry (November 2003); "Oscar Micheaux Given Special Award By DGA," *Variety* (May 10, 1986); Saundra Sharp, "At Long Last: Director's Guild Honors Oscar Micheaux," *Black Film Review* (Summer 1987).

FILMOGRAPHY

Key sources: *Oscar Micheaux & His Circle;* Bernard L. Peterson Jr., "A Filmography of Oscar Micheaux: America's Legendary Black Filmmaker," in *Celluloid Power: Social Film Criticism from* The Birth of a Nation *to* Judgment at Nuremberg (David Platt, ed., Scarecrow Press, 1992); Bernard L. Peterson, Jr., *The African-American Theatre Directory, 1816–1960* (Greenwood Press, 1997); *Black Entertainers in African-American Newspaper Articles, Volume 1;* Larry Richards, *African-American Films Through 1959* (McFarland, 1997); *Blacks in Black and White: A Source Book on Black Films;* and my own supplemental research.

PERMISSIONS

PHOTOGRAPHS AND ILLUSTRATIONS:

Photographs of Micheaux from the *Simms' Blue Book and National Negro Business and Professional Directory* and at the M.O.W.M. Bookstore in Harlem, courtesy of the General Research and Reference Division, Schomburg Center for Research in Black Culture, the New York Public Library, Astor, Lenox and Tilden Foundations; Micheaux's Pullman porter records courtesy of Pullman Archives, the Newberry Library, Chicago; re-creation of "Oscar's homestead in South Dakota" courtesy of Don Shorock and the website www.micheaux.org; group portrait of the Lafayette Players courtesy of Sister Francesca Thompson; newspaper photograph of Shingzie Howard, stills of *The Homesteader* and *Birthright* (sound version), frame enlargements from *Within Our Gates* and *Body and Soul,* and newspaper advertisement for *The Symbol of the Unconquered* courtesy of Pearl Bowser, Jane Gaines, and Charles Musser, *Oscar Micheaux & His Circle,* and the Oscar Micheaux Society; all photographs from Pearl Bowser's collection courtesy of African Diaspora Images; photograph of Lorenzo Tucker from *The Black Valentino*; frame enlargements (with Micheaux) from *Lem Hawkins' Confession,* courtesy of Matthew Bernstein; promotional material for *Murder in Harlem, Birthright,* and *God's Stepchildren* courtesy of the W. Ward Marsh Cinema Archives, Cleveland Public Library; advertisement for *The Betrayal* courtesy of Leroy Collins; special thanks to Allied Digital Photo, Mequon, Wisconsin.

CITATIONS:

Charles Waddell Chesnutt papers, Western Reserve Historical Society, Cleveland, Ohio; George P. Johnson Negro Film Collection, University of California, Los Angeles; George P. Johnson Oral History, Special Collections, University of California, Los Angeles; Richard E. Norman Collection, Lilly Library, Indiana University; Paul and Eslanda Goode Robeson Papers, Moorland-Spingarn Research Center, Howard University, Washington, D.C.; Oral Histories of Edna Mae Harris (interview by Richard Grupenhoff), Elcora "Shingzie" Howard McClane (interview by Pearl Bowser), Carl-

ton Moss (interview by Bowser) and Frances Williams (interview by Bowser) are from the "From Harlem to Hollywood" collection of the American Museum of the Moving Image, Astoria, New York.

Portions of chapter 17 originally appeared in *Film Quarterly* and the *Los Angeles Times*.

INDEX